WOMEN AND RELIGION
A Bibliographic Guide to
Christian Feminist Liberation Theology

Among the many institutions throughout Western society that have been affected by the women's movement, organized religion has had one of the most difficult struggles. A new consciousness among many Christian women recognizes that the experience of countless women within the institutional church and its traditions has been shaped by patriarchal oppression. Today the role of women in the church and the contribution of women to its leadership and future are hotly debated issues.

This bibliography offers a catalogue of resources for teachers and students wishing to explore these issues. Its entries include books, articles, dissertations, reports, and other useful materials published between 1975 and 1988.

The topics range through the Bible, the history of the Christian church, Judaism, inclusive language, sexism, Mariology, the Christian ministry, pastoral care, spirituality, worship, and related topics. The focus throughout is on Christian feminist resources.

This is an invaluable sourcebook for all those in theological, religious, political, and women's studies who focus on the reality of women's lives within the church.

Shelley Davis Finson is Associate Professor of Pastoral Theology, Atlantic School of Theology, Halifax.

Women and Religion

A Bibliographic Guide to
Christian Feminist
Liberation Theology

compiled by

Shelley Davis Finson

UNIVERSITY OF TORONTO PRESS
Toronto Buffalo London

© University of Toronto Press 1991
Toronto Buffalo London
Printed in Canada

ISBN 0-8020-5881-7

Printed on acid-free paper

Canadian Cataloguing in Publication Data

Finson, Shelley
 Women and religion

 Includes index.
 ISBN 0-8020-5881-7

 1. Feminist theology – Bibliography. 2. Women in
 Christianity – Bibliography. 3. Liberation
 theology – Bibliography. 4. Feminism – Religious
 aspects – Christianity – Bibliography. I. Title

 Z7963.R45F5 1991 016.23'0046 C91-093714-1

Contents

Acknowledgments

In April 1987, the Atlantic School of Theology Library was awarded a 'Challenge 1987' grant from Employment and Immigration Canada. This grant was used to begin the research for a bibliography of resources in the area of feminist liberation theology. The initial money allowed for the hiring of three students: a project director, a bibliographer, and a typist. Later, other money was granted by several church agencies, including the Women in Ministry Committee of the United Church of Canada, the United Church faculty group of Atlantic School of Theology, and the Ecumenical Foundation of Canada.

The bibliography is the first of its kind in Canada. Many students were involved in the project. Researchers included Marie Esdon, Margaret Harrison, Nancy MacLeod, Anne McKnight, Jennifer Uhryniw, and Nancy Warder. Their enthusiastic participation and the work of Donna Wallingham, Carol Anningson, Megan Ardyche, Brenda Conroy, and Debbie Mathers in preparing the manuscript are gratefully acknowledged.

Several Canadian feminist theological educators and women who work in the church provided feedback at different stages of the production of the bibliography. In particular I would like to thank Barbara Elliot, Charlotte Caron, Glenys Huws, Helen Hobbs, Ann Naylor, Wendy Hunt, Margaret O'Gara, Mary Rose D'Angelo, Mary Malone, Jane Doull, Marilyn Legge, Eileen Schuller, Carol Penner, Pamela Dickey Young, and Gwyn Griffith. Their help was essential to the development of the project.

Barbara Rumscheidt has given me ongoing support and encouragement throughout this project. Her assistance in writing the introduction enabled me to finally bring the work to completion. Betty-Ann Lloyd, Jacob, Alice, and Tramp provided a day-to-day domestic structure and the kind of emotional and spiritual care needed during a long journey.

None of the work could have been accomplished without the willing and competent help of the staff in the library of Atlantic School of Theology. Lloyd Melanson, the Technical Services Librarian, provided extraordinarily useful feedback as an editor and Alice Harrison, Head Librarian, and the rest of the library staff provided direction and support. The efforts of these people made the project possible.

As the faculty person accountable for the administration, oversight, and supervision of the project, I carried the final responsibility for the selection or rejection of resources in the bibliography. I trust that this bibliography will serve as a base for future entries as the field of women and theology continues to grow.

Introduction

Since the late sixties the resources that address the issues confronting women and the Christian church have been growing in volume. Increasingly, academic courses have been developed on a broad range of issues which are being examined under such topics as Feminist Liberation Theology, Women in the Bible, and the Pastoral Care of Women. Issues such as the ordination of women and inclusive language have been hotly debated in most of our churches. At the same time there is a growing interest in the contribution of women to the history of the church, its leadership, and its future. This burgeoning Christian feminist movement has generated a need for the means to identify and make available the volume of existing documentation of this experience. Recognition of this need has been the motivating factor for the production of this particular bibliography. Its primary purpose is both to demonstrate the range of Christian feminist liberation resources and to make such resources accessible to teachers and learners in this field. The bibliography aims to provide a reasonably accessible catalogue of resources for teachers in theological education and in religious and women's studies. In doing so it will also provide resources from a feminist perspective for those who are interested in subjects related to women and the Christian church.

Focus and Scope

The focus of the bibliography is Christian feminist liberation resources. This means that resources which address the subject of women and the church are included only when they come from a Christian, feminist, and liberation perspective or when they have a significant impact on that perspective.

What understanding of the terms Christian, feminist, and liberation has informed the selection process and determined criteria for inclusion or exclusion? Posed in the light of the purpose of this bibliography, this question does not lend itself to a definitive or categorical answer. Rather, it relates to the whole process and method of Christian theology done from a feminist, liberationist perspective. This involves several dynamics present in the lives and faith experience of some Christian women. These dynamics include: conscious critical reflection on our experience of the Christian church and its tradition; rejecting or denouncing what we have experienced as oppressive in that tradition; reconstructing what we find usable; and announcing what we experience as a liberating source of new life.

What has been included in this bibliography are resources known to be engaged in this liberating process and actualizing the critical consciousness which gives rise to it. Excluded are those resources relating to women and the church in which this critical consciousness is not discernible, or those for which it is judged to be irrelevant or hostile. It should be noted, of course, that existing materials missing from this bibliography should not necessarily be viewed as those found unsuitable for inclusion. The comprehensiveness of the bibliography is limited by constraints of time and resources as well as by its own criteria for inclusion. The overall focus and scope become more apparent in the explanations provided for the range and limits of each chapter.

Data Base

This is a bibliography of books, anthologies, journal articles, special issues of journals, dissertations, newsletters, reports, study kits, and other resources published during the years 1975–1988. A few significant early resources published between 1969 and 1975 have also been included.

The bibliography incorporates citations from various sources:
a) The resources of the Atlantic School of Theology in Halifax, Nova Scotia;
b) The data base of NOVANET (the computer network linking the libraries of Dalhousie University, St. Mary's University, Mount Saint Vincent University, Technical University of Nova Scotia, and Nova Scotia College of Art and Design, all in Halifax, Nova Scotia);
c) The National Library of Canada DOBIS data base, used through the facilities of the Nova Scotia Provincial Library;
d) Various publications of the American Theological Library Association:

Religion Index One: Periodicals (1977–1988),
Religion Index Two: Multi-Author Works (1970–1988),
Index to Religious Periodical Literature (1975–1976),
*Women and Religion: A Bibliography Selected from the ATLA Religion
Database* (covering period up to and including November 1983);
e) Canadian and American dissertation indexes for the period 1970–
1988: *Dissertation Abstracts International* (UMI) and *Canadian Theses/
Thèses canadiennes* (National Library of Canada);
f) Various suggestions from colleagues across Canada.

Contents

The selection and organization of the contents of the bibliography have
involved dealing with the highly integrated nature of the subject-matter.
Seemingly discrete topics have been identified, e.g. theology, Bible,
spirituality, pastoral care. However, many items within a category could
easily be cross-listed in another or several other categories. As in other
areas of feminist study, one is rarely dealing with an isolated topic or
with just one dynamic of an issue. The multi-dimensionality of the
subject-matter can be accounted for in several ways.

Feminist methodology is characterized by a unity of theory and
practice resulting from the process in which women reflect on and
analyse their collective experience and name the structures which
oppress them. The documentation of this process and its conclusions,
although analytical and theoretical, is often expressed in terms which
are descriptive of the concrete experience upon which it is based, e.g.
the experience of exclusion from ordination. Therefore, an item osten-
sibly about women's ordination may also be found to be dealing with
history, theology, ministry, etc. Or, a dissertation on the pastoral care of
women may be based on material which would be appropriate to the
chapter on theology or spirituality.

In addition to the theorists' common experience of oppression, there
is another factor which contributes to overlap and interdependence in
feminist theological scholarship. The nature of the process is such that
those working in this field may be documenting different phases of the
discipline. For example, in addressing an issue such as inclusive lan-
guage, they may be working in the deconstruction phase with historical
data, or in the reconstruction or methodology phase with biblical and
theological categories. Their work might be found relevant for chapters
listing resources on language, history, theology, or Bible. Therefore,
users of this bibliography may expect to find the resources it includes in
the various chapters to be highly interrelated and seldom, if ever,

mutually exclusive. The chapter divisions, although not arbitrary, have been made in the light of this interdependence. In the interests of length, the bibliography has not cross-listed resources. For this reason, it is emphasized here that in dealing with these resources documenting the experience of Christian feminism, one is rarely dealing with a specific topic in isolation from a larger process of analysis, reflection, and action.

The contents of this bibliography are almost all in English, the work of writers in Canada and the United States, although there are references to works by francophone writers. Also included are limited resources of Jewish-Christian dialogue and some perspectives from women in non-industrialized countries as well as the Goddess/Wicca traditions.

Chapter 1 – Bible

This chapter identifies work reflecting a feminist critique of the Hebrew and Christian texts which constitute the Christian Bible. It incorporates several broad themes which are usually addressed generally, or specifically, within a critique of patriarchy. Works relating to the theme of women in the Bible examine the presentation of women in biblical tradition as a whole, and the role and status of women in that tradition. Or, they examine the stories of specific biblical women and how those stories have functioned in the Christian tradition. Then there are works which introduce, develop, and discuss principles and method for feminist exegesis and hermeneutics. Such titles document the experience of women who read the Bible from a feminist perspective. They incorporate the findings of those who have reflected on biblical texts and themes in the light of women's experience. These titles range from specific work on particular texts, themes, and genres (e.g. parables) to more comprehensive work demonstrating feminist analysis of traditional understandings of the authority and interpretation of Scripture.

Chapter 2 – History

This chapter lists resources which record and analyse the past experience of women in the Christian church. Such works examine the historical role of women in the polity and practice of the church and interpret how the institutional church has viewed women. Some titles provide comprehensive recapturing of the invisible (lost or subjugated) history of women's activity in and contribution to the life of the church. Others document the history of women's resistance in a male-dominated church. These topics are pursued in works about women in specific periods of

history or in particular religious orders or denominations, or their engagement in various religious/political movements. There are titles dealing with the lives and faith experiences of individual women and of groups of women. This historical material is mostly limited to work which documents the lives of women whose involvement in the church reveals or actualizes some degree of critical feminist consciousness.

Chapter 3 – Judaism

While this chapter by no means includes all available material, it does contain the range of topics covered in the bibliography as a whole, featuring works which approach these topics from the context of the experience of Jewish women. This perspective is included in a bibliography of Christian feminist liberation resources because of the close relationship between Christianity and Judaism and, therefore, the relevance for Christian feminists of the experience of feminists within Judaism. The chapter includes works on the role and status of women in Judaism, and the experience of being feminist and Jewish. There are also titles which address issues for Jewish feminist theology and Jewish feminist critique of Torah. These works, as well as those dealing with women as rabbis, are consciously included in this chapter rather than in chapters dealing with the Bible, feminist theology, women and ministry, etc. Such works are here perceived to be dealing with issues of feminist biblical criticism, feminist theology, and ordination of women which arise out of women's experience within Judaism. This is distinctively different from but comparable to women's experience within Christianity. The chapter includes works dealing with Christian-Jewish dialogue, which not only provide discussion of different and comparable experiences of the oppression of women, but also raise issues such as Christian feminism and anti-Semitism. These are resources for understanding the Jewish feminist critique of Judaism. They may reveal some shared analysis with regard to Christian feminist critique of the Judeo-Christian tradition. But the works included in this chapter demonstrate that Christian feminism has been experienced as anti-Jewish and this phenomenon shows how feminist existence within Judaism is a distinct experience which must be treated as such.

Chapter 4 – Language

This chapter contains the substance of a debate. A sampling of the titles listed reveals the polemical style and content of these resources for exploring and understanding this debate:

On the Meaning of 'Man' and Maybe 'Woman'
'Ye That Are Men Now Serve Him' ... or Did We Really Sing That in
 Chapel This Morning?
The Language of Unequal Opportunity
God Our Father and Mother: A Bisexual Nightmare from the
 National Council of Churches
Hymn Tinkering: Gnats or Camels?
Beyond the He-Man Approach: The Case for Non-Sexist Language
The God of the NCC Lectionary Is Not the God of the Bible
God-Talk after the End of Christendom
De Divinis Nominibus. The Gender of God

These resources include works which raise and discuss issues inherent in the inclusive language debate in the church. Such issues focus on the relationship of language to epistemology, the analysis of the power dynamics of language (e.g. the power to name one's reality), and the dynamics of identifying sexist language and of naming God and one's experience of God. The chapter also contains references for guidelines and study materials promoting the use of religious language and god-language which is inclusive and non-sexist. These added listings include language lectionaries and other worship resources useful for workshops and other teaching/learning situations.

Chapter 5 – Mariology

The increased volume of works examining Mariology, i.e. belief systems and faith traditions about Mary, the mother of Jesus, is a good example of how the field of feminist theology has expanded. Feminist analysis of Christianity has always pointed to traditions about Mary as prime evidence of patriarchal ideology and theology. From being one of many subjects of attention in an overall feminist critique of Christianity, Mariology has become a particular focus for in-depth study, particularly by Christian feminists. This chapter contains resources which reflect such activity around questions of what has been taught, preached, believed, rejected, or reconstructed about Mary. They include works which examine the biblical and historical tradition to see how Mary has been presented and explore images such as Virgin Mary, Virgin Mother, Mother of God, Mother of Jesus. Other works concentrate on how such images have functioned in the tradition and how they have affected the faith and lives of women. Identification of patriarchal interests vested in particular images of Mary has been part of this analysis of the nature and role of Mariology in the biblical tradition and in the worship,

liturgy, and practice of the church. The titles indicate many layers and dimensions in this analysis, from Mary and the eternal feminine, Mary and feminism, Mary and feminist theology, to Mary as a theological symbol and Mary as a model of faith and discipleship. This chapter also includes works focusing on the Mary of the 'Magnificat' and the contemporary phenomenon of Mariology in a liberation mode in which Mary functions as a paradigm for liberation.

Chapter 6 – Ministry

This chapter focuses on resources which specifically document and reflect on the actual experience of women in ministry in the Christian church. However, these works play an important role in the larger task of feminist liberation theology. They provide a tangible data base for determining how, through the way it has defined and deployed women, the church has shaped women's role in the ministry of the church. By implication they provide insight into how the church, through its theology, doctrine, liturgy, and worship, has objectified its beliefs about women, who they are, and what purpose they are intended to serve. This chapter lists works which try to recover and document the struggle of Christian women for inclusion, recognition, and full partnership in the church. These works, historical and contemporary, reflect a critical process in which women vision, actualize, and re-vision on the basis of their experience their role in the ministry of the church. Analysed collectively and individually is the experience in ministry of lay women, women in religious orders and diakonal ministry, and ordained women. This chapter contains resources dealing with the many dimensions – biblical, theological, ecclesial, political – of the historical and contemporary debate regarding the ordination of women. These resources not only rehearse the traditional arguments for and against women's ordination but also reflect the faith experience which has confirmed women in their role as ordained clergy and has affirmed them in their ministry.

Chapter 7 – Pastoral Care

The resources listed in this chapter provide insight gained from pastoral theology and pastoral psychology done from a feminist perspective. They focus on Christian feminist understandings of care for women and the pastoral care exercised by women. The titles include works on feminist counselling which range from discussions of what constitutes feminist counselling and how it is practised to issues for counselling

which is informed by a Christian feminist critique. There are resources listed which are concerned with pastoral care of women in crisis due to abuse, poverty, homelessness, unwanted pregnancy. These resources often include social analysis of these situations of crisis. There are also works dealing with issues of identity, assertiveness, and sexual self-determination. In the selection of the titles for inclusion in this chapter, criteria have been applied which should be identified. They originate in what feminist analysis has found to be gender-based, religiously grounded obstacles to wholeness in women. Relatively absent in this chapter are resources for counselling women in distress due to alcoholism, psychological depression, bereavement, terminal illness, or other situations addressed by mainstream pastoral care resources. This chapter focuses rather on resources which are experienced to be relevant to a Christian feminist critique of the pastoral care of women who live in the context of patriarchal power structures, in particular, female victims of male violence. Included are resources which acknowledge the accountability of the church, ministers, priests, counsellors, and others who name themselves Christian, for patterns and traditions of pastoral care which have been unsupportive or harmful to women. There are works listed which diagnose Christian understandings of sin, suffering, obedience, forgiveness, reconciliation, and other theological themes and their implications for the well-being of women. There are works which indict theology, faith language, or any religiously based attitudes or ideologies which deny or mystify the reality of male violence against women. Included are resources which document the work of deconstruction of patriarchal modes of pastoral care and the reconstruction of liberating, redemptive responses based on a feminist analysis of male violence in the light of a feminist reading of the Bible.

Chapter 8 – Religion and the Church

This chapter contains resources which provide the structural analysis upon which the feminist critique of sexism is based. It concentrates on the work of those who articulate a feminist critique of religion and especially the sexism inherent in Christianity and the Christian church. Titles included are those engaged in identifying the defining sexism and those naming women's experience of sexism in the church. These works describe what exists, analyse why that reality exists, vision what should exist, and consider strategy for changing reality. These are works which constitute a challenge to patriarchy and its religion. These resources incorporate and demonstrate the theory and practice of feminist critique. Some works are engaged in re-visioning Christianity and provid-

ing models for Christianity in women's voice. They envision trans-
formed structures and power relationships and they set a feminist
agenda for the church. Although these resources as a whole originate
from those who share a common identity as Christian feminists, some
reflect black women's consciousness and some name a denominational
or theological identity, e.g. Baptist, Roman Catholic, evangelical.

Chapter 9 – Spirituality

Women's spirituality as a distinct and unique phenomenon is the focus
of the resources in this chapter. Works included explore various aspects
of the nature and source of women's spiritual energy and the religious
forms it takes. These resources provide insight into the experiential
basis of Christian feminist theology and feminist reimaging of God.
They show how female experience of the divine becomes objectified in
new expressions of spirituality and new metaphors for God. These
resources document the ways in which women actualize themselves
and each other in the affirmation of their religious and spiritual ex-
perience. In addition to the work of women who record their spiritual
experience out of a Christian consciousness, this chapter contains some
resources about the traditions of the Goddess and Wicca (a term for
witchcraft dating from Anglo-Saxon times). Such resources include
writings from those traditions themselves, historical material, and
expository works. These resources are included in this chapter to shed
further light on the nature and scope of women's spirituality. Although
not exhaustive, they are consciously included in a bibliography of
Christian feminist liberation theology because they represent liberating
traditions which are important, life-giving resources for women en-
gaged in deconstructing patriarchal religious traditions and reconstruct-
ing the foundations of their spiritual life.

Chapter 10 – Theology

Although theology is implicit in most of the resources in the bibliog-
raphy, this, perhaps the most extensive, chapter contains resources
which are explicitly and definitively theological. They constitute the
work of women and a few men who have documented their own and
others' experience of doing theology from a feminist perspective. These
theological works are not in the mode of systematic theology, i.e. theo-
logical systems which explain the nature of God and the relationship
between the divine and the human. Rather, they incorporate critique of
such theological systems in the light of women's experience of God.

They examine theological themes such as grace, Christology, the Trinity, redemption, sin, and eschatology and they pose questions to the received traditions concerning these themes. They ask what these traditions have taught, what women have learned, and how we have been affected by what we have learned. Women ask whom these traditions have empowered or disempowered. Such works may address the task of identifying the usable elements of the Christian tradition. They may engage in a reconstruction of a transformed tradition on the basis of women's experience of liberation/salvation/redemption. Some of these resources centre around the problematic of imaging God; others are concerned with theological methodology. Some provide overall theoretical grounding for feminist hermeneutics and exegesis. Others examine particulars such as the androcentrism of Christian anthropology or the misogynous content in patristic writings. There are works listed which provide resources for feminist ethics. Again, these titles include works which critique traditional male approaches to Christian ethics and offer new paradigms and new ethical understandings of such concepts as the Realm of God.

This chapter includes the experience and more recent writing of women in non-industrialized countries and the voice of those doing theology out of concrete engagement in struggles for economic, political, and sexual liberation. These global perspectives embody theological reflection based on a different reading of Scripture, i.e. a reading of the Bible with different eyes than those of Western, white Christian culture and ideology.

Because the process of feminist liberation theology determines how it is taught and learned, this chapter also includes resources related to religious and theological education. It contains work which examines and critiques traditions of Christian education and offers feminist alternatives for both seminary and field-based learning as well as congregation-based study. These works concentrate particularly on the theological education of women, both lay and ordained, and identify issues arising from feminist understandings of God, church, and ministry.

Chapter 11 – Worship

This final chapter deals with what might be considered objectifications of Christian feminist faith experience, namely, worship and liturgy. Included are works related to homiletics, especially preaching by and for women, and principles of feminist preaching. Some of these works contain analytical, theoretical discussion about homiletics, while others

represent actualized Christian feminist consciousness in such forms as sermons and reflections. This chapter also includes Christian feminist resources for liturgy and worship, women's rituals and meditations, and works which discuss women's worship.

Appendix

The appendix lists several bibliographies and some journals and news-letters on the topic of women and religion. This appendix is not all-inclusive but is meant to suggest to the reader some ongoing resources which should be consulted to keep up-to-date on the topic.

WOMEN AND RELIGION

1

Bible

General – Hebrew and Christian Texts

BOOKS, DISSERTATIONS, COLLECTED WORKS

Achtemeier, Paul J., ed. *The Bible, Theology and Feminist Approaches.*
Special issue of *Interpretation: A Journal of Bible and Theology*, Vol. 42,
No. 1 (Jan. 1988).

Bacchiocchi, Samuele. *Women in the Church: A Biblical Study on the Role of
Women in the Church* (Biblical Perspectives, 7). Berrien Springs, MI:
Biblical Perspectives, 1987.

Bal, Mieke. *Lethal Love: Feminist Literary Readings of Biblical Love Stories.*
Bloomington: Indiana University Press, 1987.

Bergant, Dianne, ed. *Biblical Update: Esther and Judith.* Special issue of
*Bible Today: A Periodical Promoting Popular Appreciation of the Word of
God*, Vol. 24, No. 1 (1986).

Bilezikian, Gilbert A. *Beyond Sex Roles: A Guide for the Study of Female
Roles in the Bible.* Grand Rapids: Baker Books, 1985.

Carmichael, Calum M. *Women, Law, and the Genesis Traditions.* Edin-
burgh: Edinburgh University Press, c1979.

Collins, Adela Yarbro, ed. *Feminist Perspectives in Biblical Scholarship.*
Atlanta: Scholars Press, 1985.

Deen, Edith. *All the Women of the Bible.* New York: Harper and Row,
1988.

Dumais, Monique. *Les femmes dans la Bible: Expérience et interpellations.*
Montreal: Socabi, 1985. In Spanish: *Las mujeres en la Biblia: Experiencias
y interpelaciones.* Madrid: Ediciones Paulinas, 1987.

Exum, Cheryl J., and Johanna W.H. Bos, eds. *Reasoning with the Foxes:
Female Wit in a World of Male Power.* Special issue of *Semeia: An
Experimental Journal for Biblical Criticism*, No. 28 (1983).

Filer, Kathryn Irish. 'The Lost Coin: Guiding a Congregation in Reclaiming Feminine Biblical Images for God and Incorporating Them into Life and Worship.' Dissertation, Pittsburgh Theological Seminary, 1988.

Fiorenza, Elisabeth Schüssler. *Bread Not Stone: The Challenge of Feminist Biblical Interpretation*. Boston: Beacon Press, c1984.

Foh, Susan T. *Women and the Word of God: A Response to Biblical Feminism*. [Philadelphia]: Presbyterian and Reformed Pub. Co., 1980.

Gagnon, Micheline. 'Le rapport stérilité-fécondité dans l'Ancien Testament comme signe annonciateur du mystère virginité-maternité dans le Nouveau Testament.' M.A. dissertation, Théologie, Université du Québec à Trois Rivières, 1986.

Halse, Susan. 'Claiming the Bible: Feminist Biblical Interpretation and the Local Church.' D. Min. dissertation, Wesleyan Theological Seminary, 1988.

Hantsoree, Colleen Ivey. *Dear Daughters – Letters from Eve and Other Women in the Bible*. [N.p.].: Morehouse-Barlow, 1987.

Hardesty, Nancy. *Great Women of Faith*. Nashville: Abingdon Press, 1982.

Harris, Keith. *Sex, Ideology and Religion: The Representation in the Bible*. Brighton: Wheatsheaf, 1984.

Hayter, Mary. *The New Eve in Christ: The Use and Abuse of the Bible in the Debate about Women in the Church*. Grand Rapids: Eerdmans, 1987.

Jensen, Mary E. *Bible Women Speak to Us Today*. Minneapolis: Augsburg, 1983.

Johnson, Ann. *Miryam of Judah: Witness in Truth and Tradition*. Notre Dame: Ave Maria Press, 1987.

– *Miryam of Nazareth: Woman of Strength and Wisdom*. Notre Dame: Ave Maria Press, 1984.

Kirk, Martha Ann. 'The Prophetess Led Them in Praise: Women's Stories in Ritual.' Th.D. dissertation, Graduate Theological Union, 1986.

Lieberman, Sarah Roth. 'The Eve Motif in Ancient Near Eastern and Classical Greek Sources.' Ph.D. dissertation, Boston University Graduate School, 1975.

Mickelsen, Alvera, ed. *Women, Authority, and the Bible*. Downers Grove, IL: Inter-varsity Press, 1986.

Mollenkott, Virginia Ramey. *Godding: Human Responsibility and the Bible*. New York: Crossroads, 1987.

– *Women, Men, and the Bible*. Nashville: Abingdon Press, 1977.

Nunnally-Cox, Janice. *Foremothers: Women of the Bible*. New York: Seabury Press, 1981.

Pagels, Elaine. *The Gnostic Gospels*. New York: Random House, 1979.

Quéré-Jaulmes, France. *Les femmes de l'Évangile*. Paris: Seuil, 1982.

Russell, Letty M., ed. *Changing Contexts of Our Faith*. Philadelphia: Westminster Press, 1985.

- ed. *Feminist Interpretation of the Bible*. Philadelphia: Westminster Press, 1985.

- ed. *The Liberating Word: A Guide to Nonsexist Interpretation of the Bible*. Philadelphia: Westminster Press, 1976.

Scanzoni, Letha, and Nancy Hardesty. *All We're Meant to Be: Biblical Feminism for Today*. Rev. ed. Nashville: Abingdon Press, 1986.

Stanton, Elizabeth Cady. *The Woman's Bible*. Seattle: Coalition Task Force on Women and Religion, 1974, c1895–1898.

Steinberg, Naomi. 'Adam's and Eve's Daughters Are Many: Gender Roles in Ancient Israelite Society.' Ph.D. dissertation, Columbia University, 1984.

Stendahl, Krister. *The Bible and the Role of Women: A Case in Hermeneutics*. Philadelphia: Fortress Press, 1966.

Swartley, Willard M. *Slavery, Sabbath, War, and Women: Case Issues in Biblical Interpretation*. Kitchener: Herald Press, 1983.

Swidler, Leonard J. *Biblical Affirmations of Woman*. Philadelphia: Westminster Press, 1979.

Thurston, Bonnie B. *The Widows: A Women's Ministry in the Early Church*. Philadelphia: Fortress Press, 1989.

Tolbert, Mary Ann, ed. *The Bible and Feminist Hermeneutics*. Chico, CA: Scholars Press, 1983.

- ed. *The Bible and Feminist Hermeneutics*. Special issue of *Semeia: An Experimental Journal for Biblical Criticism*, No. 28 (1983).

Trenchard, Warren C. *Ben Sira's View of Women: A Literary Analysis* (Brown Judaic Studies, 38). Chico, CA: Scholars Press, 1982.

Trible, Phyllis, ed. *The Effects of Women's Studies on Biblical Studies*. Special issue of *Journal for the Study of the Old Testament*, Issue 22 (Feb. 1982).

Wold, Margaret. *Women of Faith and Spirit: Profiles of Fifteen Biblical Witnesses*. Minneapolis: Augsburg, 1987.

The Word for Us: The Gospels of John and Mark; Epistles to the Romans and the Galatians; Restated in Inclusive Language, by Joann Haugerud. Seattle: Coalition on Women and Religion, c1977.

ARTICLES, BOOK REVIEWS

Abrahamsen, V. 'Women at Philippi: The Pagan and Christian Evidence,' *Journal of Feminist Studies in Religion*, Vol. 3, No. 2 (Fall 1987), pp. 17–30.

Basinger, David. 'Gender Roles, Scripture, and Science: Some Clarifications,' *Christian Scholar's Review*, Vol. 17, No. 3 (1988), pp. 241–253.

Blanton, Alma E. 'In Praise of Ugly Women: A Lesson from Leah' [Gen 29; Matt 1:2], *Other Side*, No. 149 (Feb. 1984), pp. 38–39.

– 'Women and the Churches in Early Christianity,' *Ecumenical Trends*, Vol. 14, No. 4 (Apr. 1985), pp. 51–54.

Brenner, Athalya. 'Female Social Behavior: Two Descriptive Patterns within the Birth of the Hero Paradigm,' *Vetus Testamentum*, Vol. 36, No. 3 (July 1986), pp. 257–273.

Broshi, Magen. 'Beware the Wiles of the Wanton Woman: Dead Sea Scroll Fragment Reflects Essene Fear of, and Contempt for, Women,' *Biblical Archaeology Review*, Vol. 9, No. 4 (July–Aug. 1983), pp. 54–56.

Camp, Claudia V. 'Book Review of *Texts of Terror: Literary-Feminist Readings of Biblical Narratives* by P. Trible,' *Journal of the American Academy of Religion*, Vol. 54, No. 1 (Spring 1986), pp. 159–161.

Campbell, T. 'Eve, Esther, Ruth, Rebecca, Mary, Martha ...,' *U.S. Catholic*, Vol. 40 (Nov. 1975), pp. 32–34.

Collins, Adela. 'Inclusive Biblical Anthropology,' *Theology Today*, Vol. 34, No. 3 (Jan. 1978), pp. 358–369.

Doohan, Helen. 'Women in Scripture and the Christian Tradition,' *Review for Religious*, Vol. 41, No. 4 (July–Aug. 1982), pp. 576–584.

Doyle, Sharon. 'The Barren Ache: The Barren Woman in Scripture,' *Desert Call*, Vol. 16, No. 2 (Summer 1981), p. 4.

'Evangelical Scholars Discuss Women and the Bible,' *TSF Bulletin*, Vol. 8, No. 3 (Jan.–Feb. 1985), p. 23.

Fiorenza, Elisabeth Schüssler. 'Towards a Feminist Biblical Hermeneutics: Biblical Interpretation and Liberation Theology,' in *A Guide to Contemporary Hermeneutics: Major Trends in Biblical Interpretation*, ed. by Donald K. McKim, pp. 358–381. Grand Rapids: Eerdmans, 1986.

– 'Understanding God's Revealed Word,' *Catholic Charisma*, Vol. 1 (Feb.–Mar. 1977), pp. 4–10.

Fleming, D. 'Review of *Women and the Word: The Gender of God in the New Testament and the Spirituality of Women*, by Sandra M. Schneiders,' *Review of Religious Research*, Vol. 47, No. 2 (Mar.–Apr. 1988), p. 310.

Fox-Genovese, Elizabeth. 'For Feminist Interpretation,' *Union Seminary Quarterly Review*, Vol. 35, No. 1 and 2 (Fall and Winter 1979/80), pp. 5–14.

Freyne, S. 'Theology Forum: Woman in the Bible,' *Furrow*, Vol. 26, No. 8 (Aug. 1975), pp. 480–483.

Friedman, Theodore. 'The Shifting Role of Women, from the Bible to the Talmud,' *Judaism: A Quarterly Journal of Jewish Life and Thought*, Vol. 36, No. 4 (Fall 1987), pp. 479–487.

Frymer-Kensky, Tikva. 'Review of *Bread Not Stone: The Challenge of Feminist Biblical Interpretation* by E.S. Fiorenza,' *Bible Review*, Vol. 3, No. 2 (Summer 1987), pp. 48–51.

Gamlich, Miriam Louise. 'Biblical Women of Prayer,' *Contemplative Review*, Vol. 17 (Summer 1984), pp. 22–29.

Gengel, Kenneth O. 'Biblical Feminism and Church Leadership,' *Bibliotheca Sacra*, Vol. 140 (Jan.–Mar. 1983), pp. 55–63.

Getty, Mary A. 'Review of *Women in the Church: A Biblical Study on the Role of Women in the Church* (Biblical Perspectives, 7), by Samuele Bacchiocchi,' *Worship*, Vol. 62 (Jan. 1988), pp. 90–92.

Grey, Mary C. 'Be My Witness: Women in the Bible Reconsidered,' *Scripture Bulletin*, Vol. 15 (Winter 1984), pp. 12–14.

Groome, Thomas H. 'Letty M. Russell: Keeping the Rumor Alive,' *Reflection: Journal of Opinion at Yale Divinity School*, Vol. 79, No. 2 (Jan. 1982), pp. 10–12.

Hoehler, Judith L. 'The Bible as a Source of Feminist Theology,' *Unitarian Universalist Christian*, Vol. 37, No. 3 (Fall–Winter 1982), pp. 21–27.

Hollyday, Joyce. 'Voices out of the Silence: Recovering the Biblical Witness of Women,' *Sojourners*, Vol. 15, No. 6 (June 1986), pp. 20–23.

Huber, Elaine. 'A Closer Look at the Woman's Bible,' *Andover Newton Quarterly*, Vol. 16 (1976), pp. 271–276.

Lutz, Helene A. 'Women in the Book,' *New Catholic World*, Vol. 228 (Mar.–Apr. 1985), pp. 81–88.

McHatten, Mary Timothy. 'Biblical Roots of Women,' *Emmanuel*, Vol. 89, No. 7 (Sept. 1983), p. 392.

Maurer, Sylvia. 'Biblical Aspects of Feminine Wisdom,' *Bible Today: A Periodical Promoting Popular Appreciation of the Word of God*, Vol. 20, No. 5 (Sept. 1982), pp. 297–304.

Meyer, Lauree Hersch. 'In the Image of God, or, What Does Scripture Say about the Equality of Women and Men?' *Brethren Life and Thought*, Vol. 30 (Winter 1985), pp. 15–18.

Meyers, Carol. 'Book Review of *Feminist Interpretation of the Bible*, ed. by Letty Russell,' *Journal of the American Academy of Religion*, Vol. 54, No. 3 (Fall 1986), pp. 608–609.

Neusner, Jacob. 'Review of *Bread Not Stone: The Challenge of Feminist Biblical Interpretation*, by E. Schüssler Fiorenza,' *Bible Review*, Vol. 3, No. 2 (Summer 1987), pp. 49–50.

Page, Ruth. 'Re-review: Elizabeth Cady Stanton's *The Woman's Bible*,' *Modern Churchman*, Vol. 29, No. 4 (1987), pp. 37–41.

Phipps, William E. 'Eve and Pandora Contrasted,' *Theology Today*, Vol. 45, No. 1 (Apr. 1988), pp. 34–48.

Reese, Boyd. 'Review of *Women, Authority, and the Bible* by Alveera Mickelsen, ed.' *Sojourners*, Vol. 17 (Feb. 1988), pp. 42–43.

Roffey, John W. 'Review of *Feminist Perspectives in Biblical Scholarship*, Adela Yarbro Collins, ed.,' *Australian Biblical Review*, Vol. 34 (Oct. 1986), pp. 80–81.

Ruether, Rosemary Radford. 'Book Review of *Bread Not Stone: The Challenge of Feminist Biblical Interpretation*, by E.S. Fiorenza,' *Journal of the American Academy of Religion*, Vol. 54, No. 1 (Spring 1986), pp. 141–143.

— 'Feminism and Patriarchal Religion: Principles of Ideological Critique of the Bible,' *Journal for the Study of the Old Testament*, Vol. 22 (1982), pp. 54–66.

Russell, Letty. 'Beginning from the Other End' [Biblical Authority], *Duke Divinity School Review*, Vol. 45, No. 2 (1980), pp. 98–106.

Sakenfeld, Katherine. 'The Bible and Women: Bane or Blessing?' *Theology Today*, Vol. 32, No. 3 (Oct. 1975), pp. 222–233.

— 'Bread of Heaven,' *Princeton Seminary Bulletin*, Vol. 7, No. 1 (Feb. 1986), pp. 20–24.

Selvidge, Marla J. 'Mark 5:25–34 and Leviticus 15:19–20: A Reaction to Restrictive Purity Regulations,' *Journal of Biblical Literature*, Vol. 103, No. 4 (Dec. 1984), pp. 619–623.

Sered, Susan Starr. 'Rachel's Tomb and the Milk Grotto of the Virgin Mary: Two Women's Shrines in Bethlehem,' *Journal of Feminist Studies in Religion*, Vol. 11, No. 2 (Fall 1986), pp. 7–22.

Throckmorton, Burton H. 'Some Contributions of Feminist Biblical Scholars,' *Union Seminary Quarterly Review*, Vol. 42, No. 1–2 (1988), pp. 87–88.

Tolbert, Mary Ann. 'Defining the Problem: The Bible and Feminist Hermeneutics,' *Semeia: An Experimental Journal for Biblical Criticism*, No. 28 (1983), pp. 3–126.

Trible, Phyllis. 'The Bible and Women's Liberation,' *Theology Digest*, Vol. 22, No. 1 (Spring 1974), pp. 32–37.

— 'A Daughter's Death: Feminism, Literary Criticism and the Bible' [abbreviated from *Union Seminary Quarterly Review*, Vol. 36 (1981), pp. 59–73], *Michigan Quarterly Review*, Vol. 22, No. 3 (Summer 1983), pp. 176–189.

— 'Depatriarchalizing in Biblical Interpretation,' *Journal of the American Academy of Religion*, Vol. 41, No. 1 (Mar. 1973), pp. 30–48.

— 'Feminist Hermeneutics and Biblical Study,' *Christian Century*, Vol. 99, No. 4 (Feb. 3–10, 1982), pp. 116–118.

— 'Good Tidings of Great Joy: Biblical Faith without Sexism,' *Christianity and Crisis: A Christian Journal of Opinion*, Vol. 34, No. 1 (Feb. 4, 1974), pp. 12–16.

Waltke, Bruce. 'The Relationship of the Sexes in the Bible,' *Crux: A Quarterly Journal of Christian Thought and Opinion*, Vol. 19, No. 3 (Sept. 1983), pp. 10–16.

Zappone, Katherine E. 'A Feminist Hermeneutics of Scripture: The Standpoint of the Interpreter,' *Proceedings of the Irish Biblical Association*, Vol. 8 (1984), pp. 25–34.

Hebrew Texts

BOOKS, DISSERTATIONS

Aschkenasy, Nehama. *Eve's Journey; Feminine Images in Hebraic Literary Tradition*. Philadelphia: University of Pennsylvania Press, 1986.

Bal, Mieke. *Femmes imaginaires: l'Ancien Testament au risque d'une narratologie critique*. Montreal: Hurtubise hmh, 1985.

– *Murder and Difference: Gender, Genre, and Scholarship on Sisera's Death*. Bloomington: Indiana University Press, 1988.

Bankson, Marjory Z. *Seasons of Friendship: Naomi and Ruth as a Pattern*. San Diego: Lura Media, 1987.

Brenner, Athalya. *The Israelite Women: Social Role and Literary Type in Biblical Narrative*. Sheffield: JSOT Press, 1985.

Burns, Rita J. *Has the Lord Indeed Spoken Only through Moses? A Study of the Biblical Portrait of Miriam*. Atlanta: Scholars Press, 1987.

Callaway, Mary Chilton. *Sing O Barren One: A Study in Comparative Midrash* (SBL Dissertation Series, 91). Atlanta: Scholars Press, 1986.

Camp, Claudia V. *Wisdom and the Feminine in the Book of Proverbs*. Decatur, GA: Almond Press, 1985.

Havice, Harriet Katherine. 'The Concern for the Widow and the Fatherless in the Ancient Near East: A Case Study in Old Testament Ethics.' Ph.D. dissertation, Yale University, 1978.

Laffey, Alice. *An Introduction to the Old Testament: A Feminist Perspective*. Philadelphia: Fortress Press, 1988.

Lang, Bernhard. *Wisdom and the Book of Proverbs: A Hebrew Goddess Redefined*. Long Island City, NY: Pilgrim Press, 1986.

Meyers, Carol L. *Discovering Eve: Ancient Israelite Women in Context*. New York: Oxford University Press, 1988.

Otwell, John H. *And Sarah Laughed: The Status of Woman in the Old Testament*. Philadelphia: Westminster Press, c1977.

Phillips, John A. *Eve: The History of an Idea*. New York: Harper and Row, 1984.

Poethig, Eunice Blanchard. 'The Victory Song Tradition of Israel.' Ph.D. dissertation, Union Theological Seminary in City of New York, 1985.

Teubal, Savina J. *Sarah the Priestess: The First Matriarch of Genesis*. Athens, OH: Swallow Press, c1984.

Trible, Phyllis. *God and the Rhetoric of Sexuality*. Philadelphia: Fortress Press, 1978.

— *Texts of Terror: Literary-Feminist Readings of Biblical Narratives* (Overtures to Biblical Theology, 13). Philadelphia: Fortress Press, 1984.

Williams, James G. *Women Recounted: Narrative Thinking and the God of Israel*. Sheffield: Almond Press, 1982.

ARTICLES, BOOK REVIEWS

Aitken, Kenneth T. 'The Wooing of Rebekah: A Study in the Development of the Tradition' [Gen 24], *Journal for the Study of the Old Testament*, Issue 30 (Oct. 1984), pp. 3–23.

Andreasen, Neils Erik A. 'The Role of the Queen Mother in Israelite Society' [Gen 16:4; 2 Kings 5:3; Ps 123:2; Prov 30:23], *Catholic Biblical Quarterly*, Vol. 45, No. 2 (Apr. 1983), pp. 179–194.

Bal, Mieke. 'Tricky Thematics,' *Semeia: An Experimental Journal for Biblical Criticism*, No. 42 (1988), pp. 133–155.

Bass, D.C. 'Women's Studies and Biblical Studies: An Historical Perspective,' *Journal for the Study of the Old Testament*, Issue 22 (Feb. 1982), pp. 6–12.

Berlin, Adele. 'Characterization in Biblical Narrative: David's Wives,' *Journal for the Study of the Old Testament*, Issue 23 (July 1982), pp. 69–85.

Bettenhausen, Elizabeth. 'Hagar Revisited,' *Christianity and Crisis: A Christian Journal of Opinion*, Vol. 47, No. 7 (May 4, 1987), pp. 157–160.

Bird, Phyllis. 'Gen 1–3 as a Source for a Contemporary Theology of Sexuality,' *Ex Auditu: An Annual of the Frederick Neumann Symposium on Theological Interpretation of Scripture*, Vol. 3 (1987), pp. 31–44.

— 'Male and Female, He Created Them: Gen. 1:27b in the Context of the Priestly Account of Creation,' *Harvard Theological Review*, Vol. 74, No. 2 (Apr. 1981), pp. 129–159.

Blanton, Alma E. 'Unclean: Who, Me – An Appreciative Look at the Mosaic Law,' *Perspectives, Other Side*, Vol. 19, No. 5 (May 1983), p. 34.

Bos, Johanna W.H. 'Out of the Shadows: Genesis 38; Judges 4:17–22; Ruth 3' [Tamar, Yjael, and Ruth], *Semeia: An Experimental Journal for Biblical Criticism*, No. 42 (1988), pp. 37–67.

Brenner, Athalya. 'Female Social Behavior: Two Descriptive Patterns within the "Birth of the Hero" Paradigm,' *Vetus Testamentum*, Vol. 36, No. 3 (July 1986), pp. 257–273.

- 'Naomi and Ruth,' *Vetus Testamentum*, Vol. 33, No. 4 (Oct. 1983), pp. 385–397.

Brock, Sebastian P. 'Genesis 22: Where Was Sarah?' *Expository Times*, Vol. 96, No. 1 (Oct. 1984), pp. 14–17.

Camp, Claudia V. 'Book Review of *Texts of Terror: Literary-Feminist Readings of Biblical Narratives* by P. Trible,' *Journal of the American Academy of Religion*, Vol. 54, No. 1 (Spring 1986), pp. 159–161.

- 'Wise and Strange: An Interpretation of the Female Imagery in Proverbs in Light of Trickster Mythology,' *Semeia: An Experimental Journal for Biblical Criticism*, No. 42 (1988), pp. 14–36.

- 'The Wise Women of 2 Samuel: A Role Model for Women in Early Israel?' *Catholic Biblical Quarterly*, Vol. 43, No. 1 (Jan. 1981), pp. 14–29.

Carroll, Michael P. 'Myth, Methodology and Transformation in the Old Testament: The Stories of Esther, Judith, and Susanna,' *Studies in Religion/Sciences Religieuses: A Canadian Journal*, Vol. 12, No. 3 (1983), pp. 301–312.

Caspi, Mishael Maswari. 'The Story of the Rape of Dinah: The Narrator and the Reader,' *Hebrew Studies*, Vol. 26, No. 1 (1985), pp. 24–45.

Christensen, Duane L. 'Huldah and the Men of Anathoth: Women in Leadership in the Deuteronomic History,' *Society of Biblical Literature Seminar Papers*, No. 23 (1984), pp. 399–404.

Coggins, Richard. 'The Contribution of Women's Studies to Old Testament Studies: A Male Reaction,' *Theology*, Vol. 91, No. 739 (Jan. 1988), pp. 5–16.

Costas, Orlando E. 'The Subversiveness of Faith: Esther as a Paradigm for a Liberating Theology,' *Ecumenical Review*, Vol. 40, No. 1 (Jan. 1988), pp. 66–78.

Cox, Patricia. 'Origin and the Witch of Endor: Toward an Iconoclastic Typology' [homily on 1 Sam 28], *Anglican Theological Review*, Vol. 66, No. 2 (Apr. 1984), pp. 137–147.

Craghan, John F. 'Esther: A Fully Liberated Woman,' *Bible Today: A Periodical Promoting Popular Appreciation of the Word of God*, Vol. 24, No. 1 (Jan. 1986), pp. 6–11.

- 'Esther, Judith and Ruth: Paradigms for Human Liberation,' *Biblical Theology Bulletin: A Journal of Bible and Theology*, Vol. 12 (1982), pp. 11–19.

Craven, Toni. 'Tradition and Convention in the Book of Judith,' *Semeia: An Experimental Journal for Biblical Criticism*, No. 28 (1983), pp. 49–61.

Crowley, Joann. 'Faith of Our Mothers: The Dark Night of Sara, Rebeka and Rachel,' *Review for Religious*, Vol. 46, No. 4 (July–Aug. 1986), pp. 531–537.

Daviau, Pierette T. 'Review of *Femmes imaginaires: l'Ancien Testament au*

risque d'une narratologie critique by Mieke Bal,' *Studies in Religion/ Sciences Religieuses: A Canadian Journal*, Vol. 16, No. 1 (1987), pp. 119–120.

De Merode de Croy, Marie. 'The Role of Woman in the Old Testament,' in *Women in a Men's Church* (Concilium, 134), ed. by Virgil Elizondo and Norbert Greinacher, pp. 71–79. Edinburgh: T. and T. Clark, 1980.

Eslinger, Lyle. 'The Case of an Immodest Lady Wrestler in Deuteronomy XXV:11–12,' *Vetus Testamentum*, Vol. 31 (1981), pp. 269–281.

Exum, Cheryl J. 'The Mothers of Israel: The Patriarchal Narratives from a Feminist Perspective,' *Bible Review*, Vol. 11, No. 1 (Spring 1986), pp. 60–67.

– ' "You Shall Let Every Daughter Live": A Study of Exodus 1:8–2:10,' *Semeia: An Experimental Journal for Biblical Criticism*, No. 28 (1983), pp. 63–82.

Freedman, R. David. 'Woman, a Power Equal to Man: Translation of Woman as a "Fit Helpmate" for Man Is Questioned' [Gen 2:18], *Biblical Archaeology Review*, Vol. 9, No. 1 (Jan.–Feb. 1983), pp. 56–58.

Fuchs, Esther. 'Biblical Betrothal Scenes,' *Journal of Feminist Studies in Religion*, Vol. 3 (Spring 1987), pp. 7–15.

– 'For I Have the Way of Women: Deception, Gender, and Ideology in Biblical Narrative,' *Semeia: An Experimental Journal for Biblical Criticism*, No. 42 (1988), pp. 68–83.

Garrett, Duane A. 'Ecclesiastes 7:25–29 and the Feminist Hermeneutic,' *Criswell Theological Review*, Vol. 2 (Spring 1988), pp. 309–321.

Geyer, Marcia L. 'Stopping the Juggernaut: A Close Reading of 2 Samuel 20:13–22,' *Union Seminary Quarterly Review*, Vol. 41, No. 1 (1986), pp. 33–42.

Gitay, Zefira. 'Hagar's Expulsion – A Tale Twice-Told in Genesis,' *Bible Review*, Vol. 11, No. 4 (Winter 1986), p. 26.

Gordon, Cynthia. 'Hagar: A Throw-away Character among the Matriarchs?' *Society of Biblical Literature Seminar Papers*, No. 24 (1985), pp. 271–277.

Graham, Ronald W. 'Review of *Ruth, Esther, Jonah* (Knox Preaching Guides) by Johanna W.H. Bos,' *Lexington Theological Quarterly*, Vol. 23, No. 1 (Jan. 1988), p. 7.

Greenspahn, Frederick. 'A Typology of Biblical Women,' *Judaism: A Quarterly Journal of Jewish Life and Thought*, Vol. 32, No. 125 (Winter 1983), pp. 43–50.

Gruber, Mayer I. 'The Motherhood of God in Second Isaiah,' *Revue Biblique*, Vol. 90, No. 3 (July 1983), pp. 351–359.

Hackett, Jo Ann. 'In the Days of Jael: Reclaiming the History of Women in Ancient Israel,' in *Immaculate and Powerful*, ed. by Clarissa W.

Atkinson, Constance H. Buchanan, and Margaret R. Miles, pp. 15–38. Boston: Beacon Press, 1985.

– 'Women Studies and the Hebrew Bible,' in *The Future of Biblical Studies: The Hebrew Scriptures* (Semeia Studies), ed. by Richard Eliot Friedman and Hugh William, pp. 143–164. Atlanta: Scholars Press, 1987.

Hambrick-Stowe, Charles E. 'Ruth, the New Abraham; Esther, the New Moses,' *Christian Century*, Vol. 100, No. 37 (Dec. 7, 1983), pp. 1130–1134.

Higgins, Jean. 'The Myth of Eve: The Temptress,' *Journal of the American Academy of Religion*, Vol. 44, No. 4 (Dec. 1976), pp. 639–647.

Horowitz, Maryanne. 'The Image of God in Man – Is Woman Included?' *Harvard Theological Review*, Vol. 72 (1979), pp. 175–206.

Hummel, Horace D. 'The Image of God' [Gen 1:26-27; Gen 2–3], *Concordia Journal*, Vol. 10 (May 1984), pp. 83–93.

Jagendorf, Zvi. ' "In the Morning, Behold It Was Leah": Genesis and the Reversal of Sexual Knowledge,' *Prooftexts: A Journal of Jewish Literary History*, Vol. 4 (May 1984), pp. 187–192.

Karay, Diane. 'Out of the Shadows: Hagar's Story,' *Christian Ministry*, Vol. 17, No. 1 (Mar. 1986), pp. 33–34.

Kent, Dan. 'Review of *Texts of Terror: Literary Feminist Readings of Biblical Narratives* (Overtures to Biblical Theology, 13) by Phyllis Trible,' *Southwestern Journal of Theology*, Vol. 30 (Spring 1988), p. 58.

Knierim, Rolf. 'The Role of the Sexes in the Old Testament,' *Lexington Theological Quarterly*, Vol. 10, No. 4 (Oct. 1975), pp. 2–10.

Lawton, Robert B. 'Irony in Early Exodus' [role of women; Ex 1:10], *Zeitschrift für die alttestamentliche Wissenschaft*, Vol. 97, No. 3 (1985), p. 414.

Levison, Jack. 'Is Eve to Blame?: A Contextual Analysis of Sirach 25:24,' *Catholic Biblical Quarterly*, Vol. 47, No. 4 (Oct. 1985), pp. 617–623.

Lindars, Barnabas. 'Deborah's Song: Women in the O.T.' [Judges 4–5], *Bulletin of the John Rylands University Library of Manchester*, Vol. 65, No. 3 (Spring 1983), pp. 158–175.

Malchow, Bruce V. 'Postexilic Defense of Women,' *Bible Today: A Periodical Promoting Popular Appreciation of the Word of God*, Vol. 23, No. 5 (Sept. 1985), pp. 325–331.

Manes, Claire. 'Ruth: A Foremother in Faith,' *Sisters Today*, Vol. 55, No. 7 (Mar. 1984), pp. 386–387.

Meyers, Carol. 'Gender Roles and Genesis 3:16 Revisited,' in *The Word of the Lord Shall Go Forth*, ed. by Carol Meyers and M. O'Connor, pp. 337–359. Winona Lake, IN: Eisenbrauns, 1983.

– 'Procreation, Production, and Protection: Male-Female Balance in

Early Israel,' *Journal of the American Academy of Religion*, Vol. 51, No. 4 (Dec. 1983), pp. 569–593.

– 'The Roots of Restriction: Women in Early Israel,' *Biblical Archaeologist*, Vol. 41 (1978), pp. 91–103.

Milne, Pamela. 'Eve and Adam: Is a Feminist Reading Possible?' *Bible Review*, Vol. 4, No. 3 (June 1988), pp. 12–22.

– 'Review of *Sarah the Priestess: The First Matriarch of Genesis*, by Savina J. Teubal,' *Studies in Religion/Sciences Religieuses: A Canadian Journal*, Vol. 16, No. 1 (1987), pp. 121–123.

– 'Review of *Texts of Terror: Literary-Feminist Readings of Biblical Narratives* (Overtures to Biblical Theology, 13), by Phyllis Trible,' *Studies in Religion/Sciences Religeuses: A Canadian Journal*, Vol. 16, No. 1 (1987), pp. 121–123.

Moore, Carey A. 'Eight Questions Most Frequently Asked about the Book of Esther,' *Bible Review*, Vol. 3, No. 1 (Spring 1987), pp. 16–31.

Neusner, Jacob. 'Review of *Bread Not Stone: The Challenge of Feminist Biblical Interpretation* by E.S. Fiorenza,' *Bible Review*, Vol. 3, No. 2 (Summer 1987), pp. 49–50.

Niditch, Susan. 'The Wronged Woman Righted: An Analysis of Genesis 38,' *Harvard Theological Review*, Vol. 72, No. 1 (Jan.–Apr. 1979), pp. 143–149.

Nixon, Rosemary. 'The Priority of Perfection' [Gen 1:1–3; 3], *Modern Churchman*, n.s., Vol. 27, No. 1 (1984), pp. 30–37.

Nowell, Irene. 'Judith: A Question of Power,' *Bible Today: A Periodical Promoting Popular Appreciation of the Word of God*, Vol. 24, No. 1 (Jan. 1986), pp. 12–17.

O'Day, Gail R. 'Singing Woman's Song: A Hermeneutic of Liberation' [Ex 15:21; 1 Sam 2:1–10; Lk 1:46–55], *Currents in Theology and Mission*, Vol. 12 (Aug. 1985), pp. 203–210.

Okure, Teresa S. 'Biblical Perspectives on Women, Eve, the Mother of All the Living: Gen 3:20,' *Voices from the Third World*, Vol. 8, No. 3 (Sept. 1985), pp. 82–92.

Osiek, Carolyn, 'Jacob's Well: Feminist Hermeneutics,' *Bible Today: A Periodical Promoting Popular Appreciation of the Word of God*, Vol. 24, No. 1 (1986), pp. 18–19.

Pappas, Harry S. 'Deception as Patriarchal Self-Defense in a Foreign Land: A Form Critical Study of the Wife-Sister Stories in Genesis,' *Greek Orthodox Theological Review*, Vol. 29, No. 1 (Spring 1984), pp. 35–50.

Reuther, Rosemary Radford. 'Book Review of *Bread Not Stone: The Challenge of Feminist Biblical Interpretation* by E.S. Fiorenza,' *Journal of the American Academy of Religion*, Vol. 54, No. 1 (Spring 1986), pp. 141–143.

Russell, Letty. 'Feminist Critique: Opportunity for Co-operation,' *Journal for the Study of the Old Testament*, Issue 22 (Feb. 1982), pp. 68–71.

Sakenfeld, Katherine. 'Old Testament Perspectives: Methodological Issues,' *Journal for the Study of the Old Testament*, Issue 22 (Feb. 1982), pp. 13–20.

Sandberg, Jessie Rice. 'Entreat Me Not to Leave Thee: Ruth – Every Woman's Example of Courage and Loyalty,' *Fundamentalist Journal*, Vol. 5, No. 5 (May 1986), pp. 26–27.

Schmitt, John J. 'The Gender of Ancient Israel,' *Journal for the Study of the Old Testament*, Issue 26 (June 1983), pp. 115–125.

– 'The Motherhood of God and Zion as Mother,' *Revue Biblique*, Vol. 92 (1985), pp. 557–569.

Schungel-Straumann, Helen. 'God as Mother in Hosea 11,' *Theology Digest*, Vol. 34, No. 1 (Spring 1987), pp. 3–8.

Selvidge, Marla J. Schierling. 'Primeval Woman: A Yahwistic View of Woman in Genesis 1–11:9,' *Journal of Theology for Southern Africa*, No. 42 (Mar. 1983), pp. 5–9.

Smith, Mark S. 'God Male and Female in the Old Testament: Yahweh and His "Asherah," ' *Theological Studies*, Vol. 48, No. 2 (June 1987), pp. 333–340.

Sokoloff, Naomi B. 'Review of *Eve's Journey; Feminist Images in Hebraic Literary Tradition* by Nehama Aschkenasy,' *Prooftexts: A Journal of Jewish Literary History*, Vol. 8 (Jan. 1988), pp. 143–156.

Sölle, Dorothee. 'Peace Needs Women' [with feminist analysis of Cain and Abel], *Union Seminary Quarterly Review*, Vol. 38, No. 1 (1983), pp. 83–91.

Steinberg, Naomi. 'Gender Roles in the Rebekah Cycle' [Gen 25:12–35: 29], *Union Seminary Quarterly Review*, Vol. 39, No. 3 (1984), pp. 175–188.

Steinmetz, Devora. 'A Portrait of Miriam in Rabbinic Midrash,' *Prooftexts: A Journal of Jewish Literary History*, Vol. 8 (Jan. 1988), pp. 35–65.

Summers, Janet. 'Review of *Eve: The History of an Idea* by John A. Phillips,' *Journal of Religion*, Vol. 68, No. 1 (Jan. 1988), pp. 152–153.

Swidler, Arlene. 'In Search of Huldah,' *Bible Today: A Periodical Promoting Popular Appreciation of the Word of God*, No. 98 (Nov. 1978), pp. 1780–1785.

Tamez, Elsa. 'The Woman Who Complicated the History of Salvation,' *Cross Currents: A Quarterly Review to Explore the Implications of Christianity for Our Times*, Vol. 36, No. 2 (Summer 1986), pp. 129–139.

Trible, Phyllis. 'Biblical Theology as Women's Work' [five female models of faith in the Old Testament], *Religious Life*, Vol. 44 (Spring 1985), pp. 7–13.

- 'The Effects of Women's Studies on Biblical Studies: An Introduction,' *Journal for the Study of the Old Testament*, Issue 22 (Feb. 1982), pp. 3–5.
- 'Eve and Adam: Genesis 2–3 Reread,' *Andover Newton Quarterly*, Vol. 13, No. 4 (Mar. 1973), pp. 251–258.
- 'Huldah's Holy Writ: On Women and Biblical Authority,' *Touchstone: Heritage and Theology in a New Age*, Vol. 3, No. 1 (Jan. 1985), pp. 6–13.
- 'A Meditation in Mourning: The Sacrifice of the Daughter of Jephthah,' *Union Seminary Quarterly Review*, Vol. 36, Supplementary Issue (1981), pp. 59–73.
- 'Two Women in a Man's World: A Reading of the Book of Ruth,' *Soundings: An Interdisciplinary Journal*, Vol. 59, No. 1 (Fall 1976), pp. 251–279.
- 'Women in the Old Testament,' in *Interpreter's Dictionary of the Bible, Supplementary Volume*, pp. 963–966. Nashville: Abingdon Press, 1976.
Turner, Mary Donovan. 'Rebekah: Ancestor of Faith,' *Lexington Theological Quarterly*, Vol. 20, No. 2 (Apr. 1985), pp. 42–50.
Vogels, Walter W.F. ' "It Is Not Good That the 'Mensch' Should Be Alone; I Will Make Him/Her a Helper Fit for Him/Her" (Gen. 2:18),' *Église et Théologie*, Vol. 6, No. 1 (1978), pp. 9–35.
Walker, William O., Jr. 'The "Theology of Woman's Place" and the "Paulist" Tradition,' *Semeia: An Experimental Journal for Biblical Criticism*, No. 28 (1983), pp. 101–112.
West, Angela. 'Genesis and Patriarchy, Part I,' *New Blackfriars*, Vol. 62, No. 727 (Jan. 1981), pp. 17–32.
- 'Genesis and Patriarchy Part II: Women and the End of Time,' *New Blackfriars*, Vol. 62, No. 736 (Oct. 1981), pp. 420–432.
Yulish, Stephen. 'Adam: Male, Female or Both?' *Anima: An Experimental Journal of Celebration*, Vol. 9 (Fall 1982), pp. 59–62.

Christian Texts

BOOKS, DISSERTATIONS

Armstrong, Karen. *The Gospel According to Women*. Garden City, NY: Anchor Press, 1987.
Arthur, Rose Horman. 'Feminine Motifs in Right Nag Hammadi Documents.' Ph.D. dissertation, Graduate Theological Union, 1979.
Aworinde, Sunday Olusola. 'First Corinthians 14:33b–36 in Its Literary and Socio-Historical Contexts.' Ph.D. dissertation, Southern Baptist Theological Seminary, 1985.

Balch, David. *Let Wives Be Submissive: The Domestic Code in 1 Peter.* Chico, CA: Scholars Press, 1981.

Carlson, Gregory C. 'Andragogy and the Apostle Paul.' Ph.D. dissertation, University of Nebraska – Lincoln, 1987.

Dollar, Marvin Stephen. 'The Significance of Women in the Fourth Gospel.' Th.D. dissertation, New Orleans Baptist Theological Seminary, 1983.

Dunham, Craig R. 'An Advent Christian Interpretation of the Role of Women in the Pauline Epistles: A Study for the Advent Christian Church.' D. Min. dissertation, San Francisco Theological Seminary, 1985.

Emrey, Elizabeth Virginia. 'Paul's Ethics and Feminism in Light of I Corinthians.' D. Min. dissertation, School of Theology at Claremont, 1980.

Faxon, Alicia Craig. *Women and Jesus.* Philadelphia: United Church Press, 1973.

Good, Deirdre Joy. 'Sophia as Mother and Consort: Eugnostos the Blessed (NHC III, 3 and V, 1) and the Sophia of Jesus Christ (NHC III, 4 and BG 8502, 3).' Th.D. dissertation, Harvard University, 1983.

LaPorte, Jean. *The Role of Women in Early Christianity* (Studies in Women and Religion, 7). Lewiston, NY: E. Mellen Press, 1982.

Leslie, William Houghton. 'The Concept of Woman in the Pauline Corpus in Light of the Social and Religious Environment of the First Century.' Ph.D. dissertation, Boston University Graduate School, 1975.

MacDonald, Dennis R. *There Is No Male and Female* (Harvard Dissertations in Religion, 20). Philadelphia: Fortress Press, 1987.

MacDonald, Margaret. *The Pauline Churches: A Socio-Historical Study of Institutionalisation in the Pauline Writings* (Society for New Testament Studies Monograph Series, 60). New York: Cambridge University Press, 1988.

Mercadante, Linda. *From Hierarchy to Equality: A Comparison of Past and Present Interpretations of 1 Corinthians 11:2–16 in Relation to the Changing Status of Women in Society.* Berkeley: Mercadante, 1979.

Meyers, Carol. *Discovering Eve.* Oxford: Oxford University Press, 1988.

Moloney, Francis J. *Women: First among the Faithful: A New Testament Study.* London: Darton, Longman and Todd, 1984.

Moltmann-Wendel, Elisabeth. *The Women around Jesus.* New York: Crossroads, 1982.

Schneiders, Sandra M. *Women and the Word: The Gender of God in the New Testament and the Spirituality of Women.* New York: Paulist Press, 1986.

Selvidge, Marla J. Schierling. *Daughters of Jerusalem.* Kitchener: Herald Press, 1987.

- 'Woman, Cult, and Miracle Recital: Mark 5:24–34.' Ph.D. dissertation, Saint Louis University, 1980.
Tetlow, Elizabeth M. *Women and Ministry in the New Testament*. New York: Paulist Press, c1980.
Wahlberg, Rachel Conrad. *Jesus According to a Woman*. New York: Paulist Press, 1975.
- *Jesus and the Freed Woman*. New York: Paulist Press, c1978.
Witherington, Ben. *Women in the Earliest Churches* (Society for New Testament Studies Monograph Series, 58). New York: Cambridge University Press, 1988.
- *Women in the Ministry of Jesus: A Study of Jesus' Attitudes to Women and Their Roles as Reflected in His Earthly Life* (Society for New Testament Studies Monograph Series, 51). New York: Cambridge University Press, 1987.

ARTICLES, BOOK REVIEWS

Adeney, Miriam. 'Women of Fire: A Response to Watke, Nolland and Gasque,' *Crux: A Quarterly Journal of Christian Thought and Opinion*, Vol. 9, No. 3 (Sept. 1983), pp. 24–31.
Allison, Robert W. 'Let Women Be Silent in the Churches (1 Cor 14:33b–36): What Did Paul Really Say, and What Did It Mean?' *Journal for the Study of the New Testament*, Issue 32 (1988), pp. 27–60.
Amoah, Elizabeth. 'On Being Near the Fire' [Mk 5:25–29], *Witness*, Vol. 68, No. 12 (Dec. 19, 1985), p. 19.
Anderson, Janice Capel. 'Matthew: Gender and Reading,' *Semeia: An Experimental Journal for Biblical Criticism*, No. 28 (1983), pp. 3–27.
Bassler, Jouette M. 'Review of *There Is No Male and Female* (Harvard Dissertations in Religion, 20) by Dennis R. MacDonald,' *Perkins Journal*, Vol. 41 (Jan. 1988), pp. 33–34.
- 'The Widow's Tale: A Fresh Look at 1 Tim 5:3–16,' *Journal of Biblical Literature*, Vol. 103, No. 1 (Mar. 1984), pp. 23–41.
Beavis, Mary Ann. 'Women as Models of Faith in Mark,' *Biblical Theology Bulletin*, Vol. 18, No. 1 (Jan. 1988), pp. 3–8.
Boucher, Madeleine. 'Women and Priestly Ministry: The New Testament Evidence,' *Catholic Biblical Quarterly*, Vol. 41, No. 4 (Oct. 1979), pp. 608–613.
Bozart, Bryna. 'Martha: Rising in Light,' *Sisters Today*, Vol. 60 (Aug.–Sept. 1988), pp. 34–37.
Brooten, Bernadette J. 'Feminist Perspective on New Testament Exegesis,' in *Conflicting Ways of Interpreting the Bible* (Concilium, 138), ed. by Hans Küng and Jürgen Moltmann, pp. 55–61. New York: Seabury Press, 1980.

- 'Women and the Churches in Early Christianity,' *Ecumenical Trends*, Vol. 14, No. 4 (Apr. 1985), pp. 51–54.

Brown, Raymond E. 'Roles of Women in the Fourth Gospel,' *Theological Studies*, Vol. 36 (1975), pp. 688–699.

Bullard, R.A. 'Feminist Touches in the Centenary New Testament,' *Bible Translator, Technical Papers*, Vol. 38, No. 1 (Jan. 1987), pp. 118–122.

Burrus, Virginia. 'Chastity as Autonomy: Women in the Stories of the Apocryphal Acts,' *Semeia: An Experimental Journal for Biblical Criticism*, No. 38 (1986), pp. 101–117.

Cameron, Averil. 'Neither Male Nor Female,' *Greece and Rome*, Vol. 27 (1980), p. 65.

Carter, Nancy Corson. 'The Prodigal Daughter: A Parable Re-visioned,' *Soundings: An Interdisciplinary Journal*, Vol. 68, No. 1 (Spring 1985), pp. 88–105.

Cleary, Francis X. 'Women in the New Testament: St. Paul and the Early Pauline Churches,' *Biblical Theology Bulletin*, Vol. 10, No. 2 (Apr. 1980), pp. 78–82.

Collins, Adela Yarbro. 'Women's History and the Book of Revelation,' *Society of Biblical Literature Seminar Papers*, No. 26 (1987), pp. 80–91.

Conn, Joann Wolski. 'A Discipleship of Equals: Past, Present, Future,' *Horizons: The Journal of the College Theology Society*, Vol. 14, No. 2 (Fall 1987), pp. 231–261.

D'Angelo, Mary R. 'Beyond Father and Son,' in *Justice as Mission: An Agenda for the Church*, ed. by C. Lind and T. Brown, pp. 107–118. Burlington, ON: Trinity Press, 1985.

- 'Images of Jesus and the Christian Call in the Gospels of Luke and John,' *Spirituality Today*, Vol. 37 (Fall 1985), pp. 196–212.

- 'Images of Jesus and the Christian Call in the Gospels of Mark and Matthew,' *Spirituality Today*, Vol. 36 (Fall 1984), pp. 220–235.

- 'Remembering Her: Feminist Readings of the Christian Tradition,' *Toronto Journal of Theology*, Vol. 2, No. 1 (Spring 1986), pp. 118–125.

Dougherty, Josephine. 'The Woman taken in Adultery,' *Canadian Catholic Review*, Vol. 3, No. 2 (Dec. 1985), p. 38.

Ellis, E. Earle. 'Review of *Women in the Ministry of Jesus* by Ben Witherington,' *Southwestern Journal of Theology*, Vol. 30 (Spring 1988), pp. 70–71.

Finger, Reta. 'Paul: A Woman's Ally – How Paul Led Me Deeper into the Mysteries and Freedoms of Christ,' *Other Side*, No. 143 (Aug. 1983), pp. 19–20.

Fiorenza, Elisabeth Schüssler. 'A Feminist Critical Interpretation for Liberation; Martha and Mary: Lk 10:38–42,' *Religion and Intellectual Life*, Vol. 3, No. 2 (Winter 1986), pp. 21–36.

- 'Feminist Theology and New Testament Interpretation,' *Journal for the*

Study of the Old Testament, Issue 22 (Feb. 1982), pp. 32–46.

– 'The Study of Women in Early Christianity: Some Methodological Considerations,' in *Critical History and Biblical Faith: New Testament Perspectives* (College Theology Society Annual Publication Series), ed. by Thomas J. Ryan, pp. 30–58. Villanova, PA: Horizons, 1979.

– 'Women in the New Testament,' *New Catholic World*, Vol. 219 (Nov.–Dec. 1976), pp. 256–260.

– 'Women in the Pre-Pauline and Pauline Churches,' *Union Seminary Quarterly Review*, Vol. 33, No. 3 (Spring 1978), pp. 153–166.

Flora, Jerry R. 'Biblical Feminism and the New Testament: A Review of Selected Literature,' *Ashland Theological Journal*, Vol. 14, No. 1 (Fall 1981), p. 34.

Franke, Chris. 'Jesus and Women,' *Catholic Charisma*, Vol. 1 (Feb.–Mar. 1977), pp. 26–29.

Frymer-Kensky, Tikva. 'The Trial before God of an Accused Adulteress,' *Bible Review*, Vol. 11, No. 3 (Fall 1986), p. 46.

Fuller, Daniel P. 'Paul and Galatians 3:28,' *TSF Bulletin*, Vol. 9, No. 2 (Nov.–Dec. 1985), pp. 9–13.

Gaden, Janet, and John Gaden. 'Women and Discipleship in the New Testament,' *Way: Contemporary Christian Spirituality*, Vol. 26, No. 2 (Apr. 1986), pp. 113–124.

Gasque, W. Ward. 'The Role of Women in the Church, in Society, and in the Home,' *Crux: A Quarterly Journal of Christian Thought and Opinion*, Vol. 19, No. 3 (Sept. 1983), pp. 3–9.

Genest, Olivette. 'Femmes et ministères dans le Nouveau Testament,' *Studies in Religion/Sciences Religieuses: A Canadian Journal*, Vol. 16, No. 1 (1987), pp. 7–20.

Graham, Ronald W. 'Women in the Ministry of Jesus and in the Early Church,' *Lexington Theological Quarterly*, Vol. 18, No. 1 (Jan. 1983), pp. 1–42.

– 'Women in the Pauline Churches: A Review Article,' *Lexington Theological Quarterly*, Vol. 11, No. 1 (Jan. 1976), pp. 25–33.

Hall, Barbara. 'Paul and Women,' *Theology Today*, Vol. 31, No. 1 (Apr. 1974), pp. 50–55.

Hellwig, M. 'Review of *The Role of Women in Early Christianity* (Studies in Women and Religion, v. 7) by Jean Laporte,' *Spirituality Today*, Vol. 40 (Spring 1988), p. 70.

Johnson, Elizabeth A. 'Jesus, the Wisdom of God: A Biblical Basis for Non-Androcentric Christology,' *Ephemerides Theologicae Lovaniensis*, Vol. 61, No. 4 (Dec. 1985), pp. 261–294.

Karris, Robert J. 'St. Paul and Women,' *Catholic Charisma*, Vol. 1 (Feb.–Mar. 1977), pp. 30–32.

Keir, Howard J. 'Neither Male Nor Female: An Examination of the Status of Women in the New Testament' [1 Cor 11:3–17; 14:34–35; 1 Tim 11:11–12], *Evangelical Quarterly*, Vol. 55 (Jan. 1983), pp. 31–42.

Kopas, Jane. 'Jesus and Women in Mark's Gospel,' *Review for Religious*, Vol. 44, No. 6 (Nov.–Dec. 1985), pp. 912–920.

– 'Jesus and Women: John's Gospel,' *Theology Today*, Vol. 41, No. 2 (July 1984), pp. 201–205.

– 'Women in Luke's Gospel,' *Theology Today*, Vol. 44, No. 2 (July 1986), pp. 192–202.

Kun, Jeanne. 'A Woman of Valor,' *New Covenant*, Vol. 10, No. 8 (Feb. 1981), pp. 7–9.

Lane, Alice Buchanan, 'The Significance of the Thirteen Women in the Gospel of Mark,' *Unitarian Universalist Christian*, Vol. 38, No. 3–4 (Fall–Winter 1983), pp. 18–27.

Laurentian, René. 'Jesus and Women: An Underestimate and Revolution,' in *Women in a Men's Church* (Concilium, 134), ed. by Virgil Elizondo and Norbert Greinacher, pp. 80—92. Edinburgh: T. and T. Clark, 1980.

Layman, Fred D. 'Male Headship in Paul's Thought,' *Wesleyan Theological Journal: Bulletin of the Wesleyan Theological Society*, Vol. 15, No. 1 (Spring 1980), pp. 46–67.

Lemaire, A. 'The Ministries in the New Testament: Recent Research,' *Biblical Theology Bulletin: A Journal of Bible and Theology*, Vol. 3 (1973), pp. 133–166.

Levison, Jack. 'Is Eve to Blame: A Contextual Analysis of Sirach 25:24,' *Catholic Biblical Quarterly*, Vol. 47, No. 4 (Oct. 1985), pp. 617–623.

Linss, Wilhelm C. 'St. Paul and Women,' *Dialog: A Journal of Theology*, Vol. 24, No. 1 (Winter 1985), pp. 36–40.

Love, Stuart L. 'Women's Roles in Certain Second Testament Passages: A Macrosociological View,' *Biblical Theology Bulletin: A Journal of Bible and Theology*, Vol. 17, No. 2 (Apr. 1987), pp. 50–59.

MacDonald, Dennis Ronald. 'The Role of Women in the Production of the Apocryphal Acts of Apostles,' *Illif Review*, Vol. 41 (Winter 1984), pp. 21–38.

Malbon, Elizabeth Struthers. 'Fallible Followers: Women and Men in the Gospel of Mark,' *Semeia: An Experimental Journal for Biblical Criticism*, No. 28 (1983), pp. 29–48.

Malinowski, Francis. 'The Brave Women of Philippi,' *Biblical Theology Bulletin: A Journal of Bible and Theology*, Vol. 15, No. 2 (Apr. 1985), pp. 60–64.

Maly, Eugene H. 'Women in the Gospel of Luke,' *Biblical Theology*

Bulletin: A Journal of Bible and Theology, Vol. 10, No. 3 (July 1980), pp. 99–104.

Mickelsen, Berkeley, and Alvera Mickelsen. 'The "Head" of the Epistles,' *Christianity Today*, Vol. 24, No. 4 (Feb. 20, 1981), pp. 20–23.

Munro, Winsome. 'Women Disciples in Mark?' *Catholic Biblical Quarterly*, Vol. 44, No. 2 (Apr. 1982), pp. 225–241.

– 'Women, Text and the Canon: The Strange Case of 1 Corinthians 14:33–35,' *Bible Today: A Periodical Promoting Popular Appreciation of the Word of God*, Vol. 26, No. 1 (Jan. 1988), pp. 24–29; *Biblical Theology Bulletin: A Journal of Bible and Theology*, Vol. 18 (Jan. 1988), pp. 26–31.

Nolland, John L. 'Women in the Public Life of the Church' [1 Tim 2; 1 Cor 11:2–16], *Crux: A Quarterly Journal of Christian Thought and Opinion*, Vol. 19, No. 3 (Sept. 1983), p. 1.

Norquist, Marilyn J. 'Was St. Paul a Chauvinist?' *Liguorian*, Vol. 70 (July 1982), pp. 25–29.

O'Collins, Gerald Glynn. 'The Fearful Silence of Three Women' [Mark 16:8c], *Gregorianum*, Vol. 69, No. 3 (1988), p. 489.

O'Collins, Gerald Glynn, and Daniel Kendall. 'Mary Magdalene as a Major Witness to Jesus' Resurrection,' *Theological Studies*, Vol. 48, No. 4 (Dec. 1987), pp. 631–646.

O'Connell, Mary. 'Isn't That Just Like a Woman?' *Salt*, Vol. 8 (Mar. 1988), pp. 29–30.

Omanson, Roger L. 'The Role of Women in the New Testament Church,' *Review and Expositor: A Baptist Theological Journal*, Vol. 83, No. 1 (Winter 1986), pp. 15–25.

Padgett, Alan G. 'Feminism in First Corinthians: A Dialogue with Elisabeth Schüssler Fiorenza,' *Evangelical Quarterly*, Vol. 58, No. 2 (Apr. 1986), pp. 121–132.

– 'Paul on Women in the Church: The Contradictions of Coiffure in 1 Corinthians 11:2–16,' *Journal for the Study of the New Testament*, Issue 20 (1984), pp. 69–86.

– 'Wealthy Women at Ephesus (1 Timothy 2:8–15 in Social Context),' *Interpretation: A Journal of Bible and Theology*, Vol. 41, No. 1 (Jan. 1987), pp. 19–31.

Pagels, Elaine. 'Paul and Women: A Response to Recent Discussion,' *Journal of the American Academy of Religion*, Vol. 42, No. 3 (Sept. 1974), pp. 538–549.

Parvez, Emmanuel. 'Mary Magdalene: Sinner or Saint,' *Bible Today: A Periodical Promoting Popular Appreciation of the Word of God*, Vol. 23, No. 2 (Mar. 1985), pp. 122–124.

Paull, Benson M. 'St. Paul as Egalitarian: A Response to Wilhelm Linss,' *Dialogue: A Journal of Theology*, Vol. 24, No. 3 (Summer 1985), pp. 226–228.

Perkins, Pheme. 'In Jesus' Time, Women's Faith-Building Role Vital,' *National Catholic Reporter*, Vol. 20 (Apr. 13, 1984), pp. 16–17.

Picard, Marie B. 'Martha's Hands with a Mary Mind,' *Spiritual Life*, Vol. 33, No. 4 (Winter 1987), pp. 222–225.

Platt, Elizabeth. 'The Ministry of Mary of Bethany,' *Theology Today*, Vol. 34, No. 1 (Apr. 1977), pp. 29–39.

Riggs, Marcia. 'A Reflection Based on a Re-reading of John 4:7–15: Jesus and the Woman at the Well,' *Reflection: Journal of Opinion at Yale Divinity School*, Vol. 79, No. 2 (Jan. 1982), p. 13.

Ringe, Sharon H. 'Luke 9:28–36: The Beginning of an Exodus,' *Semeia: An Experimental Journal for Biblical Criticism*, No. 28 (1983), pp. 83–99.

Ruether, Rosemary Radford. 'The Sexuality of Jesus: What Do the Synoptics Say?' *Christianity and Crisis: A Christian Journal of Opinion*, Vol. 38, No. 7 (May 29, 1978), pp. 134–137.

Ryan, Rosalie. 'Lydia, a Dealer in Purple Goods,' *Bible Today: A Periodical Promoting Popular Appreciation of the Word of God*, Vol. 22, No. 5 (Sept. 1984), pp. 285–289.

– 'The Women from Galilee and Discipleship in Luke' [Mary Magdalene, Joanna, Susanna], *Biblical Theology Bulletin: A Journal of Bible and Theology*, Vol. 15, No. 2 (Apr. 1985), pp. 56–59.

Schmitt, John J. 'Women in Mark's Gospel,' *Bible Today: A Periodical Promoting Popular Appreciation of the Word of God*, Vol. 19, No. 4 (July 1981), pp. 229–233.

Schneiders, Sandra M. 'Apostleship of Women in John's Gospel,' *Catholic Charisma*, Vol. 1 (Feb.–Mar. 1977), pp. 16–20.

– 'Women and Power in the Church: A New Testament Reflection,' *Proceedings of Catholic Theological Society of America*,' Vol. 37 (1982), pp. 127–128.

– 'Women in the Fourth Gospel and Contemporary Church,' *Biblical Theology Bulletin: A Journal of Bible and Theology*, Vol. 12, No. 2 (Apr. 1982), pp. 35–45.

Schottroff, Luise. 'Women as Followers of Jesus in New Testament Times: An Exercise in Social Historical Exegesis of the Bible,' in *The Bible and Liberation: Political and Social Hermeneutics*, ed. by Norman K. Gottwald, pp. 418–427. Maryknoll, NY: Orbis Books, 1983.

Scroggs, R. 'Paul and the Eschatological Woman: Revisited,' *Journal of the American Academy of Religion*, Vol. 42, No. 3 (1974), pp. 532–537.

Selvidge, Marla J. Schierling. ' "And Those Who Followed Feared" ' [Mark 10:32], *Catholic Biblical Quarterly*, Vol. 45, No. 3 (July 1983), pp. 396–400.

Slee, Nicola. 'Parables and Women's Experiences' [reprinted from *The Modern Churchman*, n.s., Vol. 26, No. 2 (1984), pp. 20–31], *Religious Education*, Vol. 80, No. 2 (Spring 1985), pp. 232–245.

– 'Violence, Woman, and the Future of the Matthean Community: A Redactional Critical Essay,' *Union Seminary Quarterly Review*, Vol. 39, No. 3 (1984), pp. 213–223.

Snell, Priscilla. 'The Women at the Tomb: A Feminist Perspective,' *Sisters Today*, Vol. 52, No. 8 (Apr. 1981), pp. 450–455.

Stagg, Frank. 'The Gospel, Haustafel, and Women: Mark 1:1; Colossians 3:18–4:1' [Exegesis], *Faith and Mission*, Vol. 2, No. 2 (Spring 1985), pp. 59–63.

Tamez, Elsa. 'The Woman Who Complicated the History of Salvation,' *Cross Currents: A Quarterly Review to Explore the Implications of Christianity for Our Time*, Vol. 36, No. 2 (Summer 1986), pp. 129–139.

Thiemann, Ronald F. 'The Unnamed Woman at Bethany,' *Theology Today*, Vol. 44, No. 2 (July 1987), pp. 179–188.

Thomas, W.E. 'The Place of Women in the Church of Philippi,' *Expository Times*, Vol. 83 (1972), pp. 117–120.

Van der Broek, Lyle. 'Women and the Church: Approaching Difficult Passages' [1 Pet 3:1–7; 1 Tim 2:8–15; 1 Cor 11:2–16], *Reformed Review*, Vol. 38 (Spring 1985), pp. 225–231.

Vermès, Géza. 'Miriam the Jewess,' *Way Supplement*, No. 45 (June 1982), pp. 55–64.

Via, E. Jane. 'Women, the Discipleship of Service, and the Early Christian Ritual Meal in the Gospel of Luke,' *St. Luke's Journal of Theology*, Vol. 29 (Dec. 1985), pp. 37–60.

Wahlberg, Rachel Conrad. 'Jesus and the Adulterous Men: A New Look at John 8:2–11,' *A.D.: Presbyterian Life Edition*, Vol. 3, No. 5 (May 1974), p. 27.

Wenham, Gordon J. 'Gospel Definitions of Adultery and Women's Rights,' *Expository Times*, Vol. 95, No. 11 (Aug. 1984), pp. 330–332.

West, Angela. 'Sex and Salvation: A Christian Feminist Study of 1 Corinthians 6:12–7:39,' *Modern Churchman*, Vol. 29, No. 3 (1987), pp. 17–24.

Wicker, Kathleen O'Brien. 'First Century Marriage Ethics: A Comparative Study of the Household Codes and Plutarch's Conjugal Precepts,' in *No Famine in the Land*, ed. by J.W. Flanagan and A.W. Robinson, pp. 141–153. Missoula, MT: Scholars Press, 1975.

Witherington, Ben. 'The Anti-Feminist Tendencies of the Western Text in Acts,' *Journal of Biblical Literature*, Vol. 103, No. 1 (Mar. 1984), pp. 82–84.

Youart, Jan. 'Jesus, the Womanizer,' *Sisters Today*, Vol. 60, No. 1 (Aug.–Sept. 1988), pp. 38–40.

Zens, Jon. '1 Corinthians 11 and 14: Half the Priesthood Silent,' *Searching Together*, Vol. 13, No. 4 (Winter 1984), pp. 29–30.

Bible Study

BOOKS

Buswell, Sara. *The Challenge of the Old Testament Women – Bible Study Guide*. [N.p.]: Barker Books, 1986.

Clarkson, J. Shannon, and Letty M. Russell. *Speaking of God: Wellspring VII, 1987 – A Church Women United Bible Study*. New York: Church Women United, 1986.

Gonzalez, Catherine Gunsalus, and Justo Luis Gonzalez. *Their Souls Did Magnify the Lord: Studies on Biblical Women* [workbook]. Atlanta: General Assembly Mission Board, Presbyterian Church U.S.A., 1977–1978.

Robins, Wendy W. *Through the Eyes of a Woman: Bible Studies on the Experience of Women*. Stanley Hut, Rushden, England: World YWCA, 1986.

World Council of Churches. *By Our Lives: Studies of Women Today and in the Bible*. Geneva: World Council of Churches, 1985.

ARTICLES

Eberhart-Moffat, Elizabeth. 'Poverty and Prosperity: A Bible Study,' *Exchange: For Leaders of Adults*, Vol. 11, No. 1 (Fall 1986), pp. 21–22.

Graham, Ferne. 'Jesus Offers Dignity and Freedom: A Bible Study about Women,' *Exchange: For Leaders of Adults*, Vol. 3, No. 2 (Winter–Spring 1979), pp. 24–25.

Marshall, Deborah. 'Jesus and the Bent Woman: Bible Study,' *Exchange: For Leaders of Adults*, Vol. 11, No. 3 (Spring 1987), pp. 12–13.

– 'A Model for Studying Women of the Bible,' *Exchange: For Leaders of Adults*, Vol. 11, No. 3 (Spring 1987), p. 24.

Mathew, Aley. 'Bible Study: Administration of Law and the Oppressed, Particularly Women,' *Religion and Society (Bangalore)*, Vol. 31, No. 1 (Mar. 1984), pp. 48–52.

2

History

General – Women in the Church

BOOKS, DISSERTATIONS, COLLECTED WORKS

Allen, Catherine. *A Century to Celebrate: History of Woman's Missionary Union*. Birmingham: Woman's Missionary Union, 1987.

Anderson, Bonnie S., and Judith P. Zinsser. *A History of Their Own: Women in Europe from Prehistory to the Present*, Vol. I and II. New York: Harper and Row, 1988.

Anderson, Gerald H., ed. *Women and Mission*. Special issue of *International Bulletin of Missionary Research*, Vol. 8, No. 1 (Jan. 1984).

Arnold, Odile. *Le corps et l'âme: La vie des religieuses au XIXe siècle*. Paris: Seuil, 1984.

Aubert, Jean-Marie. *La femme: Antiféminisme et christianisme*. Paris: Cerf-Desclée, 1975.

Bacon, Margaret Hope. *Mothers of Feminism: The Story of Quaker Women in America*. New York: Harper and Row, 1986.

Baker, Derek, ed. *Medieval Women*. Oxford: Blackwell for the Ecclesiastical History Society, 1985.

– ed. *Mediaeval Women* (Studies in Church History Subsidia, 1). Oxford: Blackwell for the Ecclesiastical History Society, 1978.

Barrett, Ellen Marie. 'From the Zeal of Seven Women: The Evolution and Monastic Ideals of the Gilbertine Order, 1131.' Ph.D. dissertation, New York University, 1986.

Beaver, R. Pierce, ed. *American Protestant Women in World Mission: History of the First Feminist Movement in North America*. Rev. ed. Grand Rapids: Eerdmans, 1980.

Beddoe, Deirdre. *Discovering Women's History*. London: Pandora Press, 1983.

Beecher, Maureen Ursenbach, and Lavina Fielding Anderson. *Sisters in

Spirit: Mormon Women in Historical and Cultural Perspective. Urbana: University of Illinois Press, 1987.

Behnke, Donna Alberta. 'Created in God's Image: Religious Issues in the Woman's Rights Movement of the Nineteenth Century.' Ph.D. dissertation, Northwestern University, 1975.

– *Religious Issues in Nineteenth Century Feminism*. Troy, NY: Witston Publishing Co., 1982.

Bell, Carmine Jane. 'The Role of Monastic Women in the Life and Letters of Early Medieval England and Ireland.' Ph.D. dissertation, University of Virginia, 1975.

Bennasser, Khalifa Abubakr. 'Gender and Sanctity in Early Byzantine Monasticism: A Study of the Phenomenon of Female Ascetics in Male Monastic Habit with a Translation of the Life of St. Mationa.' Ph.D. dissertation, Rutgers State University of New Jersey, 1984.

Bonsnes, Marjorie P. 'The Pilgrimage to Jerusalem: A Typological Metaphor for Women in Early Medieval Religious Orders.' Ph.D. dissertation, New York University, 1982.

Bordin, Ruth Birgitta Anderson. *Woman and Temperance: The Quest for Power and Liberty, 1873–1900*. Philadelphia: Temple University Press, 1981.

Borrensen, Kari Elisabeth. *Subordination and Equivalence: The Nature and Role of Women in Augustine and Aquinas*. Trans. from the French. Washington, DC: University Press of America, 1981.

Boulding, Elise. *The Underside of History: A View of Women through Time*. Boulder, CO: Westview Press, 1976.

Boyd, Lois A., and Douglas R. Brackenridge. *Presbyterian Women in America: Two Centuries of a Quest for Status* (Presbyterian Historical Society Contributions to the Study of Religion, 9). Westport, CT: Greenwood Press, 1983.

Boyd, Nancy. *Three Victorian Women Who Changed Their World*. New York: Oxford University Press, 1982.

Boyd, Sandra. *Cultivating Our Roots: A Guide to Gathering Church Women's History*. Cincinnati: Forward Movement Publications, 1984.

Boyer, Paul. *Women in American Religion*. Philadelphia: University of Pennsylvania Press, 1980.

Bridenthal, Renate, and Claudia Koonz, eds. *Becoming Visible: Women in European History*. Boston: Houghton Mifflin, 1977.

Brown, Judith C. *Immodest Acts: The Life of a Lesbian Nun in Renaissance Italy*. New York: Oxford University Press, 1986.

Buhle, Mari Jo, and Paul Buhle. *The Concise History of Women Suffrage: Selections from the Classic Work of Stanton, Anthony, Gage, Harper*. Urbana: University of Illinois Press, 1978.

Burke, Linda Barney. 'Women in the Medieval Manuals of Religious

Instruction and John Gower's "Confessio Amantis." ' Ph.D. dissertation, Columbia University, 1982.

Bynum, Caroline Walker. *Holy Feast and Holy Fast: The Religious Significance of Food to Medieval Women*. Berkeley: University of California Press, 1987.

– *Jesus as Mother: Studies in the Spirituality of the High Middle Ages*. Berkeley: University of California Press, c1982.

Carroll, Bernice, ed. *Liberating Women's History*. Urbana: University of Illinois Press, 1976.

Clark, Elizabeth A. *Ascetic Piety and Women's Faith: Essays on Late Ancient Christianity* (Studies in Women and Religion, 20). Lewiston, NY: E. Mellen Press, 1986.

– *Jerome, Chrysostom, and Friends: Essays and Translations* (Studies in Women and Religion, 2). New York: E. Mellen Press, 1979.

– *Women in the Early Church*. Wilmington, DE: Michael Glazier, 1983.

Clark, Elizabeth A., and Herbert Richardson, eds. *Women and Religion: Readings in the Western Tradition from Aeschylus to Mary Daly*. New York: Harper and Row, 1976.

Danylewycz, Marta Helen. *Taking the Veil in Montreal, 1840–1920, an Alternative to Marriage, Motherhood and Spinsterhood*. Toronto: McClelland and Stewart, 1987.

Davies, Stevan. *The Revolt of the Widows: The Social World of the Apocryphal Acts*. Carbondale: Southern Illinois University Press, 1980.

De Swarte, Carolyn G., and Donald W. Dayton, eds. *The Defense of Women's Rights to Ordination in the Methodist Episcopal Church* (Women in American Protestant Religion Series 1800–1930). New York: Garland Pub., 1987.

Donovan, Mary Sudman. *A Different Call: Women's Ministries in the Episcopal Church 1850–1920*. Wilton, CT: Morehouse-Barlow, 1986.

Douglas, Ann. *The Feminization of American Culture*. New York: Alfred A. Knopf, 1977.

Dumont, Micheline, and Nadia Fahmy-Eid. *Les couventines: L'éducation des filles au Québec dans les congrégations religieuses enseignantes 1840–1960*. Montreal: Boréal, 1986.

Eisler, Riane. *The Chalice and the Blade*. Cambridge, MA: Harper and Row, 1987.

Fahmy-Eid, Nadia, and Micheline Dumont. *Maîtresses de maison, maîtresses d'école*. Montreal: Boréal, 1983.

Fell, Christine. *Women in Anglo-Saxon England and the Impact of 1066*. Oxford: Basil Blackwell, 1984.

Fishburn, Janet Forsythe. *The Fatherhood of God and the Victorian Family: The Social Gospel in America*. Philadelphia: Fortress Press, 1981.

Foster, Lawrence. *Religion and Sexuality: Three American Communal*

Experiments of the Nineteenth Century. New York: Oxford University Press, 1981.

Frantz, Nadine Pentz, and Lauree Hersch Meyer, eds. *Women's Contribution to the Church*. Special issue of *Brethren Life and Thought: A Quarterly Journal Published in the Interests of the Church of the Brethren*, Vol. 30 (Winter 1985).

Fraser, Antonia. *The Weaker Vessel: Woman's Lot in Seventeenth Century England*. London: Methuen, 1985.

Gage, Matilda Joselyn. *Woman, Church, and State*. Watertown, MA: Persephone Press, 1980.

Gardner, Jane F. *Women in Roman Law and Society*. Bloomington: Indiana University Press, 1986.

Gies, Frances, and Joseph Gies. *Women in the Middle Ages: The Lives of Real Women in a Vibrant Age of Transition*. Toronto: Fitzhenry and Whiteside, 1980.

Gold, Penny Schive. *The Lady and the Virgin: Image, Attitude and Experience in 12th Century France* (Women in Culture and Society Series). Chicago: University of Chicago Press, 1985.

Gorrell, Donald K., ed. *'Woman's Rightful Place': Women in United Methodist History*. Dayton, OH: United Theological Seminary, 1980.

Greaves, Richard L., ed. *Triumph over Silence: Women in Protestant History*. Westport, CT: Greenwood Press, 1985.

Gryson, Roger. *The Ministry of Women in the Early Church*, trans. by Jean Laporte and Mary Louise Hall. Collegeville, MN: Liturgical Press, 1976.

Hallett, Judith P. *Fathers and Daughters in Roman Society: Women and the Elite Family*. Princeton: Princeton University Press, 1984.

Hammack, Mary L. *A Dictionary of Women in Church History*. Chicago: Moody Press, c1984.

Hardesty, Nancy. *Women Called to Witness: Evangelical Feminism in the 19th Century*. Nashville: Abingdon Press, 1986.

Harkness, Georgia Elma. *Women in Church and Society: A Historical Theological Inquiry*. Nashville: Abingdon Press, 1971.

Harley, Marta Powell. *A Revelation of Purgatory by an Unknown Fifteen Century Woman Visionary: Introduction, Critical Text, and Translation* (Studies in Women and Religion, 18). Lewiston, NY: E. Mellen Press, 1986.

Hassey, Janette. *No Time for Silence: Evangelical Women in Public Ministry around the Turn of the Century*. Grand Rapids: Zondervan, 1986.

Heine, Susanne. *Women and Early Christianity: Are the Feminists Right?* London: SCM Press, 1987.

– *Women and Early Christianity: A Reappraisal*, trans. by John Bowden. Minneapolis: Augsburg, 1988.

Hickey, Anne Ewing. *Women of the Roman Aristocracy as Christian Monastics*. Ann Arbor, MI: UMI Research Press, 1986.
– 'Women of the Senatorial Aristocracy of Late Rome as Christian Monastics: A Sociological and Cultural Analysis of Motivation.' Ph.D. dissertation, Vanderbilt University, 1983.
Higgins, John Robert. 'Aspects of the Doctrine of the Holy Spirit during the Antinomiam Controversy of New England with Special Reference to John Cotton and Anne Hutchinson.' Th.D. dissertation, Westminster Theological Seminary, 1984.
Hitchings, Catherine F. *Universalist and Unitarian Women Ministers*. 2nd ed. Boston: Unitarian Universalist Historical Society, c1985.
Hochstellar, Donald Dee. 'A Conflict of Traditions: Consecration for Women in the Early Middle Ages.' Ph.D. dissertation, Michigan State University, 1981.
Hogrefe, Pearl. *Women of Action in Tudor England*. Ames: Iowa State University Press, 1977.
Huber, Elaine Clare. 'Women and the Authority of Inspiration: A Reexamination of Two Prophetic Movements from a Christian Feminist Perspective.' Ph.D. dissertation, Graduate Theological Union, 1984.
– *Women and the Authority of Inspiration: A Re-examination of Two Prophetic Movements from a Contemporary Feminist Perspective*. Lanham, MD: University Press of America, 1985.
Huff, Ronald Paul. 'Social Christian Clergymen and Feminism during the Progressive Era 1890–1920.' Ph.D. dissertation, Union Theological Seminary in City of New York, 1978.
Hunter, Jane. *The Gospel of Gentility: American Women Missionaries in Turn of the Century China*. New Haven: Yale University Press, 1984.
Ide, Arthur Frederick. *Woman as Priest, Bishop and Laity in the Early Catholic Church to 440 A.D.* Mesquite, TX: Ide House, 1984.
Irwin, Joyce L. *Womanhood in Radical Protestantism, 1525–1675* (Studies in Women and Religion, 1). New York: E. Mellen Press, c1979.
James, Janet Wilson. *Women in American Religion*. Philadelphia: University of Pennsylvania Press, 1980.
Johnson, Dale. *Women in English Religion, 1700–1925* (Studies in Women and Religion, 10). New York: E. Mellen Press, 1983.
Karlsen, Carol Frances. 'The Devil in the Shape of a Woman: The Witch in Seventeenth-Century New England.' Ph.D. dissertation, Yale University, 1980.
Kealey, Linda, ed. *A Not Unreasonable Claim: Women and Reform in Canada, 1880–1920's*. Toronto: Women's Press, 1979.
Kelso, Ruth. *Doctrine for the Lady of the Renaissance*. Champaign: University of Illinois Press, 1978.

Kimball, Gayle, ed. *Women's Culture: The Women's Renaissance of the Seventies*. Metuchen, NJ: Scarecrow Press, 1981.

Kinder, Donald Michael. 'The Role of the Christian Woman as Seen by Clement of Alexandria.' Ph.D. dissertation, University of Iowa, 1987.

Kirchner, Julian, and F. Suzanne Wengle, eds. *Women? Medieval World*. Oxford: Blackwell, 1985.

Kitch, Sally L. 'A Body of Her Own: Female Celibacy in Three Nineteenth-Century American Utopian Communities.' Ph.D. dissertation, Emory University, 1984.

Kraemer, Ross S., ed. *Maenads, Martyrs, Matrons, Monastics: A Sourcebook on Women's Religions in the Graeco-Roman World*. Philadelphia: Fortress Press, 1988.

Labarge, Margaret Wade. *A Small Sound of the Trumpet: Women in Medieval Life*. Boston: Beacon Press, 1986.

Laporte, Jean. *The Role of Women in Early Christianity* (Studies in Women and Religion, 7). New York: E. Mellen Press, c1982.

Lee, Susan Earls Dye. 'Evangelical Domesticity: The Origins of the Woman's National Christian Temperance Union under Frances E. Willard.' Ph.D. dissertation, Northwestern University, 1980.

Lerner, Gerda. *The Creation of Patriarchy*. New York: Oxford University Press, 1986.

Loewenberg, Bert James, and Ruth Bogin. *Black Women in 19th Century American Life*. University Park: Pennsylvania State University Press, 1976.

Lucas, Angela. *Women in the Middle Ages: Religion, Marriage, Letters*. Brighton: Harvester Press, 1983.

Ludlow, Dorothy Paula. ' "Arise and Be Doing": English "Preaching" Women, 1640–1660.' Ph.D. dissertation, Indiana University, 1978.

McBeth, Leon. *Women in Baptist Life*. Nashville: Broadman, 1979.

MacHaffie, Barbara J. *Her Story: Women in Christian Tradition*. Philadelphia: Fortress Press, c1986.

Malmgreen, Gail, ed. *Religion in the Lives of English Women, 1760–1930*. London: Croom Helm Ltd., 1986.

Malone, Mary Teresa Philomena. 'Christian Attitudes towards Women in the Fourth Century: Background and New Directions.' Ph.D. dissertation, University of Toronto, 1971.

Marguerite, Jean. 'Évolution des communautés religieuses de femmes au Canada, 1639–1973.' Ph.D. dissertation, University of Ottawa, 1974.

Martin, Patricia Summerlin. 'Hidden Work: Baptist Women in Texas, 1880–1920.' Ph.D. dissertation, Rice University, 1982.

Meagher, Katherine Marie. 'The Status of Women in the Postconciliar Church.' Ph.D. dissertation, University of Ottawa, 1977.

Metral, Marie-Odile. *Le mariage: Les hésitations de l'Occident* (Présence et Pensée). Paris: Aubier Montaigne, 1977.

Metz, René. *La femme et l'enfant dans le droit canonique médiéval*. London: Variorum Reprints, 1985.

Miller, Page P. *A Claim to New Roles*. Philadelphia: American Theological Library Association, 1985.

Mockridge, Diane Lois. 'From Christ's Soldier to His Bride: Changes in the Portrayal of Women Saints in Medieval Hagiography.' Ph.D. dissertation, Duke University, 1984.

Morewedge, Rosemarie T., ed. *The Role of Woman in the Middle Ages*. Albany: State University of New York Press, 1975.

Morris, Joan. *The Lady Was a Bishop: The Hidden History of Women with Clerical Ordination and the Jurisdiction of Bishops*. New York: Macmillan, 1973.

Nichols, John, and M. Thomas Shank, eds. *Distant Echoes* (Medieval Religious Women, 1; Cistercian Studies, 71). Kalamazoo: Cistercian Publications, 1984.

– eds. *Peace Weavers* (Medieval Religious Women, 2; Cistercian Studies, 72). Kalamazoo: Cistercian Publications, 1987.

O'Faolain, Julia, and Lauro Martinez. *Not in God's Image: Women in History from the Greeks to the Victorians*. New York: Harper and Row, 1973.

Pagels, Elaine. *The Gnostic Gospels*. New York: Vintage Books, 1981.

Pelletier-Baillargeon, Hélène. *Marie Gérin-Lajoie: De mère en fille, la cause des femmes*. Montreal: Boréal, 1985.

Pernoud, Régine. *La femme au temps des cathédrales*. Paris: Stock, 1980.

Petroff, Elizabeth Alvida, ed. *Medieval Women's Visionary Literature*. New York: Oxford University Press, 1986.

Pomeroy, Sarah B. *Goddesses, Whores, Wives, and Slaves: Women in Classical Antiquity*. New York: Schocken Books, 1975.

Porterfield, E. Amanda. 'Maidens, Missionaries, and Mothers: American Women as Subjects and Objects of Religiousness.' Ph.D. dissertation, Stanford University, 1975.

Power, Eileen Edna. *Mediaeval Women*. Cambridge, England: Cambridge University Press, 1975.

Proctor-Smith, Marjorie. *Women in Shaker Community and Worship: A Feminist Analysis of the Uses of Religious Symbolism* (Studies in Women and Religion, 16). Lewiston, NY: E. Mellen Press, 1985.

Rader, Rosemary. *Breaking Boundaries: Male/Female Friendship in the Early Christian Communities*. New York: Paulist Press, 1983.

Rakow, Mary Martina. 'Melinda Rankin and Magdalen Hayden: Evangelical and Catholic Forms of Nineteenth Century Christian Spirituality.' Ph.D. dissertation, Boston College, 1982.

Ruether, Rosemary Radford, and Rosemary Skinner Keller, eds. *Women and Religion in America*, Volumes 1–3. San Francisco: Harper and Row, 1981–1986.

Ruether, Rosemary Radford, and Eleanor McLaughlin, eds. *Women of Spirit: Female Leadership in the Jewish and Christian Traditions*. New York: Simon and Schuster, 1979.

Scott, Sarah Moore. 'A Thematic Study of the Writings of Puritan Women from the Time of the Original Settlers to 1770.' Ph.D. dissertation, Southern Illinois University at Carbondale, 1981.

Spender, Dale. *Women of Ideas: And What Men Have Done to Them from Aphra Behn to Adrienne Rich*. London: ARK, 1982.

Swans, Mary. *The Role of the Nun in Nineteenth-Century America: Variations on the International Theme*. New York: Arno Press, 1978.

Szatmach, Paul. *An Introduction to the Medieval Mystics*. Albany: State University of New York Press, 1984.

Tappan, Richard R. 'The Dominance of Men in the Domain of Women: The History of Four Protestant Church Training Schools, 1880–1918.' Ed.D. dissertation, Temple University, 1979.

Tavard, George Henri. *Woman in Christian Tradition*. Notre Dame, IN: University of Notre Dame Press, 1973.

Thomas, Hilah F., and Rosemary Skinner Keller, eds. *Women in New Worlds: Historical Perspectives on Wesleyan Tradition*, Volumes 1 and 2. Nashville: Abingdon Press, 1981–1982.

Trebbi, Diana. 'Daughters in the Church Becoming Mothers of the Church: A Study of the Roman Catholic Women's Movement.' Ph.D. dissertation, City University of New York, 1986.

Valenze, Deborah. *Prophetic Sons and Daughters: Female Preaching and Popular Religion in Industrial England*. Princeton: Princeton University Press, 1985.

Vincinus, Martha, ed. *Suffer and Be Still: Women in the Victorian Age*. Bloomington: Indiana University Press, 1973.

Waisbrooker, Lois. *A Sex Revolution*. Philadelphia: New Society Publishers, 1985.

Warnicke, Retha M. *Women of the English Renaissance and Reformation* (Contribution in Women's Studies, 38). Westport, CT: Greenwood Press, 1983.

Wemple, Susan. *Women in Frankish Society: Marriage and the Cloister: 500–900*. Philadelphia: University of Pennsylvania Press, 1983.

Williams, Margaret. *The Society of the Sacred Heart – History 1800–1975*. London: Darton, Longman and Todd, 1978.

Wilson-Kastner, Patricia, J. Ronald Kastner, Ann Millin, Rosemary Rader, and Jeremiah Reedy. *A Lost Tradition: Women Writers of the Early Church*. Washington, DC: University Press of America, 1981.

Witherington, Ben, III. *Women in the Earliest Churches* (Society for New Testament Studies Monograph Series, 59). New York: Cambridge University Press, 1988.

Woolverton, John F., ed. *Episcopal Women's History 1.* Special issue of *Historical Magazine of the Protestant Episcopal Church*, Vol. 51 (Dec. 1982).

Yoshioka, Barbara Gerd Samuelson. 'Imaginal Worlds: Woman as Witch and Preacher in Seventeenth-Century England.' Ph.D. dissertation, Syracuse University, 1977.

ARTICLES, BOOK REVIEWS

Allen, Catherine. 'Review of *A Century to Celebrate: History of Woman's Missionary Union* by Carolyn D. Blevins,' *Baptist History and Heritage*, Vol. 23 (Jan. 1988), pp. 60–61.

Barstow, Anne Llewellyn. 'The First Generation of Anglican Clergy Wives: Heroines or Whores?' *Historical Magazine of the Protestant Episcopal Church*, Vol. 52 (1983), pp. 3–16.

Bednarowski, Mary Farrell. 'Outside the Mainstream: Women's Religion and Women Religious Leaders in Nineteenth Century America,' *Journal of the American Academy of Religion*, Vol. 48 (June 1980), pp. 207–231.

Belonick, Deborah Malacky. 'Women in Orthodoxy,' *Ecumenism*, No. 77 (Mar. 1985), pp. 14–16.

Bendroth, Margaret L. 'Millennial Themes and Private Visions: The Problems of "Woman's Place" in Religious History' [review article], *Fides et Historia*, Vol. 20 (June 1988), pp. 24–30.

Bentall, Shirley. 'The Experience of Women in Canadian Evangelicalism,' *Ecumenism*, No. 85 (Mar. 1987), pp. 17–19.

Boylan, Anne M. 'Women in Groups: Analysis of Women's Benevolent Organizations in New York and Boston, 1797–1840,' *Journal of American History*, Vol. 71, No. 3 (Dec. 1984), pp. 497–523.

Brooten, Bernadette. 'Women and the Churches in Early Christianity,' *Ecumenical Trends: Graymore Ecumenical Institute*, Vol. 14, No. 4 (Apr. 1985), pp. 51–54.

Brown, Earl Kent. 'Women of the Word: Selected Leadership Roles of Women in Mr. Wesley's Methodism,' in *Women in New Worlds: Historical Perspective on the Wesleyan Tradition*, Vol. 1, ed. by Hilah F. Thomas and Rosemary Skinner, pp. 69–87. Nashville: Abingdon Press, 1981.

Brubaker, Pamela. 'History of Women in the Church,' *Brethren Life and Thought*, Vol. 30 (Winter 1985), pp. 9–16.

Bullard, M. 'Review of *Immodest Acts: The Life of a Lesbian Nun in Renaissance Italy* by Judith C. Brown,' *Church History*, Vol. 73 (Oct. 1987), pp. 619–620.

Calvo, Janis. 'Quaker Women Ministers in Nineteenth Century America,' *Quaker History*, Vol. 63 (Autumn 1974), pp. 75–93.

Campbell, D'Ann. 'Women's Life in Utopia: The Shaker Experiment in Sexuality Reappraised: 1810–1860,' *New England Quarterly*, Vol. 51 (Mar. 1978), pp. 23–38.

Chervin, Ronda. 'Wholeness and Holiness in the Women Saints,' *Studies in Formative Spirituality*, Vol. 9 (May 1988), pp. 151–160.

Clark, Elizabeth A. 'Ascetic Renunciation and Feminine Advancement: A Paradox of Late Ancient Christianity,' *Anglican Theological Review*, Vol. 63, No. 3 (July 1981), pp. 240–257.

– 'Sexual Politics in the Writings of John Chrysostom,' *Anglican Theological Review*, Vol. 59, No. 1 (Jan. 1977), pp. 3–20.

Cohen, Alfred. 'Prophecy and Madness: Women Visionaries during the Puritan Revolution,' *Journal of Psychohistory*, Vol. 11 (Winter 1984), pp. 411–430.

Corrington, Gail. 'Salvation, Celibacy, and Power: "Divine Women" in Late Antiquity,' *Society of Biblical Literature Seminar Papers*, No. 24 (1985), pp. 321–325.

Cross, Claire. 'Great Reasoners in Scripture: The Activities of Women Lollards 1380–1530,' in *Medieval Women*, ed. by Derek Baker, pp. 359–380. Oxford: Blackwell for the Ecclesiastical History Society, 1978.

Cunningham, Agnes. 'Holy Women,' *Church*, Vol. 4, No. 1 (Spring 1988), pp. 23–28.

Danforth, Loring M. 'Power through Submission in the Anastenaria,' *Journal of Modern Greek Studies*, Vol. 1, No. 1 (May 1983), pp. 203–223.

Dayton, Lucille Siter, and Donald W. Dayton. 'Your Daughters Shall Prophesy: Feminism in the Holiness Movement,' *Methodist History*, Vol. 14 (Jan. 1976), pp. 67–92.

Donovan, Mary Sudman. 'Women and Mission: Towards a More Inclusive Historiography,' *Historical Magazine of the Protestant Episcopal Church*, Vol. 53 (Dec. 1984), pp. 297–305.

– 'Zealous Evangelists: The Woman's Auxiliary to the Board of Missions' [Protestant Episcopal Church], *Historical Magazine of the Protestant Episcopal Church*, Vol. 51 (Dec. 1982), pp. 371–383.

Douglass, Jane Dempsey. 'Christian Freedom: What Calvin Learned at the School of Women,' *Church History*, Vol. 53, No. 2 (June 1984), pp. 155–173.

Dubois, Christine. 'Review of *A Different Call: Women's Ministries in the*

Episcopal Church: 1850–1920 by Mary Sudman Donovan,' *Daughters of Sarah,* Vol. 14 (Mar.–Apr. 1988), pp. 30–31.

Dumais, Monique. 'Féminisme et religion au Québec depuis 1960,' *Relations,* Vol. 37, No. 429 (Sept. 1977), pp. 244–250.

– 'Les religieuses, leur contribution à la société québécoise,' *Les Cahiers de la Femme/Canadian Women's Studies,* Vol. 3, No. 1 (1981), pp. 18–20.

Eaton, John H. 'A Review of *A Century to Celebrate: History of Woman's Missionary Union* by Catherine Allen,' *Expository Times,* Vol. 99 (Jan. 1988), p. 116.

Farmer, Sharon. 'A Review of *The Lady and the Virgin: Image, Attitude and Experience in 12th Century France* (Women in Culture and Society Series), by Penny S. Gold,' *Journal of Religion,* Vol. 68, No. 1 (Jan. 1988), p. 102.

Fiorenza, Elisabeth Schüssler. 'The Study of Women in Early Christianity: Some Methodological Considerations,' in *Critical History and Biblical Faith: New Testament Perspectives,* ed. by T. Ryan, pp. 30–58. Villanova, PA: College Theological Society, 1979.

– 'You Are Not to Be Called Father: Early Christian History in a Feminist Perspective,' *Cross Currents: A Quarterly Review to Explore the Implications of Christianity for Our Times,* Vol. 39 (1979), pp. 301–323.

Fishburn, Janet Forsythe. 'The Methodist Social Gospel and Woman Suffrage,' *Drew Gateway,* Vol. 54, No. 2–3 (Winter/Spring 1984), pp. 85–104.

Flanders, Alden. 'Dorothy Sayers: The Holy Mysteries,' *Anglican Theological Review,* Vol. 59, No. 4 (Oct. 1977), pp. 366–386.

Fox-Genovese, Elizabeth. 'Two Steps Forward, One Step Back: New Questions and Old Models in the Religious History of American Women,' *Journal of the American Academy of Religion,* Vol. 53 (Sept. 1985), pp. 465–471.

Frohnhogen, Herbert. 'Women Deacons in the Early Church,' *Theology Digest,* Vol. 34, No. 2 (Summer 1987), pp. 149–153.

Garrett, Shirley S. 'Sisters All: Feminism and the American Women's Missionary Movement,' in *Missionary Ideologies in the Imperialist Era: 1800–1920,* ed. by Torben Christiansen and William R. Hutchinson, pp. 221–230. Aboulevarden, DK: Aros, 1982.

Gifford, Carolyn DeSevarte. 'Sisterhoods of Service and Reform: Organized Methodist Women in the Late 19th Century – An Essay on the State of Research,' *Methodist History,* Vol. 24 (Oct. 1985), pp. 15–30.

Giles, Mary. 'The Feminist Mystic,' in *The Feminist Mystic and Other Essays on Women and Spirituality,* ed. by M. Giles, pp. 6–38. New York: Crossroads, 1982.

Good, Deirdre J. 'Sophia in Valentinianism,' *Second Century: A Journal of Early Christian Studies*, Vol. 4, No. 4 (Winter 1984), pp. 193–201.

Grant, Robert McQueen. 'A Woman of Rome: The Matron in Justin, 2 Apology 2:1–9,' *Church History*, Vol. 54, No. 4 (Dec. 1985), pp. 461–472.

Greathouse, Gordon. 'Historical Turbulence of Scudder, Spofford Years' [1920–1950; excerpt from *Which Side Are We On?* 1980], *Witness*, Vol. 67, No. 7 (July 1984), pp. 14–18.

Greaves, Richard L. 'The Role of Women in Early English Nonconformity,' *Church History*, Vol. 52, No. 3 (Sept. 1983), pp. 299–311.

Hallett, Mary E. 'Ladies We Give You the Pulpit,' *Touchstone: Heritage and Theology in a New Age*, Vol. 4, No. 1 (Jan. 1986), pp. 6–17.

Hardesty, Nancy. 'The Wesleyan Movement and Women's Liberation,' in *Sanctification and Liberation*, ed. by Theodore Runyon, pp. 164–173. Nashville: Abingdon Press, 1981.

Harvey, Susan Ashbrook. 'Women in Early Syrian Christianity,' in *Images of Women in Antiquity*, ed. by Averil Cameron and Amelia Kurlurt, pp. 288–298. London: Croom Helm, 1983.

Heeney, Brian. 'Women's Struggle for Professional Work and Status in the Church of England, 1900–1930,' *Historical Journal*, Vol. 26 (June 1983), pp. 329–347.

Hogan, L. 'Review of *Women and Early Christianity: Are the Feminists Right?*, Suzanne Heine, ed.,' *Furrow*, Vol. 39, No. 3 (Mar. 1988), p. 195.

Hohn, Janis Butler. 'The Myth of a Feminist Humanism: Thomas Salter's *The Mirror of Modestie*,' *Soundings: An Interdisciplinary Journal*, Vol. 67, No. 4 (Winter 1984), pp. 443–452.

Huber, Elaine Clare. 'They Weren't Prepared to Hear ... (Woman's Bible),' *Andover-Newton Quarterly*, Vol. 16, No. 3 (Mar. 1976), pp. 271–276.

Hunter, David G. 'Review of *Ascetic Piety and Women's Faith: Essays on Late Ancient Christianity* (Studies in Women and Religion, v. 20) by Elizabeth A. Clark,' *Theological Studies*, Vol. 49, No. 2 (June 1988), pp. 380–381.

Irvin, Dorothy. 'The Ministry of Women in the Early Church: The Archaeological Evidence,' *Touchstone: Heritage and Theology in a New Age*, Vol. 4, No. 1 (Jan. 1986), pp. 24–33.

Jamal, Mieguel. 'Shamaness Religion,' *Journal of Women and Religion*, Vol. 1, No. 1 (Spring 1981), pp. 13–20.

Kalugila, Leonidas. 'Women in the Ministry of Priesthood in the Early Church: An Inquiry,' *Africa Theological Journal*, Vol. 14, No. 1 (1985), pp. 35–45.

Klawiter, Frederick C. 'The Role of Martyrdom and Persecution in

Developing the Priestly Authority of Women in Early Christianity: A Case Study of Montanism,' *Church History*, Vol. 49, No. 3 (Sept. 1980), pp. 251–261.

Kraemer, Ross S. 'The Conversion of Women to Ascetic Forms of Christianity,' *Signs: Journal of Women in Culture and Society*, Vol. 6, No. 2 (Winter 1980), pp. 298–307.

– 'Women in the Religions of the Greco-Roman World,' *Religious Studies Review*, Vol. 19, No. 2 (1983), pp. 127–139.

Lagorio, Valeria M. 'The Continental Women Mystics of the Middle Ages: An Assessment,' in *The Spirituality of Western Christendom, II: The Roots of the Modern Christian Tradition*, ed. by E. Rozanne Elder, pp. 71–90. Kalamazoo: Cistercian Publications, 1984.

Leclercq, Jean. 'Feminine Monasticism in the 12th and 13th Century,' in *The Continuing Quest for God: Monastic Spirituality in Tradition and Transition*, ed. by W. Skudlarek, pp. 114–127. Collegeville, MN: Liturgical Press, 1982.

– 'The Spirituality of Medieval Feminine Monasticism,' in *The Continuing Quest for God: Monastic Spirituality in Tradition and Transition*, ed. by W. Skudlarek, pp. 127–139. Collegeville, MN: Liturgical Press, 1982.

Lewis, Gertrud Jaron. 'Studying Women Mystics: Some Methodological Concerns,' *Mystics Quarterly*, Vol. 10, No. 4 (Dec. 1984), pp. 175–181.

Mack, Phyllis. 'Feminine Behaviour and Radical Action: Franciscans, Quakers, and the Followers of Gandhi,' *Signs: Journal of Women, Culture, and Society*, Vol. 11, No. 3 (Spring 1986), pp. 457–477.

McNamara, Jo Ann. 'The Ordeal of Community: Hagiography of Discipline in Merovingian Convents,' *Vox Benedictina*, Vol. 3, No. 4 (Oct. 1986), pp. 293–321.

Macpherson, Margaret. 'Head, Hand and Purse: The Presbyterian WMS in Canada, 1875–1925,' in *Prairie Spirit: Perspectives on the Heritage of the United Church in the West*, ed. by Dennis L. Butcher, Catherine Macdonald, Margaret E. Macpherson, Raymond R. Smith, and A. McKibbin Watts, pp. 145–171. Winnipeg: University of Manitoba Press, 1985.

Masson, Margaret. 'The Typology of the Female as a Model for the Regenerate: Puritan Preaching, 1690–1730,' *Signs: Journal of Women in Culture and Society*, Vol. 2 (Winter 1976), pp. 304–315.

Matter, E. Ann. 'My Sister, My Spouse: Woman – Identified Women in Medieval Christianity,' *Journal of Feminist Studies in Religion*, Vol. 2, No. 2 (Fall 1986), pp. 81–94.

Mercadante, Linda A. 'Review Article of *Mothers of Feminism: The Story of Quaker Women in America* by M.H. Bacon and *Women in Shaker*

Community and Worship: A Feminist Analysis of the Uses of Religious Symbolism by M. Proctor-Smith,' *Theology Today*, Vol. 44, No. 2 (July 1987), pp. 274–275.

Miller, Page. 'Women in the Vanguard of the Sunday School Movement,' *Journal of Presbyterian History*, Vol. 58 (Winter 1980), pp. 311–325.

Milton, Bev. 'The First Woman Ordained: An Interview with Lydia Gruchy,' *PMC: The Practice of Ministry in Canada*, Vol. 2, No. 3 (Autumn 1985), pp. 6–8.

Mitchell, Norma. 'From Social to Radical Feminism: A Survey of Emerging Diversity in Methodist Women's Organizations, 1869–1974,' *Methodist History*, Vol. 13 (Apr. 1975), pp. 21–44.

Mitchison, Wendy. 'The WCTU – For God, Home and Native Land – A Study in 19th Century Feminism,' in *A Not Unreasonable Claim*, ed. by Linda Kealey, pp. 151–169. Toronto: Women's Press, 1979.

Motte, Mary. 'The Involvement of Roman Catholic Women in Mission since 1965,' *International Bulletin of Missionary Research*, Vol. 8, No. 1 (Jan. 1984), pp. 9–10.

Neaman, Judith S. 'Potentiation, Elevation, Acceleration: Prerogatives of Women Mystics,' *Mystics Quarterly*, Vol. 14 (Mar. 1988), pp. 22–31.

Newell, Linda King. 'The Historical Relationship of Mormon Women and Priesthood,' *Dialogue: A Journal of Mormon Thought*, Vol. 18 (Fall 1985), pp. 21–32.

Nicholson, Joan. 'Feminae Gloriosae: Women in the Age of Bede,' in *Medieval Women*, ed. by Derek Baker, pp. 15–28. Oxford: Blackwell for the Ecclesiastical History Society, 1978.

Nutt, Rick. 'Robert Lewis Dabney, Presbyterians and Women's Suffrage,' *Journal of Presbyterian History*, Vol. 62 (Winter 1984), pp. 339–353.

Oduyoye, Mercy A. 'Women Theologians and the Early Church: An Examination of Historiography,' *Voices from the Third World*, Vol. 8, No. 3 (Sept. 1985), pp. 70–72, 92.

Pagels, Elaine. 'What Became of God the Mother? Conflicting Images of God in Early Christianity,' in *The Signs Reader*, ed. by E. Abel, pp. 97–109. Chicago: University of Chicago Press, 1983.

Patrick, Anne E. 'Women and Religion: A Survey of Significant Literature: 1965–1974,' *Theological Studies*, Vol. 36, No. 4 (Dec. 1975), pp. 737–765.

Pickle, Linda Schelbitzki. 'Women of the Saxon Immigration and Their Church' [19th cent. Missouri], *Concordia Historical Institute Quarterly*, Vol. 57 (Winter 1984), pp. 146–161.

Prelinger, Catherine M. 'Women and Religion, Women as Episcopalians:

Some Methodological Observations,' *Historical Magazine of the Protestant Episcopal Church*, Vol. 52 (June 1983), pp. 141–152.

Putnam, Johnette. 'American Benedictine Women in the Pre- and Post-Conciliar Church,' in *The Continuing Quest for God: Monastic Spirituality in Tradition and Transition*, ed. by W. Skudlarek, pp. 181–200. Collegeville, MN: Liturgical Press, 1982.

Rader, Rosemary. 'Early Forms of Communal Spirituality: Women's Communities,' in *The Continuing Quest for God: Monastic Spirituality in Tradition and Transition*, ed. by W. Skudlarek, pp. 88–99. Collegeville, MN: Liturgical Press, 1982.

Ratigan, V. 'Review of *Women and Religion in America: v. 3, 1900–1968, a Documentary History* by Rosemary Radford Ruether and Rosemary Skinner Keller,' *American Catholic Historical Society Records*, Vol. 98 (Mar.–Dec. 1987), p. 113.

Rodgers, Margaret. 'Attitudes to the Ministry of Women in the Diocese of Sidney: An Historical Study, 1834–1839,' *Reformed Theological Journal*, Vol. 29 (1980), pp. 73–82.

Rolfson, H. 'Review of *Peace Weavers* (Medieval Religious Women, v. 2), John A. Nichols and Lillian Thomas Shank, eds.,' *Sisters Today*, Vol. 59 (Feb. 1988), p. 361.

Ruether, Rosemary Radford. 'Patristic Spirituality and the Experience of Women in the Early Church,' in *Western Spirituality: Historical Roots and Ecumenical Routes*, ed. by Matthew Fox, pp. 140–163. Santa Fe: Bear and Co., 1981.

Scheffler, Judith. 'Prison Writings of Early Quaker Women. ''We Were Stronger Afterward Than Before,'' ' *Quaker History*, Vol. 73 (Fall 1984), pp. 25–37.

Sweet, Leonard I. 'The Female Seminary Movement and Woman's Mission in Antebellum America,' *Church History*, Vol. 54, No. 1 (Mar. 1985), pp. 41–55.

Swidler, Arlene. 'Women in American Catholic History,' *Horizons: The Journal of the College Theology Society*, Vol. 10, No. 2 (Fall 1983), pp. 334–340.

Taves, Ann. 'Mothers and Children and the Legacy of Mid-Nineteenth Century American Christianity,' *Journal of Religion*, Vol. 62, No. 2 (Apr. 1987), pp. 203–219.

Trofimenkoff, Susan Mann. 'Feminism, Nationalism and the Clerical Defensive,' in *Rethinking Canada: The Promise of Women's History*, ed. by V. Strong-Boag and A.C. Fellmann, pp. 123–137. Toronto: Copp Clark, 1986.

Valerio, Adriana. 'Women in Church History,' in *Christianity among World Religions* (Concilium, 183), ed. by Hans Küng and Jurgen Moltmann, pp. 63–71. Edinburgh: T. and T. Clark, 1986.

Wegner, Judith. 'Image of Women in Philo,' *Society of Biblical Literature Seminar Papers*, No. 21 (1982), pp. 551–563.

Welter, Barbara. 'The Feminization of American Religion, 1800–1860,' in *Dimity Convictions: The American Woman in the Nineteenth Century*, pp. 83–102. Athens: Ohio University Press, 1976.

White, Ann. 'Counting the Cost of Faith: America's Early Female Missionaries,' *Church History*, Vol. 57 (Mar. 1988), pp. 19–30.

Yarborough, A. 'Christianization in the Fourth Century: The Example of Roman Women,' *Church History*, Vol. 45, No. 2 (1976), pp. 149–165.

Ziegler, Joanna. 'Some Questions involving the Beguines and Devotional Art,' *Vox Benedictina*, Vol. 3, No. 4 (Oct. 1986), pp. 338–358.

Specific – Women in the Church

BOOKS, DISSERTATIONS, COLLECTED WORKS

Atkinson, Clarissa. *Mystic and Pilgrim: The Book and the World of Margery Kempe*. Ithaca, NY: Cornell University Press, 1983.

Barnett, Lucy C. 'Pioneers, Pedagogues, and Preachers: Expanding Opportunities for Women in Presbyterian Mission to the American Indians, 1833–1893,' M.A. dissertation, Trinity Evangelical Divinity School, 1985.

Barstow, Anne Llewellyn. *Joan of Arc: Heretic, Mystic, Shaman* (Studies in Women and Religion, 17). Lewiston, NY: E. Mellen Press, 1986.

Bechtle, Regina Marie. 'The Mystic and the Church in the Writings of Evelyn Underhill.' Ph.D. dissertation, Fordham University, 1979.

Berkeley, Gail Alva. 'Julian of Norwich: The Rhetoric of Revelation.' Ph.D. dissertation, Princeton University, 1982.

Brame, Grace Adolphsen. 'Divine Grace and Human Will in the Writing of Evelyn Underhill.' Ph.D. dissertation, Temple University, 1988.

Brands, Laurie Elizabeth. 'The Spiritual Journey of Simone Weil and the Vision That Emerged from It.' Ph.D. dissertation, University of Notre Dame, 1983.

Brown, Earl Kent. *Women of Mr. Wesley's Methodism* (Studies in Women and Religion, 11). Lewiston, NY: E. Mellen Press, 1984.

Brown, Joanne Carlson. 'Jennie Fowler Willing (1834–1916): Methodist Church Woman and Reformer.' Ph.D. dissertation, Boston University Graduate School, 1983.

Busshart, Helen Marie. 'Christ as Feminine in Julian of Norwich in the Light of the Psychology of C.G. Jung.' Ph.D. dissertation, Fordham University, 1985.

Cazden, Elizabeth. *Antoinette Brown Blackwell: A Biography*. Old Westbury, NY: Feminist Press, 1982.

Chilcote, Paul Wesley. 'John Wesley and the Women Preachers of Early Methodism.' Ph.D. dissertation, Duke University, 1984.

Christ Church Cathedral Anglican Women. *Five Pioneers of One Anglican Church in the Yukon*. Whitehorse: CCCAW Press, 1983.

Cipar, Mary Cleophas. 'The Portrait of Teresa of Avila as Woman and as Saint in *Camino de Perfeccion*.' Ph.D. dissertation, University of Pittsburgh, 1983.

Clark, Elizabeth A. *The Life of Melania the Younger: Introduction, Translation and Commentary* (Studies in Women and Religion, 14). Lewiston, NY: E. Mellen Press, 1985.

Coles, Robert. *Dorothy Day: A Radical Devotion*. Reading, MA: Addison-Wesley, 1987.

Corrigan, Felicitas. *Helen Waddell: A Biography*. London: Gollancz, 1986.

Daily, Steven Gerald. 'The Irony of Adventism: The Role of Ellen White and Other Adventist Women in Nineteenth Century America.' D.Min. dissertation, School of Theology at Claremont, 1985.

Eggebroten, Anne Marie. 'Women in the Katherine Group and Ancrene Riwle.' Ph.D. dissertation, University of California at Berkeley, 1979.

Fatula, Mary Ann. *Catherine of Siena's Way*. Wilmington, DE: Michael Glazier, 1987.

Fernandez, Gil Gutierrez. 'Ellen G. White: The Doctrine of the Person of Christ.' Ph.D. dissertation, Drew University, 1978.

Forest, James H. *Love Is the Measure: A Biography of Dorothy Day*. Mahwah, NJ: Paulist Press, 1986.

Fox, Matthew. *Illuminations of Hildegard of Bingen*. Santa Fe: Bear and Co., 1985.

Frary, Thomas D. 'The Ecclesiology of Dorothy Day.' Ph.D. dissertation, Marquette University, 1972.

Gerson, Theresa Krystyniak. 'Maude D. Petre and Catholic Modernism in England.' M.A. dissertation, University of St. Michael's College, Toronto, 1975.

Goldman, Maureen. 'American Women and the Puritan Heritage: Anne Hutchinson to Harriet Beecher Stowe.' Ph.D. dissertation, Boston University Graduate School, 1975.

Graybill, Ronald D. 'The Power of Prophesy: Ellen G. White and the Women Religious Founders of the Nineteenth Century.' Ph.D. dissertation, Johns Hopkins University, 1983.

Green, Dana, ed. *Evelyn Underhill: Modern Guide to the Ancient Quest for the Holy*. New York: New York State University Press, 1988.

Griffith, Elisabeth. *In Her Own Right: The Life of Elizabeth Cady Stanton*. Oxford: Oxford University Press, 1984.

Hancock, Carol L. *No Small Legacy: A Study Guide [Canada's Nellie McClung]*. Winfield, BC: Wood Lake Books, c1986.

Hansen, Penny. 'Woman's Hour: Feminist Implications of Mary Baker Eddy's Christian Science Movement, 1855–1910.' Ph.D. dissertation, University of California, Irvine, 1981.

Hearn, Virginia, ed. *Our Struggle to Serve: The Stories of Fifteen Evangelical Women*. Waco, TX: Word Books, 1979.

Hemmel, Jennifer Perone. ' "God Is Our Mother". Julian of Norwich and the Medieval Image of Christian Feminine Divinity.' Ph.D. dissertation, St. John's University, 1980.

Hilda Helleby Commemoration. Northern Lights, No. 87. Whitehorse: Diocese of Yukon, 1984.

Jackson, Rebecca. *Gifts of Power: The Writings of Rebecca Jackson, Black Visionary, Shaker Eldress*, ed., with an introduction, by Jean McMahon Humez. Amherst: University of Massachusetts Press, 1981.

Keane, Patricia. 'Elizabeth Ann Seton: A Grain of Wheat; Her Life and Influence on the First 100 Years of the Sisters of Charity of St. Vincent de Paul, Halifax.' M.A. dissertation, Saint Louis University, 1977.

Kempe, Margery. *The Book of Margery Kempe*, trans. by B.A. Windeatt. New York: Penguin, 1985.

Kennedy, Mary Therese. 'A Study of the Charism Operative in Mary Josephine Rogers (1882–1955), Founder of the Maryknoll Sisters.' Ph.D. dissertation, Saint Louis University, 1980.

Kimball, Gayle. *The Religious Ideas of Harriet Beecher Stowe* (Studies in Women and Religion, 8). Lewiston, NY: E. Mellen Press, 1982.

Koenig, Elisabeth Kathleen Jameson. 'The Book of Showings of Julian of Norwich: A Test-Case for Paul Ricoeur's Theories of Metaphor and Imagination.' Ph.D. dissertation, Columbia University, 1984.

Lee, Jairyong. 'Faith and Works in Ellen G. White's Doctrine of the Last Judgement.' Th.D. dissertation, Andrews University, 1985.

Lincoln, Victoria. *Teresa: A Woman: A Biography of Teresa of Avila* (Series in Cultural Perspective), ed. by Elias Rivers and Antonio T. de Nicolas. Albany: State University of New York Press, 1985.

Littlehales, Margaret Mary. *Mary Ward: A Woman of All Seasons*. London: Catholic Truth Society, 1982.

– ed. *The Heart and Mind of Mary Ward*. London: Clarke, 1985.

Lyndle, Susan Hill. 'Woman's Profession in the Life and Thought of Catherine Beecher: A Study of Religion and Reform.' Dissertation, Duke University, 1974.

Meany, Mary Frances Walsh. 'The Image of Christ in *The Revelations of Divine Love of Julian of Norwich*.' Ph.D. dissertation, Fordham University, 1975.

Miller, Ida Tetrault. 'Frances Elizabeth Willard: Religious Leader and Social Reformer.' Ph.D. dissertation, Boston University Graduate School, 1978.

Moore, Arthur Leroy. 'Ellen G. White's Concept of Righteousness by Faith as It Relates to Contemporary SDA Issues.' Ph.D. dissertation, New York University, 1980.

Mott, Lucretia, ed. *Lucretia Mott: Her Complete Speeches and Sermons* (Studies in Women and Religion, 4), ed. by Dana Green. Lewiston, NY: E. Mellen Press, 1980.

Newman, Barbara. *Sister of Wisdom: St. Hildegard's Theology of the Feminine.* Berkeley: University of California Press, 1987.

North, Patricia Ann. 'Mysticism and Prophetism in *Hildegard of Bingen* and *Ramanuja*: An Essay in History and Hermeneutics.' Ph.D. dissertation, University of California, Los Angeles, 1977.

Padovano, Rose Marie Bernadette. 'The Influence of Elizabeth Seton Reflected in Dimensions of Her Charism and Educational Ministry: A Renewal Program.' D.Min. dissertation, Drew University, 1984.

Raser, Harold E. *Phoebe Palmer: Her Life and Thought* (Studies in Women and Religion, 22). Lewiston, NY: E. Mellen Press, 1987.

Seton, Elizabeth. *Elizabeth Seton: Selected Writings*, ed. by Kelly Ellin and Annabelle Melville. New York: Paulist Press, 1987.

Setta, Susan. 'Woman of the Apocalypse: The Reincorporation of the Feminine through the Second Coming of Christ in Ann Lee.' Ph.D. dissertation, Pennsylvania State University, 1979.

Spencer, Ralph Wakefield. 'Dr. Anna Howard Shaw, the Evangelical Feminist.' Ph.D. dissertation, Boston University Graduate School, 1972.

Stanley, Susie Cunningham. 'Alma White: Holiness Preacher with a Feminist Message.' Ph.D. dissertation, Iliff School of Theology and University of Denver, 1987.

Tibbets, Joel Whitney. 'Women Who Were Called: A Study of the Contributions to American Christianity of Ann Lee, Jemima Wilkinson, Mary Baker Eddy and Aimee Semple McPherson.' Ph.D. dissertation, Vanderbilt University, 1976.

Troutt, Margaret. *The General Was a Lady: The Story of Evangeline Booth.* Nashville: Holman, 1980.

Uhlein, Gabriele. *Meditations with Hildegard of Bingen.* Santa Fe: Bear and Co., 1982.

Vinje, Patricia Mary. 'An Understanding of Love according to the Anchoress Julian of Norwich.' Ph.D. dissertation, Marquette University, 1982.

Von Behren, Ruth Lechner. 'Woman in Late Medieval Society: Catherine of Siena; a Psychological Study.' Ph.D. dissertation, University of California, Davis, 1972.

Ward, Mary. *Till God Wills: Mary Ward through Her Writings*, ed. by M.E. Orchard. London: Darton, Longman and Todd, 1985.

Warne, Randi R. 'Literature as Pulpit: Narrative as a Vehicle for the Transmission and Transformation of Values in the Christian Social Activism of Nellie L. McClung.' Ph.D. dissertation, University of Toronto, 1988.

Warner, Marina. *Joan of Arc: The Image of Female Heroism*. New York: Knopf, 1981.

Weaver, Maria I. Coyle. 'Christ and Antichrist: A Study of Anne Marbury Hutchinson and the Antinomian Debate in Seventeenth Century New England.' M.A. dissertation, Concordia University, 1976.

White, Charles Edward. *The Beauty of Holiness: Phoebe Palmer as Theologian, Revivalist, Feminist and Humanitarian*. Grand Rapids: Zondervan, 1986.

William, Selena. *Divine Rebel: The Life of Anne Marbury Hutchinson*. New York: Holt, Rinehart and Winston, 1981.

Wilson, Norman Clair. 'A Study of Ellen G. White's Theory of Urban Religious Work as It Relates to Seventh-Day Adventist's Work in N.Y. City.' Ph.D. dissertation, New York University, 1981.

A Woman of Genius: The Intellectual Autobiography of Sor Juana Ines de la Cruz, trans. by Margaret Sayers Pendan. Salisbury, CT: Lime Rock Press, 1982.

Woodruff, Sue. *Meditations with Mechtild of Magdeburg*. Santa Fe: Bear and Co., 1982.

Yamagata, Masao. 'Ellen G. White and American Premillennialism.' Ph.D. dissertation, Pennsylvania State University, 1983.

ARTICLES, BOOK REVIEWS

Adeney, Miriam. 'A Woman Liberated – For What,' *Christianity Today*, Vol. 28, No. 1 (Jan. 13, 1984), pp. 28–30.

Allen, Prudence. 'Two Medieval Views in Women's Identity: Hildegard of Bingen and Thomas Aquinas,' *Studies in Religion/Sciences Religieuses: A Canadian Journal*, Vol. 16, No. 1 (1987), pp. 21–36.

Avery, Valeen Tippets. 'Emma Smith through Her Writings,' *Dialogue: A Journal of Mormon Thought*, Vol. 17 (Autumn 1984), pp. 101–106.

Bache, Christopher M. 'A Reappraisal of Teresa of Avila's Supposed Hysteria,' *Journal of Religion and Health*, Vol. 24, No. 4 (Winter 1985), pp. 300–315.

Barker, Paula S. Datsko. 'The Motherhood of God in Julian of Norwich's Theology,' *Downside Review*, Vol. 100, No. 341 (Oct. 1982), pp. 290–304.

Barstow, Anne Llewellyn. 'Joan of Arc and Female Mysticism,' *Journal of Feminist Studies in Religion*, Vol. 1, No. 2 (Fall 1985), pp. 29–42.

Blinkoff, J. 'Review of *Teresa, a Woman: A Biography of Teresa of Avila* by Victoria Lincoln,' *Church History*, Vol. 73 (Oct. 1987), pp. 613–615.

Bradford, Clare. 'Julian of Norwich and Margery Kempe,' *Theology Today*, Vol. 35, No. 2 (July 1978), pp. 153–158.

Bradley, Ritamary. 'Mysticism in the Motherhood Similitude of Julian of Norwich,' *Studia Mystica*, Vol. 8, No. 2 (Summer 1985), pp. 4–14.

Brigden, Beatrice. 'One Woman's Campaign for Social Purity and Social Reform,' in *The Social Gospel of Canada*, ed. by R. Allen, pp. 36–63. Ottawa: National Museum, 1975.

Brooke, Rosalind, and C.W.L. Brooke. 'St. Clare,' in *Medieval Women*, ed. by Derek Baker, pp. 275–289. Oxford: Blackwell for the Ecclesiastical History Society, 1978.

Brooks, Evelyn. 'Religion, Politics and Gender: The Leadership of Nannie Helen Burroughs,' *Journal of Religious Thought*, Vol. 44, No. 2 (Winter–Spring 1988), pp. 7–22.

Brown, Joanne Carlson. 'To Set Christendom in Order' [Jennie Fowler Willing, 19th century religious reformer], *Union Seminary Quarterly Review*, Vol. 39, No. 1–2 (1984), pp. 63–71.

Campbell, D. 'Review of *Elizabeth Seton: Selected Writings*, Kelly Ellin and Annabelle Melville, eds.,' *American Catholic Historical Society Records*, Vol. 98 (Mar.–Dec. 1987), p. 116.

Campbell, Debra. 'The Catholic Earth Mother: Dorothy Day and Women's Power in the Church,' *Cross Currents: A Quarterly Review to Explore the Implications of Christianity for Our Times*, Vol. 34, No. 3 (Fall 1984), pp. 270–282.

Chinnici, Joseph P. 'Review of *Elizabeth Seton: Selected Writings*, Kelly Ellin and Annabelle Melville, eds.,' *Theological Studies*, Vol. 49, No. 2 (June 1988), pp. 386–387.

Chorpenning, Joseph F. 'The Monastery, Paradise and the Castle: Literary Images and Spiritual Development in St. Theresa of Avila,' *Bulletin of Hispanic Studies*, Vol. 62, No. 3 (July 1985), pp. 245–257.

Conn, Joann Wolski. 'Thérèse of Liseaux from a Feminist Perspective,' *Spiritual Life*, Vol. 28, No. 4 (Winter 1982), pp. 233–239.

Cook, Ramsay. 'Frances Marion Benyon and the Crisis of Reformism,' in *The West and the Nation*, ed. by Carl Berger and Ramsay Cook, pp. 197–208. Toronto: McClelland and Stewart, 1976.

Corcoran, Theresa. 'Vida Dutton Scudder: The Impact of World War I on the Radical Woman Professor,' *Anglican Theological Review*, Vol. 57, No. 2 (Apr. 1975), pp. 164–181.

Corless, Roger. 'The Dramas of Spiritual Progress: The Lord and the Servant in Julian's Showings 51 and the Lost Heir in Lotus Sutra 4,' *Mystics Quarterly*, Vol. 11, No. 2 (June 1985), pp. 65–75.

Cunningham, Laurence. 'Review of *Catherine of Siena's Way* by Mary Ann Fatula,' *Church*, Vol. 3, No. 4 (Winter 1987), pp. 48–51.

Deslandres, Dominique. 'L'éducation des Amérindiennes d'après la correspondance de Marie Guyart de l'Incarnation,' *Studies in Religion/ Sciences Religieuses: A Canadian Journal*, Vol. 16, No. 1 (1987), pp. 91–101.

Despres, Denise. 'Franciscan Spirituality: Margery Kempe and Visual Meditation,' *Mystics Quarterly*, Vol. 11, No. 1 (Mar. 1985), pp. 12–18.

Dowell, Graham. 'Julian of Norwich: Dialogue,' *Christian*, Vol. 6, No. 1 (Christmas 1980), pp. 58–60.

Feldman, Laurie A. 'St. Catherine of Siena: An Exploration of the Feminine and Mystic,' *Anima: An Experimental Journal of Celebration*, Vol. 4 (Spring 1978), pp. 57–63.

George, Carol. 'Anne Hutchinson and the Revolution Which Never Happened,' in *Remember the Ladies: New Perspective on Women in American History*, ed. by Carol V.R. George, pp. 13–37. Syracuse, NY: Syracuse University Press, 1975.

Gillespie, Joanna B. 'Mary Briscoe Baldwin (1811–1877): Single Woman Missionary and "Very Much My Own Mistress," ' *Anglican and Episcopal History*, Vol. 57 (Mar. 1988), pp. 63–92.

Green, Deirdre. 'Saint Teresa of Avila and Hekhalot Mysticism,' *Studies in Religion/Sciences Religieuses: A Canadian Journal*, Vol. 13, No. 3 (1984), pp. 279–287.

Hallett, Mary. 'Lydia Gruchy: The First Woman Ordained in the United Church of Canada,' *Touchstone: Heritage and Theology in a New Age*, Vol. 4, No. 1 (Jan. 1986), pp. 18–24.

Hancock, Carol L. 'Nellie McClung: A Part of the Pattern,' in *Prairie Spirit: Perspectives on the Heritage of the United Church of Canada in the West*, ed. by Dennis L. Butcher, Catherine Macdonald, Margaret E. McPherson, Raymond R. Smith, and A. McKibbin Watts, pp. 203–217. Winnipeg: University of Manitoba Press, 1985.

– 'Profile: Nellie L. McClung,' *Touchstone: Heritage and Theology in a New Age*, Vol. 1, No. 1 (Jan. 1983), pp. 31–35.

Hodder, Morley. 'Stella Annie Burry: Dedicated Deaconess and Pioneer Community Worship,' *Touchstone: Heritage and Theology in a New Age*, Vol. 3, No. 3 (Oct. 1985), pp. 24–34.

Hovet, Theodore. 'Phoebe Palmer's "Altar Phraseology" and the Spiritual Dimension of Woman's Sphere,' *Journal of Religion*, Vol. 63, No. 3 (July 1983), pp. 264–280.

Howard, John. 'The German Mystic: Mechtild of Magdeburg,' in *Medieval Women Writers*, ed. by K. Wilson, pp. 153–185. Athens: University of Georgia Press, 1984.

Hoyt, Frederick B. ' "When a Field Was Found too Difficult for a Man, a Women Should Be Sent": Adele M. Fielde in Asia, 1865–1890,' *Historian*, Vol. 44, No. 3 (May 1982), pp. 314–334.

Jones, Catherine. 'The English Mystic: Julian of Norwich,' in *Medieval Women Writers*, ed. by K. Wilson, pp. 269–296. Athens: University of Georgia Press, 1984.

Jones, John A. 'The Sweet Harmony of Luis de Leon's *La Perfecta Casada*' [women in 16th century Spain; first principles of order and harmony of creation], *Bulletin of Hispanic Studies*, Vol. 62, No. 3 (July 1985), pp. 259–269.

Keller, Rosemary Skinner. 'Women and the Nature of Ministry in the United Methodist Tradition,' *Methodist History*, Vol. 22 (Jan. 1984), pp. 99–114.

King, Anne. 'Anne Hutchinson and Anne Bradstreet,' *International Journal of Women's Studies*, Vol. 1, No. 4 (Sept./Oct. 1978), pp. 445– 467.

Klass, Denis, and Richard A. Hutch. 'Elisabeth Kübler-Ross as a Religious Leader,' *Omega: Journal of Death and Dying*, Vol. 16, No. 2 (1985–1986), pp. 89–109.

Laffey, A. 'Review of *Sister of Wisdom: St. Hildegard's Theology of the Feminine* by Barbara Newman,' *America*, Vol. 158, No. 3 (Jan. 23, 1988), pp. 68–69.

Lahutsky, Nadia M. 'The Radical Dorothy Day, or, How a Leftist Communist Journalist Found Her Way in the Roman Catholic Church,' *Religious Publisher Edition*, Vol. 14 (Fall 1987), pp. 401–404.

Latz, Dorothy L. 'The Writings of St. Angela Merici in the Light of Bonaventuran Exemplarism: The Motherhood, Fatherhood, and Transcendence of God,' *Mystics Quarterly*, Vol. 10, No. 3 (Sept. 1984), pp. 126–135.

Lindley, Susan Hill. 'The Ambiguous Feminism of Mary Baker Eddy,' *Journal of Religion*, Vol. 64, No. 3 (July 1984), pp. 318–331.

Lucas, Elona K. 'The Enigmatic Threatening Margery Kempe,' *Downside Review*, Vol. 105 (Oct. 1987), pp. 294–305.

McDonald, Jean A. 'Mary Baker Eddy and the Nineteenth Century "Public Woman": A Feminist Reappraisal,' *Journal of Feminist Studies in Religion*, Vol. 2, No. 1 (Spring 1986), pp. 89–112.

McMullen, Lorraine. 'Lily Dougall: The Religious Vision of a Canadian Novelist,' *Studies in Religion/Sciences Religieuses: A Canadian Journal*, Vol. 16, No. 1 (1987), pp. 79–90.

Mitchison, Wendy. 'The W.C.T.U.: For God, Home and Native Land: A Study of Nineteenth-Century Feminism,' in *A Not Unreasonable Claim*, ed. by Linda Kealey, pp. 151–167. Toronto: Women's Press, 1979.

Moltmann, Jürgen. 'Teresa of Avila and Martin Luther: The Turn to the

Mysticism of the Cross,' *Studies in Religion/Sciences Religieuses: A Canadian Journal*, Vol. 13, No. 3 (1984), pp. 265–278.

Morey, Ann-Janine. 'American Myth and Biblical Interpretation in the Fiction of Harriet Beecher Stowe and Mary E. Wilkins Freeman,' *Journal of the American Academy of Religion*, Vol. 55 (Winter 1987), pp. 741–763.

Murdoch, Norman H. 'Female History in the Thought and Work of Catherine Booth,' *Church History*, Vol. 53, No. 3 (Sept. 1984), pp. 348–362.

Newman, Barbara. 'Hildegard of Bingen: Visions and Validation,' *Church History*, Vol. 54, No. 2 (June 1985), pp. 163–175.

Nugent, Donald C. 'The Annihilation of St. Catherine of Genoa,' *Mystics Quarterly*, Vol. 10, No. 4 (Dec. 1984), pp. 182–188.

O'Connor, June Elizabeth. 'Dorothy Day and Gender Identity: The Rhetoric and the Reality,' *Horizons: The Journal of the College Theology Society*, Vol. 15, No. 1 (Spring 1988), pp. 7–20.

O'Driscoll, Mary. 'Catherine the Theologian,' *Spirituality Today*, Vol. 40 (Spring 1988), pp. 4–17.

O'Higgins-O'Malley, Una. 'St. Joan of Arc,' *Furrow*, Vol. 38, No. 4 (Apr. 1987), pp. 226–231.

Orthman, James. 'Hildegard of Bingen on the Divine Lights,' *Mystics Quarterly*, Vol. 11, No. 2 (June 1985), pp. 60–64.

Parks, Carola. 'Social and Political Consciousness in the Letters of Catherine of Siena,' in *Western Spirituality: Historical Roots, Ecumenical Routes*, ed. by M. Fox, pp. 249–260. Santa Fe: Bear and Co., 1981.

Paulsell, William O. 'Review of *Love Is the Measure: A Biography of Dorothy Day* by James Forest,' *Lexington Theological Quarterly*, Vol. 23, No. 1 (Jan. 1988), pp. 8–10.

Pettersen, Alvyn L. 'Perpetua – Prisoner of Conscience,' *Vigiliae Christianae: A Review of Early Christian Life and Language*, Vol. 41, No. 2 (1987), pp. 139–153.

Pozniak, Karen. 'Motherhood of God: A Theme from Julian of Norwich: Relevance for Present Spirituality,' *Sisters Today*, Vol. 58 (Jan. 1987), pp. 289–297.

Provost, William. 'The English Religious Enthusiast: Margery Kempe,' in *Medieval Women Writers*, ed. by K. Wilson, pp. 297–320. Athens: University of Georgia Press, 1984.

Reineke, Martha J. 'A Review of *Dorothy Day: A Radical Devotion* by Robert Coles,' *Christian Century*, Vol. 105, No. 1 (Jan. 6–13, 1988), pp. 28–29.

Renolds, Anna Maria. 'Julian of Norwich: Woman of Hope,' *Mystics Quarterly*, Vol. 10, No. 3 (Sept. 1984), pp. 118–125.

Rogal, Samuel J. 'The Epworth Woman: Susanna Wesley and Her Daughters,' *Wesleyan Theological Journal: Bulletin of the Wesleyan Theological Society*, Vol. 18, No. 2 (Fall 1983), pp. 80–89.

Romano, Catherine. 'A Psycho-Spiritual History of Teresa of Avila,' in *Western Spirituality: Historical Roots, Ecumenical Routes*, ed. by M. Fox, pp. 261–295. Santa Fe: Bear and Co., 1981.

Spender, Lynne. 'Matilda Joslyn Gage,' in *Feminist Theorists: Three Centuries of Key Thinkers*, ed. by Dale Spender, pp. 137–146. London: Women's Press, 1983.

Stein, Stephen. 'A Note on Ann Dutton, Eighteenth Century Evangelical,' *Church History*, Vol. 44, No. 4 (Dec. 1975), pp. 485–491.

Strong-Boag, Veronica. 'Ever a Crusader: Nellie McClung, First Wave Feminist,' in *Rethinking Canada: The Promise of Women's History*, ed. by V. Strong-Boag and A. Fellman, pp. 178–191. Toronto: Copp Clark, 1986.

Sumption, Jonathan. '*Joan of Arc: The Image of Female Heroism* by Marina Warner,' *Overview*, Vol. 9, No. 9 (Dec. 1981), p. 6.

Taves, Ann. 'Spiritual Purity and Sexual Shame: Religious Themes in the Writings of Harriet Jacobs,' *Church History*, Vol. 56, No. 1 (Mar. 1987), pp. 59–72.

Trevett, Christine. 'Woman, God and Mary Baker Eddy,' *Religion: Journal of Religion and Religions*, Vol. 14, No. 2 (Apr. 1984), pp. 143–153.

Van Liere, Carma. 'Murray, Pauli, 1910–1985: Many Lives,' *Witness*, Vol. 68, No. 10 (Oct. 1985), pp. 10–11.

Walker-Moskop, Ruth M. 'Health and Cosmic Continuity: Hildegard of Bingen's Unique Concern,' *Mystics Quarterly*, Vol. 11, No. 1 (Mar. 1985), pp. 19–25.

Wallace, Charles. 'Susanna Wesley's Spirituality: The Freedom of a Christian Woman,' *Methodist History*, Vol. 22 (Apr. 1984), pp. 158–173.

Watkins, Renee Neu. 'Two Women Visionaries and Death: Catherine of Siena and Julian of Norwich,' *Numen: International Review for the History of Religions*, Vol. 30 (Dec. 1983), pp. 174–198.

Wymward, Eleanor B. 'Mary Gordon: Her Religious Sensibility,' *Cross Currents: A Quarterly Review to Explore the Implications of Christianity for Our Times*, Vol. 37, No. 2–3 (Summer–Fall 1987), pp. 147–158.

3

Judaism

Women in Judaism

BOOKS, DISSERTATIONS, COLLECTED WORKS

Adler, Rachel, and Lynn Gottlieb. *On Being a Jewish Feminist: A Reader.* New York: Schocken Books, 1983.

Appleman, Solomon. *The Jewish Woman in Judaism: The Significance of Woman's Status in Religious Culture.* Hicksville, NY: Exposition Press, c1979.

Baum, Charlotte, Paula Hyman, and Sonya Michel. *The Jewish Woman in America.* New York: Dial Press, 1976.

Berger-Sofer, Rhonda Edna. 'Pious Women: A Study of the Women's Roles in a Hasidic and Pious Community: Meah She'arim.' Ph.D. dissertation, Rutgers University, 1979.

Biale, Rachael. *Women and Jewish Law: An Exploration of Women's Issues in Halakhic Sources.* New York: Schocken Books, 1984.

Bitton-Jackson, Livia. *Madonna or Courtesan? The Jewish Woman in Christian Literature.* New York: Seabury Press, 1982.

Brooten, Bernadette J. *Women Leaders in the Ancient Synagogue: Inscriptional Evidence and Background Issues.* Chico, CA: Scholars Press, c1982.

Davidman, Lynn R. 'Strength of Tradition in a Chaotic World: Women Turn to Orthodox Judaism.' Ph.D. dissertation, Brandeis University, 1986.

Elwell, Ellen Sue Levi. 'The Founding and Early Programs of the National Council of Jewish Women: Study and Practice as Jewish Women's Religious Expression.' Ph.D. dissertation, Indiana University, 1982.

Greenberg, Blu. *On Women in Judaism: A View from Tradition.* Philadelphia: Jewish Publication Society, 1981.

Greenberg, Simon. *The Ordination of Women as Rabbis: Studies and Response*. New York: Jewish Theological Seminary of America, 1987.

Hammelsdorf, Ora, and Sandra Adelsberg. *Jewish Women and Jewish Law*. New York: Biblio Press, 1982.

Henry, Sondra, and Emily Taitz. *Written Out of History: Our Jewish Foremothers*. New York: Schocken Books, 1987.

Heschel, Susannah, ed. *On Being a Jewish Feminist: A Reader*. New York: Schocken Books, 1983.

– ed. *Towards a Feminist Rejuvenation of Judaism*. New York: Schocken Books, 1976.

Kaye, Evelyn. *The Hole in the Sheet: A Modern Woman Looks at Orthodox and Hasidic Judaism*. Secaucus, NJ: L. Stuart, c1987.

Koltun, Elizabeth, ed. *The Jewish Woman: New Perspectives*. New York: Schocken Books, 1976.

Lack, Roslyn. *Women and Judaism: Myth, History, and Struggle*. Garden City, NY: Doubleday, 1980.

Mann, Denese Berg. *The Woman in Judaism*. Hartford, CT: Jonathan Publications, 1979.

Montagu, Lily. *Lily Montagu: Sermons, Addresses, Letters and Prayers* (Studies in Women and Religion, 15), ed. by Ellen M. Umansky. Lewiston, NY: E. Mellen Press, 1984.

Patai, Raphael. *The Hebrew Goddess*. New York: Avon Press, 1978.

Priesand, Sally. *Judaism and the New Woman*. Introduction by Bess Myerson. New York: Behrman House, 1975.

Schneider, Susan Weidman. *Jewish and Female: Choices and Changes in Our Lives Today*. New York: Simon and Schuster, 1984.

Swidler, Leonard J. *Women in Judaism: The Status of Women in Formative Judaism*. Metuchen, NJ: Scarecrow Press, 1976.

Umansky, Ellen M. *Lily Montagu and the Advancement of Liberal Judaism: From Vision to Vocation* (Studies in Women and Religion, 12). Lewiston, NY: E. Mellen Press, 1984.

– 'Lily H. Montagu and the Development of Liberal Judaism in England.' Ph.D. dissertation, Columbia University, 1981.

Wegner, Judith Romney. 'Chattel or Person? The Status of Women in the System of the Mishnah.' Ph.D. dissertation, Brown University, 1986.

– *Chattel or Person: The Status of Women in the Mishnah*. Oxford: Oxford University Press, 1988.

ARTICLES, BOOK REVIEWS

Ackelsberg, Martha. 'Spirituality, Community, and Politics: B'not Esh and the Feminist Reconstruction of Judaism,' *Journal of Feminist Studies in Religion*, Vol. 2, No. 2 (Fall 1986), pp. 109–120.

Aronson, David. 'Creation in God's Likeness' [ordination of women: Takkanah], *Judaism: A Quarterly Journal of Jewish Life and Thought*, Vol. 33, No. 4 (Winter 1984), pp. 13–20.

Bledstein, Adrien Janis. 'The Trials of Sarah,' *Judaism: A Quarterly Journal of Jewish Life and Thought*, Vol. 30, No. 4 (Fall 1981), pp. 411–417.

Bluestone, Naomi. 'Exodus from Eden: One Woman's Experience,' *Judaism: A Quarterly Journal of Jewish Life and Thought*, Vol. 23, No. 1 (Winter 1974), pp. 95–99.

Breslauer, S. Daniel. 'Women, Religious Rejuvenation and Judaism,' *Judaism: A Quarterly Journal of Jewish Life and Thought*, Vol. 32, No. 4 (Fall 1983), pp. 466–475.

Brooten, Bernadette J. 'Inscriptional Evidence for Women as Leaders in the Ancient Synagogue,' *Society of Biblical Literature Seminar Papers*, No. 20 (1981), pp. 1–17.

– 'Jewish Women's History in the Roman Period: A Task for Christian Theology,' in *Christians among Jews and Gentiles*, ed. by George W.E. Nickelsburg with George MacRae, pp. 22–30. Philadelphia: Fortress Press, 1986.

Carmody, Denise Lardner. 'Women in Modern Judaism,' *Horizons: The Journal of the College Theology Society*, Vol. 11 (Spring 1984), pp. 28–41.

Chernin, Kim. 'In the House of the Flame Bearers: Feminist Consciousness Today,' *Tikkun: A Quarterly Jewish Critique of Politics, Culture and Society*, Vol. 2, No. 3 (1987), pp. 55–59.

Cohen, Sharon. 'Reclaiming the Hammer: Toward a Feminist Midrash,' *Tikkun: A Quarterly Jewish Critique of Politics, Culture and Society*, Vol. 3 (Mar.–Apr. 1988), pp. 55–57, 93–95.

Cohen, Shaye J.D. 'The Matrilineal Principle in Historical Perspective,' *Judaism: A Quarterly Journal of Jewish Life and Thought*, Vol. 34, No. 1 (Winter 1985), pp. 5–13.

Ehglard-Schaffer, Naomi Y. 'Review Essay on Blu Greenberg's *On Women and Judaism: A View from Tradition*,' *Tradition: A Journal of Orthodox Jewish Thought*, Vol. 21 (Summer 1983), pp. 132–145.

Friedman, Theodore. 'The Shifting Role of Women, from the Bible to Talmud,' *Judaism: A Quarterly Journal of Jewish Life and Thought*, Vol. 36, No. 4 (Fall 1987), pp. 479–487.

Fuch-Kreimer, Nancy. 'Feminism and Scriptural Interpretation: A Contemporary Jewish Critique,' *Journal of Ecumenical Studies*, Vol. 20 (Fall 1983), pp. 534–548.

Goldfeld, Anne. 'Women as Sources of Torah in the Rabbinic Tradition,' *Judaica: Beiträge zum Verständnis des jüdischen Schicksals in Vergangenheit und Gegenwart*, Vol. 24 (Spring 1975), pp. 245–256.

Goldstein, Elyse. 'A Feminist Approach to Judaism,' *Grail: An Ecumenical Journal*, Vol. 3, No. 2 (June 1987), pp. 49–59.

Gordis, Daniel H. 'Lies, Wives, and Sisters: The Wife-Sister Motif Revisited,' *Judaism: A Quarterly Journal of Jewish Life and Thought*, Vol. 34, No. 3 (Summer 1985), pp. 344–359.

Gordis, Robert, ed. 'Women as Rabbis: A Many-Sided Examination of All Aspects – Halakhic, Ethical, Pragmatic,' *Judaism: A Quarterly Journal of Jewish Life and Thought*, Vol. 33, No. 1 (Winter 1984), pp. 6–12.

Gottlieb, Freeman. 'Three Mothers,' *Judaism: A Quarterly Journal of Jewish Life and Thought*, Vol. 30, No. 2 (Spring 1981), pp. 104–203.

Green, Kathy. 'Many Hyphens: Reflection of an American-Jewish-Feminist, Writing from Jerusalem during the Summer of 1985,' *Religion and Intellectual Life*, Vol. 3, No. 2 (Winter 1986), pp. 37–44.

Greenberg, Blu. 'Abortion: A Challenge to Halakhah,' *Judaica: Beiträge zum Verständnis des jüdischen Schicksals in Vergangenheit und Gegenwart*, Vol. 25 (Spring 1976), pp. 201–208.

– 'Marriage in the Jewish Tradition,' *Journal of Ecumenical Studies*, Vol. 22, No. 1 (Winter 1985), pp. 3–20.

Greenspahn, Frederick E. 'A Typology of Biblical Women,' *Judaism: A Quarterly Journal of Jewish Life and Thought*, Vol. 32, No. 1 (Winter 1983), pp. 43–50.

Gross, Rita M. 'Steps toward Feminist Imagery of Deity in Jewish Theology,' *Judaism: A Quarterly Journal of Jewish Life and Thought*, Vol. 30, No. 2 (Spring 1981), pp. 183–193.

Heschel, Susannah. 'Current Issues in Jewish Feminist Theology,' *Christian Jewish Relations*, Vol. 19, No. 2 (June 1986), pp. 23–32.

Hyman, Frieda Clark. 'The Education of a Queen,' *Judaism: A Quarterly Journal of Jewish Life and Thought*, Vol. 35, No. 1 (Winter 1986), pp. 78–85.

Hyman, Paula. 'Gender and Jewish History,' *Tikkun: A Quarterly Jewish Critique of Politics, Culture and Society*, Vol. 3 (Jan.–Feb. 1988), pp. 35–38.

Johnson, Cecilia P. 'Conservative Jews to Ordain Woman Rabbi,' *National Catholic Reporter*, Vol. 21 (Apr. 26, 1985), p. 48.

Kaufman, Debra R. 'Women Who Return to Orthodox Judaism: A Feminist Analysis,' *Journal of Marriage and Family*, Vol. 47, No. 3 (Aug. 1985), pp. 543–551.

Kruemer, Ross S. 'Hellenistic Jewish Women: The Epigraphical Evidence,' *Society of Biblical Literature Seminar Papers*, No. 25 (1986), pp. 183–191.

Lerner, Anne Lapidus. 'Judaism and Feminism: The Unfinished Agenda,' *Judaism: A Quarterly Journal of Jewish Life and Thought*, Vol. 36, No. 2 (Spring 1987), pp. 167–173.

Novak, David. 'Women in the Rabbinate?' *Judaism: A Quarterly Journal of Jewish Life and Thought*, Vol. 33, No. 4 (Winter 1984), pp. 39–49.

Ochs, Carol. 'Called to the Torah,' *Religion and Intellectual Life*, Vol. 3, No. 1 (Fall 1985), pp. 68–69.

Prell, Riv-Ellen. 'The Vision of Woman in Classical Reform Judaism,' *Journal of the American Academy of Religion*, Vol. 50 (Dec. 1982), pp. 575–589.

'Rabbinical Assembly in Favor of Women Rabbis,' *Ecumenical Trends: Graymore Ecumenical Institute*, Vol. 14, No. 4 (Apr. 1985), p. 6.

Setel, T. Dorah. 'Feminist Reflections on Separation and Unity in Jewish Theology,' *Journal of Feminist Studies in Religion*, Vol. 2, No. 1 (Spring 1986), pp. 113–118. Replies by Catherine Keller, pp. 118–121; Marcia Falk, pp. 121–125; Anne M. Solomon, pp. 125–127; Rita M. Gross, pp. 127–130.

Sigal, Phillip. 'Elements of Male Chauvinism in Classical Halakhah,' *Judaica: Beiträge zum Verständnis des jüdischen Schicksals in Vergangenheit und Gegenwart*, Vol. 24 (Spring 1975), pp. 226–244.

Umansky, Ellen M. 'Creating a Jewish Feminist Theology: Possibilities and Problems,' *Anima: An Experimental Journal of Celebration*, Vol. 10 (Spring 1984), pp. 125–135.

– 'Sources of My Theology,' *Journal of Feminist Studies in Religion*, Vol. 1, No. 1 (Spring 1985), pp. 123–127.

Wiess-Rosmarin, Trude. 'Matriliny: A Survival of Polygyny' [reply to S.J.D. Cohen], *Judaism: A Quarterly Journal of Jewish Life and Thought*, Vol. 34, No. 1 (Winter 1985), pp. 112–118.

'Women Cantors,' *Christian Century*, Vol. 104, No. 9 (Mar. 18–25, 1987), p. 266.

Yudkin, Marjorie S. 'The Shalom Ideal' [ordination of women as rabbis], *Judaism: A Quarterly Journal of Jewish Life and Thought*, Vol. 33, No. 4 (Winter 1984), pp. 85–90.

Zarsvitel, Yair. 'The Woman's Rights in the Biblical Law of Divorce,' *Jewish Law Annual*, 1981, pp. 28–46.

Jewish/Christian Feminist Dialogue

ARTICLES

Chittister, Joan D. 'Women: Icon, Rebel, Saint,' *Grail: An Ecumenical Journal*, Vol. 4, No. 2 (June 1988), pp. 53–65.

Eckardt, A. Roy. 'Christian, Jews and the Women's Movement,' *Christian Jewish Relations*, Vol. 19, No. 2 (June 1986), pp. 13–22.

Engel, Mary Potter. 'Dialogue between Jewish and Christian Feminists,' *Ecumenical Trends*, Vol. 17, No. 6 (June 1988), pp. 84–87.

Gibel, Inge Lederer. 'The Women's Movement and Anti-Semitism,' *Ecumenical Trends*, Vol. 14, No. 4 (Apr. 1985), pp. 57–61.

Kellenbach, Katherine Von. 'Jewish-Christian Dialogue on Feminism and Religion,' *Christian Jewish Relations*, Vol. 19, No. 2 (June 1986), pp. 33–40.

McCauley, Deborah, and Annette Daum. 'Jewish-Christian Feminist Dialogue: A Wholistic Vision,' *Union Seminary Quarterly Review*, Vol. 38, No. 2 (1983), pp. 147–190.

Ruether, Rosemary Radford. 'An Invitation to Jewish-Christian Dialogue: In What Sense Can We Say That Jesus Was "The Christ"? ' *Ecumenist: A Journal for Promoting Christian Unity*, Vol. 10, No. 2 (Jan.–Feb. 1972), pp. 17–24.

Singh, Heidi. 'Roman Catholic–Jewish Women's Dialogue in Los Angeles,' *Journal of Ecumenical Studies*, Vol. 19, No. 4 (Fall 1982), pp. 870–871.

4

Language

Inclusive Language Discussion

BOOKS, DISSERTATIONS, COLLECTED WORKS

Coe, Alexandra, and Earl Kooperkamp, eds. *Religious Language.*
Special issue of *Union Seminary Quarterly Review,* Vol. 40, No. 3
(1985).

Colman, Penelope Morgen. *Use and Power of Language.* Englewood Cliffs,
NJ: Granger Publications Inc., 1981.

Faull, Vivienne, and Jane Sinclair. *Count Us In: Inclusive Language in
Liturgy.* Nottingham: Grove Books, 1986.

Hardesty, Nancy A. *Inclusive Language in the Church.* Atlanta: John Knox
Press, 1987.

Inclusive Language. Special issue of *Religious Education: The Journal of
the Religious Education Association,* Vol. 80, No. 4 (Fall 1985).

Lakoff, Robin. *Language and Women's Place.* New York: Harper and Row,
1976.

The Language of Hymns. Special issue of *The Hymn: A Journal of Congrega-
tional Song,* Vol. 34, No. 4 (Oct. 1983).

Lutheran Church of America. *Guidelines for Inclusive Language.* Avail-
able from LCA Office for Communication, 231 Madison Ave., New
York, NY 10016.

Mayhall, Carole. *Words That Hurt, Words That Heal.* Colorado Springs:
Navpress, 1986.

Miller, Casey, and Kate Swift. *Words and Women.* Garden City, NY:
Anchor Press, 1977.

Spender, Dale. *Manmade Language.* London: Routledge and Kegan Paul,
1980.

ARTICLES, BOOK REVIEWS

Achtemeier, Elizabeth. 'The Translators Dilemma: Inclusive Language,'
 Living Light: An Interdisciplinary Review of Christian Education, Vol. 22,
 No. 3 (Mar. 1986), p. 242.
Allen, Pamela Payne. 'Taking the Next Step in Inclusive Language,'
 Christian Century, Vol. 103, No. 14 (Apr. 23, 1986), pp. 410–413.
'Avoid Sexism,' *Christian Century*, Vol. 104, No. 13 (Apr. 22, 1987), p. 376.
Bechtle, Regina. 'Theological Trends: Feminist Approaches to Theology,
 (1),' *Way: Contemporary Christian Spirituality*, Vol. 27, No. 2 (Apr.
 1987), pp. 124–131.
Beifuss, Joan Turner. 'Reports Garbled on Refusal to Change Language,'
 National Catholic Reporter, Vol. 21 (Nov. 30, 1983), p. 4.
Bird, Phyllis. 'Translating Sexist Language as a Theological and Cultural
 Problem,' *Union Seminary Quarterly Review*, Vol. 42 (1988), pp. 89–95.
Bloomquist, Karen L. 'Help or Hindrance to Feminist Theology,' *Dialog:
 A Journal of Theology*, Vol. 24, No. 1 (Winter 1985), pp. 50–51.
Bondi, Roberta C. 'Some Issues Relevant to a Modern Interpretation of
 the Language of the Nicene Creed with Special Reference to "Sexist"
 Language,' *Union Seminary Quarterly Review*, Vol. 40, No. 3 (1985), pp.
 21–30.
Boucher, Madeleine. 'Scriptural Readings: God-Language and Non-
 sexist Translation,' in *Language and the Church: Articles and Designs for
 Workshops*, ed. by Barbara A. Withers, pp. 28–32. New York: National
 Council of Churches of Christ in the U.S.A., 1984.
Collins, Mary. 'Naming God in Public Prayer,' *Worship*, Vol. 59, No. 4
 (July 1985), pp. 291–304.
Cutsinger, James S. 'On the Meaning of "Man" and Maybe "Woman," '
 Perspectives in Religious Studies, Vol. 9 (Fall 1982), pp. 229–236.
Deibert, Joseph H. 'S-e-x is Not a Four-Letter Word,' *Dialog: A Journal of
 Theology*, Vol. 23, No. 4 (Autumn 1984), pp. 290–292.
Downing, Barray H., and others. 'Inclusive Language Lectionary'
 [readers' response to J.C. Lyles, Dec. 14, 1983], *Christian Century*, Vol.
 101 (Mar. 7, 1984), p. 252.
Dumais, Monique. 'Jésus notre mère,' *Vie des Communautés Religieuses*,
 No. 6 (June 1983), pp. 188–191.
Forsberg, Joan Bates. ' "Ye That Are Men Now Serve Him ..." or Did We
 Really Sing That in Chapel This Morning?' *Reflection: Journal of
 Opinion at Yale Divinity School*, Vol. 74, No. 1 (1976), pp. 3–4.
French, Marilyn. 'Women in Language,' *Soundings: An Interdisciplinary
 Journal*, Vol. 59, No. 3 (Fall 1976), pp. 329–344.
Graham, Alma. 'The Language of Unequal Opportunity,' *A.D.: Pres-
 byterian Life Edition*, Vol. 4, No. 2 (Feb. 1975), p. 32.

Haines, Denise G. 'Women's Ordination: What Difference Has It Made?'
[the battle for the trinity: the debate over inclusive God-language],
Christian Century, Vol. 103, No. 30 (Oct. 15, 1986), p. 903.

Hardesty, Nancy A. ' "Whosoever Surely Meaneth Me": Inclusive
Language and the Gospel,' *Christian Scholar's Review*, Vol. 17, No. 3
(1988), pp. 231–240.

Hefner, Philip J. 'Four Questions and a Few Statements,' *Dialog: A
Journal of Theology*, Vol. 24, No. 1 (Winter 1985), pp. 41–42.

Hodgetts, Michael. 'Revising the I.C.E.L. Texts,' *Music and Liturgy*, Vol.
10 (June 1984), pp. 38–40.

– 'Sense and Sound in Liturgical Translation,' *Worship*, Vol. 57, No. 6
(Nov. 1983), pp. 496–513.

Hughes, Robert D., III. 'The Case for Inclusive Language by a White
Male,' *Religious Education*, Vol. 80, No. 4 (Fall 1985), pp. 616–633.

Jenson, Robert W. 'The Inclusive Lectionary,' *Dialog: A Journal of Theol-
ogy*, Vol. 23, No. 1 (Winter 1984), pp. 4–6.

Jones, Alan W. 'Men, Women and Sex: Make Way for the Image of God!'
Worship, Vol. 62, No. 1 (Jan. 1988), pp. 25–44.

Jones, Kellie Corlew. 'Inclusive Language: Why and How,' *Haelan:
Journal of Worship, Prayer and Meditation*, Vol. 6, No. 2 (Fall 1985),
pp. 9–21.

Keylock, Leslie R. 'God Our Father and Mother: A Bisexual Nightmare
from the National Council of Churches,' *Christianity Today*, Vol. 27,
No. 17 (Nov. 11, 1983), pp. 50–51.

Lloyd, Sharon. 'Changing Liturgical Language,' *Christian Ministry*, Vol.
16, No. 1 (Jan. 1985), pp. 23–24.

Lovelace, Austin C. 'Hymn Tinkering: Gnats or Camels' [ideological
alteration of hymn texts], *Journal of Church Music*, Vol. 27, No. 9 (Nov.
1985), pp. 7–9.

Lyles, Jean Caffey. 'The NCC's Nonsexist Lectionary,' *Christian Century*,
Vol. 100 (Dec. 14, 1983), pp. 1148–1150.

McKim, Donald. 'Inclusive Language in the Churches,' *Presbyterian
Outlook*, Vol. 168, No. 8 (Mar. 3, 1986), p. 7.

Mairs, Nancy. ' "I Have Not Yet Begun to Speak," or the Naked Woman
with No Tongue or toward a Feminist Linguistics of Dress,' *Anima:
An Experimental Journal of Celebration*, Vol. 14 (Spring 1988), pp. 75–86.

Mallon, Elias D. 'An Inclusive Language Lectionary: An Appraisal,'
Ecumenical Trends, Vol. 13, No. 2 (Feb. 1984), pp. 20–22.

Martyna, Wendy. 'Beyond the "He-Man" Approach: The Case for Non-
Sexist Language,' *Signs: Journal of Women in Culture and Society*, Vol. 5
(1980), pp. 482–493.

May, Melanie A. 'Conversations on Language and the Imagery of God:
Occasioned by the Community of Women and Men in the Church

Study,' *Union Seminary Quarterly Review*, Vol. 40, No. 3 (1985), pp. 11–20.

Miller, Casey, and Kate Swift. 'Women and the Language of Religion,' *Christian Century*, Vol. 93, No. 13 (Apr. 14, 1976), pp. 353–358.

Miller, Lynette P. 'What's That You Say?' *Touchstone: Heritage and Theology in a New Age*, Vol. 1, No. 2 (May 1983), pp. 25–29.

Miller, Patrick D. 'The *Inclusive Language Lectionary*,' *Theology Today*, Vol. 41, No. 1 (Apr. 1984), pp. 26–33.

Miller, Randolph C. 'Theological and Philosophical Fragments: A Response' [reply to S.B. Thistlethwaite], *Religious Education*, Vol. 80, No. 4 (Fall 1985), pp. 551–570.

Mills, Steven. 'New Names for God,' *PMC: The Practice of Ministry in Canada*, Vol. 2, No. 3 (Autumn 1985), pp. 10–11.

Mollenkott, Virginia Ramey. 'A Unity That Affirms Diversity: An Inclusive Language Lectionary,' *Ecumenical Trends*, Vol. 15, No. 11 (Jan. 1986), pp. 9–10.

Moore, Mary Elizabeth. 'Inclusive Language and Power: A Response' [reply to L. Russell], *Religious Education*, Vol. 80, No. 4 (Fall 1985), pp. 603–614.

Morton, Nelle. 'The Rising Women's Consciousness in a Male Language,' *Andover-Newton Quarterly*, Vol. 12, No. 4 (Mar. 1972), pp. 177–190.

'NCC's Bisexual Lectionary Brings More Problems,' *Christianity Today*, Vol. 27, No. 19 (Dec. 16, 1983), p. 40.

'A New Revised Standard Bible Will Make Limited Use of Inclusive Language,' *Christianity Today*, Vol. 28, No. 18 (Dec. 14, 1984), p. 58.

Olson, Mark. 'Comparing Two Inclusive Language Lectionaries,' *Other Side*, Vol. 20, No. 150 (Mar. 1984), p. 34.

Orso, Jim. 'Women's Liturgy Raises Key Sacramental Issues,' *National Catholic Register*, Vol. 59 (Jan. 2, 1983), p. 1.

Patterson, Ben. 'The God of NCC Lectionary Is Not the God of the Bible' [reprinted from *Wittenburg Door*, 1983], *Christianity Today*, Vol. 28, No. 2 (Feb. 3, 1984), pp. 12–13.

Pearson, Helen Bruch. 'The Battered Bartered Bride,' *Hymn: A Journal of Congregational Song*, Vol. 34, No. 4 (Oct. 1983), pp. 216–220.

Porter, Ellen J.L. 'The "Her" in the Hymn or Who Was the Mysterious "Pilgrim Stranger"?' *Hymn: A Journal of Congregational Song*, Vol. 35, No. 3 (July 1984), pp. 143–146.

Ramshaw-Schmidt, Gail. 'An Inclusive Language Lectionary,' *Worship*, Vol. 58, No. 1 (Jan. 1984), pp. 29–37.

– 'The Naming of God: Muddle and Mystery,' *Reformed Liturgy and Music*, Vol. 17, No. 4 (Fall 1983), pp. 147–151.

Rayburn, Carole A. 'Impact of Nonsexist Language and Guidelines for Women in Religion,' *Journal of Pastoral Counseling*, Vol. 17, No. 2 (Fall–Winter 1982), pp. 61–64.

Reed, Roy. 'Sexual Imagery and Our Language of Devotion,' *Hymn: A Journal of Congregational Song*, Vol. 34, No. 4 (Oct. 1983), pp. 221–226.

Ross, David F. 'Holistic Scripture,' *Witness*, Vol. 67, No. 2 (Feb. 1984), pp. 10–11.

Ruether, Rosemary Radford. 'Foundations of Liberation Languages: Christianity and Revolutionary Movements,' *Journal of Religious Thought*, Vol. 32 (Spring–Summer 1975), pp. 74–85.

– 'God-talk after the End of Christendom,' *Commonweal: A Review of Public Affairs, Literature and the Arts*, Vol. 105, No. 12 (June 1978), pp. 369–375.

– 'Theological Trends (2): Feminist Critique and Re-visioning of God-Language,' *Way: Contemporary Christian Spirituality*, Vol. 27, No. 2 (Apr. 1987), pp. 132–143.

Russell, Letty M. 'Inclusive Language a Power,' *Religious Education*, Vol. 80, No. 4 (Fall 1985), pp. 582–602.

– 'The Power of Partnership in Language,' *Theological Markings: A UTS Journal*, Vol. 14 (Winter 1986), pp. 1–8.

Schmidt, Gail Ramshaw. 'De Divinis Nominibus: The Gender of God,' *Worship*, Vol. 56, No. 2 (Mar. 1982), pp. 117–131.

Shepherd, Janice M. 'Language, Sex and Lectionary' [reply to B. Throckmorton], *Christian Century*, Vol. 101, No. 28 (Sept. 26, 1984), pp. 875–876.

Smith, Joanmarie. 'Case for Inclusive Language: A Response' [reply to R.D. Hughes], *Religious Education*, Vol. 80, No. 4 (Feb. 1985), pp. 634–643.

Somerville, Stephen. 'Liturgy; ICEL,' *Canadian Catholic Review*, Vol. 2 (July–Aug. 1984), p. 32.

Stevenson, Kenneth. 'Review of *Count Us In: Inclusive Language in Liturgy* by Vivienne Faull and Jane Sinclair,' *Theology*, Vol. 90 (Sept. 1987), pp. 413–415.

Tamez, Elsa. 'Eros, Language and Machismo; Interview with Rubem Alves by Elsa Tamez,' *Cross Currents: A Quarterly Review to Explore the Implications of Christianity for Our Times*, Vol. 37, No. 4 (Winter 1987–1988), pp. 456–460.

Thistlethwaite, Susan Brooks. 'Inclusive Language: Theological and Philosophical Fragments,' *Religious Education*, Vol. 80, No. 4 (Fall 1985), pp. 551–570.

Throckmorton, Burton H. 'Why the *Inclusive Language Lectionary*?' *Christian Century*, Vol. 101, No. 24 (Aug. 1–8, 1984), pp. 742–744.

Turner, Rosa Shard. 'The Increasingly Visible Female and the Need for Generic Terms,' *Christian Century*, Vol. 64, No. 9 (Mar. 16, 1977), pp. 248–252.

Vanek, Elizabeth-Anne. 'From Mankind to Humankind,' *Today's Parish*, Vol. 20 (Jan. 1988), pp. 10–12.

Wainwright, Geoffrey, Pheme Perkins, and David M. Bossman. '*An Inclusive Language Lectionary*: Three Views,' *Biblical Theology Bulletin: A Journal of Bible and Theology*, Vol. 14, No. 1 (Jan. 1984), pp. 28–35.

Westerhoff, John H., III, ed. 'Inclusive Language,' *Religious Education*, Vol. 80, No. 4 (Fall 1985), pp. 507–653.

White, Richard C. 'Inclusive Language: A Personal Interpretation,' *Lexington Theological Quarterly*, Vol. 20, No. 2 (Apr. 1985), pp. 51–57.

– 'Review of *Inclusive Language in the Church* by Nancy A. Hardesty,' *Lexington Theological Quarterly*, Vol. 23, No. 1 (Jan. 1988), pp. 17–18.

Wilson, Beclee Newcomer, and Edwina Hunter. 'Celebration of the Inclusive Language Lectionary' [sermon], *Journal of Women and Religion*, Vol. 3, No. 21 (Summer 1984), pp. 5–11.

Withers, Barbara A. 'Inclusive Language and Religious Education,' *Religious Education*, Vol. 80, No. 4 (Fall 1985), pp. 507–521.

Young, Carlton R., ed. 'The Language of Hymns,' *Hymn: A Journal of Congregational Song*, Vol. 34, No. 4 (Oct. 1983), pp. 201–237.

Zelechow, Bernard. 'Gender and Speech: Redeeming the Text,' *Grail: An Ecumenical Journal*, Vol. 4, No. 2 (June 1988), pp. 37–40.

Other Related Resources

Inclusive Language Kit. Regina: Division of Mission, Saskatchewan Conference, [1977].

Language and the Church: Designs for Workshops. New York: National Council of Churches, 1984.

Language about God in Liturgy and Scripture: A Study Guide. Philadelphia: Geneva Press, 1980.

Mundle, Dorothy. 'Language and Imagery: Words Are Important' [workshop on inclusive language], *Exchange: Bulletin of Third World Christian Literature*, Vol. 8, No. 3 (Spring 1984), pp. 30–31.

United Church of Canada. Interdivisional Task Force on Changing Roles of Women and Men in Church and Society. *Daughters and Sons of God*. Toronto: General Council Office of the United Church of Canada, 1981.

United Methodist Publishing House. *Guidelines for Eliminating Racism, Ageism, Handicappism and Sexism*, prepared by the General Council in Ministries. Nashville, Tenn., May 1984.

5

Mariology

BOOKS, DISSERTATIONS, COLLECTED WORKS

Allue, Emil Simeon. 'The Image of Virgo-Mater in the *Liber Mozarabicus Sacramentorum*.' Ph.D. dissertation, Fordham University, 1981.
Ashe, Geoffrey. *The Virgin*. London: Routledge and Kegan Paul, 1976.
Boff, Leonardo. *The Maternal Face of God: The Feminine and Its Religious Expressions*. San Francisco: Harper and Row, 1987.
Brown, Raymond E., ed. *Mary in the New Testament: A Collaborative Assessment by Protestant and Roman Catholic Scholars*. Philadelphia: Fortress Press, 1978.
Carlisle, Thomas J. *Beginning with Mary*. Grand Rapids: Eerdmans, 1986.
Carroll, Michael P. *The Cult of the Virgin Mary: Psychological Origins*. Princeton: Princeton University Press, 1986.
Feuillet, André. *Jesus and His Mother: According to the Lucan Infancy Narratives, and According to St John: The Role of the Virgin Mary in Salvation History and the Place of Woman in the Church*, trans. by Leonard Maluf. Still River, MA: St. Bede's Publications, c1984.
Flusser, David, Jaroslav J. Pelikan, and Justin Lang. *Mary: Images of the Mother of Jesus in Jewish and Christian Perspective*. Philadelphia: Fortress Press, 1986.
Greeley, Andrew M. *The Mary Myth: On the Femininity of God*. New York: Seabury Press, 1977.
Hure, Jacqueline Saveria. *I Mary, Daughter of Israel: A Fictional Memoir*, trans. by Nina de Voogd. London: Weidenfeld and Nicolson, 1987.
Jegen, Carol Frances, ed. *Mary According to Women*. Kansas City: Leaven, 1985.
Kirwin, George Francis. 'The Nature of the Queenship of Mary' (Studies

in Sacred Theology, Vol. 2, No. 246). Ph.D. dissertation, Catholic
University of America, 1973.

Küng, Hans, and Jürgen Moltmann, eds. *Mary in the Churches* (Concilium, 168). New York: Seabury Press, 1983.

McHugh, John. *The Mother of Jesus in the New Testament.* Garden City, NY: Doubleday, 1975.

Malone, Mary T. *Who Is My Mother? Rediscovering the Mother of Jesus.* Dubuque, IA: W.C. Brown, 1984.

Mary and the Church. Special issue of *New Catholic World,* Vol. 229 (Nov.–Dec. 1986).

Matter, Edith Ann. 'The *De Partu Virginis* of Pas Chasuis Radbertus: Critical Edition and Monographic Study.' Ph.D. dissertation, Yale University, 1976.

Preston, James J. *Mother Worship: Theme and Variations.* Chapel Hill: University of North Carolina Press, c1982.

Roden, Lois I. *In Her Image.* Waco, TX: Living Waters, 1981.

Ruether, Rosemary Radford. *Mary, the Feminine Face of the Church.* Philadelphia: Westminster Press, c1977.

Simard, Luc. 'Exégèse de Jn 19, 25–27: Contribution pour une mariologie dans le quatrième Évangile.' M.Th. dissertation, University of St. Michael's College, Toronto, 1975.

Vukmanic, Mary Catherine. 'The Marian Question in the Light of Vatican II: A Critique and a Proposal.' Th.D. dissertation, Southern Baptist Theological Seminary, 1972.

Warner, Marina. *Alone of All Her Sex: The Myth and Cult of the Virgin Mary.* New York: Knopf, 1976.

ARTICLES, BOOK REVIEWS

Beinert, Wolfgang. 'Maria in der Feministischen Theologie,' *Catholica: Vierteljahresschrift für ökumenische Theologie,* Vol. 42 (June 5, 1988), pp. 1–27.

– 'Mary and Feminism,' *Theology Digest,* Vol. 31, No. 3 (Fall 1984), pp. 235–239.

De Bertrand, Marjorie. 'Mary in Latin American Liberation Theologies,' *Marian Library Studies,* Vol. 38 (1987), pp. 47–62.

Browner, Carole, and Ellen Lewin. 'Female Altruism Reconsidered: The Virgin Mary as Economic Woman,' *American Ethnologist,* Vol. 9, No. 1 (Feb. 1982), pp. 61–75.

Bynum, Caroline Walker. 'A Review of *Mary: Images of the Mother of Jesus in Jewish and Christian Perspective,* by David Flusser, Jaroslav J. Pelikan and Justin Lang,' *Church History,* Vol. 57, No. 1 (Mar. 1988), p. 118.

Campbell, T. 'Review of *The Maternal Face of God: The Feminine and Its Religious Expression* by Leonardo Boff,' *Sisters Today*, Vol. 59, No. 5 (Jan. 1988), p. 298.

Caron, Gérald. 'Seeing "Mary" with New Eyes,' *AFER: African Ecclesial Review*, Vol. 14 (Aug. 1985), pp. 238–244.

Dalton, Kathleen. 'Mariology and Feminine Freedom,' *Sisters Today*, Vol. 60, No. 1 (Aug.–Sept. 1988), pp. 24–29.

Donnelly, Doris. 'Maternity's Raw Faith: The Courage of Mary,' *Sojourners*, Vol. 12, No. 10 (Nov. 1983), pp. 23–24.

Flanagan, Donal. 'The Impact of Feminism on Mariology,' *One in Christ: A Catholic Ecumenical Review*, Vol. 21, No. 1 (1985), pp. 75–78.

Gordon, Mary. 'Coming to Terms with Mary,' *Commonweal: A Review of Public Affairs, Literature and the Arts*, Vol. 109, No. 3 (Jan. 15, 1982), p. 11.

Halkes, Catharina. 'Marie et les femmes,' *Concilium*, 188 (1983), pp. 119–130.

Harrington, Patricia A. 'Mary and Femininity: A Psychological Critique,' *Journal of Religion and Health*, Vol. 23, No. 3 (Fall 1984), pp. 204–217.

Hennaux, Jean-Maria. 'L'esprit et le féminin: La Mariologie de Leonardo Boff – A propos d'un livre récent,' *Nouvelle Revue Théologique*, Vol. 109, No. 5 (Nov.–Dec. 1987), pp. 884–895.

Hiatt, Suzanne. 'The Great Thing about Mary,' *Witness*, Vol. 69, No. 12 (Dec. 1986), pp. 6–8.

Johnson, Elizabeth A. 'The Marian Tradition and the Reality of Women,' *Horizons: The Journal of the College Theology Society*, Vol. 12, No. 1 (Spring 1985), pp. 116–135.

– 'Mary and Contemporary Christology: Rahner and Schillebeeckx,' *Église et Théologie*, Vol. 15 (1984), pp. 155–182.

– 'The Symbolic Character of Theological Statements about Mary,' *Journal of Ecumenical Studies*, Vol. 22, No. 2 (Spring 1985), pp. 312–336.

LaVerdière, Eugène. 'His Mother Mary,' *Emmanuel*, Vol. 93, No. 4 (May 1987), pp. 190–197.

Lewela, M. Pauline W. 'Mary's Faith Model of Our Own: A Reflection,' *AFER: African Ecclesial Review*, Vol. 14 (Apr. 1985), pp. 92–98.

Lewis, Manon. 'Les fées ont soif, ou la vision sotériologique de la femme, lecture religiologique,' *Approches*, No. 7 (Nov. 1987), pp. 23–34.

Little, Joyce A. 'Mary and Feminist Theology,' *Thought: A Review of Culture and Idea*, Vol. 52 (Dec. 1987), pp. 343–357.

McClory, Robert. 'Mary's Pence to Women as Peter's to Pope,' *National Catholic Reporter*, Vol. 23 (May 15, 1987), p. 5.

Meyer, Marvin W. 'Making Mary Male: The Categories "Male" and "Female" in the Gospel of Thomas,' *New Testament Studies: An International Journal*, Vol. 31, No. 4 (Oct. 1985), pp. 553–570.

Panikkar, Raimundo. 'The Marian Dimensions of Life' [revised and translated from *Dimensioni Marianne Della Vita*, 1972], *Epiphany: A Journal of Faith and Insight*, Vol. 4, No. 4 (Summer 1984), pp. 3–9.

Quinn, Jerome D. 'Mary the Virgin, Mother of God,' *Bible Today: A Periodical Promoting Popular Appreciation of the Word of God*, Vol. 25, No. 3 (May 1987), pp. 177–180.

Royden, Maude. 'A Woman's View of the Virgin Birth,' *Christian Century*, Vol. 101, No. 22 (July 4–11, 1984), pp. 680–682.

Ruether, Rosemary Radford. 'Liberation Mariology,' *Witness*, Vol. 62, No. 10 (Oct. 1979), pp. 15–18.

Schulte, A. 'Review of *The Maternal Face of God: The Feminine and Its Religious Expression* by Leonardo Boff,' *Saint Anthony Messenger*, Vol. 95 (Jan. 1988), p. 48.

Smith, Patricia. 'Will the Mary of History Please Stand Up?' *Emmanuel*, Vol. 93, No. 4 (May 1987), pp. 186–189.

Stuhlmueller, Carroll. 'Old Testament Settings for Mary in the Liturgy,' *Bible Today: A Periodical Promoting Popular Appreciation of the Word of God*, Vol. 24, No. 3 (May 1986), pp. 159–166.

Thomas, Carole. 'A Modern Mother Questions Mary,' *New Catholic Times*, Vol. 11, No. 9 (May 3, 1987), p. 13.

Van den Hengel, John. 'Mary: Miriam of Nazareth or the Symbol of the "Eternal Feminine," ' *Science et Esprit*, Vol. 37 (Oct.–Dec. 1985), pp. 319–333.

Zion, William P. 'Review of *The Cult of the Virgin Mary: Psychological Origins* by Michael P. Carroll,' *Studies in Religion/Sciences Religieuses: A Canadian Journal*, Vol. 16, No. 4 (1987), pp. 493–494.

6

Ministry

General – Women in Ministry

BOOKS, DISSERTATIONS, COLLECTED WORKS

Adams, Daniel W. 'Parishioners' Image of the Ideal Head of Staff: A Major Impediment to the Equal Employment Opportunity for Clergywomen in the United Presbyterian Church.' D.Min. dissertation, San Francisco Theological Seminary, 1984.

Adams, James R., and Celia A. Hahn. *Learning to Share the Ministry*. Washington, DC: Alban Institute, 1975.

Beard, Helen. *Women in Ministry Today*. Plainfield, NJ: Distributed by Logos International, c1980.

Chittister, Joan D. *Women, Ministry and the Church*. New York: Paulist Press, 1983.

Clowse, Barbara Barksdale. *Women, Decision Making and the Future*. Atlanta: J. Knox Press, 1985.

Coger, Marian. *Women in Parish Ministry: Stress and Support*. Washington, DC: Alban Institute, 1985.

Coll, Regina. *Women and Religion: A Reader for the Clergy*. Mahwah, NJ: Paulist Press, 1982.

Daigeler, Hans W., and Albert Dufour, comps. *Survey on the Participation of Women in the Official Pastoral Work of the Catholic Church in Canada*. [N.p.]: Concacan Inc., 1979.

Engelsman, John, ed. *Women in Ministry*. Special issue of *Drew Gateway*, Vol. 48, No. 3 (Spring 1978).

Gundry, Patricia. *Neither Slave Nor Free: Helping Women Answer the Call to Church Leadership*. San Francisco: Harper and Row, 1987.

Handley, Thomas Beck. 'Congregational Leader's Perception of the Pastoral Role: An Analysis of the Acceptance of Women Pastors.' Dissertation, University of Tennessee, 1985.

Howe, E. Margaret. *Women and Church Leadership*. Grand Rapids: Zondervan, 1982.

Hultgren, Arland J., ed. *Feminism*. Special issue of *Word and World: Theology for Christian Ministry*, Vol. 8, No. 4 (Fall 1988).

Kaeser, Miriam F. 'A Study of Feminine Role Models Selected by Catholic Women.' Ph.D. dissertation, University of San Diego, 1987.

Kelley, Ann Elizabeth. 'Catholic Women in Campus Ministry: An Emerging Ministry for Women in the Catholic Church.' Ph.D. dissertation, Boston University Graduate School, 1975.

Kleinman, Sherryl. *Equals before God*. Chicago: University of Chicago Press, 1984.

Mathew, Annamma Nainan. 'Women and Ministry: A Case for the Ordination of Women in the Central Kerala Diocese of the Church of South India.' D.Min. dissertation, Lutheran School of Theology at Chicago, 1988.

Mornson, Susan Murch. 'Ministry Shaped by Hope: Toward Wholeness, the Woman as Ordained Minister.' D.Min. dissertation, Wesley Theological Seminary, 1986.

Niebling, Glenn E. 'A Study of Perception of Women's Role within the Church.' D.Min. dissertation, Graduate Seminary of Phillips University, 1981.

Page, Franklin Stuart. 'Toward a Biblical Ethic of Women in Ministry.' Ph.D. dissertation, Southwestern Baptist Theological Seminary, 1980.

Prokes, Mary Timothy. 'The Flesh Was Made Word: An Initial Exploration of This Proposition as It Applies to Women's Ministries in the Light of Four Post–Vatican II Orientations within the Roman Catholic Church.' Ph.D. dissertation, University of St. Michael's College, 1976.

Rhodes, Lynn Nell. *Co-creation: A Feminist Vision of Ministry*. Philadelphia: Westminister Press, 1987.

– 'Toward a Liberation/Feminist Theory of Ministry: A Contextual Perspective.' Th.D. dissertation, Boston University School of Theology, 1983.

Robinson-Harris, Tracey. 'Toward Shared Ministry.' D.Min. dissertation, Vanderbilt University Divinity School, 1987.

Russell, Letty M. *The Future of Partnership*. Philadelphia: Westminster Press, c1979.

– *Growth in Partnership*. Philadelphia: Westminster Press, 1981.

Schaller, Lyle E., ed. *Women as Pastors*. Nashville: Abingdon Press, 1982.

Schreckengost, George Earl. 'The Effect of Latent Racial, Ethnic, and Sexual Biases on Open Itineracy in East Ohio Conference, the United Methodist Church.' D.Min. dissertation, Lancaster Theological Seminary, 1984.

Simmons, Thomas Eastland. 'The Role of the Woman Pastoral Associate in Pastoral Ministry.' D.Min. dissertation, Catholic University of America, 1981.

Spahr, Jane Adams. 'Approaches to the Spirituality of Lesbian Women: Implications for Ministry.' D.Min. dissertation, San Francisco Theological Seminary, 1987.

Spencer, Aida Besancon. *Beyond the Curse: Women Called to Ministry.* Nashville: T. Nelson, 1985.

Tucker, Ruth. *Daughters of the Church: A History of Women in Ministry.* Grand Rapids: Zondervan, 1987.

Verdesi, Elizabeth Howell. 'The Professionally-Trained Woman in the Presbyterian Church: The Role of Power in the Achievement of Status and Equality.' Ph.D. dissertation, Columbia University, 1975.

Walsh, Mary Paula. 'Role Conflicts among Women in Ministry.' Ph.D. dissertation, Catholic University of America, 1984.

Weidman, Judith L., ed. *Women Ministers: How Women Are Redefining Traditional Roles.* San Francisco: Harper and Row, 1985.

Williams, Martha Ann. 'Shall the Sisters Speak?: Recovering Women's Story as Empowerment for Leadership in the Christian Church (Disciples of Christ).' Ph.D. dissertation, School of Theology at Claremont, 1988.

Women, Work and Worship in the United Church of Canada. Shirley Davy, project coordinator, Nancy Hardy, ed. Toronto: UCC, 1983.

ARTICLES, BOOK REVIEWS

Ackermann, Denise. 'Liberation and Practical Theology: A Feminist Perspective on Ministry,' *Journal of Theology for Southern Africa,* Vol. 52 (Sept. 1985), pp. 30–41.

Alsdurf, Phyllis E. 'Review of *Neither Slave Nor Free: Helping Women Answer the Call to Church Leadership* by Patricia Gundry,' *Christianity Today,* Vol. 22, No. 1 (Jan. 15, 1988), pp. 59–61.

Anders, Sarah F. 'Women in Ministry: The Distaff of the Church,' *Review and Expositor: A Baptist Theological Journal,* Vol. 80 (Summer 1983), pp. 427–436.

Anderson, Lavina Fielding. 'Ministering Angels: Single Women in Mormon Society,' *Dialogue: A Journal of Mormon Thought,* Vol. 16, No. 3 (Autumn 1983), pp. 59–72.

Anderson, Phyllis Brosch. 'Liberation in a Pastoral Perspective,' *Word and World: Theology for Christian Ministry,* Vol. 7, No. 1 (Winter 1987), pp. 70–77.

- 'The Ministry of Women: Past, Present, and Future,' *Lutheran Theological Seminary Bulletin*, Vol. 65, No. 4 (Fall 1985), pp. 35–44.

Arakawa, D. 'Women in Ministry Program of the National Council of Churches of Christ,' *Unitarian Universalist Christian*, Vol. 41, No. 1 (Spring 1986), pp. 59–60.

Armstrong, Jean. 'Women in Authority: Operating out of a Different Perspective,' *PMC: The Practice of Ministry in Canada*, Vol. 1, No. 3 (Sept. 1984), pp. 20–21.

Baker, Rosemary. 'Preparing the Yeast: Training of Women for Leadership,' *Point: Forum for Melanesian Affairs*, Vol. 4, No. 2 (1975), pp. 78–94.

Baker-Johnson, Sharon, ed. 'Keeping Our Balance: Work, Family and Self,' *Daughters of Sarah*, Vol. 14, No. 2 (Mar.–Apr. 1988), pp. 3–27.

Beifuss, Joan Turner. 'Women Ministers Fit Comfortably in Parishes,' *National Catholic Reporter*, Vol. 18 (Dec. 11, 1981), p. 28.

Blake, Richard A. 'World without Nuns,' *America*, Vol. 156, No. 9 (Oct. 11, 1986), pp. 185–186.

Bowers, Joyce M. 'Roles of Married Women Missionaries: A Case Study,' *International Bulletin of Missionary Research*, Vol. 8, No. 1 (Jan. 1984), p. 4.

- 'Women's Roles in Mission: Where Are We Now?' *Evangelical Missions Quarterly*, Vol. 21, No. 4 (Oct. 1985), pp. 352–360.

Brown, Margaret. 'Liberation and Ministry of Women and Laity,' *Encounter*, Vol. 38, No. 1 (Winter 1977), pp. 54–71.

Buchwalter, Gail G. 'Women in Ministry,' *Christian Ministry*, Vol. 6, No. 3 (May 1975), pp. 7–10.

Carlson, Carole. 'Clergywomen and Senior Pastorates,' *Christian Century*, Vol. 105, No. 1 (Jan. 6–13, 1988), pp. 15–17.

Caron, Charlotte. 'The Significance of Women in Ministry,' *Touchstone: Heritage and Theology in a New Age*, Vol. 4, No. 1 (Jan. 1986), pp. 3–5.

Carpenter, Delores Causion. 'The Professionalization of the Ministry by Women,' *Journal of Religious Thought*, Vol. 43, No. 1 (Spring–Summer 1986), pp. 59–75.

Carr, Anne E. 'Summary of the Discussion: Women and Power in the Church,' *Proceedings of the Catholic Theological Society of America*, Vol. 37 (1982), pp. 128–129.

Chatfield, Joan. 'Women and Men: Colleagues in Mission,' *Gospel in Context*, Vol. 2 (Apr. 1979), pp. 4–14.

Chervin, Ronda. 'Voices in the Church Today: A Woman Speaks Out,' *Liguorian*, Vol. 74 (Sept. 1986), pp. 14–18.

Chittister, Joan D. 'Leaven and Labor: The Ministry of American Religious,' *Sojourners*, Vol. 14, No. 4 (Apr. 1985), pp. 25–26.

- 'Pastoral Called Fuel for Future of U.S. Women,' *National Catholic Reporter*, Vol. 24 (Apr. 21, 1988), p. 1.

Clarke, Douglas. 'Female Ministry in the Salvation Army,' *Expository Times*, Vol. 95 (May 1984), pp. 232–235.

Collins, Mary. 'The Ministers: Male and Female,' *Pastoral Music*, Vol. 10 (June–July 1986), pp. 20–22.

Combee, Danielle. 'Command Performance: The Great Role Reversal,' *Fundamentalist Journal*, Vol. 4, No. 5 (May 1985), pp. 43–44.

Crawford, Carolyn A. 'Ministry from a Single Perspective: Assets and Liabilities,' *Journal of Pastoral Care*, Vol. 42, No. 2 (Summer 1988), pp. 117–123.

Cully, Iris. 'Feminism and Ministerial Education,' *Christian Century*, Vol. 96, No. 5 (Feb. 7, 1979), pp. 141–145.

'Deacons Suspended' [self-acknowledged Lesbians, Anglican Church of Canada], *Christian Century*, Vol. 103, No. 11 (Apr. 2, 1986), p. 322.

Dockery, David S. 'The Role of Women in Worship and Ministry: Some Hermeneutical Questions,' *Criswell Theological Review*, Vol. 1 (Spring 1987), pp. 363–386.

Donnenwirth, Richard A., Georgann Hilbert, and Barbara Sheehan. 'CPE Training Model on Gender, Sexuality, and Collegiality,' *Journal of Supervision and Training in Ministry*, Vol. 6 (1983), pp. 141–152.

Doohan, Helen. 'Today's Church Needs Women's Leadership,' *Human Development*, Vol. 7 (Summer 1986), pp. 7–11.

Dumais, Monique. 'La double signification de la notion de "service" dans l'église,' *Institut Simone de Beauvoir. Annual Report 1979–1980 and Conference Proceedings* (1981), pp. 80–94.

- 'Les religieuses, leur contribution à la société québécoise,' *Les Cahiers de la Femme/Canadian Women Studies*, Vol. 3, No. 1 (1981), pp. 18–20.

Duquoc, Christian. 'Vatican II and Crisis in Ministry,' *Theology Digest*, Vol. 30, No. 2 (Summer 1982), pp. 111–114.

Durkin, Mary G. 'Women in the Future of the Parish,' *Pastoral Life: The Magazine for Today's Ministry*, Vol. 32, No. 3 (Mar. 1983), p. 2.

Egolf-Fox, Kim. 'A Family Affair: Sharing a Pastorate,' *Christian Ministry*, Vol. 17, No. 1 (Jan. 1986), pp. 14–15.

Eikenberry, Mary. 'Women as Missionaries,' *Brethren Life and Thought*, Vol. 30 (Winter 1985), pp. 47–49.

Elsesser, Suzanne E. 'Laywomen and the Mission of the Church,' *Sisters Today*, Vol. 54, No. 2 (Oct. 1982), pp. 90–94.

Eyrich, Jean A. 'On Planting a Few Seeds,' *Christian Ministry*, Vol. 6, No. 3 (May 1975), pp. 15–18.

Faber, Heije. 'The Ministry in a Changing Society,' *Perkins Journal*, Vol. 34, No. 1 (Fall 1980), pp. 1–27.

Farley, Margaret Ann. 'Ministry: Homeless and Ordained, Sermon at the Ordination of Marie M. Fortune,' *Reflection: Journal of Opinion at Yale Divinity School*, Vol. 74, No. 1 (Nov. 1976), pp. 12–13.

Felder, Cain H. 'The Bible, Black Women and Ministry,' *Journal of the Interdenominational Theological Center*, Vol. 12 (Fall 1984–Spring 1985), pp. 9–21.

Ferrell, Velma McGee. 'Called to Serve: Women in the Southern Baptist Convention,' *Faith and Mission*, Vol. 2, No. 1 (Fall 1984), pp. 18–29.

Finson, Shelley Davis. 'Review of *Women Ministers: How Women Are Redefining Tradition Roles*, Judith Weidman, ed.,' *Journal of Supervision and Training in Ministry*, Vol. 8 (1986), pp. 153–154.

'First Women Deacons' [Melbourne, Australia], *Christian Century*, Vol. 103, No. 13 (Apr. 16, 1986), p. 384.

Fitzgerald, Kyriaki Kaudoyanes. 'The Ministry of Women in the Orthodox Church: Some Theological Presupposition,' *Journal of Ecumenical Studies*, Vol. 20, No. 4 (Fall 1983), pp. 558–575.

Fitzpatrick, Donna R. 'The Third Stage: A Successful Career Woman Asks: "Has Feminism Helped Me or Hurt Me?" ' *Critic*, Vol. 6, No. 3 (May 1988), pp. 25–29.

Foley, Nadine. 'Celibacy in the Men's Church,' in *Women in a Men's Church* (Concilium, 134), ed. by Virgil Elizondo and Norbert Greinacher, pp. 26–42. Edinburgh: T. and T. Clark, 1980.

Frey, Stephanie, and Lawrence R. Wohlrabe. 'Partners in Ministry: Men and Women,' *Word and World: Theology for Christian Ministry*, Vol. 8, No. 4 (Fall 1988), pp. 366–373.

Gallagher, Tricia. 'Bishops' Pastoral on Women Draws Mixed Reaction,' *Our Sunday Visitor*, Vol. 77 (May 8, 1988), p. 3.

Gateley, Edwina. 'Ministry on the Edges,' *Way: Contemporary Christian Spirituality*, Vol. 27, No. 2 (Apr. 1987), pp. 89–98.

Geray, Marietta. 'Expressing the Feminine: In Search of a Model,' *Review for Religious*, Vol. 47, No. 1 (Jan.–Feb. 1988), pp. 42–46.

Gerlach, Barbara A., and Emily C. Hewitt. 'Training Women for Ministry,' *Andover Newton Quarterly*, Vol. 17, No. 2 (Nov. 1976), p. 133.

Gibson, Mary Irwin, Shirley Herman, Maureen Kabwe, Faye Mount, and Allison Stewart Patterson. 'Call Me by My Name' [issues involved in being a woman in ministry], *Arc*, Vol. 10, No. 2 (Spring 1983), pp. 6–11.

Gilkes, Cheryl Townsend. 'The Role of Women in the Sanctified Church,' *Journal of Religious Thought*, Vol. 43, No. 1 (Spring–Summer 1986), pp. 24–41.

– ' "Together and in Harness": Women's Traditions in the Sanctified Church,' *Signs: Journal of Women, Culture and Society*, Vol. 10, No. 4 (Summer 1985), pp. 678–699.

Grant, Jacquelyn. 'Black Women and the Church,' in *All the Women Are White, All the Blacks Are Men, But Some of Us Are Brave*, ed by Gloria T. Hull, Patricia Bell Scott, and Barbara Scott, pp. 141–152. Old Westbury, NY: Feminist Press, 1982.

Hampson, Daphne. 'On Power and Gender,' *Modern Theology: A Quarterly Journal of Systematic and Philosophical Theology*, Vol. 4, No. 3 (Apr. 1988), pp. 234–250.

Hansen, Susan. 'Diocesan Workers Initiate Teamwork on Woman's Issues,' *National Catholic Reporter*, Vol. 24 (Jan. 15, 1988), p. 20.

– 'Draft of Women's Pastoral Makes Strong Appeal,' *National Catholic Reporter*, Vol. 24 (Apr. 1, 1988), p. 21.

– 'Laywoman Leads the Way in Northwestern Parish,' *National Catholic Reporter*, Vol. 22 (Sept. 5, 1986), pp. 7–8.

Harrison, Marilyn. 'Putting the Pieces Together in the United Church,' *Exchange: For Leaders of Adults*, Vol. 10, No. 1 (Fall 1985), pp. 2–3, 12.

Hayes, Pamela. 'Women and the Passion,' *Way Supplement*, No. 58 (Spring 1987), pp. 56–73.

Hefner, Philip J. 'Paying the Price of Equal Opportunity,' *Dialog: A Journal of Theology*, Vol. 24, No. 3 (Summer 1985), pp. 167–168.

Hendricks, Jean Lichty. 'Pastoring as a Woman,' *Brethren Life and Thought*, Vol. 30 (Winter 1985), pp. 43–45.

Hiatt, Suzanne, Beverly Anderson, Nancy Hardesty, Barbara Zikmund Brown, and Letty Russell. 'Women Clergy: How Their Presence Is Changing the Church' [a symposium on the seminary campus], *Christian Century*, Vol. 96, No. 5 (Feb. 7, 1979), pp. 122–127.

Hunt, Mary E. 'New Models of Ministry: A Feminist Challenge' [Roman Catholic perspective], *Journal of Women and Religion*, Vol. 4, No. 1 (Winter 1984), pp. 40–44.

– 'Women Ministering in Mutuality: The Real Connection,' *Sisters Today*, Vol. 51, No. 1 (Aug./Sept. 1979), pp. 35–43.

Hutch, Richard A. 'Types of Women Religious Leaders,' *Religion: Journal of Religion and Religions*, Vol. 14 (Apr. 1984), pp. 155–173.

Huws, Glenys. 'Women in Ministry,' *PMC: The Practice of Ministry in Canada*, Vol. 1, No. 1 (Mar. 1984), pp. 18–21.

Ice, Martha Long. 'Clergywomen and the Future,' *Word and World: Theology for Christian Ministry*, Vol. 8, No. 4 (Fall 1988), pp. 366–373.

Jones, Judie. 'The Woman in Leadership, Pt. 3: Examining Your Objectives,' *Journal of Church Music*, Vol. 25, No. 2 (Feb. 1983), pp. 8–11.

Josee, Marie. 'Collaboration in the Promotion of Woman: The Role of Women in the Missionary Church in Relation to the Role of Woman in the Contemporary World,' *Point: Forum for Melanesian Affairs*, Vol. 4, No. 2 (1975), pp. 44–64.

Josselyn, Lynne. 'Pastoral Ministry? Detours and Washout Bridges,' *Drew Gateway*, Vol. 48, No. 3 (Spring 1978), pp. 53–61.
- 'Women in Ministry in the Small Congregation,' in *New Possibilities for Small Churches*, ed. by Douglas Alan Walrath, pp. 67–87. New York: Pilgrim Press, 1983.
Kastner, Patricia Wilson. 'In the Teaching Ministry,' *Christian Ministry*, Vol. 6, No. 4 (May 1975), pp. 19–22.
Keller, Rosemary Skinner. 'Women and the Nature of Ministry in the United Methodist Tradition,' *Methodist History*, Vol. 22 (Jan. 1984), pp. 99–114.
Kieren, Dianne K., and Brenda Munro. 'Handling Greedy Clergy Roles: A Dual Clergy Example' [Lutheran Church in Western Canada], *Pastoral Psychology*, Vol. 36, No. 4 (Summer 1988), pp. 239–248.
Kraus, M. 'I'm Not the Minister's Wife, I'm the Minister,' *New Catholic World*, Vol. 218, No. 1305 (May–June 1975), pp. 116–119.
Krekeler, Kathleen. 'Women According to Luke: Models of Prayers and Ministry,' *Sisters Today*, Vol. 56, No. 5 (Jan. 1985), pp. 271–272.
Krotz, Larry. 'Mr. and Mrs. Minister,' *United Church Observer*, Vol. 39, No. 3 (Sept. 1975), p. 22.
Kwilecki, S. 'Contemporary Pentecostal Clergywomen: Female Christian Leadership, Old Style,' *Journal of Feminist Studies in Religion*, Vol. 3, No. 2 (Fall 1987), pp. 57–75.
Lacelle, Elisabeth J. 'Women in the Catholic Church of Canada,' *Ecumenist: A Journal for Promoting Christian Unity*, Vol. 23, No. 4 (May–June 1985), pp. 49–54.
Lahutsky, Nadia M. 'Women and Ministry: Changes in the Future?' *Lexington Theological Quarterly*, Vol. 20, No. 2 (Apr. 1985), pp. 33–41.
Lyles, Jean Caffey. 'UMC's Women Clergy: Sisterhood and Survival,' *Christian Century*, Vol. 96, No. 5 (Feb. 7–14, 1979), pp. 117–119.
McClory, Robert Joseph. 'Protestant Women Ministers: The Cutting Edge Can Hurt,' *U.S. Catholic*, Vol. 53 (Mar. 1988), pp. 32–38.
McKenzie, Marna. 'Exploring Issues of Work for Women in the Church,' *Journal of Women and Religion*, Vol. 1, No. 2 (Fall 1981), pp. 15–22.
McLean, Cynthia. 'Women's Project Gives "Historical Corrective" to Church Ministry,' *Witness*, Vol. 66, No. 11 (Nov. 1983), pp. 14–16.
Mains, Karen. 'The New Look of Women's Ministry,' *Leadership: A Practical Journal for Church Leaders*, Vol. 4, No. 4 (Fall 1983), pp. 121–123.
Makundi, Kaanaeli. 'On Ministry' [excerpt from *Let Us Share the Hope*], *IDOC Bulletin*, No. 8–9 (1984), p. 9.
- 'Women in the Ministry – Only Certain Tasks' [reprinted from

Lutheran World Information, 3/84 (Jan. 19, 1984)], *International Review of Mission*, Vol. 73, No. 291 (July 1984), pp. 353–354.

Malcolm, Margaret. 'The Ministry of Women in the Church' [reprinted from *Journal: Christian Brethren Research Fellowship*, No. 98 (Nov. 1983)], *Evangelical Review of Theology*, Vol. 9, No. 1 (Jan. 1985), pp. 18–26.

'The Malone Report' [expanded role for US women in Roman Catholic Church], *Christian Century*, Vol. 102, No. 29 (Oct. 2, 1985), p. 856.

Marshall, Deborah. 'Ministry of Women,' *Exchange: For Leaders of Adults*, Vol. 11, No. 2 (Winter 1987), pp. 38–39.

Mehl, L. Guy. 'Marriage and Ministry in Midlife Women,' *Journal of Religion and Health*, Vol. 23, No. 4 (Winter 1984), pp. 290–298.

Minter, Ruth Brandon. 'Hidden Dynamics Block Women's Access to Pulpits,' *Christian Century*, Vol. 101, No. 26 (Aug. 29–Sept. 5, 1984), pp. 805–806.

– 'Women in Ministry: Beyond the Obstacles,' *Christian Ministry*, Vol. 16, No. 2 (Mar. 1985), pp. 19–22.

Moore, Robert L., and Janet A. MacKenzie. 'A Symposium: Gender Issues and Supervision' [introduction], *Journal of Supervision and Training in Ministry*, Vol. 6 (1983), pp. 138–140.

Murphy, P. 'The Future Based on Present, New Experiences: Women in Ministry,' *Origins*, Vol. 7, No. 17 (Oct. 13, 1977), pp. 267–272.

Nyberg, Kathleen Neill. 'Whatever Happened to Ministers' Wives?' *Christian Century*, Vol. 96, No. 5 (Feb. 1979), pp. 151–156.

Oduyoye, Mercy Amba. 'Church Women and the Church's Mission in Contemporary Times: A Study of Sacrifice in Missions,' *Bulletin de Théologie Africaine*, Vol. 6, No. 12 (June–Dec. 1984), pp. 259–272.

Ohanneson, J. 'Historians Foresee Larger Role for Women in Church Ministry,' *National Catholic Reporter*, Vol. 10 (Jan. 11, 1974), pp. 3–4.

Park, Sandra Winter. 'Coming through the Waters: Sermon, Women, Worship,' *Journal of Women and Religion*, Vol. 1, No. 1 (Spring 1981), pp. 31–34.

Parsons, Jody, and others. 'Women of the United Church of Christ: Reflections on Ministry,' *Journal of Women and Religion*, Vol. 4, No. 1 (Winter 1984), pp. 14–21.

Paulus, V. 'Report of Consultation on Women and Ministry Held at the United Theological College, Bangalore February 10, 1982,' *Bangalore Theological Forum*, Vol. 14 (Jan.–June 1982), pp. 85–88.

Payne, Sara A. 'Welcome, Sisters,' *Christian Ministry*, Vol. 6, No. 3 (May 1975), pp. 11–15.

'Placement Problems' [Protestant clergywomen], *Christian Century*, Vol. 101, No. 36 (Nov. 21, 1984), p. 1090.

Prokes, Mary Timothy. 'Women, Men and the Call to Mutuality,'
 Ecumenism, No. 73 (Mar. 1984), pp. 3–5.
Ramos, J. Antonia. 'July 29, 1984 Sermon: Oppressed Must Unite to Be
 Effective' [10th Anniversary, Episcopal Women Priests], *Witness*, Vol.
 67, No. 9 (Sept. 1984), pp. 15–18.
Rediger, G. Lloyd. 'The Feminine Mystique and the Ministry,' *Christian
 Century*, Vol. 96, No. 23 (July 4–11, 1979), pp. 699–702.
Ricciutti, G.A., Elizabeth Achtemeier, Jean Anne Swope, and Daphne
 Parker Hawkes. 'Women and the Pastorate,' *Theology Today*, Vol. 34,
 No. 1 (Jan. 1978), pp. 422–428.
Robb, Carol, and Nancy Richardson. 'The Politics and Theology
 of Ministry with Women: A Working Paper,' *Radical Religion: A
 Quarterly Journal of Critical Thought*, Vol. 2, No. 1 (1975), pp.
 28–35.
Ruether, Rosemary Radford. 'Male Clericalism and the Dread of Wom-
 en,' *Ecumenist: A Journal for Promoting Christian Unity*, Vol. 11, No. 5
 (July–Aug. 1973), pp. 65–69.
– 'Women in Ministry: Where Are They Heading?' [from *Sexism and
 God-talk: Toward a Feminist Theology*], *Christianity and Crisis: A Chris-
 tian Journal of Opinion*, Vol. 43, No. 5 (Apr. 4, 1983), pp. 111–116.
Runcie, Robert Alexander Kennedy. 'Women in the Church: The Ecu-
 menical Issue,' *Origins*, Vol. 11 (Sept. 17, 1981), pp. 219–221.
Russell, Letty M. 'Authority in Mutual Ministry,' *Quarterly Review: A
 Scholarly Journal for Reflection on Ministry (Methodist)*, Vol. 6, No. 1
 (Spring 1986), pp. 10–23.
Ruston, R. 'Women and the Priesthood,' *New Blackfriars*, Vol. 58, No. 689
 (Oct. 1977), pp. 462–472.
Scalise, Pamela. 'Women in Ministry: Reclaiming Our Old Testament
 Heritage,' *Review and Expositor: A Baptist Theological Journal*, Vol. 83,
 No. 1 (Winter 1986), pp. 7–13.
Shriver, Peggy A.L. 'Context, Challenge, and Contribution: Women in
 Ministry Research,' *Review of Religious Research*, Vol. 28, No. 4 (June
 1987), pp. 377–382.
Soskie, Janet Martin. 'Women and the Priesthood,' *Tablet*, Vol. 241, No.
 7660 (May 9, 1987), pp. 15–22.
Spencer-Miller, Althea. 'Caribbean Clergywomen Workshop-Seminar
 1987' [Antigua], *Caribbean Journal of Religious Studies*, Vol. 9 (Apr.
 1988), pp. 13–18.
Stahel, Thomas H. 'Partners in Christ: The Women's Pastoral, Draft I,'
 America, Vol. 158, No. 16 (Apr. 23, 1988), pp. 419–420.
Stanley, Paula J. 'A String of Pearls: Women's Work and Fellowship
 Groups,' *Brethren Life and Thought*, Vol. 30 (Winter 1985), pp. 33–36.

Steele, Elizabeth. 'The Role of Women in the Church,' *Currents in Theology and Mission*, Vol. 13, No. 1 (1986), pp. 13–21.

Steinfels, Margaret O'Brien. 'Women and Work,' *New Catholic World*, Vol. 230, No. 1377 (May–June 1987), pp. 140–143.

Strohl, Jane E. 'The Lord's Wooers,' *Lutheran Theological Seminary Bulletin*, Vol. 65, No. 4 (Fall 1985), pp. 45–47.

Suvarska, Eva. 'Women's Christian Service in the Modern World,' *Journal of the Moscow Patriarchate*, No. 4 (1984), pp. 65–68.

Swidler, Arlene. 'Bring Back Women Deacons,' *U.S. Catholic*, Vol. 52 (Aug. 1987), pp. 30–31.

Swidler, Arlene, D. O'Brian, N. Foley, and P. Perkins. 'Review Symposium on Mary Jo Weaver's *New Catholic Women: A Contemporary Challenge to Traditional Religious Authority*,' *Horizons: The Journal of the College Theology Society*, Vol. 14, No. 1 (Spring 1987), pp. 115–128.

Tanner, Mary. 'The Ministry of Women: An Anglican Reflection,' *One in Christ: A Catholic Ecumenical Review*, Vol. 21, No. 4 (1985), pp. 284–292.

Taylor, Mary G. 'Two-Person Career or Two-Career Marriage?' *Christian Ministry*, Vol. 8, No. 1 (Jan. 1977), pp. 18–20.

Thornton, Edward W. 'Women in Ministry,' *Journal of Pastoral Care*, Vol. 32, No. 1 (Mar. 1978), p. 1.

Tobin, Mary Luke. 'Women in the Church: Vatican II and After,' *Ecumenical Review*, Vol. 37, No. 3 (July 1985), pp. 295–305.

– 'Women in the Church since Vatican II,' *America*, Vol. 155, No. 12 (Nov. 1, 1986), pp. 243–246.

Townend, Ellinor. 'Rainbow Connection II: Consultation of Women of the United Church,' *Exchange: For Leaders of Adults*, Vol. 10, No. 2 (Winter 1986), pp. 32–33.

Tucker, Ruth. 'The Role of Bible Women in World Evangelism,' *Missiology: An International Review*, Vol. 13 (Apr. 1985), pp. 133–146.

Tuite, Marjorie, Melinda Roper, Luanne Schinzel, Joan Chittister, and Rosemary Radford Ruether. 'Gifted with Hope: Five Religious Women Talk about Their Changing Roles,' *Sojourners*, Vol. 14, No. 4 (Apr. 1985), pp. 12–19, 21–22.

Wade, Cheryl H. 'Women's Work: A Feminine Perspective on Ministry,' *American Baptist Quarterly*, Vol. 3, No. 2 (June 1984), pp. 172–174.

Way, Peggy Ann. 'Reflections, the Birthing of Futures,' *Center for Women and Religion Newsletter*, Vol. 4 (Winter 1978), pp. 11–15.

West, Angela. 'The Greenham Vigil: A Women's Theological Initiative for Peace,' *New Blackfriars*, Vol. 67, No. 789 (Mar. 1986), pp. 125–137.

Wharton, Ann. 'LaHaye's Concerned Women for America: Training

Women to Make a Difference,' *Fundamentalist Journal*, Vol. 4, No. 11 (Dec. 1985), pp. 67–69.

Wilson, Eloise V. 'What's a Nice Girl Like You ...?' *Christian Ministry*, Vol. 6, No. 3 (May 1975), pp. 23–25.

Wilson, Lois M. 'Choosing to Be God's Change Agents,' *International Review of Mission*, Vol. 73, No. 291 (July 1984), pp. 310–316.

'Woman Bishop Talk Sparks Debate,' *Witness*, Vol. 69, No. 4 (Apr. 1986), pp. 9–10.

'Women and Leadership in the Church: Symposium,' *New Catholic World*, Vol. 228 (Mar.–Apr. 1985), pp. 52–71.

'Women in Ministry: Symposium,' *Spirituality Today*, Vol. 30, No. 4 (Mar. 1978), pp. 4–63.

'Women in the Latin American, Asian and African Church,' *IDOC Bulletin*, No. 8–9 (1984), pp. 18–23.

'Women Religious Meet with Pope to Discuss Their Life,' *Origins*, Vol. 13, No. 29 (Dec. 29, 1983), pp. 481, 483–486.

Wraw, John. 'An Active Community of Coptic Orthodox Nuns,' *Sobornost*, Vol. 8, No. 1 (1986), pp. 47–50.

Ziegler, Harriet A. 'Ministry amid the Ordinary,' *Brethren Life and Thought*, Vol. 30 (Winter 1985), pp. 29–31.

Zikmund, Barbara Brown. 'The Contributions of Women to North American Church Life,' *Mid-Stream: An Ecumenical Journal*, Vol. 22, No. 3 and 4 (July–Oct. 1983), pp. 363–377.

– 'Upsetting the Assumptions,' *Christian Century*, Vol. 96, No. 5 (Feb. 7–14, 1979), pp. 127–128.

– 'Women in Ministry Face the 80s,' *Christian Century*, Vol. 99, No. 4 (Feb. 3–10, 1982), pp. 113–115.

OTHER RELATED RESOURCES

National Conference of Catholic Bishops, Washington, DC. *Partners in the Mystery of Redemption: A Pastoral Response to Women's Concerns for Church and Society. First Draft*, March 23, 1988. Washington, DC: United States Catholic Conference, 1988.

Silman, Janet. *Women in Ministry Research Report*. Toronto: Division of Ministry Personnel and Education of the United Church of Canada, 1984.

United Church of Canada. Division of Ministry Personnel and Education. Women in Ministry Overview. *Women in Ministry*. Toronto: Division of Ministry Personnel and Education, 1983.

– Division of Ministry Personnel and Education. *When Calling a Minis-*

ter ... Consider a Woman. Toronto: Produced by Berkeley Studio for the Division of Ministry Personnel and Education, United Church of Canada, 1980.

– Division of Mission in Canada. *God's Hidden People: A Study of Women and the Christian Church.* Toronto: Division of Mission in Canada, United Church of Canada, 1980.

World Council of Churches. Subunit on Women and Church and Society. *Orthodox Women: Their Role and Participation in the Orthodox Church, Report on the Consultation of Orthodox Women, 11–17 September 1976, Agapia Romania, 1976.* Geneva: World Council of Churches, 1977.

Deaconess/Diakonal Ministry

BOOKS, DISSERTATIONS, COLLECTED WORKS

Aubert, Marie-Josephe. *Des femmes diacres: Un nouveau chemin pour l'église.* Paris: Beauchesne, 1987.

Grierson, Janet. *The Deaconess.* London: CIO Pub., 1981.

Hardy, Nancy. *Called to Serve – A Story of Diaconal Ministry in the United Church of Canada.* Toronto: Division of Ministry Personnel and Education, United Church of Canada, 1985.

Martimort, Aimé Georges. *Deaconesses: An Historical Study,* trans. by K.D. Whitehead. San Francisco: Ignatius Press, 1986.

Swensson, Gerd. *The Churches and the Diaconate.* Uppsala: [s.n.], 1985.

Williams, Janet Smith. 'Women in a Diakonal Ministry to the Physically Ill.' D.Min. dissertation, Denver Conservative Baptist Seminary, 1983.

ARTICLES, BOOK REVIEWS

Desmond, Joan Frawley. 'Deaconesses: Interpreting the Evidence,' *National Catholic Register,* Vol. 64 (May 8, 1988), p. 1.

Dougherty, Mary A. 'The Methodist Deaconess: A Case of Religious Feminism' [1888], *Methodist History,* Vol. 21 (Jan. 1983), pp. 90–98.

Flood, Marie Walter. 'Review of *Deaconesses: An Historical Study* by Aimé Georges Martimort,' *Living Light: An Interdisciplinary Review of Christian Education,* Vol. 24, No. 3 (Mar. 1988), pp. 279–280.

Hodder, Morley F. 'Stella Annie Burry: Dedicated Deaconess and Pioneer Community Worker,' *Touchstone: Heritage and Theology in a New Age,* Vol. 3, No. 3 (Oct. 1985), pp. 24–33.

Philsy, Sister. 'Diakonia of Women in the New Testament,' *Indian Journal of Theology,* Vol. 32 (Jan.–June 1983), pp. 110–118.

Thomas, John D. 'Servants of the Church: Canadian Methodist Deacon-
ess Work 1890–1926,' *Canadian Historical Review*, Vol. 65, No. 3 (Sept.
1984), pp. 371–395.

OTHER RELATED SOURCES

All about Diakonal Ministry in the United Church of Canada (Study Kit).
[Toronto]: Division of Ministry Personnel and Education, United
Church of Canada, 1987.

Ordination Discussion

BOOKS, DISSERTATIONS, COLLECTED WORKS

L'admission des femmes au sacerdoce ministériel. Special issue of *Église et
Théologie*, Vol. 9, No. 1 (1978).
Anderson, Phyllis Brosch. 'Power and Ministry: A Theological Inves-
tigation of the Relationship between Authority and Servanthood in
Pastoral Ministry in View of the Ordination of Women.' Ph.D. disser-
tation, Aquinas Institute, 1984.
Behr-Sigel, Elisabeth. *Le ministère de la femme dans l'église* (Coll. 'Théolo-
gies'). Paris: Cerf, 1987.
Berere, Marie-Jeanne. *Le jeu de la tradition dans la pratique masculine du
ministère apostolique* (Les Cahiers de l'Institut Catholique de Lyon, 3).
Paris: Operex, 1980.
Berere, Marie-Jeanne, Renée Dufourt, and Donna Singles. *Et si on ordon-
nait des femmes ...?* Paris: Le Centurion, 1982.
Bozarth-Campbell, Alla. *Womanpriest: A Personal Odyssey*. New York:
Paulist Press, c1978.
Carroll, Jackson W., Barbara Hargrove, and Adair T. Lummis. *Women of
the Cloth: A New Opportunity for the Churches*. San Francisco: Harper
and Row, c1983.
Catholic Church. Congregatio pro Doctrina Fidei. *Declaration on the
Question of the Admission of Women to the Ministerial Priesthood*. Vatican
City, 1976.
Donovan, Mary S. *Women Priests in the Episcopal Church: The Experience of
the First Decade*. Cincinnati: Forward Movement Publications, 1988.
Eldred, O. John. *Women Pastors: If God Calls, Why Not the Church?* Valley
Forge, PA: Judson Press, 1981.
Episcopal Church. Board of Clergy Deployment. *Their Call Answered:
Women in Priesthood*. New York: Board for Clergy Deployment, 1979.

Femmes dans l'église. Special issue of *Prêtre et Posteur,* Vol. 88, No. 4 (1985).

Ferder, Fran. *Called to Break Bread?* Mt. Rainier, MD: Quixote Center, 1978.

Flood, Marie Walter. 'The Place of Women in the Ministerial Offices of the Church as Witnessed by Ecclesial Tradition and Rites of Ordination.' Ph.D. dissertation, Institute of Christian Thought, University of St. Michael's College, Toronto, 1977.

Gardiner, Anne Marie, ed. *Women and Catholic Priesthood: An Expanded Vision. Proceedings of the Detroit Ordination Conference.* New York: Paulist Press, 1976.

Gorman, Jon Gifford. 'The Ordination of Women: The Bible and the Fathers.' D.Min. dissertation, School of Theology at Claremont, 1976.

Handley, Thomas Beck. 'Congregational Leader's Perception of the Pastoral Role: An Analysis of the Acceptance of Women Pastors.' Dissertation, University of Tennessee, 1985.

Hewitt, Emily C. *Women Priests: Yes or No?* New York: Seabury Press, 1973.

Heyward, Isabel Carter. *A Priest Forever.* New York: Harper and Row, 1976.

Hopko, Thomas, ed. *Women and the Priesthood.* New York: St. Vladimir's Seminary Press, 1983.

Huyck, Heather Ann. 'To Celebrate a Whole Priesthood: The History of Women's Ordination in the Episcopal Church.' Ph.D. dissertation, University of Minnesota, 1981.

Ice, Martha Long. *Clergy Women and Their Worldviews: Calling for a New Age.* New York: Praeger, 1987.

– 'The Real Worlds of Clergy Women.' Ph.D. dissertation, University of Michigan, 1985.

Ide, Arthur Frederick. *God's Girls: Ordination of Women in the Early Christian and Gnostic Churches.* Garland, TX: Tangelwuld, 1986.

Jewett, Paul King. *The Ordination of Women: An Essay on the Office of Christian Ministry.* Grand Rapids: Eerdmans, c1980.

Lakeland, Paul. *Can Women Be Priests?* (Theology Today Series, 34). Hales Corners, WI: Clergy Book Service, 1975.

Lehman, Edward C., Jr. *Women Clergy: Breaking through Gender Barriers.* New Brunswick, NJ: Transaction Books, c1985.

– *Women Clergy in England: Sexism, Modern Consciousness, and Church in Viability* (Studies in Religion and Society, 16). Lewiston, NY: E. Mellen Press, 1987.

Marrett, Michael McFarlene. 'The Historical Background and Spiritual
 Authority of the Lambeth Conferences and Their Impact on the
 Protestant Episcopal Church in the United States of America with
 Particular Emphasis on the Ordination of Women to the Priesthood.'
 Ph.D. dissertation, New York University, 1980.
Mascall, Eric Lionel. *Women Priests?* London: Church Literature Associa-
 tion, 1972.
Meer, Haye van der. *Women Priests in the Catholic Church? A Theological-
 Historical Investigation.* Translated and with a foreword and afterword
 by Arlene and Leonard Swidler. Foreword by Cynthia C. Wedel.
 Philadelphia: Temple University Press, 1973.
Micks, Marianne H., and Charles P. Price, eds. *Towards a New Theology of
 Ordination: Essays on the Ordination of Women.* Somerville, MA:
 Greeno, Hadden and Co., 1976.
Mollenkott, Virginia Ramey. *Women of Faith in Dialogue.* New York:
 Crossroads, 1987.
Montefiore, Hugh, ed. *Yes to Women Priests.* Great Wavering, [England]:
 Mayhew-McCrimmon in Association with A.R. Mowbray, 1978.
Moors, Peter, ed. *Man, Woman, and Priesthood.* London: SPCK, 1978.
Morgan, John. *Women Priests: An Emerging Ministry in the Episcopal
 Church (1960–1980).* Bristol, IN: Wyndham Hall, 1985.
Mylet, Pamela Ann. 'Dogmatism and Acceptance of Women Priests in the
 Episcopal Church.' Ph.D. dissertation, Northwestern University, 1988.
Proctor, Priscilla, and William Proctor. *Women in the Pulpit: Is God an Equal
 Opportunity Employer?* Garden City, NY: Doubleday and Co., 1976.
Raming, Ida. *The Exclusion of Women from the Priesthood: Divine Law or
 Sex Discrimination?: An Historical Investigation of the Juridical and
 Doctrinal Foundations of the Code of Canon Law, Canon 968, 1,* trans. by
 Norman R. Adams. Preface by Arlene and Leonard Swidler. Metu-
 chen, NJ: Scarecrow Press, 1976.
Rhodes, Wickett Sharon Kay. 'Your Daughters Did Prophesy (Women
 Clergy).' D. Min. dissertation, School of Theology at Claremont, 1983.
Shipton, Brenda J. 'A Study of Vocation of Women to the Priesthood in
 the Anglican Church of Canada.' M.Th. dissertation, Atlantic School
 of Theology, 1977.
Stuhlmueller, Carroll, ed. *Women and the Priesthood: Future Directions.*
 Collegeville, MN: Liturgical Press, 1978.
Swidler, Leonard, and Arlene Swidler, eds. *Women Priests, a Catholic
 Commentary on the Vatican Declaration.* New York: Paulist Press, 1977.
Wakelin, Rosemary. *Call Accepted: Reflections on Woman's Ordination in
 the Free Churches.* London: Movement for the Ordination of Women,
 1988.

ARTICLES, BOOK REVIEWS

Anderson, Phyllis. 'Both Kinds of Pastor,' *Modern Churchman*, n.s., Vol. 25, No. 2 (1982), pp. 27–30.

Antinarelli, Ronald. 'Will Women Be Ordained?' *Homiletic and Pastoral Review*, Vol. 77, No. 7 (Apr. 1977), pp. 7–23.

Badham, Linda. 'The Irrationality of the Case against Ordaining Women,' *Modern Churchman*, Vol. 27 (1984), pp. 13–22.

Baker, John Austin. 'Eucharistic Presidency and Women's Ordination,' *Theology*, Vol. 88, No. 725 (Sept. 1985), pp. 350–357.

Barnhouse, R.T. 'An Examination of the Ordination of Women to the Priesthood in Terms of the Symbolism of the Eucharist,' *Anglican Theological Review*, Vol. 56 (1974), pp. 279–291.

Barry, William. 'Women and the Priesthood,' *Tablet*, Vol. 239, No. 7581 (Oct. 26, 1985), pp. 1121–1122.

Beifuss, Joan Turner. 'A Women's Religious Revolution,' *National Catholic Reporter*, Vol. 18 (Mar. 5, 1982), pp. 9–13.

Benedek, Ann. 'Mary Lucas Makes History: Canadian Anglicans Ordain Their First Women Priests,' *United Church Observer*, Vol. 40, No. 5 (Nov. 1976), p. 12.

'Berhardin: Theology Says Women Can't Be Priests,' *National Catholic Reporter*, Vol. 11 (Oct. 17, 1975), p. 20.

Berhardin, J. 'Further Statement on Women's Ordination,' *Catholic Mind: The Monthly Review of Christian Thought*, Vol. 74, No. 1300 (Feb. 1976), p. 9.

— 'The Ordination of Women: A Statement,' *Our Sunday Visitor Magazine*, Vol. 64 (Nov. 9, 1975), p. 9.

— 'The Ordination of Women: A Statement by the President of the National Conference of Catholic Bishops,' *Commonweal: A Review of Public Affairs, Literature and the Arts*, Vol. 103, No. 2 (Jan. 1976), pp. 42– 44. Replies by B. Cooke, D. Donnelly, J. Ford, G. Tavard, pp. 44–47.

Bezaire, Anne. 'A Modest Proposal,' *Grail: An Ecumenical Journal*, Vol. 4, No. 2 (June 1988), pp. 21–26.

'Biblical Commission: Scripture Not Enough to Exclude Women Priests,' *National Catholic Reporter*, Vol. 12 (July 2, 1976), p. 15.

Blackwell, J. Miriam. 'The Ordination of Women,' *Modern Ministries*, Vol. 3 (Mar. 1982), pp. 25–26.

Boulding, Maria. 'The Priest and the Feminine,' *Way Supplement*, No. 47 (Summer 1983), pp. 34–42.

Bourgoin, M. 'Women Priests Celebrate Anniversary,' *National Catholic Reporter*, Vol. 11 (Aug. 15, 1975), p. 3.

Boys, M., R. Muschal-Reinhardt, N. Philbin, and K. Daly. 'I Want to Be a

Priest: Interviews by St. Anthony Messenger,' *St. Anthony Messenger*, Vol. 83 (Mar. 1976), pp. 12–17.

Brackenridge, Douglas R., and Lois A. Boyd. 'Even Women Were Slow to Embrace the Idea of Women's Ordination,' *A.D.: Presbyterian Life Edition*, Vol. 10, No. 7 (Aug. 1981), p. 27.

Bray, Gerald. 'Debate in the General Synod of the Church of England; Editorial,' *Churchman: Journal of Anglican Theology*, Vol. 99, No. 4 (1985), pp. 291–292.

Brennan, M. 'Why We Need Women Priests: Interview by Sr. P. Knopp,' *U.S. Catholic*, Vol. 41 (Feb. 1976), pp. 18–23.

Brown, Marie James. 'Women's New Role,' *Sisters Today*, Vol. 52, No. 3 (Nov. 1980), pp. 158–164.

Burkholder, Steve. 'First Woman Elected Bishop in Anglican Church,' *National Catholic Reporter*, Vol. 24 (Oct. 7, 1988), p. 12.

Burrell, D. 'The Vatican Declarations: Another View on the Admission of Women to the Ministerial Priesthood,' *America*, Vol. 136, No. 13 (Apr. 2, 1977), pp. 289–292. Reply by D. Gelpi, *America*, Vol. 137, No. 4 (Aug. 13–20, 1977), pp. 75–77; Rejoinder, pp. 77–78.

Canham, Elizabeth. 'Let the Women Keep Silence,' *Christian Century*, Vol. 100, No. 3 (Oct. 12, 1983), pp. 893–895.

Carr, Anne E. 'Women's Place, Ordination, and Christian Thought: Old Answers to New Questions?' *Listening: A Journal of Religion and Culture*, Vol. 13 (Spring 1978), pp. 158–175.

Carroll, Jackson W., Barbara Watts Hargrove, and Adair T. Lummis. 'Women in Ministry: How Are They Doing?' [excerpted from *Women of the Cloth: A New Opportunity for the Churches*, 1983], *Christianity and Crisis: A Christian Journal of Opinion*, Vol. 43, No. 110 (Apr. 4, 1983), pp. 117–120.

Casey, R. 'Women Seek Priesthood to Complete Ministry,' *National Catholic Reporter*, Vol. 11 (Sept. 12, 1975), p. 1.

'Catholic Women Claim Priestly Calls: God Called Me; My Community Ordained Me,' *National Catholic Reporter*, Vol. 17 (July 17, 1981), p. 1.

Chilton, Bruce D. 'Opening the Book: Biblical Warrant for the Ordination of Women,' *Modern Churchman*, Vol. 20, No. 1 (New Year 1977), pp. 32–35.

Chittister, Joan D. 'Brotherly Love in Today's Church: The Elimination of Sexist Language from Church Documents and the Ordination of Female Priests,' *America*, Vol. 136, No. 11 (Mar. 19, 1977), pp. 233–236.

– 'Divinely Ordained: The Religious Doctrine of Female Inferiority,' *Sojourners*, Vol. 13, No. 10 (Nov. 1984), pp. 16–19.

- 'Questioning the Limited State of Women's Lives,' *Origins*, Vol. 16, No. 18 (Oct. 30, 1986), pp. 357–360.
Condolo, Marta. 'Canadian Catholics for Women's Ordination,' *Ecumenism*, No. 73 (Mar. 1984), pp. 18–20.
Connell, Desmond. 'Women Priests: Why Not?' *Osservatore Romano* (English Edition), Vol. 102a, No. 10 (Mar. 7, 1988), pp. 6–8.
Cunneen, Sally. 'Women's Ordination in the Mother Church,' *Christian Century*, Vol. 94, No. 9 (Mar. 16, 1977), pp. 256–258.
Darling, Pam. 'Episcopal Visitors: Symbols of Institutional Sexism,' *Witness*, Vol. 71, No. 9 (Sept. 1988), pp. 8–10.
Derr, Jill Mulvay. 'Women and Priesthood – An Endowment of Power: The LDS Tradition,' *Dialogue: A Journal of Mormon Thought*, Vol. 17, No. 3 (Autumn 1984), pp. 17–21.
Dewitt, Robert L. '1964–1974: Decade of Crisis in a Stormy See' [episcopal diocese of Pennsylvania], *Witness*, Vol. 67, No. 7 (July 1984), pp. 6–8.
'Dialogue on Women in the Church: Interim Report on the Dialogue between the Women's Ordination Conference and the Bishops Committee on Women in Society and in the Church,' *Origins*, Vol. 11, No. 6 (June 25, 1981), pp. 81–91.
Dirks-Blatt, Henry G. 'The Ordination of Women to the Ministry in the Member Churches of the World Alliance of Reformed Churches, Pt. I,' *Reformed World*, Vol. 38, No. 8 (Dec. 1985), pp. 434–443.
- 'The Ordination of Women to the Ministry in the Member Churches of the World Alliance of Reformed Churches, Pt. II,' *Reformed World*, Vol. 39, No. 1 (Mar. 1986), pp. 284–289.
Donahue, J. 'Women, Priesthood and the Vatican,' *America*, Vol. 136, No. 13 (Apr. 2, 1977), pp. 285–289.
Donnelly, Doris. 'Why Ordain Anybody ... for a While,' *Cross Currents: A Quarterly Review to Explore the Implications of Christianity for Our Times*, Vol. 28 (Summer 1978), pp. 134–136.
Donnelly, Mary R. 'Still Unready for Women Clergy: Study,' *United Church Observer*, Vol. 47, No. 7 (Jan. 1984), p. 37. Also in *Ecumenism*, No. 73 (Mar. 1984), pp. 16–18.
Eaton, Sally. 'Womanpriest: Coming into Full Power,' *Journal of Women and Religion*, Vol. 2, No. 1 (Spring 1982), pp. 15–20.
Edwards, Denis. 'The Ordination of Women and Anglican–Roman Catholic Dialogue,' *Pacifica*, Vol. 1 (June 1988), pp. 125–140.
Fichter, Joseph Henry. 'Blaming Women Priests: A Note on the Anglican Split,' *Church*, Vol. 3, No. 3 (1987), pp. 45–47.
Fuller, Georgia. 'Catholics for Women's Ordination: Confronting the Roman Patriarchy,' *Witness*, Vol. 61, No. 5 (May 1978), pp. 6–9.

Greeley, Andrew. 'Review of *Women Clergy in England: Sexism, Modern Consciousness, and Church Viability* (Studies in Religion and Society, v. 16) by Edward C. Lehman Jr.,' *Contemporary Sociology*, Vol. 17, No. 2 (Mar. 1988), pp. 231–232.

Hallett, Mary. 'Ladies, We Give You the Pulpit,' *Touchstone: Heritage and Theology in a New Age*, Vol. 4, No. 1 (Jan. 1986), pp. 6–17.

— 'Nellie McClung and the Ordination of Women in the United Church of Canada,' *Atlantis*, Vol. 4, No. 2 (Spring 1979), pp. 2–16.

Hargrove, Barbara. 'A Place in a Church: The Challenge of Ordained Protestant Women,' *Sojourners*, Vol. 16, No. 7 (July 1987), pp. 14–17.

Harris, Barbara C. 'Canterbury Tales of 1986,' *Witness*, Vol. 69, No. 6 (June 1986), p. 15.

— 'Celebrating a Dream Yet to Come True' [10th anniversary of Episcopal women priests], *Witness*, Vol. 67, No. 9 (Sept. 1984), pp. 12–14.

Harrison, Beverly W. 'Early Feminists and the Clergy: A Case Study in the Dynamics of Secularization,' *Review and Expositor*, Vol. 72 (Winter 1975), pp. 41–52.

Hays, Charlotte. 'Patriarchal Church Ripped by Women at WOC Gathering,' *National Catholic Register*, Vol. 61 (Nov. 10, 1985), p. 1.

Hebblethwaite, Peter. 'Case against Women Priests Not Built on Rock,' *National Catholic Reporter*, Vol. 22 (Nov. 29, 1986), p. 16.

— 'Conference Asks if Church Opposes Women's Ordination: New Approach to Old Question,' *National Catholic Reporter*, Vol. 23 (May 1, 1987), p. 4.

— 'Women Priests?' *Tablet*, Vol. 229 (July 12, 1975), pp. 645–646.

— 'Women's Ordination Horse Led to Water, Fails to Drink,' *National Catholic Reporter*, Vol. 22 (July 1986), p. 8.

Heyward, Isabel Carter, and others. 'Women of the Episcopal Church Ten Years after Philadelphia: Women Priests' [reprinted from *Witness*, Summer 1984], *Journal of Women and Religion*, Vol. 4, No. 1 (Winter 1984), pp. 22–25.

Hiatt, Suzanne. 'More Women Priests, Bishops Still Angry,' *Witness*, Vol. 62, No. 7 (July 1979), pp. 4–6.

— 'Priests Wanted: No Women Need Apply,' *Witness*, June 1977, pp. 8–12.

Hiatt, Suzanne, and Ellen K. Wondra. 'On the Politics of Episcopal Ordination: A Conversation,' *Radical Religion: A Quarterly Journal of Critical Thought*, Vol. 2, No. 1 (1975), pp. 45–53.

Holland, D. 'Drive for Women Priests Not Over: Cleveland Women's Ordination Task Force, Meeting Feb. 18–19, 1977,' *National Catholic Reporter*, Vol. 13 (Mar. 4, 1977), p. 3.

Holmes, David L. 'Are "Mother" and "Father" Appropriate Titles for

Protestant Clergy?' *Christian Century*, Vol. 102, No. 35 (Dec. 4, 1985), pp. 1120–1122.

Hook, Donald D. ' "Mother" as a Title for Women Priests: A Prescriptive Paradigm,' *Anglican Theological Review*, Vol. 65, No. 4 (Oct. 1983), pp. 419–424.

'Hume Says Women's Ordination Will Delay Catholic-Anglican Unity,' *National Catholic Reporter*, Vol. 23 (Mar. 6, 1987), p. 2.

Hurley, K. 'Women Priests: The State of the Question,' *St. Anthony Messenger*, Vol. 83 (Mar. 1976), pp. 18–22.

Huyck, Heather. 'Indelible Change: Woman Priests in the Episcopal Church,' *Historical Magazine of the Protestant Episcopal Church*, Vol. 51 (Dec. 1982), pp. 385–398.

Jennings, Peter. 'Anglican Okay to Ordain Women Causes Problems,' *Our Sunday Visitor Magazine*, Vol. 77 (Aug. 21, 1988), p. 4.

– 'Ordination Issue Clouds Catholic-Anglican Talks,' *Our Sunday Visitor Magazine*, Vol. 77 (Aug. 7, 1988), p. 3.

Jewett, Paul King. 'Why I Favor the Ordination of Women,' *Christianity Today*, Vol. 19, No. 18 (June 6, 1975), pp. 7–10.

Joyce, Mary R. 'Reflections on Women Priests,' *Sisters Today*, Vol. 48, No. 2 (Oct. 1976), pp. 88–96.

Kepler, Patricia Budd. 'Women Clergy and the Cultural Order,' *Theology Today*, Vol. 34, No. 4 (Jan. 1978), pp. 402–409.

Kinast, R. 'The Ordination of Women: Acceptable Doctrinal Development?' *Review for Religious*, Vol. 37, No. 6 (Nov. 1978), pp. 905–919.

King, J.A. 'The Ordination of Women to the Priesthood: Some Current Roman Catholic Attitudes,' *Theology*, Vol. 78, No. 657 (Mar. 1975), pp. 142–147.

Kirkman, Maggie, and Norma Grieve. 'Women, Power and Ordination: A Psychological Interpretation of Objections to the Ordination of Women to the Priesthood,' *Women's Studies International Forum* (Melbourne, Australia: University of Melbourne), Vol. 7, No. 6 (1984), pp. 487–494.

Knight, George W., III. 'The Ordination of Women: No,' *Christianity Today*, Vol. 25, No. 4 (Feb. 20, 1981), p. 16.

Komonchak, Joseph. 'Theological Questions on the Ordination of Women,' *Catholic Mind: The Monthly Review of Christian Thought*, Vol. 75, No. 1309 (Jan. 1977), pp. 13–28.

Koning, Jean. 'The Anglican Experience,' *PMC: The Practice of Ministry in Canada*, Vol. 2, No. 3 (Autumn 1985), pp. 8–10.

Kubeck, John C. 'The Church, Woman and the Priesthood,' *Homiletic and Pastoral Review*, Vol. 75, No. 5 (Feb. 1975), pp. 56–61.

Küng, Hans. 'Küng on Women as Priests: Theology No Barrier,' *National Catholic Reporter*, Vol. 12 (Dec. 12, 1975), p. 2.

Lamb, Jean. 'Women Priests – Any More Objections?' *Christian*, Vol. 8, No. 2 (1983), p. 73.

'The Lambeth Conference/Three Resolutions,' *Origins*, Vol. 8, No. 13 (Sept. 21, 1978), pp. 212–214.

Lefevere, Patricia Scharber. 'Women Already Do the Job, without the Title; in European Church,' *National Catholic Reporter*, Vol. 15 (Nov. 10, 1978), pp. 21–22.

Lehman, Edward C., Jr. 'Organized Resistance to Women in Ministry,' *Sociological Analysis: A Journal in the Sociology of Religion*, Vol. 42 (Summer 1981), pp. 101–118.

– 'Research on Lay Church Members Attitudes toward Women Clergy: An Assessment,' *Review of Religious Research*, Vol. 28, No. 4 (June 1987), pp. 319–329.

Ligier, L. 'Women and the Ministerial Priesthood,' *Origins*, Vol. 7, No. 42 (Apr. 20, 1978), pp. 694–702.

Lyles, Jean Caffey. 'Episcopalians: Wounded Healers,' *Christian Century*, Vol. 93, No. 30 (Sept. 29, 1976), pp. 803–804.

Lynch, John E. 'The Ordination of Women: Protestant Experience in Ecumenical Perspective,' *Journal of Ecumenical Studies*, Vol. 12, No. 2 (Spring 1975), pp. 173–197.

McCarthy, A. 'Sanity and Sister Says: Second Women's Ordination Conference,' *Commonweal: A Review of Public Affairs, Literature and the Arts*, Vol. 105, No. 24 (Dec. 8, 1978), pp. 773–775.

McClellan, Monique. 'LiFim-Oi: The First Woman Ordained Anglican Priest' [China, 1944], *One World*, No. 94 (Apr. 1984), pp. 9–11.

McClung, Patricia Austin. 'Twenty Years of the Ordination of Women: A Progress Report' [Presbyterian Church U.S.], *Seminary Bulletin*, Vol. 99 (May 1984), pp. 15–21.

McGuire, Daniel. 'The Exclusion of Women from Orders: A Moral Evaluation,' *Cross Currents: A Quarterly Review to Explore the Implications of Christianity for Our Times*, Vol. 34, No. 2 (Summer 1984), pp. 141–152.

MacLeod, A. Donald. 'Ordination as Shared Servanthood,' *Crux: A Quarterly Journal of Christian Thought and Opinion*, Vol. 19, No. 2 (June 1983), pp. 15–19.

Maher, Frances, ed. 'The Ordination of Women in Lutheran Churches: Analysis of an LWF Survey,' *LWF Documentation*, No. 18 (Mar. 1984), pp. 1–36.

Malone, Mary. 'The Case for Ordination,' *Grail: An Ecumenical Journal*, Vol. 4, No. 2 (June 1988), pp. 9–20.

Maloney, Raymond. 'The Ordination of Women,' *Furrow*, Vol. 32, No. 7 (July 1981), pp. 439–448.

Marshall, Deborah. 'Ministry of Women' [50th anniversary of ordination of women], *Exchange: For Leaders of Adults*, Vol. 10, No. 3 (Spring 1986), pp. 31–33.

Martin, John Hilary. 'The Injustice of Not Ordaining Women: A Problem for Medieval Theologians,' *Theological Studies*, Vol. 48, No. 2 (June 1987), p. 303.

Medsger, Betty. 'Episcopal Ordinations: Where Have the Liberal Bishops Gone?' *Christianity and Crisis: A Christian Journal of Opinion*, Vol. 35, No. 13 (Aug. 18, 1975), pp. 188–192.

Merrell, James L., Janette Pierce, John Stapert, Kermon Thomasson, Edgar R. Trexler, and Martin Emil Marty. 'Why Don't Catholics Have Women Priests? ... And Why Other Christian Churches Do,' *U.S. Catholic*, Vol. 49, No. 1 (Jan. 1984), pp. 13–19.

Meyer, E. 'Are There Theological Reasons Why the Church Should Not Ordain Women Priests?' *Review for Religious*, Vol. 34 (Nov. 1975), pp. 957–967.

Mork, Carol J. 'Women's Ordination and the Leadership of the Church,' *Word and World: Theology for Christian Ministry*, Vol. 7, No. 4 (Fall 1987), pp. 374–379.

Morris, Roberta. 'Canadian Women "Re-vision" Priesthood,' *New Catholic Times*, Vol. 11, No. 12 (June 14, 1987), pp. 1, 14.

Murphy, Margaret. 'Why Catholic Women Have Stopped Skirting the Issues,' *U.S. Catholic*, Vol. 48, No. 10 (Oct. 1983), pp. 22–26.

Nason-Clark, Nancy. 'Ordaining Women as Priests: Religious vs. Sexist Explanation for Clerical Attitudes,' *Sociological Analysis: A Journal in the Sociology of Religion*, Vol. 48, No. 3 (Fall 1987), pp. 259–273.

National Conference of Catholic Bishops. 'Theological Reflections on the Ordination of Women,' *Review for Religious*, Vol. 32, No. 2 (Mar. 1973), p. 221; *Journal of Ecumenical Studies*, Vol. 10 (1973), pp. 695–699.

Neilsen, Mark. 'Though Ordination Remote, Women Persevere in Cause,' *National Catholic Reporter*, Vol. 22 (Nov. 1985), p. 8.

Nelson, J. Robert. 'Christian Ministry and Sacraments: A Comment on the COCU Ministry Statement,' *Quarterly Review: A Scholarly Journal for Reflection on Ministry*, Vol. 1, No. 3 (Spring 1981), pp. 86–93.

Newell, Linda King, and L. Jackson Newell, eds. 'LDS Women and Priesthood' [Papers, Sunstone Symposium, Salt Lake City, Aug. 1984], *Dialogue: A Journal of Mormon Thought*, Vol. 18, No. 3 (Fall 1985), pp. 14–42.

Newsom, George H. 'The Ordination of Women' [Acts of Parliament

and the Church of England; reply D. Pattinson], *Theology*, Vol. 87, No. 717 (May 1984), pp. 180–185.

Novak, M. 'On the Ordination of Women,' *Commonweal: A Review of Public Affairs, Literature and the Arts*, Vol. 104, No. 15 (July 1977), pp. 425–427. Replies, Vol. 104, No. 18 (Sept. 2, 1977), pp. 556–561; Vol. 104, No. 19 (Sept. 16, 1977), pp. 589–591; Rejoinder, Vol. 104, No. 18 (Sept 2, 1977), pp. 561–564; Vol. 104, No. 19 (Sept. 16, 1977), pp. 591–593.

O'Connell, Mary. 'Why Don't Catholics Have Women Priests?' *U.S. Catholic*, Vol. 49, No. 1 (Jan. 1984), pp. 6–12.

Olmstead, Bob. 'Feminists, in a Cathedral Protest, Spurn Tokenism,' *National Catholic Register*, Vol. 64 (May 22, 1988), p. 1.

'The Ordination of Women; Second Conference on the Ordination of Roman Catholic Women, Baltimore, Maryland, November 10–12, 1978,' *America*, Vol. 139, No. 17 (Nov. 25, 1978), pp. 374–375.

Pantoga, Fritizie. 'Why Some Women Want to Be Priests,' *U.S. Catholic*, Vol. 46, No. 3 (Mar. 1981), pp. 31–38.

Papa, Mary Bader. 'Catholics Would Accept Women Priests by 1988,' *National Catholic Reporter*, Vol. 15 (Nov. 10, 1978), p. 5.

– 'Valiant Woman, Pioneer Priest,' *National Catholic Reporter*, Vol. 17 (June 5, 1981), p. 15.

– 'Women Mix Social Change, Ordination Aims,' *National Catholic Reporter*, Vol. 15 (Nov. 24, 1978), p. 1.

Park, Patricia. 'Lambeth: An Outsider Looks Inside,' *Witness*, Vol. 61, No. 9 (Sept. 1978), pp. 10–15.

Parvey, Constance F. 'Where We Are Going: The Threefold Ministry and the Ordination of Women,' *Word and World: Theology for Christian Ministry*, Vol. 5, No. 1 (Winter 1985), pp. 5–11.

Patrick, Anne E. 'Conservative Case of the Ordination of Women,' *New Catholic World*, Vol. 218, No. 1305 (May/June 1975), pp. 108–111.

Pattillo, Zelma Mullins. 'You Know Women Can't Be Preachers,' *Christian Century*, Vol. 101, No. 19 (May 30, 1984), pp. 566–567.

Pawlikowski, J. 'Let's Ordain Women,' *U.S. Catholic*, Vol. 40, No. 5 (May 1975), pp. 2–12.

Powers, Jean Audrey. *Women Clergy: Breaking through Gender Barriers* by Edward C. Lehman: A Review,' *Christian Century*, Vol. 193, No. 21 (July 2–9, 1986), p. 624.

Raming, Ida. 'Equal But Other and Ordination of Women,' *Theology Digest*, Vol. 29, No. 1 (Spring 1981), pp. 19–22.

Rand, Laurence. 'Ordination of Women to the Diaconate,' *Communio: International Catholic Review*, Vol. 8, No. 4 (Winter 1981), pp. 370–383.

Rausch, Thomas P. 'Women in the Church,' *Priest*, Vol. 37 (Nov. 1981), pp. 33–35.

Reeves, Joy B. 'Broadening the Sex Role Perspective of Clergy,' *Journal of Pastoral Care*, Vol. 32, No. 1 (Mar. 1978), pp. 34–41.

'Reject Idea of Women Priests, Pope Tells U.S. Bishops,' *Our Sunday Visitor Magazine*, Vol. 72 (Sept. 18, 1983), p. 8.

Round, W.D. 'Does the Concept of Priesthood Exclude Womanhood?' *Churchman: Journal of Anglican Theology*, Vol. 102, No. 1 (1988), pp. 30–43.

Ruether, Rosemary Radford. 'Why Males Fear Women Priests: Historical Analysis,' *Witness*, Vol. 63 (July 1980), pp. 19–21.

Russell, Letty M. 'Clerical Ministry as a Female Profession,' *Christian Century*, Vol. 96, No. 5 (Feb. 7–14, 1979), pp. 125–126.

Ryan, Dick. 'Is Someone Still Afraid?' *National Catholic Reporter*, Vol. 20 (Sept. 28, 1984), p. 10.

Schneiders, Sandra M. 'Ministry and Ordination,' *Way: Contemporary Christian Spirituality*, Vol. 21, No. 2 (Apr. 1981), pp. 137–149.

Schwab, Marian. 'Dancing Sarah's Circle,' *Priest*, Vol. 37 (July–Aug. 1981), pp. 7–12.

Sheets, J.R. 'Ordination of Women: The Issues,' *American Ecclesiastical Review*, Vol. 169, No. 1 (Jan. 1975), pp. 17–36.

Simpson, Mary Michael. 'She Is the Vicar, I Am the Canon,' *Sisters Today*, Vol. 56, No. 5 (Jan. 1985), pp. 291–294.

Slack, Kenneth. 'Anglicans Move toward Women's Ordination,' *Christian Century*, Vol. 104, No. 13 (Apr. 22, 1987), pp. 374–375.

– 'Voting on Women's Ordination' [Church of England], *Christian Century*, Vol. 102, No. 3 (Jan. 23, 1985), pp. 69–71.

– 'Women's Ordination: The Fight Is On' [Church of England], *Christian Century*, Vol. 102, No. 38 (Dec. 4, 1985), pp. 1108–1109.

Stacpoole, Alberic. 'Ordination of Women: Two Traditions,' *Month: A Review of Christian Thought and World Affairs*, Vol. 18, No. 1 (Jan. 1985), pp. 15–22.

Stouffer, Austin H. 'The Ordination of Women: Yes,' *Christianity Today*, Vol. 25, No. 4 (Feb. 20, 1981), pp. 12–15.

Stravinskas, Peter M.J. 'Why Can't Our Women Be Ordained?' *National Catholic Register*, Vol. 60 (June 17, 1984), p. 1.

Stuhlmueller, Carroll. 'Women Priests: A Biblical Response within Roman Catholicism,' *Catholic Charisma*, Vol. 1 (Feb.–Mar. 1977), pp. 12–15.

Suhor, Mary Lou. 'Womanpriest, St. Jude, and the Pope' [J.A. Dementi], *Witness*, Vol. 67, No. 6 (June 1984), pp. 12–14.

Sumner, David E. 'Women Deputies' Struggle Overshadowed by Nation' [Episcopal church general convention], *Witness*, Vol. 6, No. 11 (Nov. 1983), pp. 10–12.

'Support Emerges for Episcopal Women Bishops,' *National Catholic Reporter*, Vol. 24 (Jan. 29, 1988), p. 20.

Tavard, George H. 'The Ordination of Women,' *One in Christ: A Catholic Ecumenical Review*, Vol. 23, No. 3 (1987), pp. 200–201.

'Theological Reflections on the Ordination of Women: NCCB Committee on Pastoral Research and Practices,' *Review for Religious*, Vol. 32, No. 2 (Mar. 1973), pp. 218–222.

Tortras, Monclus Antonio M. 'Women Priests or Women Deacons,' *Theology Digest*, Vol. 29, No. 3 (Fall 1981), pp. 245–247.

Turner, J. 'Women Priests,' *Ligourian*, Vol. 63 (July 1975), pp. 19–20.

Tyrwhitt, Janice. 'Women in the Clergy,' *Reader's Digest* (Mar. 1978), pp. 84–88.

'What (Some) Catholic Women Want: Symposium,' *Today's Parish*, Vol. 16 (Oct. 1984), pp. 34–36.

Wheatley-Pesci, Meg. 'An Expanded Definition of Priesthood: Some Present and Future Consequences' [Mormons], *Dialogue: A Journal of Mormon Thought*, Vol. 18, No. 3 (Fall 1985), pp. 33–42.

Wilson-Kastner, Patricia. 'The Once and Future Church: Women's Ordination in England,' *Christian Century*, Vol. 100, No. 7 (Mar. 9, 1983), pp. 214–216.

Winner, Christopher P. 'Bishops, Women Debate Women's Church Status,' *National Catholic Reporter*, Vol. 17 (June 5, 1981), p. 3.

'*Women Clergy: Breaking through Gender Barriers* by Edward C. Lehman: A Review,' *Christian Century*, Vol. 193, No. 21 (July 2–9, 1986), p. 621.

'Women as Parish Clergy' [Presbyterian Church (US)], *Christian Century*, Vol. 102, No. 3 (Jan. 23, 1985), p. 72.

'Women Pastors Vetoed,' *Christian Century*, Vol. 103, No. 8 (Mar. 5, 1986), p. 234.

'Women Priests,' *Sojourners*, Vol. 16, No. 5 (May 1987), p. 13.

'Women Priests in Britain,' *Christian Century*, Vol. 104, No. 10 (Apr. 1, 1987), p. 305.

'Women's Clergy Status,' *Christian Century*, Vol. 104, No. 1 (Jan. 7–14, 1987), p. 9.

'Women's Ordination: The Future of Equality,' *America*, Vol. 136, No. 6 (Feb. 12, 1977), pp. 118–119.

'Women's Ordination and the Progress of Ecumenism,' *Origins*, Vol. 16, No. 3 (July 17, 1986), p. 153.

Wright, J. 'Women Priests: Continued Dialogue,' *Ecumenist: A Journal for Promoting Christian Unity*, Vol. 14, No. 6 (Sept.–Oct. 1976), pp. 92–96.

OTHER RELATED RESOURCES

Church of England. Advisory Council of the Church's Ministry. *The Ordination of Women to the Priesthood*. London: Church Information Office, 1973.

Church of England. General Synod House of Bishops. *The Ordination of Women to the Priesthood: First Report by the House of Bishops*. London: Church of England General Synod, 1987.

– *The Ordination of Women to the Priesthood: Second Report by the House of Bishops*. London: General Synod of the Church of England, June 1988.

Consultation on the Ordination of Women, Cartigny, Switzerland, 1970. *What Is Ordination Coming To?* ed. by Brigalia Bam. Geneva: World Council of Churches, Department on Cooperation of Men and Women in Church, Family and Society, 1971.

'The Ordination of Women: CTSA Task Force; Report,' *Origins*, Vol. 8, No. 3 (June 29, 1978), pp. 86–88.

Parvey, Constance F., ed. *Ordination of Women in Ecumenical Perspective: Workbook for the Church's Future* (Faith and Order Paper 105). Geneva: World Council of Churches, c1980.

7

Pastoral Care

Care of and by Women

BOOKS, DISSERTATIONS, COLLECTED WORKS

Aldred-Tiller, J. Neel. 'Clues from the Experiences of Pregnant Ministers about the Nature of Reality of God.' D.Min. dissertation, Louisville Presbyterian Theological Seminary, 1984.

Alsdurf, James Monte. 'Wife Abuse and Christian Faith: An Assessment of the Church's Response.' Ph.D. dissertation, Fuller Theological Seminary School of Psychology, 1985.

Burns, Robert. *Women in Religion, Women in Ministry.* Special issue of *Journal of Pastoral Counseling,* Vol. 14, No. 1 (Spring–Summer 1979).

Bush, Vera Arndt. 'Toward Healing and Wholeness: Woman in Pastoral Counselling.' D.Min. dissertation, Andover Newton Theological School, 1982.

Bussert, Joy. *Battered Women: From a Theology of Suffering to an Ethic of Empowerment.* New York: Lutheran Church in America, 1986.

Cannon, Noreen. 'Psychological Androgyny: A Study of Its Relationships to Self-Esteem Achievement Motivation, Age and Group Membership on Women Religious and Women College Students.' Ph.D. dissertation, University of Southern California, 1982.

Carter, Neil Charles. 'Coping Successes and Failures in Incested Daughters: Emotional Burdens, Background Factors and Religious Resources.' Ph.D. dissertation, Boston University, 1986.

Clarke, Rita-Lou. *Pastoral Care of Battered Women.* Philadelphia: Westminster Press, 1986.

Collins, Domini Clare. 'Pastoral Counselors and the Crying Woman: A Study of Differences in Responses between Male and Female Pastoral Counselors.' Ph.D. dissertation, Graduate Theological Union, 1980.

Dillon, Bonny Kay. 'Contributions of Selected Feminist Theologians and Feminist Psychoanalytic Theorists to Pastoral Psychotherapy.' Ph.D. dissertation, Southern Baptist Theological Seminary, 1987.

Doherty, Virginia. 'A Feminist Christian Approach to the Sexual Abuse of Children by Family Members.' D.Min. dissertation, Boston University School of Theology, 1984.

Engdahl, Richard Clinton. 'The Minister's Spouse as Person.' D.Min. dissertation, School of Theology at Claremont, 1977.

Ford-Grabowsky, Mary. 'The Concept of Christian Faith in the Light of Hildegard of Bingen and C.G. Jung: A Critical Alternative to Fowler.' Ph.D. dissertation, Princeton Theological Seminary, 1985.

Fortune, Marie Marshall. *Keeping the Faith: Questions and Answers for the Abused Woman.* New York: Harper and Row, 1987.

– *Sexual Violence, the Unmentionable Sin: An Ethical and Pastoral Perspective.* New York: Pilgrim Press, 1983.

Foster, Barry Worley. 'Radical Feminist Therapies and Their Implications for Pastoral Counseling.' Ed.D. dissertation, New Orleans Baptist Theological Seminary, 1986.

Friberg, Nils Calvin. 'An Assessment of the Religious Coping of Women Cancer Patients for Purposes of Pastoral Counseling.' Ph.D. dissertation, University of Iowa, 1977.

Goldenberg, Naomi R. *The End of God: Important Directions for a Feminist Critique of Religion in the Works of Sigmund Freud and Carl Jung.* Ottawa: University of Ottawa Press, 1982.

Harrison, Rodger Delong. 'Toward a Theology for Counselors of Lesbian Women and Gay Men.' D.Min. dissertation, School of Theology at Claremont, 1983.

Hartzog, Nancy Helen. 'John Wesley's Understanding of Salvation as a Guideline to Treating Adult Female Incest Survivors.' D.Min. dissertation, School of Theology at Claremont, 1985.

Hochstein, Lorna Mary. 'Pastoral Psychotherapists: Their Attitudes toward Gay and Lesbian Clients.' Ph.D. dissertation, Boston University, 1985.

Holmen, Laurie Proctor. 'In Their Own Words: Women Defining Ministry toward a Feminist Theology of Pastoral Care.' D.Min. dissertation, School of Theology at Claremont, 1985.

Huff, Margaret Craddock. 'Women in the Image of God: Toward a Prototype for Feminist Pastoral Counseling.' Ph.D. dissertation, Boston University, 1987.

Johnson, Patricia Altenbernd, and Janet Kalven, eds. *With Both Eyes Open: Seeing beyond Gender.* New York: Pilgrim Press, 1988.

Karaban, Roslyn Ann. 'Pastoral Counselor: Role or Function? A Study of

Pastoral Counseling and Pastoring in the Roman Catholic Tradition.' Ph.D. dissertation, Graduate Theological Union, 1984.

Lytle, Vanita Louise. 'Levels of Religiosity in Relationship to Death Anxiety in Elderly Black and White Females.' Ed.D. dissertation, George Peabody College for Teachers of Vanderbilt University, 1986.

McConnell, M. Theresa. 'Women's Experiences: Implications for Theology and Pastoral Care.' D.Min. dissertation, Luther Northwestern Theological Seminary, 1981.

McGowan, Claire. 'Celibacy, Sexuality, and Meaning in Life: A Comparative Study of Religious and Catholic Lay Women.' Ph.D. dissertation, Boston College, 1977.

McKeever, Bridget Clare. 'A Pastoral Response to Dependency on Prescribed Drugs in Women.' Ph.D. dissertation, School of Theology at Claremont, 1983.

McLellan, Elizabeth Anne. 'Lesbian Identity: Theological and Psychological Inquiry into the Developmental Stages of Identity in a Lesbian.' Ph.D. dissertation, School of Theology at Claremont, 1977.

McMurry, Martha Jean. 'Religion and Women's Sex Role Traditionalism.' Ph.D. dissertation, Indiana University, 1975.

McNair, Alice Marie Graham. 'Exploratory Study of Pastoral Care Intervention with Hysterectomy Patients.' Ph.D. dissertation, Northwestern University, 1983.

Mader, Shirley Titcomb. 'Depression as Loneliness in Post-Generative Women: A Crisis of Faith Development.' Ph.D. dissertation, Boston University, 1986.

Maitland, Virginia. 'A Therapeutic Approach to Adult Victims of Sexual Abuse.' D.Min. dissertation, Andover Newton Theological School, 1988.

Moore, Diana. 'An Experiential Group Design to Explore the Impact of Patriarchal Culture and Religion on Women's Faith Development and God Images.' D.Min. dissertation, Perkins School of Theology at Southern Methodist University, 1988.

Osiek, Carolyn. *Beyond Anger.* New York: Paulist Press, 1986.

Pellauer, Mary D., Barbara Chester, and Jane Boyagian. *Sexual Assault and Abuse: A Handbook for Clergy and Religious Professionals.* San Francisco: Harper and Row, 1980.

Rzepka, Jane Ranney. 'Counseling Women Who Have Unplanned Pregnancies: A Pastoral Approach.' Ph.D. dissertation, Graduate Theological Union, 1983.

Sargent, Frank Aaron. 'Sex Role Stereotyping and Current Pastoral Counseling Practice.' Ph.D. dissertation, Boston University Graduate School, 1979.

Schmid, Margaret. 'Feminist Attitudes: Dimensions and Distribution by Gender, Religion and Class.' Ph.D. dissertation, Northwestern University, 1974.

Sinclair, Deborah. *Understanding Wife Assault, a Training Manual for Counsellors and Advocates*, 1985. Available at Ontario Government Bookstore, 880 Bay Street, Toronto, ON, M7A 1N8.

Singleton, Jeffrey C. 'Implications of the Theories of Lawrence Kohlberg and Carol Gilligan for Teaching Compassion in the Church.' Ph.D. dissertation, Temple University, 1987.

Stenzel, Eileen Joan. 'The Violence of Rape from a Theological Perspective.' Ph.D. dissertation, University of Notre Dame, 1981.

Stoddard, Gregory A. 'Pastoral Care for the Abusive Marriage.' D.Min. dissertation, Andover Newton Theological School, 1982.

Stucky-Abbott, Leona K. 'The Relationship between a Female's God Representation and Her Self Identity: A Clinical Case Study.' D.Min. dissertation, Perkins School of Theology at Southern Methodist University, 1988.

Van Scoyoc, Nancy. *Women, Change and the Church*. Nashville: Abingdon Press, 1980.

Vassar-Williams, Joan. 'The Feminine: Theological and Psychological Implications.' D.Min. dissertation, Andover Newton Theological School, 1987.

Willems, Elizabeth L. 'Ethics of Trust; Theological and Psychological Perspectives on Midlife Women.' Ph.D. dissertation, Marquette University, 1986.

Wood, Barbara Jean. 'A Comparison of Attitudes on Dying and Death between Women Who Are Self Identified and Not Identified with Feminism, Women without and with Children and Non-Religious Women and Religious Women.' Ph.D. dissertation, Ohio State University, 1985.

ARTICLES, BOOK REVIEWS

Armstrong, Ruth M. 'Women as Pastoral Counselors,' *Pastoral Psychology*, Vol. 31, No. 2 (Winter 1982), pp. 129–134.

– 'Women Pastors and the Idealization of Suffering,' *Pastoral Psychology*, Vol. 34, No. 2 (Winter 1985), pp. 77–81.

Bailey, Linda. 'Today's Women and Depression' [with Ruth as a case study], *Journal of Religion and Health*, Vol. 22, No. 1 (Spring 1984), pp. 30–38.

Bartchy, S. Scott. 'Jesus, Power, and Gender Roles,' *TSF Bulletin*, Vol. 7, No. 3 (Jan.–Feb. 1984), pp. 2–4.

Blomquist, Jean M. 'Exploring Spiritual Dimensions: Toward a Hermeneutic of Divorce,' *Pastoral Psychology*, Vol. 34, No. 3 (Spring 1986), pp. 161–172.

Bradford, Mary L. 'Committed Mormon Women and How They Cope: A Personal Approach,' *Journal of Pastoral Counseling*, Vol. 17 (Spring–Summer 1982), pp. 23–28.

Brown, Mildred McKee, and Sydney T. Brown, eds. 'Presbyterian Women Address the Feminization of Poverty' [selected proceedings, Conference, Women and Economic Justice, Washington, DC, Oct. 4–6, 1984], *Church and Society*, Vol. 76, No. 3 (Jan.–Feb. 1986), pp. 3–54.

Burns, Robert A., ed. 'Symposium Papers; Women in Religion; Stress and Religious Membership; American Psychiatric Association, Washington, DC, Aug. 1982,' *Journal of Pastoral Counseling*, Vol. 17, No. 1 (Spring–Summer 1983), pp. 3–83.

Byrne, Lavinia. 'Faith Development and Women,' *Month: A Review of Christian Thought and World Affairs*, Vol. 21, No. 6 (June 1988), pp. 746–748.

Clanton, Jann Aldredge. 'The Female Chaplain's Contributions to Breast Cancer Management,' *Journal of Pastoral Care*, Vol. 38, No. 3 (Sept. 1984), pp. 195–199.

Clark, Vivian. 'Was Jesus a Man's Man: When a Man Seeks the Ultimate Model for Manliness, to Whom Should He Go?' *Christianity Today*, Vol. 27, No. 4 (Feb. 18, 1983), pp. 16–18.

Corrington, Gail. 'Anorexia, Asceticism and Autonomy: Self-Control as Liberation and Transcendence,' *Journal of Feminist Studies in Religion*, Vol. 2, No. 2 (Fall 1986), pp. 51–62.

Day-Lower, Donna. 'Her Shattered Dream: A Look at Women and Unemployment,' *Sojourners*, Vol. 15, No. 3 (Mar. 1986), pp. 20–24.

DeArment, Daniel C. 'How My Heart Has Changed' [attitudes towards women; clinical pastoral education supervision], *Journal of Supervision and Training in Ministry*, Vol. 6 (1983), pp. 153–158.

Duin, Julia. 'We Must Learn to Celebrate Celibacy,' *Christianity Today*, Vol. 30, No. 5 (Mar. 21, 1986), p. 13.

Durka, Gloria. 'Women and Power: Leadership in Religious Organizations,' *Journal of Pastoral Counseling*, Vol. 17, No. 1 (Spring–Summer 1982), pp. 69–74.

Ehrenreich, Barbara. 'The Root Causes of Women's Poverty and What We Can Do,' *Church and Society*, Vol. 76, No. 3 (Jan.–Feb. 1986), pp. 19–28.

Flagg, Katherine. 'Psychological Androgyny and Self-Esteem in Clergywomen,' *Journal of Psychology and Theology*, Vol. 12, No. 3 (Fall 1984), pp. 222–229.

Fortune, Marie M. 'Abortion: After the Woman Has Chosen,' *Reflection: Journal of Opinion at Yale Divinity School*, Vol. 71, No. 4 (May 1974), pp. 5–7.

Foster, Jonathan. 'Review of *Basic Skills for Christian Counselors: An Introduction for Pastoral Ministers* by Richard P. Vaugh,' *Review for Religious*, Vol. 47, No. 3 (May–June 1988), pp. 470–471.

Foy, Janet O. 'Women in Pastoral Counselling: The Clients, the Therapists and the Supervisors,' *Journal of Supervision and Training in Ministry*, Vol. 6 (1983), pp. 175–186.

Gary, Margaret. 'Beating the Wedding-Sermon Blues: A New Look at Intimacy,' *Currents in Theology and Mission*, Vol. 13, No. 2 (Apr. 1986), pp. 106–107.

Gavin, Eileen. 'Stress and Conflict of Catholic Women in Relation to Feminism,' *Journal of Pastoral Counseling*, Vol. 17, No. 1 (Spring–Summer 1982), pp. 9–13.

Golden, Renny. 'Sanctuary and Women,' *Journal of Feminist Studies in Religion*, Vol. 2, No. 1 (Spring 1986), pp. 131–150.

Goldenberg, Naomi R. 'Anger in the Body: Feminism, Religion and Jungian Psychoanalytic Theory,' *Journal of Feminist Studies in Religion*, Vol. 2, No. 2 (Fall 1986), pp. 39–50.

Haimo, Sally, and Faith Blitman. 'The Effects of Assertive Training on Sex Role Concept in Female Agoraphobics,' *Women and Therapy*, Vol. 4, No. 2 (Summer 1985), pp. 53–61.

Hanks, Susan. 'The Sexual Revolution and Violence against Women: The Boundary between Liberation and Exploitation,' in *The Sexual Revolution* (Concilium, 173), ed. by Gregory Baum and John Coleman, pp. 41–50. Edinburgh: T. and T. Clark, 1984.

Hollyday, Joyce. ' "You Shall Not Afflict": A Biblical Perspective on Women and Poverty,' *Sojourners*, Vol. 15, No. 3 (Mar. 1986), pp. 26–29.

Huff, Margaret Craddock. 'The Interdependent Self: An Integrated Concept from Feminist Theology and Feminist Psychology,' *Philosophy Today*, Vol. 2 (Winter 1987), pp. 160–172.

Hughes-Tremper, Sherron L., Susan Kline, Jo Anne O'Reilly, and Janet Ryan. 'Convinced of Collegiality' [women in the Association for Clinical Pastoral Education], *Journal of Supervision and Training in Ministry*, Vol. 6 (1983), pp. 128–136.

Jegen, Mary Evelyn. 'Theology and Spirituality of Non-Violence,' *Worship*, Vol. 60, No. 2 (Mar. 1986), pp. 119–133.

Jehu, Derek, Marjorie Gazan, and Carole Klassen, 'Common Therapeutic Targets among Women Who Were Sexually Abused in Childhood,' *Journal of Social Work and Human Sexuality*, Vol. 3, No. 2–3 (Winter–Spring 1985–1986), pp. 25–45.

Jenkins, Ruth. ' "I Still Fell Indignant" ' [Episcopal Church House of Deputies, Women Members], *Witness*, Vol. 66, No. 11 (Nov. 1983), pp. 10–11.

Jessup, Mary E. 'Pastoring Women: The Economic Issues,' *Brethren Life and Thought*, Vol. 30 (Winter 1985), pp. 55–57.

Jewett, Julia, and Emily Haight. 'The Emergence of Feminine Consciousness in Supervision' [clinical pastoral education], *Journal of Supervision and Training in Ministry*, Vol. 6 (1983), pp. 164–174.

Karaban, Roslyn Ann. 'Jung's Concept of the Anima/Animus: Enlightening or Frightening?' *Bangalore Theological Forum*, Vol. 19 (Oct.–Dec. 1987), pp. 291–300.

Kaufman, Irving. 'Child Abuse – Family Victimology,' *Victimology: An International Journal*, Vol. 10 (1985), pp. 62–71.

Kemper, Vicki. 'Poor and Getting Poorer: Women Struggle for Survival,' *Sojourners*, Vol. 15, No. 3 (Mar. 1986), pp. 14–18.

Lacelle, Elisabeth J. 'Le nouveau code de droit: Pour les femmes, un baluchon d'espérance?' *Église Canadienne*, Juin 16, 1983, pp. 621–626.

Lebacqz, Karen, and Archie Smith. 'The Liberation of Language: Professional Ethics in Pastoral Counseling,' *Quarterly Review: A Scholarly Journal for Reflection on Ministry*, Vol. 5, No. 1 (Winter 1985), pp. 11–20.

Lefevere, Patricia Scharber. 'Out of the Gloom Comes Hope,' *National Catholic Reporter*, Vol. 23 (Feb. 20, 1987), p. 6.

Lilliston, Lawrence, Paula M. Brown, and Helen P. Schleibe. 'Perceptions of Religious Solutions to Personal Problems of Women,' *Journal of Clinical Psychology*, Vol. 38, No. 3 (1982), pp. 546–549.

Livezey, Lois Gehr. 'Sexual and Family Violence: A Growing Issue for the Churches,' *Christian Century*, Vol. 104, No. 31 (Oct. 28, 1987), pp. 938–942.

McWilliams, Frances. 'From "Good Mama" to "Bad Mama": A Reflection in Gender Roles, Issues,' *Journal of Supervision and Training in Ministry*, Vol. 9 (1987), pp. 125–126.

Marshall, Diane. 'Current Issues of Women and Therapy,' *Journal of Psychology and Christianity*, Vol. 4, No. 1 (Spring 1985), pp. 62–72.

Meadow, Mary J. 'Religious Unchurched Women: Yearnings, Frustrations, and Solutions,' *Journal of Pastoral Counseling*, Vol. 17, No. 1 (Spring–Summer 1982), pp. 29–32.

Merrill, Dean. 'The Sexual Hazards of Pastoral Care,' *Christianity Today*, Vol. 29, No. 16 (Nov. 8, 1985), p. 105.

Miller, Mary Cox. 'Rubble on the Road: Barriers to Women in the Workplace,' *Exchange: For Leaders of Adults*, Vol. 9, No. 4 (Fall 1984), pp. 4–7.

Morey, Ann-Janine. 'Blaming Women for the Sexually Abusive Male Pastor,' *Christian Century*, Vol. 105, No. 28 (Oct. 5, 1988), pp. 866–869.

Morgan, Edward. 'Implications of the Masculine and the Feminine in Pastoral Ministry,' *Journal of Pastoral Care*, Vol. 34, No. 4 (Dec. 1980), pp. 268–277.

Ochs, Peter, and Vanessa L. Ochs. 'A Guide to the Perplexed Jewish Woman,' *Religion and Intellectual Life*, Vol. 3, No. 2 (Winter 1986), pp. 83–94.

Parvey, Constance F. 'Homeless Women: Priorities,' *Christianity and Crisis: A Christian Journal of Opinion*, Vol. 47, No. 4 (Mar. 16, 1987), pp. 94–96.

Peterson, Kenneth W. 'Wife Abuse: The Silent Crime, the Silent Church,' *Christianity Today*, Vol. 27, No. 18 (Nov. 28, 1983), pp. 22–27.

Propst, Rebecca. 'Servanthood Redefined: Coping Mechanisms for Women within Protestant Christianity,' *Journal of Pastoral Counseling*, Vol. 17, No. 1 (Spring–Summer 1982), pp. 14–18.

Rayburn, Carole A., Lee J. Richmond, and Lynn Rogers. 'Women, Men and Religion: Stress within Sanctuary Walls,' *Journal of Pastoral Counseling*, Vol. 17, No. 1 (Spring–Summer 1982), pp. 75–83.

Reading, Janet, and Ellen S. Amatea. 'Role Deviance or Role Diversification: Reassessing the Psychosocial Factors Affecting the Parenthood Choice of Career-Oriented Women,' *Journal of Marriage and Family*, Vol. 48, No. 2 (May 1986), pp. 255–260.

Reeves, Joy B. 'Role Conflict and Resolution: The Case of the Christian Feminist,' *Journal of Pastoral Counseling*, Vol. 18, No. 1 (Spring–Summer 1983), pp. 11–19.

Samuels, Andrew. 'Gender and Psyche: Developments in Analytical Psychology,' *Anima: An Experimental Journal of Celebration*, Vol. 11 (Spring 1985), pp. 125–138.

Saunders, Judith M., and S.M. Valente. 'Suicide Risk among Gay Men and Lesbians: A Review,' *Death Studies*, Vol. 11, No. 1 (1987), pp. 1–24.

Scott, Marshall. 'Honor Thy Father and Mother: Scriptural Resources for Victims of Incest and Parental Abuse,' *Journal of Pastoral Care*, Vol. 42, No. 2 (Summer 1988), pp. 139–148.

Seggerman, Anne Crellin. 'The Eternal Female Principle and the Global Placebo,' *Journal of Religion and Psychical Research*, Vol. 8 (July 1985), pp. 169–173.

Soley, Ginny Earnest, and Rob Soley. 'Discovering Mutuality: Feminism in Marriage and Partnering,' *Sojourners*, Vol. 15, No. 1 (Jan. 1986), pp. 32–35.

Stevenson-Moessner, Jeanne. 'Review of *Pastoral Care of Battered Women*

by Rita L. Clarke,' *Journal of Pastoral Care*, Vol. 41, No. 3 (Sept. 1987), pp. 283–285.

Stewart, Dorothy Cox. 'Sex-Role Values in Pastoral Counselling,' *Journal of Pastoral Care*, Vol. 32, No. 2 (June 1978), pp. 111–117.

Tucker, Ruth A. 'Working Mothers,' *Christianity Today*, Vol. 32, No. 9 (June 15, 1988), pp. 17–21.

Ulanov, Ann B. 'Feminine and the World of CPE,' *Journal of Pastoral Care*, Vol. 29, No. 2 (Mar. 1975), pp. 11–22.

Van Herik, Judith. 'The Feminist Critique of Classical Psychoanalysis,' in *The Challenge of Psychology to Faith* (Concilium, 156), ed. by Steven Kepnas and David Tracey, pp. 83–86. Edinburgh: T. and T. Clark, 1982.

Wall, James M. 'Plenty, Gender and Vulnerability,' *Christian Century*, Vol. 102, No. 34 (Nov. 1, 1985), pp. 987–988.

Webb, Pauline. 'Gender as an Issue,' *Ecumenical Review*, Vol. 40, No. 1 (Jan. 1988), pp. 4–15.

Wehr, Demaris. 'Uses and Abuses of Jung's Psychology for Women; Animus,' *Anima: An Experimental Journal of Celebration*, Vol. 12 (Fall 1985), pp. 13–22.

Wicks, R. 'Review of *Pastoral Care of Battered Women*, by Rita-Lou Clarke,' *New Catholic World*, Vol. 231 (Mar.–Apr. 1988), p. 85.

OTHER RELATED RESOURCES

Morris, Roberta. *Ending Violence in Families: A Training Program for Pastoral Care Workers*. Toronto: United Church of Canada, 1988.

8

Religion and the Church

Critique of Sexism

BOOKS, DISSERTATIONS, COLLECTED WORKS

Armstrong, Karen. *The Gospel According to Woman: Christianity's Creation of the Sex War in the West.* Garden City, NY: Anchor Press, 1987.

Atkinson, Clarissa W., Constance H. Buchanan, and Margaret R. Miles, eds. *Immaculate and Powerful: The Female in Sacred Image and Social Reality* (Harvard Women's Studies in Religion Series). New York: Harper and Row, 1985.

Bloesch, Donald G. *Is the Bible Sexist?: Beyond Feminism and Patriarchalism.* Westchester, IL: Crossway Books, c1982.

Braxton, Bernard. *Sex and Religion in Oppression: Sexual and Religious Exploitation of Women, Anti-Abortion, Anti-Lesbianism and Wife-Beating.* Washington, DC: Verta Press, 1978.

Briscoe, Jill. *Prime Rib and Apple.* Grand Rapids: Zondervan, 1978.

By Our Lives. Geneva: World Council of Churches, 1985.

Bynum, Caroline Walker, Stephen Harvell, and Paula Richman, eds. *Gender and Religion: On the Complexity of Symbols.* Boston: Beacon Press, 1986.

Canadian Religious Conference. General Assembly. *Women: For What World? In What Church?* Ottawa: Canadian Religious Conference, 1985.

Carmody, Denise Lardner. *The Double Cross: Ordination, Abortion, and Catholic Feminism.* New York: Crossroads, 1986.

– *Women and World Religions.* Nashville: Abingdon Press, c1979.

Christ, Carol P., and Judith Plaskow, eds. *Womanspirit Rising: A Feminist Reader in Religion.* San Francisco: Harper and Row, 1977.

Conférence des Evêques Catholiques du Canada. *Sondage sur la*

participation des femmes dans le travail pastoral officiel de l'Église Catholique au Canada. Ottawa: CECC, 1979.

Conway, Sheelagh. *A Woman and Catholicism.* Toronto: Paperjacks, 1987.

Corriden, James A., ed. *Sexism and Church Law.* New York: Paulist Press, 1977.

Daly, Mary. *Gyn/Ecology, the Metaethics of Radical Feminism.* Boston: Beacon Press, 1978.

– *Pure Lust: Elemental Feminist Philosophy.* Boston: Beacon Press, c1984.

Defossez, Marie-Paule. *La parole ensevelie ou l'évangile des femmes.* Paris: Cerf, 1987.

Diehl, Judith. *A Woman's Place.* [N.p.], 1987.

Doely, Sarah Bentley, ed. *Women's Liberation and the Church: The New Demand for Freedom in the Life of the Christian Church.* New York: Association Press, 1970.

Dossier sur la femme dans l'église. Special issue of *Relations,* Mai 1979.

Dowell, Susan, and Linda Hurcombe. *Dispossessed Daughters of Eve: Faith and Feminism.* London: SPCK, 1987.

Durkin, Mary G. *The Suburban Woman: Her Changing Role in the Church.* New York: Seabury Press, 1975.

Église Catholique. Archevêché de Montréal. *La femme, un agent de changement dans l'église.* Montreal: Archevêché de Montréal, 1976.

Elizondo, Virgil, and Norbert Greinacher, eds. *Women in a Men's Church* (Concilium, 134). Edinburgh: T. and T. Clark, 1980.

Fahey, Michael A., ed. *Women in the Church.* Special issue of *Ecumenism,* Vol. 73 (Mar. 1984).

Fischer, Clare Benedicks, Betsy Brenneman, and Anne McGrew Bennett, eds. *Women in a Strange Land: Search for a New Image.* Philadelphia: Fortress Press, 1975.

Furlong, Monica. *Feminine in the Church.* London: SPCK, 1984.

Gage, Matilda Joselyn. *Women, Church and State.* Watertown, MA: Persephone Press, 1980.

Goldenberg, Naomi R. *Changing of the Gods: Feminism and the End of Traditional Religions.* Boston: Beacon Press, c1979.

Graebner, Alan. *After Eve: The New Feminism.* Minneapolis: Augsburg, 1972.

Gross, Rita M., ed. *Beyond Androcentrism: New Essays on Women and Religion.* Missoula, MT: Scholars Press for the American Academy of Religion, 1977.

Gundry, Patricia. *Neither Slave Nor Free.* New York: Harper and Row, 1987.

Haddad, Yvonne Yazbeck, and Ellison Banks Findly, eds. *Women,*

Religion, and Social Change. Albany: State University of New York Press, 1985.

Hageman, Alice L., comp. and ed. *Sexist Religion and Women in the Church: No More Silence*. New York: Association Press, 1974.

Hebrard, Monique. *Dieu et les femmes*. Paris: Le Centurion/Cerf, 1984.

– *Les femmes dans l'église*. Paris: Le Centurion/Cerf, 1984.

Hellwig, Monika Konrad. *Christian Women in a Troubled World*. New York: Paulist Press, c1985.

Herr, Edward C., ed. *Women in the Church*. Special issue of *Overview*, Vol. 17 (June 1983).

– *Women versus the Church*. Special issue of *Overview*, Vol. 18 (Mar. 1984).

– *Women versus Today's Church*. Special issue of *Overview*, Vol. 19 (Apr. 1985).

Herzel, Susannah. *A Voice for Women: The Women's Department of the World Council of Churches*. Geneva: Women in Church and Society, World Council of Churches, c1981.

Houston, James M., ed. *Women in the Church*. Special issue of *Crux: A Quarterly Journal of Christian Thought and Opinion*, Vol. 19, No. 3 (Sept. 1983).

Johnson, Sonia. *From Housewife to Heretic*. New York: Doubleday, 1981.

– *Going out of Our Minds: The Metaphysics of Liberation*. Freedom, CA: Crossing Press, 1987.

Klein, Ethel. *Gender Politics*. Cambridge, MA: Harvard University Press, 1986.

Kolbenschlag, Madonna, ed. *Authority, Community and Conflict*. New York: Sheed and Ward, 1986.

Kroll, Una. *Flesh of My Flesh*. London: Darton, Longman and Todd, 1975.

Kuhns, Dennis R. *Women in the Church*. Scottdale, PA: Herald Press, 1978.

Lacelle, Elisabeth J., ed. *La femme et la religion au Canada français: Un fait socio-culturel: Perspectives et prospectives ...* Montreal: Éditions Bellarmin, 1979.

– ed. *La femme, son corps et la religion: Approches plurdisciplinaires I*. Montreal: Éditions Bellarmin, 1983.

Lerner, Gerda. *The Creation of Patriarchy*. New York: Oxford University Press, 1986.

Les femmes d'aujourd'hui et l'église. Special issue of *Le Supplément*, No. 127 (Dec. 1978).

Les femmes de l'église à l'évangile. Special issue of *Communauté Chrétienne*, No. 141 (Mai–Juin 1985).

McCauley, Michael F., ed. *Women in the Church*. Special issue of *Overview*, Vol. 12 (July 1978).

– *Women in the Church*. Special issue of *Overview*, Vol. 14 (July/Aug. 1980).

McClung, Nellie. *In Times Like These*. With an introduction by Veronica Strong-Boag. Toronto: University of Toronto Press, 1972.

McGrath, Albertus Magnus. *Women and the Church*. Garden City, NY: Image Books, 1976.

McIllwain, Linda P. *Women on the Outside Looking In*. [Charlotte, NC]: L.P. McIllwain, c1984.

Maitland, Sara. *A Map of the New Country: Women and Christianity*. London: Routledge and Kegan Paul, 1983.

Milhaven, Annie Lally. *The Inside Stories: Thirteen Valiant Women Challenging the Church*. Mystic, CT: Twenty-Third Publications, 1987.

Miller, Sara, ed. *Women in the Church*. Special issue of *Overview*, Vol. 22, No. 7 (July 1988).

Moltmann-Wendel, Elisabeth. *Liberty, Equality, Sisterhood: On the Emancipation of Women in Church and Society*. Philadelphia: Fortress Press, c1978.

Muir, Elizabeth, ed. *Women in the Church*. Special issue of *Commonweal: A Review of Public Affairs, Literature and the Arts*, Vol. 8, No. 2 (Spring 1981).

Ochs, Carol. *Behind the Sex of God: Toward a New Consciousness – Transcending Matriarchy and Patriarchy*. Boston: Beacon Press, c1977.

Ohanneson, Joan. *Woman: Survivor in the Church*. Minneapolis: Winston Press, c1980.

Ormseth, Dennis H., ed. *Gender across Generations*. Special issue of *Word and World: Theology for Christian Ministry*, Vol. 5, No. 4 (Fall 1985).

Papa, Mary Bader. *Christian Feminism: Completing the Subtotal Woman*. Chicago: Fides/Claretian, c1981.

Phillips, John A. *Eve, the History of an Idea*. San Francisco: Harper and Row, c1984.

Pierro, Rita, and Franca Long. *L'autre moitié de l'église: Les femmes* (Dossiers Libres). Paris: Cerf, 1980.

Pintasilgo, Maria de Lourdes. *Les nouveaux feminismes: Question pour les Chrétiens?* Paris: Cerf, 1980.

Place aux femmes dans l'église. Special issue of *Communauté Chrétienne*, No. 95 (Sept.–Oct. 1977).

Plaskow, Judith, and Joan Arnold Romero, eds. *Women and Religion: Papers of the Working Group on Women and Religion. 1972–1973*. Missoula, MT: Scholars Press for the American Academy of Religion, 1974.

Quéré, France. *La femme avenir*. Paris: Seuil, 1976.

Radl, Shirley Rogers. *The Invisible Woman: Target of the Religious New Right*. New York: Dell, 1983.

The Religious Sacralization of Patriarchy. Rochester, NY: Women's Ordination Conference, 1983.

Rigney, Barbara. *Lilith's Daughters: Women and Religion in Contemporary Fiction*. Madison: University of Wisconsin Press, 1982.

Ruether, Rosemary Radford. *New Woman, New Earth: Sexist Ideologies and Human Liberation*. New York: Seabury Press, 1975.

– ed. *Religion and Sexism: Images of Woman in the Jewish and Christian Traditions*. New York: Simon and Schuster, 1974.

Savramis, Demosthenes S. *The Satanizing of Woman: Religion versus Sexuality*. New York: Doubleday, 1974.

Sayers, Dorothy Leith. *Are Women Human?* Introduction by Mary McDermott Shideler. Grand Rapids: Eerdmans, 1971.

Scheiber, Matthew Schuck, ed. *Women in the Church*. Special issue of *Overview*, Vol. 21, No. 6 (June 1987).

Sexism. Special issue of *Witness*, Vol. 60, No. 2 (Feb. 1977).

Smith, Caroline, and Trish March. *Women and the Christian Future: Issues in Christian Feminism*. Birmingham: SCM, 1981.

Stone, Merlin. *The Paradise Papers: The Suppression of Women's Rites*. London: Quartet Books, 1976. (Also published with the title *When God Was a Woman*. New York: Harcourt Brace, Jovanovich, 1976.)

Storkey, Elaine. *What's Right with Feminism*. Grand Rapids: Eerdmans, 1986.

Suleiman, Susan Rubin, ed. *The Female Body in Western Culture: Contemporary Perspectives*. Cambridge, MA: Harvard University Press, n.d.

Swidler, Arlene. *Woman in a Man's Church: From Role to Person*. New York: Paulist Press, 1972.

Thompson, Betty. *A Chance to Change: Women and Men in the Church* (Risk Book Series, 15). Geneva: World Council of Churches, c1982.

Van Vuuren, Nancy. *The Subversion of Women as Practiced by Churches, Witch-Hunters, and Other Sexists*. Philadelphia: Westminster Press, 1973.

Verdesi, Elizabeth Howell. *In But Still Out: Women in the Church*. Philadelphia: Westminster Press, 1976.

'Vers l'autre, par des femmes et des hommes: Symposium,' *Le Supplément*, No. 157 (Juillet 1986).

Weaver, Mary Jo. *New Catholic Women: A Contemporary Challenge to Traditional Religious Authority*. San Francisco: Harper and Row, c1985.

Weiser, Marjorie, and Jean Arbeiter. *Womanist*. New York: Athenaeum, 1981.

Wold, Margaret. *The Shalom Woman*. Minneapolis: Augsburg, 1974.

Women and the Church. Special issue of *Grail: An Ecumenical Journal,* Vol. 4, No. 2 (June 1988).
Women in the Church. Special issue of *Arc,* Vol. 13, No. 2 (Spring 1981).

ARTICLES, BOOK REVIEWS

Agudelo, Maria. 'The Church's Contribution to the Emancipation of Women,' in *Women in a Men's Church* (Concilium, 134), ed. by Virgil Elizondo and Norbert Greinacher, pp. 124–132. Edinburgh: T. and T. Clark, 1980.

Alexandre, Laurien. 'Whose Development: Women Strategize' [World Conference for the Review and Appraisal of the UN Decade for Women, Nairobi, Kenya, July 1985], *Christianity and Crisis: A Christian Journal of Opinion,* Vol. 45, No. 14 (Sept. 16, 1985), pp. 344–349.

Babb, Lawrence A. 'Indigenous Feminism in a Modern Hindu Sect,' *Signs: Journal of Women, Culture, and Society,* Vol. 9, No. 3 (Spring 1984), pp. 399–416.

Badertscher, John. 'The Remedy for a Severe Case of Hierarchy: A Good Dose of Equality?' *Touchstone: Heritage and Theology in a New Age,* Vol. 4, No. 3 (Oct. 1986), p. 22.

Becher, Jeanne. 'The United Nations Decade for Women, 1976–1985: The Nairobi End-of-Decade Meetings,' *Ministerial Formation: Program on Theological Education, World Council of Churches,* No. 31 (Sept. 1985), pp. 42–48.

Beifuss, Joan Turner. 'Women's Group Protests Bishop's Lector Decree,' *National Catholic Reporter,* Vol. 18 (Oct. 30, 1981), p. 3.

Berling, Judith A. 'Review of *Immaculate and Powerful* [edited by Clarissa W. Atkinson et al.] and *Women, Religion, and Social Change* [edited by Y. Haddad and E. Findley],' *History of Religions,* Vol. 26, No. 3 (Feb. 1987), pp. 329–332.

Bernand, Jessie. 'New Occasions, New Duties,' *Journal of Ecumenical Studies,* Vol. 22, No. 1 (Winter 1985), pp. 97–102.

Bobrova, N. 'Participation of Women in the Life of the Orthodox Church Today' [meetings; Canada; July, Aug. 1983], *Journal of the Moscow Patriarchate,* No. 7 (1984), pp. 68–70.

Boer, Harry R. 'Ecclesiastical Polarization,' *Reformed Journal,* Vol. 35, No. 6 (June 1985), pp. 4–5.

Boyd, Mary Thompson. 'Racism/Sexism: Making Connections,' *Exchange: For Leaders of Adults,* Vol. 8, No. 2 (Winter 1984), pp. 10–13.

Brennan, Margaret. 'Enclosure: Institutionalizing the Invisibility of Women in Ecclesiastical Communities,' in *Women Invisible in Church*

and Theology (Concilium, 182), ed. by Elisabeth Schüssler Fiorenza and Mary Collins, pp. 38–50. Edinburgh: T. and T. Clark, c1985.

– 'Women and Men in Church Office,' in *Women in a Men's Church* (Concilium, 134), ed. by Virgil Elizondo and Norbert Greinacher, pp. 102–109. Edinburgh: T. and T. Clark, 1980.

Broughton, Lynne. 'Find the Lady,' *Modern Theology: A Quarterly Journal of Systematic and Philosophical Theology*, Vol. 4, No. 3 (Apr. 1988), pp. 267–281.

Browne, J. Patrick, and Timothy J. Lukes. 'Women Called Catholics: The Sources of Dissatisfaction with the Church, County, California,' *Journal for the Scientific Study of Religion*, Vol. 27, No. 2 (June 1988), pp. 284–290.

Bührig, Marga. 'Moving on the Right Track' [women's participation, 6th WCC, 1983], *Ecumenical Review*, Vol. 36, No. 2 (Apr. 1984), pp. 163–166.

Cardman, Francine. 'B.E.M. and the Community of Women and Men,' *Journal of Ecumenical Studies*, Vol. 21, No. 1 (Winter 1983), pp. 83–98.

Carmody, Denise Lardner. 'Summary of the Discussions: The Role of Women in Theology,' *Catholic Theological Society of America Proceedings*, Vol. 38 (1983), pp. 74–76.

Carr, Anne E. 'Coming of Age in Christianity: Women and the Churches,' *Furrow*, Vol. 34, No. 6 (June 1983), pp. 345–358.

– 'The Search for Wholeness,' *Criterion: A Publication of the Divinity School of the University of Chicago*, Vol. 23 (Aug. 1984), pp. 4–7.

Carroll, Elizabeth. 'Can Male Domination Be Overcome?' in *Women in a Men's Church* (Concilium, 134), ed. by Virgil Elizondo and Norbert Greinacher, pp. 43–52. Edinburgh: T. and T. Clark, 1980.

Chittister, Joan D. 'Rome and the Religious Life,' *Ecumenist: A Journal for Promoting Christian Unity*, Vol. 23 (July–Aug. 1985), pp. 72–76.

Christiansen, Drew. 'On Relative Equality: Catholic Egalitarianism after Vatican II,' *Theological Studies*, Vol. 45, No. 4 (Dec. 1984), pp. 651–675.

Collins, Sheila D. 'Women's Revolution,' *Engage/Social Action*, Vol. 3 (July 1975), pp. 34–36.

'Consultation of Christian Church Women – A Statement on Human Rights,' *Exchange: For Leaders of Adults*, Vol. 1, No. 3 (Spring–Summer 1977), pp. 10–11, 25.

Cooper, Rhonda. 'Is There a Shortage?' *Sojourners*, Vol. 16, No. 7 (July 1987), pp. 22–23.

Crowley, Patricia Carson. 'If She Couldn't Stand the Heat, She Would Have Stayed in the Kitchen,' *U.S. Catholic*, Vol. 47, No. 5 (May 20, 1982), pp. 25–29.

Cunneen, Sally. 'Mother Church, Mother World, Mother God,' *Cross Currents: A Quarterly Review to Explore the Implications of Christianity for Our Times*, Vol. 37, No. 2–3 (Summer/Fall 1987), pp. 129–139.

– 'Women's Issues, Church/World Issues,' *Doctrine and Life*, Vol. 38 (Mar. 1988), pp. 124–135.

Daly, Mary. 'Church and Women: An Interview with Mary Daly,' *Theology Today*, Vol. 28, No. 3 (Oct. 1971), pp. 349–354.

– 'The Courage to See: Religious Implications of the New Sisterhood,' *Christian Century*, Vol. 88, No. 38 (Sept. 22, 1971), pp. 1108–1111.

'The Daughters of God Arise: Six Personal Views on the Liberation of Women,' *United Church Observer*, Vol. 148, No. 9 (Mar. 1978), pp. 18–23.

Davis, Gary. 'Woman and the Church,' *Religion in Life*, Vol. 44, No. 3 (Autumn 1975), pp. 338–346.

Delloff, Linda M. 'WCC Assembly: A Delegate Speaks Out' [interview with Elizabeth Bettenhausen], *Christian Century*, Vol. 100, No. 25 (Aug. 31–Sept. 7, 1983), pp. 763–765.

Desmond, Joan Frawley. 'Altar Girls: Small Issue, Big Impact?' *National Catholic Register*, Vol. 64 (May 1, 1988), p. 1.

– 'The Women's Pastoral: Some Big Flaws,' *National Catholic Register*, Vol. 64 (May 22, 1988), p. 1.

Dumais, Monique. 'Féminisme et religion au Québec,' in *Religion and Culture in Canada/Religion et Culture au Canada*, ed. by Peter Slater, pp. 149–186. Waterloo: Wilfrid Laurier University Press, 1977.

Dumais, Monique, with Marie-Odile Metral. 'Le statut des femmes dans l'église,' *Pouvoirs* (PUF), Vol. 17 (1981), pp. 143–152.

Duncan, Muriel. 'You Haven't Made It ... until We've All Made It: Women in the United Church Are Equal in Theory – But in Practice?' *United Church Observer*, Vol. 38, No. 9 (Mar. 1975), pp. 12–15.

Edelbeck, Lucy. 'Reconciliation: The Church and Women,' *Sisters Today*, Vol. 58, No. 5 (Jan. 1987), pp. 264–268.

Erickson, Joyce Quiring. 'Let Us Now Praise Women: Telling the Whole Story,' *Reformed Journal*, Vol. 36, No. 5 (May 1986), pp. 6–11.

Ericsson, Susan Moore. 'Opening the Door,' *Sojourners*, Vol. 16, No. 7 (July 1987), pp. 31–32.

Faber, Joan. 'Female beyond the Signs,' *Way: Contemporary Christian Spirituality*, Vol. 26, No. 91 (Apr. 1986), pp. 104–112.

Fiorenza, Elisabeth Schüssler. 'Sexism and Conversion,' *Network Quarterly*, Vol. 9, No. 3 (May–June 1981), pp. 15–22.

– 'So Far, So Bad ...,' *Commonweal: A Review of Public Affairs, Literature and the Arts*, Vol. 113, No. 2 (Jan. 31, 1986), pp. 44–46.

Flanagan, B. 'Spirit of Sisterhood Urged,' *National Catholic Reporter*, Vol. 8 (Oct. 29, 1971), p. 19.

Follmar, Mary Ann. 'Woman in the Church,' *Communio: International Catholic Review*, Vol. 9, No. 1 (Spring 1982), pp. 80–85.

Frank, Frances C. 'This Is My Body; This Is My Blood?' *New Women, New Church*, Vol. 9, No. 9 (Nov.–Dec. 1986), p. 17.

Fuller, Georgia. '2000 Catholic Women Challenge the Patriarchy,' *Witness*, Vol. 62, No. 1 (Jan. 1979), pp. 10–13.

'The Future of Women in the Church,' *Origins*, Vol. 12, No. 1 (May 20, 1982), p. 1.

Golden, Michael. 'The Vatican and the United Nations Decade for Women,' *AFER: African Ecclesial Review*, Vol. 27 (Oct. 1985), pp. 273–278.

Goldsmit, Schulamit, and Ernest S. Sweeney. 'The Church and Latin American Women in the Struggle for Equality and Justice,' *Thought: A Review of Culture and Idea*, Vol. 63 (June 1988), pp. 176–188.

Gratton-Boucher, Marie. 'Les droits des femmes dans l'église,' in *Devenirs de femmes* (Cahiers de Recherche Éthique, 8), pp. 131–146. Montreal: Fides, 1981.

Hamelin, Jean-Guy. 'Full Participation of Women,' *Living Light: An Interdisciplinary Review of Catholic Religious Education, Catechesis and Pastoral Ministry*, Vol. 24, No. 3 (Mar. 1988), pp. 207–208.

Hampson, Daphne, and Rosemary Radford Ruether. 'Is There a Place for Feminists in a Christian Church?' *New Blackfriars*, Vol. 68, No. 801 (Jan. 1987), pp. 7–24.

Hansen, Susan. 'Bishop's Letter Confesses Sexism in Church,' *National Catholic Reporter*, Vol. 24 (Apr. 15, 1988), p. 1.

Harrison, Beverly Wildung. 'Misogyny and Homophobia: The Unexplored Connections' [excerpt from *Integrity Forum*, Vol. 7, No. 2 (1981)], *Church and Society*, Vol. 73, No. 2 (Nov.–Dec. 1982), pp. 20–33.

Hays, Charlotte. 'Womanchurch,' *National Catholic Reporter*, Vol. 62 (Oct. 26, 1986), p. 1.

Heyward, Isabel Carter, and Suzanne R. Hiatt. 'The Trivialization of Women,' *Christianity and Crisis: A Christian Journal of Opinion*, Vol. 38, No. 10 (June 26, 1978), pp. 158–162.

Himmelstein, Jerome L. 'The Social Basis for Antifeminism: Religious Networks and Culture,' *Journal for the Scientific Study of Religion*, Vol. 25, No. 1 (Mar. 1986), pp. 1–15.

Hines, Mary E. 'Women Religious in Transition: Changing World, Changing Church, Changing Ministries,' *New Theology Review*, Vol. 1 (Feb. 1988), pp. 93–106.

Hudson, E. 'Church Ministry: For Men Only?' *Liguorian*, Vol. 63 (July 1975), pp. 16–18.

Hughes, P. 'The Sin of Exclusion: A Call for Conversion within the Church,' *Listening: A Journal of Religion and Culture*, Vol. 13 (Spring 1978), pp. 148–157.

Hunt, Angela E. 'All's Not Wrong with Women's Rights,' *Fundamentalist Journal*, Vol. 2, No. 10 (Nov. 1983), pp. 14–15.

Inman, Anne. 'No Neutral Stance,' *Clergy Review: The Word for the World*, Vol. 71, No. 7 (July 1986), p. 235.

Jackson, Beverly Robertson, and Jane Hull Harvey. 'Women Building Bridges of Equality, Peace and Development' [Women's Decade Conference, Nairobi], *Engage/Social Action*, Vol. 13, No. 9 (Oct. 1985), pp. 4–8, 41–44.

Jarl, Ann-Cathrin. 'The Eve of Destruction' [violence, patriarchy, and the women's movement], *Journal of Women and Religion*, Vol. 2, No. 2 (Winter 1982), pp. 23–29.

Jones, Arthur. 'It All Began with Altar Girls ...,' *National Catholic Reporter*, Vol. 22 (Sept. 19, 1986), p. 1.

Jung, Patricia Beattie. 'Give Her Justice,' *America*, Vol. 150, No. 14 (Apr. 14, 1984), pp. 276–278.

Kail, Marilyn. 'Pittsburgh to Include Women in Ritual,' *National Catholic Reporter*, Vol. 23 (Mar. 13, 1987), p. 5.

– 'Pittsburgh Women-Church Pastoral Addresses Foot-Washing Flap,' *National Catholic Reporter*, Vol. 23 (Mar. 27, 1987), p. 3.

– 'Women, Foot-Washing Together Again in Pittsburgh,' *National Catholic Reporter*, Vol. 23 (May 1, 1987), p. 3.

Kemper, Vicki. ' "The Unique Concerns of Women" ' [Women's Decade Conference, Nairobi], *Sojourners*, Vol. 14, No. 9 (Oct. 1985), pp. 5–6.

Lefevere, Patricia, and Roger Kahle. 'Women Influence Assembly' [WCC, Vancouver, 1983], *International Review of Mission*, Vol. 72, No. 288 (Oct. 1983), pp. 575–576.

Leonard, Ellen. 'How Women See Their Role in the Roman Catholic Church: One Woman's Reflections,' *Ecumenism*, No. 73 (Mar. 1984), pp. 8–10.

Lowe, Kathy. 'A Critical Test for Women in the Ecumenical Movement' [WCC, Vancouver, 1983], *One World*, No. 87 (June 1983), pp. 14–15.

McCarthy, Abigail Quigley. 'Impossible, Twenty Years Ago: Partners in the Mystery of the Redemption,' *Commonweal: A Review of Public Affairs, Literature and the Arts*, Vol. 115, No. 11 (June 3, 1988), pp. 326–327.

McDonough, Sheila. 'Women and Religion,' *Atlantis: Women's Studies Journal* (Wolfville, NS), Vol. 4, No. 2 (Spring 1979), pp. 163–169.

Mahowald, Mary. 'Remedial History: A Review of *The Creation of Patriarchy* by Gerda Lerner,' *Cross Currents: A Quarterly Review to Explore the Implications of Christianity for Our Times*, Vol. 37, No. 2–3 (Summer/Fall 1987), pp. 316–318.

Mollenkott, Virginia R. 'New Age Evangelism' [biblical feminism], *International Review of Mission*, Vol. 72, No. 285 (Jan. 1983), pp. 32–40.

Moran, Patricia. 'Review of *The Female Body in Western Culture: Contemporary Perspectives*, Susan Rubin Suleiman, ed.,' *Journal of Religion*, Vol. 68, No. 1 (Jan. 1988), pp. 153–154.

Morey-Gaines, Ann-Janine. 'Metaphor and Radical Feminism: Some Cautionary Comments on Mary Daly's *Gyn/Ecology*,' *Soundings: An Interdisciplinary Journal*, Vol. 65, No. 3 (Fall 1982), pp. 340–351.

Muchena, Olive N. 'Women and Participation' [WCC, Vancouver, 1983], *Ecumenical Review*, Vol. 36, No. 1 (Jan. 1984), pp. 22–24.

Mullins, Mary. 'Review of *New Woman, New Earth: Sexist Theologies and Human Liberation*, by Rosemary Radford Ruether,' *Horizons: The Journal of the College Theology Society*, Vol. 6, No. 1 (Spring 1979), pp. 129–130.

National Conference of Catholic Bishops, Washington, DC. 'Partners in the Mystery of Redemption: A Pastoral Response to Women's Concerns for Church and Society,' *Origins*, Vol. 17, No. 45 (Apr. 21, 1988), pp. 757, 759–788.

Neal, Marie Augusta. 'Pathology of the Men's Church,' in *Women in a Men's Church* (Concilium, 134), ed. by Virgil Elizondo and Norbert Greinacher, pp. 53–59. Edinburgh: T. and T. Clark, 1980.

Ng, Anne. 'Women of the World Church Speak Out,' *Mandate: The United Church's 'Doing Mission – Doing Justice Magazine*,' Vol. 15, No. 1 (Jan.–Feb. 1984), pp. 21–23.

Niogorski, D. 'Review of *The Inside Stories: Thirteen Valiant Women Challenging the Church*, by Annie Lally Milhaven,' *National Catholic Reporter*, Vol. 24 (Feb. 5, 1988), p. 12.

Nugent, Donald C., and Peter Marshall. 'The Domestication of the Church,' *St. Mark's Review*, No. 119 (Sept. 1984), pp. 3–12.

'Nuns of the World, Unite!' *National Catholic Reporter*, Vol. 23 (Dec. 12, 1986), p. 2.

Nyce, Fran Clemens. 'On Being a Woman, Christian, and Brethren,' *Brethren Life and Thought: A Quarterly Journal Published in the Interests of the Church of the Brethren*, Vol. 30 (Winter 1985), pp. 21–23.

Oliver, Mary E. 'The Last Woman Not to Be Seated' [Episcopal Church House of Deputies], *Witness*, Vol. 66, No. 11 (Jan. 1983), pp. 10–11.

O'Neill, M. 'Review of *Christian Women in a Troubled World*, by Monika

Konrad Hellwig,' *Catholic Library World*, Vol. 58 (Mar.–Apr. 1987), p. 220.

Ormseth, Dennis H., ed. 'Gender across Generations,' *Word and World: Theology for Christian Ministry*, Vol. 5, No. 4 (Fall 1985), pp. 351–413.

Overduin, Daniel C. 'Women, Human Rights, and Sex Discrimination,' *Lutheran Theological Journal*, Vol. 17 (Aug. 1983), pp. 70–73.

Papa, Mary Bader. 'Violence, like Church, Keeps Women in Line,' *National Catholic Reporter*, Vol. 17 (Apr. 24, 1981), p. 33.

'Parishes Protest Altar-Girl Ban during Pope's Germany Visit,' *National Catholic Reporter*, Vol. 23 (May 1, 1987), p. 3.

'The Pastoral on Women: What Should the Bishops Say?' *America*, Vol. 152, No. 19 (May 1985), pp. 404–413.

Pellauer, Mary D. 'Is There a Gender Gap in Heaven?' *Christianity and Crisis: A Christian Journal of Opinion*, Vol. 47, No. 3 (Mar. 2, 1987), pp. 60–61.

– 'Sex, Power, and the Family of God,' *Christianity and Crisis: A Christian Journal of Opinion*, Vol. 47, No. 2 (Feb. 16, 1987), pp. 47–50.

Pohlhaus, Gaile. 'A Review of the Bishops' Writing on Women,' *New Woman, New Church*, Vol. 8, No. 3 (Sept. 1985), pp. 8–9.

Quitslund, Sonya. 'A Feminist Perspective on Kings and Kingdom,' *Living Light: An Interdisciplinary Review of Christian Education*, Vol. 19, No. 2 (Summer 1982), pp. 134–139.

Ramirez, Anne West. 'A Feminist Folktale: Christian Reflections' [Tale Type 451, 'Maiden Who Seeks Her Brothers'], *Other Side*, No. 155 (Aug. 1984), pp. 17–19.

Redmont, Jane, Marylee Mitcham, Mary C. Segers, Emilie Griffin, Jean Bethke Elshtain, and Anne E. Patrick. 'Sexism, Sin and Grace: Response to the Bishops Letter,' *Commonweal: A Review of Public Affairs, Literature and the Arts*, Vol. 115, No. 12 (Jan. 17, 1988), pp. 361–366.

Reidy, Miriam. 'Women in Church and Society,' *One World*, No. 122 (Jan.–Feb. 1988), pp. 41–42.

Rieger, Renate. 'Half of Heaven Belongs to Women, and They Must Win It for Themselves: Feminist Theological Stock-Taking in the Federal Republic of Germany,' *Journal of Feminist Studies in Religion*, Vol. 1, No. 1 (Spring 1985), pp. 133–144.

Riley, Maria. 'Beyond Patriarchy,' *Sojourners*, Vol. 16, No. 7 (July 1987), pp. 25–26.

– 'Women, Church and Patriarchy,' *America*, Vol. 150, No. 17 (May 5, 1984), pp. 333–338.

Robinson, Jill. 'Women's Images of God and Prayer,' *Way Supplement*, No. 56 (Apr. 1986), pp. 91–103.

Robledo de Marchak, Frances. 'Women Will Do Greater Things,'
 Sojourners, Vol. 16, No. 7 (July 1987), pp. 28–29.
Ruether, Rosemary Radford. 'Feminism, Church and Family in the
 1980's,' *American Baptist Quarterly*, Vol. 3, No. 1 (Mar. 1984), pp. 21–30.
– 'Feminists Seek Structural Change,' *National Catholic Reporter*, Vol. 20
 (Apr. 13, 1984), pp. 4–6.
– 'Sex: Female; Religion: Catholic; Forecast: Fair,' *U.S. Catholic*, Vol. 50,
 No. 4 (Apr. 1985), pp. 19–26.
– 'Toward New Solutions, Working Women and the Male Workday,'
 Christianity and Crisis: A Christian Journal of Opinion, Vol. 37, No. 1
 (Feb. 7, 1977), pp. 3–8.
– 'Woman Church Calls Men to Exodus from Patriarchy,' *National
 Catholic Reporter*, Vol. 20 (Mar. 23, 1984), p. 16.
– 'Women-Church: Neither over nor under Men,' *National Catholic
 Reporter*, Vol. 23 (Jan. 23, 1987), p. 15.
Russell, Letty. 'Liberation and Evangelization: A Feminist Perspective,'
 Occasional Bulletin of Missionary Research, No. 2 (Oct. 1978), pp.
 128–130.
– 'Women and Unity: Problem or Possibility?' *Mid-stream: An
 Ecumenical Journal*, No. 21 (July 1982), pp. 298–304.
Sadowski, Dennis. 'Diocese Fronts "Social Sins" against Women,'
 National Catholic Reporter, Vol. 23 (Dec. 26, 1986), p. 20.
Sand, Faith A. 'Off-Putting the Male Hierarchy' [WCC Consultation,
 'The Community of Women and Men in the Church,' Sheffield, July
 10–19, 1981], *Missiology: An International Review*, Vol. 10 (Jan. 1982),
 pp. 101–106.
– 'Women at Pueblo: A Paternalistic Pat on the Head,' *Witness*, Vol. 62,
 No. 4 (Apr. 1979), pp. 7–8.
Schaper, Donna F. 'Houston's Message to the Church,' *A.D.: Presbyterian
 Life Edition*, Vol. 7, No. 4 (Apr. 1978), p. 51.
Sehested, Nancy Hastings. 'Not Ready for Women,' *Sojourners*, Vol. 16,
 No. 7 (July 1987), pp. 23–24.
Sims, Timothy C. 'Review of *The Female Body in Western Culture:
 Contemporary Perspectives*, Susan Rubin Suleiman, ed.,' *Word and
 World: Theology for Christian Ministry*, Vol. 8, No. 1 (Winter 1988), pp.
 88–89.
Singer, Linda. 'Nietzschean Mythologies: The Inversion of Value and
 the War against Women,' *Soundings: An Interdisciplinary Journal*, Vol.
 66, No. 3 (Fall 1983), pp. 281–295.
Sirico, R. 'Review of *The Double Cross: Ordination, Abortion, and Catholic
 Feminism*, by Denise Lardner Carmody,' *New Catholic World*, Vol. 231
 (Mar.–Apr. 1988), p. 84.

'Sisters Should Be Created Equal,' *National Catholic Reporter*, Vol. 23 (May 29, 1987), p. 12.

Smith, Ginny. 'Battling Sexism in Pittsburg,' *Sojourners*, Vol. 15, No. 6 (June 1986), pp. 10–11.

Smyers, Karen A. 'Women and Shinto: The Relation between Purity and Pollution,' *Japanese Religions*, Vol. 12, No. 4 (July 1983), pp. 7–18.

Sontag, Frederick E. 'The Discriminatory God; a Theodicy of Inequality,' *Encounter*, Vol. 44, No. 4 (Autumn 1983), pp. 391–393.

Sprong, John S. 'Misogyny: A Pattern as Ancient as Life' and 'Women: Less Than Free in Christ's Church,' in *Into the Whirlwind: The Future of the Church*, pp. 73–103. New York: Seabury Press, 1983.

Storrie, Kathleen. 'The Modern Movement for the Submission of Women,' *Ecumenism*, No. 73 (Mar. 1984), pp. 6–8.

Surlis, Paul J. 'Third International Congress on Women,' *Ecumenist: A Journal for Promoting Christian Unity*, Vol. 26, No. 3 (Mar.–Apr. 1988), pp. 38–41.

Swidler, Leonard J., ed. 'Graymoor Papers VII – Women and Religion: Scripture, Tradition, Institution [Conference Proceedings, 1983],' *Journal of Ecumenical Studies*, Vol. 20, No. 4 (Fall 1983), pp. 531–601.

Taber, Susan B. 'Man and Motherhood,' *Dialogue: A Journal of Mormon Thought*, Vol. 16, No. 3 (Autumn 1983), pp. 73–81.

Topping, Eva C. 'Patriarchal Prejudice and Pride in Greek Christianity: Some Notes on Origins,' *Journal of Modern Greek Studies*, Vol. 1, No. 1 (May 1983), pp. 7–17.

Toscano, Margaret Merrill. 'Beyond Matriarchy, beyond Patriarchy,' *Dialogue: A Journal of Mormon Thought*, Vol. 21, No. 1 (Spring 1988), pp. 32–57.

Traitler, Reinhild. 'An Oikoumeme of Women?' *Ecumenical Review*, Vol. 40, No. 2 (Apr. 1988), pp. 178–184.

Turcot, Gisèle. 'A la rencontre du mouvement des femmes,' *Approches*, No. 3 (Nov. 1986), pp. 19–28.

Turner, Ronny E., and Patricia Harvey. 'Six, Sex, Sin and Sorcery: The Social Construction of Gendered Religion,' *Free Inquiry in Creative Sociology*, Vol. 15, No. 2 (Nov. 1987), pp. 129–137.

Vallence, E. 'Review of *Gender Politics*, by Ethel Klein,' *Heythrop Journal: A Quarterly Review of Philosophy and Theology*, Vol. 28, No. 4 (Oct. 1987), pp. 496–497.

Van Leeuwen, Mary Stewart. 'Does God Listen to Girls? Women in Society and the Church,' *Reformed Journal*, Vol. 36, No. 6 (June 1986), pp. 7–11.

Vazquez, L. 'Equal Status for Women in the Church,' *Sisters Today*, Vol. 47, No. 2 (Oct. 1975), pp. 78–89.

Von Wartenberg, Bärbel. 'Vancouver: A Model' [WCC, Vancouver, 1983], *Ecumenical Review*, Vol. 36, No. 2 (Apr. 1984), pp. 155–163.

Watson, Sheila. ' "Converting" Some Clergy towards Sexual Equality,' *Compass: A Jesuit Journal*, Vol. 3, No. 2 (Summer 1985), pp. 17–19.

Weiss, Chris. 'Forging Global Networks for Women' [Decade Conference, Nairobi], *Witness*, Vol. 68, No. 10 (Oct 1985), pp. 18–20.

Wiebe, Marie. 'Equally Called and Responsible before God,' *Sojourners*, Vol. 16, No. 7 (July 1987), pp. 24–25.

Wilcox, Linda P. 'Crying "Change" in a Permanent World: Contemporary Mormon Women on Motherhood,' *Dialogue: A Journal of Mormon Thought*, Vol. 18, No. 2 (Summer 1985), pp. 116–127.

Williams, Delores S. 'Women's Oppression and Lifeline Politics in Black Women's Religious Narratives,' *Journal of Feminist Studies in Religion*, Vol. 1, No. 2 (Fall 1985), pp. 59–71.

Williams, Jane. 'Review of *Dispossessed Daughters of Eve*, by Susan Dowell and Linda Hurcombe,' *Christian*, Vol. 6, No. 4 (Advent 1981), pp. 19–21.

Wilson, Lois M. 'Rockers of the Cradle – Rockers of the Boat' [WCC, Vancouver, 1983], *Ecumenism*, No. 69 (Mar. 1983), pp. 31–35.

'Women and Church,' *Origins*, Vol. 14, No. 45 (May 2, 1985), pp. 750–756.

'Women in Jewish and Christian Tradition: Symposium,' *SIDIC: Service International de Documentation Judéo-Chrétienne*, Vol. 9, No. 3 (1976), pp. 4–18.

Zapata, Domingo Maria. 'The Role of Hispanic in the Church,' *New Catholic World*, Vol. 223 (July/Aug. 1980), pp. 172–174.

OTHER RELATED RESOURCES

National Conference of Catholic Bishops, Washington, DC. *Partners in the Mystery of Redemption: A Pastoral Response to Women's Concerns for Church and Society, First Draft. March 23, 1988*. Washington, DC: United States Catholic Conference, Inc., 1988.

Orthodox Church in America. Subcommittee of the Ecumenical Task Force. *Women and Men in the Church: A Study of the Community of Women and Men in the Church*. New York: Department of Religious Education, 1980.

United Church of Canada. Division of Mission in Canada. *The Changing Roles of Women and Men: A Report of the Task Force on the Changing Roles of Women and Men in Church and Society*. Toronto: Division of Mission in Canada, United Church of Canada, 1984.

United Church of Canada. Interdivisional Task Force on Changing Roles

of Women and Men in Church and Society. *Daughters and Sons of God*. Toronto: United Church of Canada, 1981.

Women's Inter-Church Council of Canada. *Women Tomorrow Today Kit*. Toronto, 1978.

World Council of Churches. *The Community of Women and Men in the Church: A Study Program*. New York: Friendship Press, 1978.

– *Sexism in the 1970s: Discrimination against Women: A Report of a World Council of Churches Consultation, West Berlin, 1974*. Geneva: World Council of Churches, 1975.

World Council of Churches. Subunit on Women and Church and Society. *Orthodox Women: Their Role and Participation in the Orthodox Church, Report on the Consultation of Orthodox Women, 11–17 September 1976, Agapia Romania*. Geneva: World Council of Churches, 1979.

World Council of Churches Conference (1981: Sheffield, Yorkshire). *The Community of Women and Men in the Church*, ed. by Constance F. Parvey. Geneva: World Council of Churches, c1983. (Also published Philadelphia: Fortress Press, 1983.)

Feminist Response

BOOKS, DISSERTATIONS, COLLECTED WORKS

Atkinson, Clarissa W., Constance H. Buchanan, and Margaret R. Miles, eds. *Shaping New Vision: Gender and Values in American Culture* (Harvard Women's Studies in Religion Series). Boston: UMI Research Press, 1987.

Carmody, Denise Lardner. *Feminism and Christianity: A Two-Way Reflection*. Nashville: Abingdon Press, 1982.

Casey, Juliana M. *Where Is God Now? Nuclear Terror, Feminism and the Search for God*. Kansas City, MO: Sheed and Ward, 1987.

Chittister, Joan D. *Winds of Change: Women Challenge the Church*. Kansas City, MO: Sheed and Ward, 1986.

Clark, Elizabeth A., and Herbert Richardson. *Women and Religion: A Feminist Sourcebook of Christian Thought*. New York: Harper and Row, c1977.

Drakeford, Robin, and John Drakeford. *In Praise of Women*. New York: Harper and Row, 1987.

Dumais, Monique. *Ferveurs d'une théologienne*. Rimouski: Université du Québec à Rimouski, 1978.

Furlong, Monica, ed. *Feminine in the Church*. London: SPCK, 1984.

Garcia, J., and S. Maitland, eds. *Walking on Water: Women Talk about Spirituality*. London: Virago Press, 1983.

Higgins, Michael, and Douglas Letson. *Women and Church: A Sourcebook.* Toronto: Griffin House, 1986.

Hurcombe, Linda, ed. *Sex and God: Some Varieties of Women's Religious Experience.* London: Routledge, Chapman and Hall, 1987.

Langley, Myrtle. *Equal Woman: A Christian Feminist Perspective.* Basingstoke: Marshalls, 1983.

Loades, Ann. *Searching for Lost Coins: Explorations in Christianity and Feminism.* Allison Park, PA: Pickwick Publications, 1987.

MacHaffie, Barbara J. *Her Story: Women in Christian Tradition.* Philadelphia: Fortress Press, 1986.

Martin, Faith. *Call Me Blessed: The Emerging Christian Woman.* Grand Rapids: Eerdmans, 1988.

Meadow, Mary Jo, and Carole A. Rayburn, eds. *A Time to Weep, a Time to Sing: Faith Journeys of Women Scholars of Religion.* Minneapolis: Winston Press, 1985.

Mollenkott, Virginia R. *Godding: Human Responsibility and the Bible.* New York: Crossroads, 1987.

– ed. *Women of Faith in Dialogue.* New York: Crossroads, 1987.

Papa, Mary Bader. *Christian Feminism: Completing the Subtotal Woman.* Chicago: Fides/Claretien, 1981.

Penn, C. Ray. 'When God Is Manly, All Men Are God-like: A Rhetorical Analysis of the Protestant Christian Feminist Movement.' Ph.D. dissertation, Northwestern University, 1987.

Scanzoni, Letha Dawson. *Sexuality: Choices: Guides for Today's Woman.* Philadelphia: Westminster Press, 1984.

Soble, Alan. *Pornography: Marxism, Feminism, and the Future of Sexuality.* New Haven: Yale University Press, 1986.

Sölle, Dorothee. *Beyond Mere Obedience.* New York: Pilgrim Press, 1982.

– *The Strength of the Weak: Toward a Christian Feminist Identity,* trans. by Robert Kimber and Rita Kimber. Philadelphia: Westminster Press, 1984.

Weidman, Judith L., ed. *Christian Feminism: Visions of a New Humanity.* San Francisco: Harper and Row, 1984.

ARTICLES, BOOK REVIEWS

Adams, Carol. 'Believe It or Not My Sisters: Pietism, Prophetism and U.S. Women,' *Radical Religion: A Quarterly Journal of Critical Thought,* Vol. 3, No. 1 (1976), pp. 25–29.

Anderson, Daphne, and David Thompson. 'Female and Male Con-

sciousness: The Pain and Joy of a Turning Point-in-Time,' *Exchange: For Leaders of Adults*, Vol. 5, No. 3 (Spring 1980), pp. 16–20.

Branca, Kathleen Peters. 'Review of *Winds of Change: Women Challenge the Church*, by Joan Chittister,' *National Catholic Reporter*, Vol. 23 (May 15, 1987), p. 13.

Bruteau, Beatrice. 'Neo-Feminism as Communion Consciousness,' *Anima: An Experimental Journal of Celebration*, Vol. 5 (Fall 1978), pp. 11–21.

Bührig, Marga. 'Marga Bührig: Working for Women from Within; Interview by Dee Dee Risher,' *Other Side*, Vol. 24, No. 1 (Jan.–Feb. 1988), pp. 12–16.

— 'Woman and Power,' *Journal of Women and Religion*, Vol. 2, No. 1 (Spring 1982), pp. 5–13.

Bunge, Marcia. 'Feminism in Different Voices: Resources for the Church,' *Word and World: Theology for Christian Ministry*, Vol. 8, No. 4 (Fall 1988), pp. 321–326.

Chittister, Joan D. 'Joan Chittister: A Model for Christian Feminism,' *Other Side*, Vol. 22, No. 3 (Apr. 1986), pp. 12–15.

— 'Yesterday's Dangerous Vision: Christian Feminism in the Catholic Church,' *Sojourners*, Vol. 16, No. 7 (July 1987), pp. 18–21.

Christ, Carol P. 'Heretics and Outsiders: The Struggle over Female Power in Western Religion,' *Soundings: An Interdisciplinary Journal*, Vol. 61, No. 3 (Fall 1978), pp. 260–280.

Collins, Sheila D. 'Historical Turning Point: Feminism and Socialism,' *Radical Religion: A Quarterly Journal of Critical Thought*, Vol. 3, No. 2 (1977), pp. 5–11.

Cooey, Paula M. 'The Power of Transformation and the Transformation of Power,' *Journal of Feminist Studies in Religion*, Vol. 1, No. 1 (Spring 1985), pp. 23–36.

Coston, Carol. 'Circles in the Water: Style and Spirit of Feminist Leadership,' *New Catholic World*, Vol. 228 (Mar.–Apr. 1985), pp. 89–94.

Dayton, Donald W. 'Evangelical Roots of Feminism,' *Covenant Quarterly*, Vol. 34 (Nov. 1976), pp. 41–56.

Donnelly, Dorothy H. 'American Sisters of 1980s Look beyond Roman Roulette to Bigger Challenges,' *National Catholic Reporter*, Vol. 17 (Feb. 27, 1981), p. 11.

Donovan, Mary Ann. 'Women's Issues: An Agenda for the Church?' *Horizons: The Journal of the College Theology Society*, Vol. 14, No. 2 (Fall 1987), pp. 283–295.

Dowell, Susan. 'Back to the Ark,' *New Blackfriars*, Vol. 69 (Jan. 1988), pp. 27–34.

Driver, Anne Barstow. 'Review Essay: Religion,' *Signs: Journal of Women in Culture and Society*, Vol. 2, No. 2 (Winter 1976), pp. 434–442.

Dudro, Vivian Warner. 'Women Gather, Discuss Feminism and Moral Values with an Eye on 1988,' *National Catholic Register*, Vol. 62 (Oct. 19, 1986), p. 1.

Erickson, Joyce Quiring. 'What Difference: The Theory and Practice of Feminist Criticism,' *Christianity and Literature*, Vol. 33, No. 1 (Fall 1983), pp. 65–74.

'Feminism and Church,' *Commonweal: A Review of Public Affairs, Literature and the Arts*, Vol. 112, No. 17 (Oct. 4, 1985), pp. 516–517.

Fox, Margery. 'Protest in Piety: Christian Science Revisited,' *International Journal of Women's Studies*, Vol. 1 (July/Aug. 1978), pp. 401–416.

Galiardi, Margaret. 'Bonding: The Critical Praxis of Feminism,' *Way: Contemporary Christian Spirituality*, Vol. 26, No. 2 (Apr. 1986), pp. 134–144.

Gatta, Julia. 'The Catholic Feminism of Holy Mother Church,' *Saint Luke's Journal of Theology*, Vol. 29 (Dec. 1985), pp. 9–23.

Gibeau, Dawn. ' "Mainline" Church Women "Empowered" by Gathering,' *National Catholic Reporter*, Vol. 23 (Oct. 24, 1986), pp. 1, 14–15.

Gibel, Inge Lederer. ' "The Women of the World Have Won" ' [Women's Decade Conference, Nairobi], *Christian Century*, Vol. 102 (Sept. 11–18, 1985), pp. 802–804.

Glasgow, Joanne. 'Revision of the Sacred: Reclaiming the World,' *New Directions for Women*, Vol. 13 (Nov.–Dec. 1984), p. 14.

Gudorf, Christine E. 'Review of *Sexuality: Choices: Guides for Today's Woman*, by Letha Dawson Scanzoni,' *Religious Studies Review*, Vol. 14 (Apr. 1988), pp. 125–127.

Hacker, Helen. 'Feminism: Its Nature and Implications,' *Month: A Review of Christian Thought and World Affairs*, Vol. 19, No. 3 (Mar. 1986), pp. 96–99.

– 'Toward a Feminist Reformation of Biblical Religion,' *New England Sociologist*, Vol. 5, No. 1 (1984), pp. 23–26.

Hasker, William, ed. 'Christianity and Feminism,' special issue of *Christian Scholar's Review*, Vol. 17, No. 3 (1988), pp. 231–323.

Hayes, Kathleen. 'Daughters of Sarah: "We Are Christians; We Are Also Feminists," ' *Other Side*, Vol. 21, No. 8 (Nov. 1985), pp. 10–11.

Hays, Charlotte. 'Chicago Meeting Draws Strong Feminist Voices,' *National Catholic Register*, Vol. 62 (Nov. 30, 1986), p. 1.

– 'Split within Catholic Feminism?' *National Catholic Register*, Vol. 63 (Nov. 15, 1987), p. 1.

Heyward, Isabel Carter. 'An Unfinished Symphony of Liberation: The Radicalization of Christian Feminism among White U.S. Women,' *Journal of Feminist Studies in Religion*, Vol. 1, No. 1 (Spring 1985), pp. 99–118.

Hill, Claire C. 'Dancing toward Freedom,' *Witness*, Vol. 66, No. 2 (Feb. 1983), p. 16.

Hogan, L. 'Review of *Searching for Lost Coins: Explorations in Christianity and Feminism* by Ann Loades,' *Furrow*, Vol. 39, No. 5 (May 1988), p. 341.

Hummel, Horace D. 'Solidarity with Our Feminist Sisters Everywhere,' *Concordia Journal*, Vol. 10 (Mar. 1984), pp. 43–44.

Hunt, Mary E. 'Sharing Feminism: Empowerment or Imperialism' [Women of the Decade Week Conference, Oct. 22, 1981], *Journal of Women and Religion*, Vol. 1, No. 2 (Fall 1981), pp. 33–46.

Hutt, Marion. 'Understanding and Overcoming Sexism: Inside and outside the Church,' *Grail: An Ecumenical Journal*, Vol. 3, No. 2 (June 1987), pp. 27–46.

Jonte-Pace, Diane. 'Object Relations Theory, Mothering, and Religion: Toward a Feminist Psychology of Religion,' *Horizons: The Journal of the College Theology Society*, Vol. 14, No. 2 (Fall 1987), pp. 310–327.

King, Ursula. 'Women in Dialogue: A New Vision of Ecumenism,' *Heythrop Journal: A Quarterly Review of Philosophy and Theology*, Vol. 26, No. 2 (Apr. 1985), pp. 125–142.

Laffey, A. 'Review of *Women of Faith in Dialogue*, by Virginia Ramey Mollenkott,' *America*, Vol. 158, No. 3 (Jan. 23, 1988), p. 68.

Lane, Dermont A. 'A Christian Feminism,' *Furrow*, Vol. 36, No. 11 (Nov. 1985), pp. 663–675.

Leonard, Ellen. 'Review of *New Catholic Women: A Contemporary Challenge to Traditional Religious Authority*, by Mary Jo Weaver,' *Studies in Religion/Sciences Religieuses: A Canadian Journal*, Vol. 16, No. 1 (1987), pp. 132–135.

Maier, Judy. 'Vision for a Future,' *Sisters Today*, Vol. 52, No. 5 (Jan. 1981), pp. 263–265.

Mainland, Mary. 'Feminist Myths Reconsidered,' *America*, Vol. 151, No. 19 (Dec. 15, 1984), pp. 396–399.

Norton, Eleanor Holmes. 'The Quiet Revolution,' *Church and Society*, Vol. 76, No. 3 (Jan.–Feb. 1986), pp. 29–39.

Olson, Mark. 'Aquila: For Men Who Dare: Feminism Isn't Just for Women,' *Other Side*, Vol. 21, No. 1 (Jan.–Feb. 1985), pp. 8–9.

Picchi, Mary Spaulding. 'Women Becoming: Through Books and Bonding,' *Journal of Women and Religion*, Vol. 2, No. 1 (Spring 1982), pp. 38–41.

Price, Connie. 'Review of *Pornography: Marxism, Feminism, and the Future of Sexuality*, by Alan Soble,' *International Journal for the Philosophy of Religion*, Vol. 23, No. 2 (1988), pp. 106–107.

Reidy, Miriam. 'Launching the Decade: Churches in Solidarity with Women,' *One World*, No. 134 (Apr. 1988), pp. 12–15.

Ringe, June E., and Helena Jacobsen. 'Images and Reflections on Women's Retreats,' *Journal of Women and Religion*, Vol. 1, No. 1 (Spring 1981), pp. 39–43.

Ronan, Marian. 'The Liturgy of Women's Lives: A Call to Celebration,' *Cross Currents: A Quarterly Review to Explore the Implications of Christianity for Our Times*, Vol. 38, No. 1 (Spring 1988), pp. 17–31.

Ross, Susan A. 'The Future of Humanity: Feminist Perspectives,' *Catholic Theological Society of America Proceedings*, Vol. 41 (1986), pp. 151–159.

Ruether, Rosemary Radford. 'Female Symbols, Values and Context,' *Christianity and Crisis: A Christian Journal of Opinion*, Vol. 46, No. 19 (Jan. 12, 1987), pp. 460–464.

– 'Feminism and Religious Faith: Renewal or New Creation?' *Religion and Intellectual Life*, Vol. 3, No. 2 (Winter 1986), pp. 7–20.

– 'A Religion for Women: Sources and Strategies,' *Christianity and Crisis: A Christian Journal of Opinion*, Vol. 39, No. 19 (Dec. 10, 1979), pp. 307–311.

– 'An Unrealized Revolution,' *Christianity and Crisis: A Christian Journal of Opinion*, Vol. 43, No. 17 (Oct. 31, 1983), pp. 398–400.

– 'Woman, Ecology, and the Domination of Nature,' *Ecumenist: A Journal for Promoting Christian Unity*, Vol. 14, No. 1 (Nov.–Dec. 1975), pp. 1–5.

Russell, Letty M. 'Unity and Renewal in Feminist Perspective,' *Ecumenical Trends: Graymore Ecumenical Institute*, Vol. 16, No. 11 (Dec. 1987), pp. 189–192; also in *Mid-Stream: An Ecumenical Journal*, Vol. 27, No. 1 (Jan. 1988), pp. 55–66.

Schaefer, K. 'Review of *Women of Faith in Dialogue* by Virginia Ramey Mollenkott,' *Marriage and Family*, Vol. 70 (Mar. 1988), p. 24.

Schiffert, Margaret Marion. 'Church Women United: On the Dynamic Diagonal,' *Ecumenical Trends: Graymore Ecumenical Institute*, Vol. 14, No. 4 (Apr. 1985), pp. 55–57.

Shoemaker, Lorna. 'Feminist Symposium on Baptism Eucharist and Ministry' [Presbyterian Church (USA)], *Ecumenical Trends: Graymore Ecumenical Institute*, Vol. 13, No. 10 (Nov. 1984), pp. 155–158.

Springer, Suzanne. 'Women Together,' *New Covenant*, Vol. 14, No. 10 (May 1985), pp. 24–26.

Squire, Anne. 'Women and the Church,' *Christian*, Vol. 6, No. 4 (Advent 1981), pp. 5–13.

Sullivan, P.J. 'Review of *Equal Woman: A Christian Feminist Perspective*, by M. Langley,' *Heythorp Journal: A Quarterly Review of Philosophy and Theology*, Vol. 28, No. 2 (Apr. 1987), pp. 206–207.

Tighe, Kathleen. 'Woman Church Speaks: Roman Catholic Women in the 80s,' *Journal of Women and Religion*, Vol. 4, No. 1 (Winter 1984), pp. 45–47.

Timiadis, Emilianos. 'From the Margin to the Forefront,' *Ecumenical Review*, Vol. 27, No. 4 (Oct. 1975), pp. 366–373.

Weaver, Mary Jo. 'Women and the Future of American Catholicism: From Immigrants to Emigrants,' *Commonweal: A Review of Public Affairs, Literature and the Arts*, Vol. 112, No. 1 (Jan. 11, 1985), pp. 12–15.

Williams, Brooke. 'The Feminist Revolution in Ultramodern Perspective,' *Cross Currents: A Quarterly Review to Explore the Implications of Christianity for Our Times*, Vol. 31, No. 3 (Fall 1981), pp. 307–319.

Williams, Delores S. 'The Colour of Feminism: Or Speaking the Black Women's Tongue,' *Journal of Religious Thought*, Vol. 43, No. 1 (Spring–Summer 1986), pp. 42–58.

Wilson-Kastner, Patricia. 'Christianity and the New Feminist Religions,' *Christian Century*, Vol. 98, No. 27 (Sept. 9, 1981), pp. 864–868.

Wintermute, Carol. 'The Relationship of Humanism to Feminism, Pt. 1,' *Religious Humanism*, Vol. 19, No. 4 (Autumn 1985), pp. 194–197.

– 'The Relationship of Humanism to Feminism, Pt. 2,' *Religious Humanism*, Vol. 20, No. 1 (Winter 1986), pp. 37–40.

Winton-Henry, Cynthia. 'Not Just a Lot of Song and Dance,' *Journal of Women and Religion*, Vol. 3, No. 2 (Summer 1984), pp. 49–50.

Zikmund, Barbara Brown. 'How the Women's Movement Is Changing the Church,' *Perspectives in Religious Studies*, Vol. 3, No. 3 (Aug. 1979), pp. 1–2.

9

Spirituality

General – Women's Spirituality

BOOKS, DISSERTATIONS, COLLECTED WORKS

Abrahamsen, Valerie Ann. 'The Rock Reliefs and the Cult of Diana at Philippi.' Th.D. dissertation, Harvard University, 1986.

Bohler, Carolyn Jane. 'The Politics of Prayer: Feminist Perspectives for Expanding Christian Prayer.' Ph.D. dissertation, School of Theology at Claremont, 1982.

Cady, Susan, Marian Ronan, and Hal Taussig. *Sophia, the Future of Feminist Spirituality*. New York: Harper and Row, 1986.

Carmody, Denise Lardner. *Seizing the Apple: A Feminist Spirituality of Personal Growth*. New York: Crossroads, 1984.

Chervin, Ronda. *The Woman's Tale: A Journal of Inner Exploration*. New York: Seabury Press, 1980.

Christ, Carol P. *Diving Deep and Surfacing: Women Writers on Spiritual Quest*. Boston: Beacon Press, 1980.

Clark, Rosalind Elizabeth. 'Goddess, Fairy Mistress, and Sovereignty: Women of the Irish Supernatural.' Ph.D. dissertation, University of Massachusetts, 1985.

Cooney, Patricia Ann. 'Karen Horney's Psychological Theory and Its Implications for a Christian Feminist Spirituality.' Ph.D. dissertation, Catholic University of America, [n.d.].

Craighead, Meinrad. *The Mother's Songs: Images of God the Mother*. Mahwah, NJ: Paulist Press, c1986.

Esway, Judy. *Womanprayer, Spiritjourney: Fifty-six Meditations on Scripture*. Mystic, CT: Twenty-Third Publications, 1987.

Field, Rebecca. 'The Return of the Goddess: The Feminine Principle in Theosophic Thought and Transpersonal Psychology.' Ph.D. disserta-

tion, California Institute of Integral Studies, 1981.

Fremantle, Ann Jackson. *Woman's Way to God*. New York: St. Martin's Press, 1977.

Gaugl, Barbara Ann Bauman. 'Unlimiting God: A Model for a Local Church Retreat and Support System for Women Exploring Images of God.' D.Min. dissertation, Drew University, 1985.

Gilbert, Paula Elizabeth. 'Choice of the Greater Good; the Christian Witness of Georgia Harkness Arising from the Interplay of Spiritual Life and Theological Perspective.' Ph.D. dissertation, Duke University, 1984.

Giles, Mary E., ed. *The Feminist Mystic, and Other Essays on Women and Spirituality*. New York: Crossroads, 1982.

Grey, Mary Cecilia. 'Towards a Christian Feminist Spirituality of Redemption as Mutuality in Relation: A Passion to Make and Make Again Where Such Un-making Reigns ...' Ph.D. dissertation, Katholiecke Universiteit Leuven (Belgium), 1987.

Haddon, Gerria Pauli. *Body Metaphor Releasing God: Feminine in Us All*. New York: Crossroads, 1988.

Harris, Maria. *Women and Teaching: Themes for a Spirituality of Pedagogy*. New York: Paulist Press, 1988.

Haughton, Rosemary. *Feminine Spirituality*. New York: Paulist Press, 1976.

Haywood, Carol Lois. 'Women's Authority in Metaphysical Groups; an Ethnographic Exploration.' Ph.D. dissertation, Boston University Graduate School, 1982.

Heine, Susanne. *Christian and the Goddess: Systematic Criticism of a Feminist Theology*, trans. by John Bowden. London: SCM Press, 1988.

Heyob, Sharon Kelly. 'The Cult of Isis among Women in the Graeco-Roman World.' Ph.D. dissertation, Catholic University of America, 1973.

Hogan, Denise. 'Woman and the Christian Experience: Feminist Ideology, Christian Theology and Spirituality.' Ph.D. dissertation, Boston University Graduate School, 1975.

Kalven, Janet, and Mary Buckley. *Women's Spirit Bonding*. New York: Pilgrim Press, c1984.

La bonne nouvelle au féminin. Special issue of *La Vie Spirituelle*, No. 635 (Nov.–Dec. 1979).

Larner, Christina. *Witchcraft and Religion: The Politics of Popular Belief*, ed. by Alan MacFarlane. New York: Blackwell, 1986.

Luke, Helen M. *Woman, Earth and Spirit: The Feminine in Symbol and Myth*. New York: Crossroads, 1984.

McDermott, Patricia. 'Women's Ministerial Experience and Its Relationship to Spirituality: A Process of Theological Reflection.' D.Min. dissertation, Catholic University of America, 1986.

Massey, Marilyn Chapin. *Feminine Soul: The Fate of an Ideal*. Boston: Beacon Press, 1985.

Mollenkott, Virginia R. *Speech, Silence, Action! The Cycle of Faith*. Nashville: Abingdon Press, c1980.

Morton, Nelle. *Journey Is Home*. Boston: Beacon Press, 1986.

Ochs, Carol. *Women and Spirituality*. Totowa, NJ: Rowman and Allanheld, 1983.

Ochshorn, Judith. *The Female Experience and the Nature of the Divine*. Bloomington: Indiana University Press, c1981.

Pettey, Richard J. 'Asherah: Goddess of Israel?' Ph.D. dissertation, Marquette University, 1985.

Porterfield, Amanda, and Barbara Welter. *Feminine Spirituality in America: From Sarah Edwards to Martha Graham*. Philadelphia: Temple University Press, 1980.

Pratt, Marilyn J. *God's Femininity Recognized: A Personal Religious Experience*. Playa del Rey, CA: Golden Puer, 1980.

Quaife, G.R. *Godly Zeal and Furious Rage: The Witch in Early Modern Europe*. New York: St. Martin's Press, 1987.

Randour, Mary Lou. *Women's Psyche, Women's Spirit: The Reality of Relationships*. New York: Columbia University Press, 1987.

Rannells, Jean Saul. 'The Individuation of Women through the Study of Deity Images: Learning from a Jungian Perspective.' Ph.D. dissertation, University of Wisconsin–Madison, 1986.

Robert, Gail Woods. 'Evelyn Underhill's Concept of Worship.' Th.D. dissertation, Southern Baptist Theological Seminary, 1971.

Scott, Martha Lynne. 'The Theology and Social Thought of Georgia Harkness.' Ph.D. dissertation, Northwestern University, 1984.

Sölle, Dorothee. *Revolutionary Patience*. New York: Orbis Books, 1974.

Spretnak, Charlene, ed. *The Politics of Women's Spirituality: Essays on the Rise of Spiritual Power within the Feminist Movement*. Garden City, NY: Anchor Books, 1982.

Villegas, Diana. 'A Comparison of Catherine of Siena's and Ignatius of Loyola's Teaching on Discernment.' Ph.D. dissertation, Fordham University, 1986.

Washbourn, Penelope. *Becoming Woman: The Quest for Wholeness in Female Experience*. New York: Harper and Row, c1977.

– *Seasons of Woman: Song, Poetry, Ritual, Prayer, Myth, Story*. San Francisco: Harper and Row, c1979.

Weber, Christin Lore. *Womanchrist: A New Vision of Feminist Spirituality.* San Francisco: Harper and Row, 1987.

ARTICLES, BOOK REVIEWS

Bacchetta, Vittorio. 'Feminist Theology Strengthens Spirituality,' *New Catholic Times*, Vol. 11, No. 5 (Mar. 8, 1987), p. 3.

Barciauskas, Rosemary Curran, and Debra B. Hull. 'Other Women's Daughters: Integrative Feminism, Public Spirituality,' *Cross Currents: A Quarterly Review to Explore the Implications of Christianity for Our Times*, Vol. 38, No. 1 (Spring 1988), pp. 32–52.

Bennett, Anne McGrew. 'Meditation on July 4, 1982,' *Journal of Women and Religion*, Vol. 2, No. 2 (Winter 1982), pp. 6–12.

Berliner, Patricia Mary. 'Journeying Together on the Strength of a Promise,' *Spiritual Life*, Vol. 31, No. 1 (Spring 1985), pp. 39–41.

Blaquiere, Georgette. 'The Women Who Walked with Jesus,' *Marriage and Family Living*, Vol. 66 (May 1984), pp. 6–9.

Bregman, Lucy. 'Women and Ecstatic Religious Experience,' *Encounter*, Vol. 38, No. 1 (Winter 1977), pp. 43–53.

Breitsprecher, Nancy. 'The Feminine, Religion and Spirituality' [review of *Seasons of Woman, The Spiral Dance,* and *The Woman's Tale*], *Anglican Theological Review*, Vol. 64, No. 2 (Apr. 1982), pp. 223–227.

Brockett, Lorna. 'Traditions of Spiritual Guidance: The Relevance of Julian for Today,' *Way: Contemporary Christian Spirituality*, Vol. 28, No. 3 (July 1988), pp. 272–279.

Cahill, L. 'Review of *Women's Psyche, Women's Spirit: The Reality of Relationships* by Mary Lou Randour,' *Theological Studies*, Vol. 48 (Dec. 1987), pp. 797–798.

Carr, Anne E. 'On Feminist Spirituality,' *Horizons: The Journal of the College Theology Society*, Vol. 9, No. 1 (Spring 1982), pp. 96–103.

Chabaku, Motlalepula. 'Changing People and Nations through Jesus' [address, 1980 Evangelical Women's Caucus, national conference], *Journal of Women and Religion*, Vol. 4, No. 1 (Winter 1984), pp. 26–39.

Chavez-Garcia, Sylvia, and Daniel A. Helminiak. 'Sexuality and Spirituality: Friends Not Foes,' *Journal of Pastoral Care*, Vol. 39, No. 2 (June 1985), pp. 151–163.

Chittister, Joan D. 'A Full Picture of God: A Look at Feminist Spirituality,' *Sojourners*, Vol. 16, No. 7 (July 1987), pp. 34–37.

– 'Post Conciliar Spirituality of American Benedictive Women,' in *The*

Continuing Quest for God, ed. by W. Skudlarek, pp. 170–180. Collegeville, MN: Liturgical Press, 1982.

— 'A Sign and a Choice: The Spirituality of a Community,' *Sojourners*, Vol. 16, No. 6 (June 1987), pp. 14–20.

Conn, Joann Wolski. 'Contemporary Women's Spirituality; a Breakthrough of Power,' *Catholic Theological Society of America Proceedings*, Vol. 37 (1982), pp. 112–115.

— 'Women's Spirituality: Restriction and Reconstruction,' *Cross Currents: A Quarterly Review to Explore the Implications of Christianity for Our Times*, Vol. 30, No. 3 (Feb. 11, 1980), pp. 293–308.

Culpepper, Emily. 'The Spiritual Movement of Radical Feminist Consciousness,' in *Understanding the New Religions*, ed. by Jacob Needham and George Baker, pp. 220–234. New York: Seabury Press, 1978.

Cummings, Lydia M. 'Women Touched by God,' *AME Zion Quarterly Review*, Vol. 97, No. 2 (July 1985), pp. 29–32.

Demetrakopoilos, Stephanie A. 'The Nursing Mother and Feminine Metaphysics: An Essay on Embodiment,' *Soundings: An Interdisciplinary Journal*, Vol. 65, No. 4 (Winter 1982), pp. 430–443.

Dinkelspiel, Anne. 'When the Sacred Canopy Rips Apart' [between the God of Christianity and the Goddess of the Womanspirit Movement], *Journal of Women and Religion*, Vol. 1, No. 1 (Spring 1981), pp. 2–6.

Dreyer, Elizabeth. 'Recovery of the Feminine in Spirituality,' *New Catholic World*, Vol. 227 (Mar.–Apr. 1984), pp. 68–72.

Dumais, Monique. 'Les défis d'être une femme religieuse,' *Possibles*, Vol. 4, No. 1 (Automne 1979), pp. 147–154.

— 'Les femmes théologiennes dans l'église,' *Studies in Religion/Sciences Religieuses: A Canadian Journal*, Vol. 8, No. 3 (Printemps/Spring 1979), pp. 191–196.

— 'Pour que les noces aient lieu entre Dieu et les femmes,' *Studies in Religion/Sciences Religieuses: A Canadian Journal*, Vol. 16, No. 1 (1987), pp. 53–64.

— 'Renaissance spirituelle chez les femmes,' *Vie des Communautés Religieuses*, No. 10 (Dec. 1982), pp. 303–314.

— 'Si Dieu s'était faite femme,' *Critère*, No. 32 (Automne 1981), pp. 228–232.

— 'Sortir Dieu du ghetto masculin,' *Prêtre et Pasteur*, Vol. 88, No. 4 (Avril 1985), pp. 194–202.

Erickson, Joyce Quiring. 'Women in the Christian Story,' *Cross Currents: A Quarterly Review to Explore the Implications of Christianity for Our Times*, Vol. 27 (Summer 1977), pp. 183–195.

Finson, Shelley Davis. 'Feminist Spirituality within the Framework of Feminist Consciousness,' *Studies in Religion/Sciences Religieuses: A Canadian Journal*, Vol. 16, No. 1 (1987), pp. 65–77.

Fischer, Kathleen R. 'Mending Broken Connections: A Process Spirituality,' *Chicago Studies*, Vol. 26, No. 1 (Apr. 1987), pp. 37–49.

Gilbert, Barbara. 'Personality Type and the Spiritual Journey,' *Haelan: Journal on Worship, Prayer and Meditation*, Vol. 5, No. 3 (Spring 1985), pp. 4–15.

Goldenberg, Naomi R. 'Archetypal Theory and the Separation of Mind and Body: Reason Enough to Turn to Freud?' *Journal of Feminist Studies in Religion*, Vol. 1, No. 1 (Spring 1985), pp. 55–72.

– 'The Return of the Goddess: Psychoanalytic Reflections on the Shift from Theology to Thealogy,' *Studies in Religion/Sciences Religieuses: A Canadian Journal*, Vol. 16, No. 1 (1987), pp. 37–52.

Green, Lorna. 'Feminine Consciousness and God,' *Contemplative Review*, Vol. 14 (Winter 1981), pp. 13–17.

Hanley, Katherine. 'Jesus and the Woman at the Well: Shared Ministry,' *Sisters Today*, Vol. 58, No. 1 (Aug.–Sept. 1986), pp. 4–7.

Haughton, Rosemary. 'The Women Who Stayed,' *Sign*, Vol. 61 (Apr. 1982), pp. 4–7.

Hayes, Pamela. 'Women and the Passion,' *Way Supplement*, No. 58 (Spring 1987), pp. 56–73.

Haywood, Carol Lois. 'The Authority and Empowerment of Women among Spiritualist Groups,' *Journal for the Scientific Study of Religion*, Vol. 22, No. 2 (June 1983), pp. 157–166.

Heyward, Isabel Carter. 'Is a Self-Respecting Christian Woman an Oxymoron?: Reflections on a Feminist Spirituality for Justice,' *Religion and Intellectual Life*, Vol. 3, No. 2 (Winter 1986), pp. 45–62.

'In the New Creation, We Do Everything for the First Time,' *Haelan: Journal on Worship, Prayer and Meditation*, Vol. 4, No. 1 (Spring 1983), pp. 5–25.

Jacobs, Janet. 'The Economy of Love in Religious Commitment: The Deconversion of Women from Nontraditional Religious Movements,' *Journal for the Scientific Study of Religion*, Vol. 23 (June 1984), pp. 155–171.

Joyce, Patricia. 'Review of *Womanprayer, Spiritjourney: Fifty-six Meditations on Scripture* by Judy Esway,' *Furrow*, Vol. 39, No. 6 (June 1988), p. 483.

Kirby, Peadar. 'Rejecting Theology for a Religionless Spirituality,' *One World*, No. 98 (Aug.–Sept. 1984), pp. 20–21.

Kirk, Martha Ann. 'Worship, Spirituality and Women,' *Journal of Women and Religion*, Vol. 3, No. 2 (Summer 1984), pp. 1–58.

Kolbenschlag, Madonna. 'Feminist, the Frog Princess, and the New Frontier of Spirituality,' *New Catholic World*, Vol. 225 (July–Aug. 1982), pp. 159–163.

Langer, Heidemarie. 'Letting Ourselves Be Found: Stories of Feminist Spirituality,' *Ecumenical Review*, Vol. 38, No. 1 (Jan. 1986), pp. 23–28.

Letis, Theodore P. 'Feminine Spirituality; Eve Shakes an Angry Fist at Yahweh, But He Triumphs through the Son,' *Journal of Christian Reconstruction*, Vol. 9, No. 1 and 2 (1982–1983), pp. 182–200.

Lindhorst, Marie. 'It Matters That We Are Women: Some Thoughts on a Spiritual Journey,' *Reflection: Journal of Opinion at Yale Divinity School*, Vol. 79, No. 2 (Jan. 1982), pp. 8–9.

Luke, Helen M. 'The Women in Christ's Life,' *Liguorian*, Vol. 59 (Feb. 1971), pp. 50–53.

McCrea, Margaret. 'Women and Spirituality,' *Rain* (Portland, OR), Vol. 9, No. 4 (Apr.–May 1983), pp. 11–12.

McLaughlin, Eleanor. 'Christ My Mother: Feminine Naming and Metaphor in Medieval Spirituality,' *Nashotah Review*, Vol. 15 (1975), pp. 228–248.

– 'Priestly Spirituality,' *Anglican Theological Review*, Vol. 66 (1987), pp. 52–69.

Macek, Ellen. 'The Emergence of a Feminine Spirituality in *The Book of Martyrs*,' *Sixteenth Century Journal*, Vol. 19, No. 1 (1988), pp. 63–80.

Morrison, Melanie. 'Love in Grief: Witness to the Resurrection,' *Sojourners*, Vol. 16, No. 4 (Apr. 1987), pp. 24–25.

Murray, Pauli. 'Minority Women and Feminist Spirituality,' *Witness*, Vol. 67, No. 2 (Feb. 1984), pp. 5–9.

Muto, Susan Annette. 'Foundations for Feminine Spirituality,' *Envoy: Journal of Formative Reading*, Vol. 17, No. 11 (Nov. 1980), pp. 166–171; Vol. 17, No. 12 (Dec. 1980), pp. 181–187.

Nadeau, Denise. 'Lesbian Spirituality,' *Resources for Feminist Research/ Documentation sur la Recherche Féministe*, Vol. 12, No. 1 (Mar. 1983), pp. 37–39.

Neitz, Mary J. 'Review of *Feminist Spirituality and the Feminine Divine: An Annotated Bibliography* by Anne Carson,' *Review of Religious Research*, Vol. 29 (Mar. 1988), pp. 321–322.

O'Connor, June. 'Sensuality, Spirituality, Sacramentality,' *Union Seminary Quarterly Review*, Vol. 40, No. 1 (1985), pp. 1–2, 59–70.

Ogden, Schubert M. 'Is the Gospel Message Liberating for Women?' *Perkins School of Theology Journal*, Vol. 38, No. 3 (Spring 1985), pp. 19–21.

Osiek, Carolyn. 'Inspired Tests: The Dilemma of the Feminist Believers,' *Spirituality Today*, Vol. 32 (1980), pp. 138–147.

Park, Sandra Winter. 'The Power of Women Dancing,' *Journal of Women and Religion*, Vol. 1, No. 1 (Spring 1981), pp. 21–23.

Perry, Deborah L. 'Ceremonies Celebrating Life,' *New Directions for Women*, Vol. 13 (Nov.–Dec. 1984), pp. 12–13.

Ruether, Rosemary Radford. 'The Call of Women in the Church Today,' *Studies in Formative Spirituality*, Vol. 4 (May 1983), pp. 243–252.

– 'Danger: Women Praying – The Women's Pilgrimage to Honduras,' *Christianity and Crisis: A Christian Journal of Opinion*, Vol. 43, No. 22 (Jan. 1983), pp. 521–522.

Sanders, Cheryl J. 'To Receive the Impossible: Witness to the Resurrection,' *Sojourners*, Vol. 16, No. 5 (Apr. 1987), pp. 17–18.

Schechter, Patricia. 'Feminist Spirituality and Radical Political Commitment,' *Journal of Women and Religion*, Vol. 1, No. 1 (Spring 1981), pp. 51–60.

Scherer, Peggy. 'A Humble Act of Faith,' *Sojourners*, Vol. 16, No. 4 (Apr. 1987), pp. 23–24.

Schneiders, S.M. 'The Effects of Women's Experience on Their Spirituality,' *Spirituality Today*, Vol. 35, No. 2 (Summer 1983), pp. 100–116.

Sölle, Dorothee. 'Toward a Critical Spirituality (Narcissist Spirituality),' *Witness*, Vol. 68, No. 12 (Dec. 1985), pp. 10–11.

'Spiritual Formation and Womanhood: Symposium,' *Studies in Formative Spirituality*, Vol. 4 (May 1983), pp. 187–252.

Steichen, Donna. 'From Convent to Coven: Neopaganism at the Witches' Sabbath,' *Epiphany: A Journal of Faith and Insight*, Vol. 8 (Summer 1988), pp. 6–15.

Thomas, Carolyn. 'Spirit Activity in the Church,' *Bible Today: A Periodical Promoting Popular Appreciation of the Word of God*, Vol. 25, No. 3 (May 1987), pp. 160–162.

Weaver, M. 'Review of *Feminine Soul: The Fate of an Ideal*, by Marilyn Chapin Massey,' *American Catholic Historical Society Records*, Vol. 98 (Mar.–Dec. 1987), p. 114.

– 'Review of *Sophia: The Future of Feminist Spirituality*, by Susan Cady, Marian Ronan and Hal Taussig,' *American Catholic Historical Society Records*, Vol. 98 (Mar.–Dec. 1987), p. 114.

Wittman, Ann. 'Spirituality: A New Force in Feminism,' *Sisters Today*, Vol. 53, No. 2 (Oct. 1981), pp. 83–91.

Yates, Gayle Graham. 'Spirituality and the American Feminist Experience,' *Signs: Journal of Women, Culture and Society*, Vol. 9, No. 1 (Autumn 1983), pp. 59–72.

Zappone, Katherine E. 'Liberating Spirituality,' *Religious Education*, Vol. 83, No. 1 (Winter 1988), pp. 67–82.

Goddess/Wicca

BOOKS, DISSERTATIONS, COLLECTED WORKS

Abrahamsen, Valerie Ann. 'The Rock Reliefs and the Cult of Diana at Philippi.' Th.D. dissertation, Harvard University, 1986.

Adler, Margaret. *Drawing Down the Moon – Witches, Druids, Goddess Worshippers* ... New York: Viking Press, 1979.

Bachofen, Johann Jakob. *Myth, Religion, and Mother Right: Selected Writings of J.J. Bachofen.* Princeton: Princeton University Press, 1967.

Berger, Pamela. *The Goddess Obscured: Transformation of the Grain Protectress from Goddess to Saint.* Boston: Beacon Press, 1985.

Bolen, Jean Shinoda. *Goddesses in Everywoman: A New Psychology of Women.* New York: Harper and Row, 1985.

Christ, Carol P. *Laughter of Aphrodite: Reflection on a Journey to the Goddess.* New York: Harper and Row, 1987.

Clark, Rosalind Elizabeth. 'Goddess, Fairy Mistress, and Sovereignty: Women of the Irish Supernatural.' Ph.D. dissertation, University of Massachusetts, 1985.

Downing, Christine. *The Goddess: Mythological Images of the Feminine.* New York: Crossroads, 1981.

Field, Rebecca. 'The Return of the Goddess: The Feminine Principle in Theosophic Thought and Transpersonal Psychology.' Ph.D. dissertation, California Institute of Integral Studies, 1981.

Gimbutas, Marija. *The Goddesses and Gods of Old Europe, 6500–3500 B.C.: Myths and Cult Images.* Berkeley: University of California Press, 1982.

Heyob, Sharon Kelly. 'The Cult of Isis among Women in the Graeco-Roman World.' Ph.D. dissertation, Catholic University of America, 1973.

Larson, Gerald J., Pratapaditya Pal, and Rebecca J. Gowen. *In Her Image: The Great Goddess in Indian Asia and the Madonna in Christian Culture.* Santa Barbara: UCSB Art Museum, University of California at Santa Barbara, 1980.

McLaughlin, Kathleen J. 'The Concept of the Mother Goddess and Its Significance: The Feminine Principle from the Perspectives of Jungian Psychology, the Hindu Tantra, and Christianity.' Ph.D. dissertation, California Institute of Asian Studies, 1977.

Olson, Carl, ed. *The Book of the Goddess, Past and Present: An Introduction to Her Religion.* New York: Crossroads, 1983.

Patai, Raphael. *The Hebrew Goddess.* New York: Avon Books, 1978.

Pettey, Richard J. 'Asherah: Goddess of Israel?' Ph.D. dissertation, Marquette University, 1985.

Pomeroy, Sarah B. *Goddesses, Whores, Wives, and Slaves: Women in Classical Antiquity*. New York: Schocken Books, 1975.

Starhawk. *Dreaming the Dark*. Boston: Beacon Press, 1982.

– *The Spiral Dance, a Rebirth of the Ancient Religion of the Great Goddess*. San Francisco: Harper and Row, 1979.

Whitmont, Edward C. *Return of the Goddess*. New York: Crossroads, 1982.

ARTICLES, BOOK REVIEWS

Christ, Carol P. 'Rituals with Aphrodite,' *Anima: An Experimental Journal of Celebration*, Vol. 12 (Fall 1985), pp. 25–33.

Downing, Marymay. 'Prehistoric Goddesses: The Cretan Challenge,' *Journal of Studies in Feminist Religion*, Vol. 1, No. 1 (Spring 1985), pp. 7–22.

Dunn, Ethel, and Cathy Jory. '*Goddesses in Everywoman*: A Review Essay' [J.S. Bolen, 1984], *Anima: An Experimental Journal of Celebration*, Vol. 12 (Fall 1985), pp. 75–78.

Neaman, Judith S. 'Review of *The Goddess Obscured* by Pamela Berger,' *Speculum: Journal of Medieval Studies*, Vol. 63 (Jan. 1988), pp. 119–121.

Perkins, Pheme. 'Sophia and the Mother-Father: The Gnostic Goddess,' in *The Book of the Goddess Past and Present*, ed. by Carl Olsen, pp. 97–109. New York: Crossroads, 1985.

Ruether, Rosemary Radford. 'Goddesses and Witches: Liberation and Counter-Cultural Feminism,' *Christian Century*, Vol. 97, No. 28 (Sept. 10–17, 1980), pp. 842–847.

– 'The Persecution of Witches: A Case of Sexism and Ageism?' *Christianity and Crisis: A Christian Journal of Opinion*, Vol. 34, No. 22 (Dec. 23, 1974), pp. 291–295.

– 'The Way of the Wicca,' *Christian Century*, Vol. 97, No. 6 (Feb. 20, 1980), pp. 208–209.

Shinn, Larry D. 'The Goddess: Theological Sign or Religious Symbol?' *Numen: International Review for the History of Religions*, Vol. 31 (Dec. 1984), pp. 175–198.

Streeter, Deborah. 'The Goddess: Power and Paradox' [Women of the Decade Week Conference], *Journal of Women and Religion*, Vol. 1, No. 2 (Fall 1981), pp. 5–14.

10

Theology

General

BOOKS, DISSERTATIONS, COLLECTED WORKS

Alexander, Myrna. *Behold Your God*. Grand Rapids: Zondervan, 1978.
Andrews, Louise Adeline. 'Sin with a Feminine Flair: Failing to Self-actualize.' Ph.D. dissertation, Florida State University, 1985.
Birmingham, William, and Joseph Conneen, eds. *Gender*. Special issue of *Cross Currents: A Quarterly Review to Explore the Implications of Christianity for Our Times*, Vol. 38, No. 1 (Spring 1988).
Boff, Leonardo. *The Maternal Face of God*. San Francisco: Harper and Row, 1987.
Bruns, J. Edgar. *God as Woman, Woman as God*. New York: Paulist Press, 1973.
Burghardt, Walter J., ed. *Woman, New Dimensions*. New York: Paulist Press, 1977.
Bynum, La Taunya Marie. Black Feminist Theology: A New Word about God.' D.Min. dissertation, School of Theology at Claremont, 1980.
Carr, Anne E. *Transforming Grace: Christian Tradition and Women's Experience*. San Francisco: Harper and Row, 1988.
Clark, S.B. *Man and Women in Christ*. Ann Arbor, MI: Servant Press, 1980.
Collins, Sheila D. *A Different Heaven and Earth*. Valley Forge, PA: Judson Press, 1974.
Conn, Walter E., ed. *Discipleship of Equals: Towards a Christian Feminist Spirituality*. Special issue of *Horizons: The Journal of the College Theology Society*, Vol. 14, No. 2 (Fall 1987).
Culpepper, Emily Erwin. 'Philosophia in a Feminist Key: Revolt of the Symbols.' Th.D. dissertation, Harvard University, 1983.

Daly, Mary. *Beyond God the Father: Toward a Philosophy of Women's Liberation*. Boston: Beacon Press, 1973.

– *The Church and the Second Sex*. New York: Harper and Row, 1975.

Douglass, Jane Dempsey, ed. *Women, Freedom and Calvin*. Philadelphia: Westminster Press, 1985.

Dunfee, Susan Nelson. 'Christianity and the Liberation of Women.' Ph.D. dissertation, Claremont Graduate School, 1985.

Eller, Vernard. *The Language of Canaan and the Grammar of Feminism*. Grand Rapids: Eerdmans, c1982.

Ellis, Ronald Fred. 'The Feminine Principle in Biblical, Theological, and Psychological Perspective.' D.Min. dissertation, Drew University, 1985.

Engelsman, Joan Chamberlain. *The Feminine Dimension of the Divine*. Philadelphia: Westminster Press, c1979.

Everson, Susan Corey. 'Bodyself: Women's Bodily Experience in Recent Feminist Theology and Women's Literature.' Ph.D. dissertation, University of Minnesota, 1984.

Fiorenza, Elisabeth Schüssler. *Claiming the Center: A Feminist Critical Theology of Liberation*. New York: Seabury Press, 1985.

– *In Memory of Her: A Feminist Theological Reconstruction of Christian Origins*. New York: Crossroads, 1983.

Fiorenza, Elisabeth Schüssler, and Mary Collins, eds. *Women, Invisible in Theology and Church* (Concilium, 182). Edinburgh: T. and T. Clark, 1985.

Fischer, Clare Benedicks. 'The Fiery Bridge: Simone Weil's Theology of Work.' Ph.D. dissertation, Graduate Theological Union, 1979.

Ford, JoAnn Christine. 'Toward an Anthropology of Mutuality: A Critique of Karl Barth's Doctrine of the Male-Female Order as A and B with a Comparison of the Pantheistic Theology of Jürgen Moltmann.' Ph.D. dissertation, Northwestern University, 1984.

Fraser, Elouise Renich. 'Karl Barth's Doctrine of Humanity: A Reconstructive Exercise in Feminist Narrative Theology.' Ph.D. dissertation, Vanderbilt University, 1986.

Froehle, Virginia Ann. *In Her Presence: Prayer Experiences Exploring Feminine Images of God*. Cincinnati: St. Anthony Messenger Press, 1987.

Gelpi, Donald. *The Divine Mother: A Trinitarian Theology of the Holy Spirit*. Lanham, MD: University Press of America, 1984.

Good, Deirdre J. *Reconstructing the Tradition of Sophia in Gnostic Literature*. Atlanta: Scholars Press, 1987.

Grant, Jacquelyn. 'The Development and Limitations of Feminist Christology: Toward an Engagement of White Women's and Black

Women's Religious Experiences.' Ph.D. dissertation, Union Theological Seminary in City of New York, 1985.

Halkes, Catherine J.M. *Gott hat nicht nur starke Söhne: Grundzüge einer feminishschen Theologie*. Gutersloh: Gutersloher Verlagshaus Gerd Mohn, 1980.

Hamerton-Kelly, Robert. *God the Father: Theology and Patriarchy in the Teaching of Jesus*. Philadelphia: Fortress Press, 1979.

Haughton, Rosemary. *The Re-creation of Eve*. Springfield, IL: Templegate Publishers, 1987.

Hayter, Mary. *The New Eve in Christ*. London: SPCK, 1987.

Hebblethwaite, Margaret. *Motherhood and God*. London: Chapman, 1984.

Heyward, Isabel Carter. *Our Passion for Justice: Images of Power, Sexuality, and Liberation*. New York: Pilgrim Press, c1984.

– *The Redemption of God: A Theology of Mutual Relation*. Washington, DC: University Press of America, c1982.

Huberdeault, Jean. *Vision divine du féminisme*. Montreal: J. Huberdeault, c1985.

Hunt, Mary Elizabeth. 'Feminist Liberation Theology: The Development of Method in Construction.' Ph.D. dissertation, Graduate Theological Union, 1980.

Hunt, Mary Elizabeth, and Rosino Gibellini, eds. *Perspectives on Feminist Theology*. Brescia, Italy: Editrice Queriniana, 1980.

Jewett, Paul K. *Man as Male and Female*. Grand Rapids: Eerdmans, 1975.

Katoppo, Marianne. *Compassionate and Free: An Asian Woman's Theology*. Maryknoll, NY: Orbis Books, 1980.

Keller, Catherine. *From the Broken Web: Separating Sexism and Self*. Boston: Beacon Press, 1986.

Lee, Janet. 'Gender Stratification and Religious Expression: Creating a Theology for Social and Personal Change.' Ph.D. dissertation, Washington State University, 1985.

Lewis, Alan E., ed. *The Motherhood of God*. Edinburgh: St. Andrew's Press, 1984.

McFague, Sallie. *Metaphorical Theology: Models of God in Religious Language*. Philadelphia: Fortress Press, 1982.

– *Models of God: Theology for an Ecological, Nuclear Age*. Philadelphia: Fortress Press, 1987.

Mangan, Celine. *Can We Still Call God Father? A Woman Looks at the Lord's Prayer Today*. Wilmington, DE: Michael Glazier, 1984.

May, Melanie Ann. 'Bonds of Unity; Women, Theology and the World-wide Church.' Ph.D. dissertation, Harvard University, 1986.

Metz, Johannes-Baptist, and Edward Schillebeeckx, eds. *God as Father?* (Concillium, 143). Edinburgh: T. and T. Clark, 1981.

Micks, Marianne H. *Our Search for Identity: Humanity in the Image of God*. Philadelphia: Fortress Press, c1982.

Mollenkott, Virginia Ramey. *The Divine Feminine: The Biblical Imagery of God as Female*. New York: Crossroads, 1983.

– *Views from the Intersection*. New York: Crossroads, 1984.

Moltmann-Wendel, Elisabeth. *Humanity in God*. New York: Pilgrim Press, c1983.

– *A Land Flowing with Milk and Honey: Perspectives on Feminist Theology*. New York: Crossroads, 1986.

Moore, Katherine. *She for God: Aspects of Women and Christianity*. London: Allison and Busby, 1978.

Newman, Barbara. *Sister of Wisdom: St. Hildegard's Theology of the Feminine*. Berkeley: University of California Press, 1987.

Oddie, William. *What Will Happen to God: Feminism and the Reconstruction of Christian Belief*. London: SPCK, 1984.

O'Rourke, Margaret. 'Female Imaging of God.' M.T.S. dissertation, Atlantic School of Theology, 1987.

Pagels, Elaine H. *Adam, Eve and the Serpent*. New York: Random House, 1988.

– *The Gnostic Gospels: A New Account of the Origins of Christianity*. New York: Random House, c1979.

Phipps, William E. *Influential Theologians on Woman*. Washington, DC: University Press of America, 1980.

Plaskow, Judith. *Sex, Sin, and Grace: Women's Experience and the Theologies of Reinhold Neibuhr and Paul Tillich*. Washington, DC: University Press of America, c1980.

Rabuzzi, Kathryn Allen. *The Sacred and the Feminine: Towards a Theology of Housework*. New York: Seabury Press, 1982.

Reineke, Martha Jane. 'Woman, Nature and Spirit: Prolegomena for a Feminist Foundational Theology.' Ph.D. dissertation, Vanderbilt University, 1983.

Richardson, Nancy. 'Authority and Responsibility in a Liberation Feminist Perspective; a Study in Ethics and Education.' Ph.D. dissertation, Boston University, 1985.

Ruether, Rosemary Radford. *Christology and Feminism: Can a Male Savior Help Women?* (United Methodist Board of Higher Education and Ministry, Occasional Paper 1). Nashville: United Methodist Center, 1976.

– *Disputed Questions on Being a Christian*. Nashville: Abingdon Press, 1982.

– *Liberation Theology: Human Hope Confronts Christian History and American Power*. New York: Paulist Press, 1972.

- *Sexism and God-talk: Toward a Feminist Theology.* Boston: Beacon Press, c1983.
- *To Change the World, Christology and Cultural Criticism.* New York: Crossroads, 1981.
- *Women-Church: Theology and Practice of Feminist Liturgical Communities.* San Francisco: Harper and Row, 1985.
- comp. *Womanguides: Readings toward a Feminist Theology.* Boston: Beacon Press, c1985.

Russell, Letty M. *Household of Freedom: Authority in Feminist Theology.* Philadelphia: Westminster Press, 1987.
- *Human Liberation in a Feminist Perspective – A Theology.* Philadelphia: Westminster Press, 1974.
- ed. *Changing Contexts of Our Faith.* Philadelphia: Fortress Press, 1985.

Schaberg, Jane. *The Illegitimacy of Jesus: A Feminist Theological Interpretation.* New York: Winston-Seabury, 1985.

Schaupp, Joan. *Woman, Image of the Holy Spirit.* Denville, NJ: Dimension Books, 1985.

Sölle, Dorothee. *The Strength of the Weak: Toward a Christian Feminist Identity.* Philadelphia: Westminster Press, 1984.
- *To Work and to Love: A Theology of Creation.* Philadelphia: Fortress Press, 1984.

Speaking of God: Feminism and the Church. Special issue of *Dialog: A Journal of Theology,* Vol. 24, No. 1 (Winter 1985).

Suchocki, Marjorie. *God, Christ, Church: A Practical Guide to Process Theology.* New York: Crossroads, 1982.

Tamez, Elsa, ed. *Against Machismo: Ruben Alves, Leonardo Boff, Gustavo Gutierrez, Jose Miguez Bonino, Juan Luis Segundo and Others Talk about the Struggle of Women.* New York: Meyer-Stone Books, 1987.

Themes in Feminist Theology. Special issue of *Union Seminary Quarterly Review,* Vol. 35, No. 1 and 2 (Fall/Winter 1979–1980).

Visser't Hooft, Willem Adolf. *The Fatherhood of God in an Age of Emancipation.* Geneva: World Council of Churches, 1982.

Vorster, W.S., ed. *Sexism and Feminism in Theological Perspective: Proceedings of the Eighth Symposium of the Institute for Theological Research (UNISA) Held at the University of South Africa in Pretoria on the 5th and 6th September 1984.* Pretoria: University of South Africa, 1984.

Wagner, Mary Antony, ed. Special issue of *Sisters Today,* Vol. 58, No. 5 (Jan. 1987).

Weir, Mary Kathryn Williams. 'The Concept of Freedom in the Work of Rosemary Radford Ruether.' Ph.D. dissertation, University of St. Andrew's, 1982.

Welch, Sharon D. *Communities of Resistance and Solidarity: A Feminist Theology of Liberation*. New York: Orbis Books, 1985.

Whitney, Ruth. 'An Understanding of Person in the Tillichian Dialectic and Its Implications for Women in American Study: An Interdisciplinary Study.' Ph.D. dissertation, Catholic University of America, 1973.

Wilson, Beclee Newcomer, ed. *Harbingers of Change surrounding Power*. Special issue of *Journal of Women and Religion*, Vol. 12, No. 1 (Spring 1982).

Wilson, Richard Francis. 'Human Liberation and Theology: An Examination of the Theology of Gustavo Gutierrez, James H. Cone and Mary Daly.' Ph.D. dissertation, Southern Baptist Theological Seminary, 1982.

Wilson-Kastner, Patricia. *Faith, Feminism, and the Christ*. Philadelphia: Fortress Press, c1983.

Women and Religion. Special issue of *Journal of Religion*, Vol. 67, No. 2 (Apr. 1987).

Women & Religion. Special issue of *Signs: Journal of Women, Culture and Society*, Vol. 9, No. 1 (Autumn 1983).

ARTICLES, BOOK REVIEWS

Ackermann, Denise. 'Feminist Liberation Theology: A Contextual Option,' *Journal of Theology for Southern Africa*, No. 62 (Mar. 1988), pp. 14–28.

Adeyemo, Tokunboh, Vinay C. Samuel, and Ronald J. Sider. 'Beyond Equality' [Image of God; Christian Subordination], *Transformation: An International Dialogue on Evangelical Social Ethics*, Vol. 1, No. 3 (July–Sept. 1984), p. 1.

Albertz, Heinrich, 'What Do I Mean When I Pray "Our Father"?' in *God as Father?* (Concilium, 143), ed. by Johannes-Baptist Metz and Edward Schillebeeckx, pp. 115–116. Edinburgh: T. and T. Clark, 1981.

Alcalà, Manuel. 'The Challenge of Women's Liberation to Theology and Church Reform,' in *Women in a Men's Church* (Concilium, 134), ed. by Virgil Elizondo and Norbert Greinacher, pp. 95–101. Edinburgh: T. and T. Clark, 1980.

Arakawa, D. 'Feminist Theology and Process Thought: Their Relationship,' *Unitarian Universalist Christian*, Vol. 37, No. 3–4 (Fall–Winter 1982), pp. 11–20.

Askew, Angela V. '*Sexism and God-Talk*' [R.R. Ruether], *Union Seminary Quarterly Review*, Vol. 40, No. 3 (1985), pp. 59–68.

Babcock, William S. '*In Memory of Her* from a Patristic Perspective: A

Review Article' [E. Schüssler Fiorenza], *Second Century: A Journal of Early Christian Studies*, Vol. 4, No. 3 (Fall 1985), pp. 177–184.

Barr, Jane. 'The Vulgate, Genesis and St. Jerome's Attitude to Women,' in *Studia Patristica*, ed. by Elizabeth A. Livingstone, Vol. 17, Pt. 1, pp. 268–273. Oxford: Pergamon Press, 1982.

Barstow, Anne Llewellyn. 'On Feminist Methodology,' *Journal of Feminist Studies in Religion*, Vol. 1, No. 2 (Fall 1985), pp. 87–88.

Barton, Stephen. 'Review of *The New Eve in Christ* by Mary Hayter,' *Theology*, Vol. 91 (Jan. 1988), pp. 65–66.

'Benedictines on Christian Feminism,' *Origins*, Vol. 12, No. 37 (Mar. 10, 1983), pp. 627–628.

Bergant, Dianne. 'Exodus as a Paradigm in Feminist Theology,' in *Exodus, a Lasting Paradigm* (Concilium, 189), ed. by Bas van Iersel and Anton Weiler, pp. 100–106. Edinburgh: T. and T. Clark, 1987.

Berry, Wanda. 'Images of Sin and Salvation in Feminist Theology,' *Anglican Theological Review*, Vol. 60, No. 1 (Jan. 1978), pp. 25–54.

Bettenhausen, Elizabeth. 'Dependence, Liberation, and Justification,' *Word and World: Theology for Christian Ministry*, Vol. 7, No. 1 (Winter 1987), pp. 59–69.

Bloomquist, Karen, and Mary M. Knutsen. 'Face to Face: Given Feminism, Does Theology Need a New Starting Point?' *Word and World: Theology for Christian Ministry*, Vol. 8, No. 4 (Fall 1988), pp. 374–377.

Boenig, Robert. 'The God-as-Mother Theme in Richard Rolle's Biblical Commentaries,' *Mystics Quarterly*, Vol. 10, No. 4 (Dec. 1984), pp. 171–174.

Bohn, Carole R. 'Book Review of *Womanguides: Readings toward a Feminist Theology* by R.R. Ruether,' *America*, Vol. 154, No. 2 (Jan. 18, 1986), p. 36.

Borrensen, Kari Elisabeth. 'God's Image, Man's Image? Female Metaphors Describing God in the Christian Tradition,' *Temenos: Studies in Comparative Religion Presented by Scholars in Denmark, Finland, Norway, and Sweden*, Vol. 19 (1983), pp. 17–32.

de Bourbon-Parma-van Oranje Nassau, Irene. 'What Do I Think When I Say "Our Father"? ' in *God as Father?* (Concilium, 143), ed. by Johannes-Baptist Metz and Edward Schillebeeckx, pp. 117–119. Edinburgh: T. and T. Clark, 1981.

Bowlby, Ronald. 'Is There a Theology of Equality?' *Modern Churchman*, n.s., Vol. 26, No. 1 (1983), pp. 3–15.

Brennan, Margaret. 'Enclosure: Institutionalising the Invisibility of Women in Ecclesiastical Communities,' in *Women Invisible in Church and Theology* (Concilium, 182), ed. by Elisabeth Schüssler Fiorenza and Mary Collins, pp. 38–50. Edinburgh: T. and T. Clark, c1985.

Briere, Elizabeth A. ' "Rejoice Sceptic of Orthodoxy": Christology and the Mother of God,' *Sobornost*, n.s., Vol. 7, No. 1 (1985), pp. 15–24.

Bringle, Mary Lou. 'Leaving the Cocoon: Moltmann's Anthropology and Feminist Theology,' *Andover Newton Quarterly*, Vol. 20, No. 3 (Jan. 1980), pp. 153–161.

Brock, Rita Nakashima. 'Special Section: Asian Women Theologians Respond to American Feminism,' *Journal of Feminist Studies in Religion*, Vol. 3, No. 2 (Fall 1987), p. 103.

Broughton, Lynne. 'Find the Lady,' *Modern Theology*, Vol. 4, No. 3 (Apr. 1988), pp. 267–281.

Brown, Karen McCarthy. 'On Feminist Methodology,' *Journal of Feminist Studies in Religion*, Vol. 1, No. 2 (Fall 1985), pp. 76–79.

Brown, Robert McAfee. 'Review of *Against Machismo: Ruben Alves, Leonardo Boff, Gustavo Gutierrez, Jose Miguez Bonino, Juan Luis Segundo and Others Talk about the Struggle of Women*, Elsa Tamez, ed.,' *Christian Century*, Vol. 105, No. 3 (Jan. 27, 1988), pp. 88–89.

Brueggemann, Walter. 'Review of *Household of Freedom: Authority in Feminist Theology*, by Letty M. Russell,' *Theology Today*, Vol. 44, No. 4 (Jan. 1988), pp. 538–539.

Buckley, Mary. 'Rediscovering the Christian God: A Feminist Perspective,' *Catholic Theological Society of America Proceedings*, Vol. 33 (1978), pp. 148–154.

– 'The Rising of the Women Is the Rising of the Race,' *Catholic Theological Society of America Proceedings*, Vol. 34 (1979), pp. 48–63.

– 'Women, Power and Liberation,' *Catholic Theological Society of America Proceedings*, Vol. 37 (1982), pp. 109–112.

Bujo, Bénézet. 'Feministische Theologie in Afrika,' *Stimmen der Zeit*, Vol. 206 (Aug. 1988), pp. 529–538.

Cahill, Lisa Sowle. 'Divorced from Experience: Rethinking the Theology of Marriage,' *Commonweal: A Review of Public Affairs, Literature and the Arts*, Vol. 119, No. 6 (Mar. 27, 1987), pp. 171–176.

Call, Marian. 'In Search of a Church with Androgynous God,' *National Catholic Reporter*, Vol. 18 (Apr. 2, 1982), p. 13.

Campbell, Debra. 'Lost Innovation: When Catholic Women Preached,' *Commonweal: A Review of Public Affairs, Literature and the Arts*, Vol. 118 (June 6, 1986), pp. 334–335.

Cardman, Francine. 'Feminist Theology: Recent Developments: Book,' *Church*, Vol. 3, No. 2 (Summer 1987), pp. 48–52.

Carr, Anne E. 'Is a Christian Feminist Theology Possible?' *Theological Studies*, Vol. 43, No. 2 (June 1982), pp. 279–297.

– 'Sources of My Theology,' *Journal of Feminist Studies in Religion*, Vol. 1, No. 1 (Spring 1985), pp. 127–131.

Castelli, Elizabeth. 'Virginity and Its Meaning for Women's Sexuality in Early Christianity,' *Journal of Feminist Studies in Religion*, Vol. 2, No. 1 (Spring 1986), pp. 61–88.

Chandran, Victoria M. 'In Christ No Male or Female,' *Ecumenical Review*, Vol. 27, No. 2 (Apr. 1975), pp. 134–138.

Chantraine, Georges. 'Women as Deprived of the Spirit: An Aspect of Luther's Thought on Woman,'*Communio: International Catholic Review*, Vol. 10 (Fall 1983), pp. 240–255.

Christ, Carol P. 'Feminist Studies in Religion and Literature: A Methodological Reflection,' *Journal of the American Academy of Religion*, Vol. 44, No. 2 (June 1976), pp. 317–325.

– 'The New Feminist Theology: A Review of the Literature,' *Religious Studies Review*, Vol. 3, No. 4 (Oct. 1977), pp. 203–212.

Christ, Carol P., Ellen M. Umansky, and Anne E. Carr. 'Roundtable Discussion: What Are the Sources of My Theology?' *Journal of Feminist Studies in Religion*, Vol. 1, No. 1 (Spring 1985), pp. 119–131.

Cocks, Nancy L. 'Magnificat: Theology by Handmaiden,' *Toronto Journal of Theology*, Vol. 2, No. 2 (Fall 1986), pp. 226–231.

Coll, Regina Audrey. 'Feminist Liberation Theology: Past and Future,' *Sisters Today*, Vol. 57, No. 9 (May 1986), pp. 527–536.

Collins, Mary. 'Daughters of the Church: The Four Theresas,' in *Women Invisible in Church and Theology* (Concilium, 182), ed. by Elisabeth Schüssler Fiorenza and Mary Collins, pp. 17–28. Edinburgh: T. and T. Clark, c1985.

Collins, Sheila D. 'Feminist Theology at the Crossroads,' *Christianity and Crisis: A Christian Journal of Opinion*, Vol. 41, No. 20 (Dec. 14, 1981), pp. 342–347.

Congar, Yves Marie Joseph. 'The Spirit as God's Femininity,' *Theology Digest*, Vol. 30, No. 2 (Summer 1982), pp. 129–132.

Conn, Joann Wolski. 'Review: *The Divine Mother: A Trinitarian Theology of the Holy Spirit*, by Donald L. Gelpi,' *Signs: A Journal of Women in Cultural Society*, Vol. 11, No. 3 (Spring 1986), p. 570.

Cooke, Bernard. 'Non-Patriarchal Salvation,' *Horizons: The Journal of the College Theology Society*, Vol. 10, No. 1 (Spring 1983), pp. 22–31.

Cox, Harvey. 'Eight Theses on Female Liberation,' *Christianity and Crisis: A Christian Journal of Opinion*, Vol. 31, No. 16 (Oct. 4, 1971), pp. 199–202. Replies by R.L. Sprague and P. Eakins, Vol. 31, No. 18 (Nov. 1, 1971), pp. 235–236.

Crane, T. 'God as the Woman,' *Bible Today: A Periodical Promoting Popular Appreciation of the Word of God*, No. 66 (Apr. 1973), pp. 1195–2000.

Culpepper, Emily Erwin. 'Philosophia: Feminist Methodology for Constructing a Female Train of Thought,' *Journal of Feminist Studies in Religion*, Vol. 3, No. 2 (Fall 1987), p. 7.

Cunneen, Sally. 'Mother Church, Mother World, Mother God,' *Cross Currents: A Quarterly Review to Explore the Implications of Christianity for Our Times*, Vol. 37, No. 2–3 (Summer–Fall 1987), pp. 129–139.

Cunningham, L. 'Review of *Can We Still Call God Father? A Woman Looks at the Lord's Prayer Today*, by Celine Mangan,' *Church*, Vol. 4, No. 2 (Summer 1988), pp. 47–50.

D'Angelo, Mary Rose. 'A Feminist Reader of Scripture' [a review of E. Schüssler Fiorenza, *In Memory of Her*], *Ecumenist: A Journal for Promoting Christian Unity*, Vol. 23, No. 6 (Sept.–Oct. 1985), pp. 86–89.

– 'Remembering Her: Feminist Readings in the Christian Tradition,' *Toronto Journal of Theology*, Vol. 2 (1986), pp. 118–126.

Dart, John. 'Integrating Women's Concerns into Total Life of Churches and WCC,' *Christian Century*, Vol. 100, No. 25 (Aug. 31–Sept. 7, 1983), pp. 763–765.

David, Stephanie. 'God the Father: A Symbol for Feminist Theology?' *Theology Digest*, Vol. 34, No. 1 (Spring 1988), pp. 35–38. Translated and condensed from *Pastoral Sciences*, Vol. 5 (1986), pp. 111–120.

Donovan, Mary Ann. 'Women's Issues: An Agenda for the Church?' *Horizons: The Journal of the College Theology Society*, Vol. 14, No. 2 (Fall 1987), pp. 235–295.

Douglass, Jane Dempsey. 'Calvin's Teaching: What Still Remains Pertinent?' *Ecumenical Review*, Vol. 39, No. 1 (Jan. 1987), pp. 23–34.

– 'Calvin's Use of Metaphorical Language for God: God as Enemy and God as Mother,' *Princeton Seminary Bulletin*, n.s., Vol. 8, No. 1 (Feb. 1987), pp. 19–32.

– 'Christian Freedom: What Calvin Learned at the School of Women,' *Church History*, Vol. 53, No. 2 (June 1984), pp. 155–173.

– 'Women, Freedom and Calvin,' *Presbyterian Outlook*, Vol. 168, No. 1 (Jan. 6–13, 1986), p. 9.

Dowell, Sue. 'Rosemary Radford Ruether and Feminist Theology,' *Christian*, Vol. 7, No. 4 (Summer 1983), p. 60.

Dumais, Monique. 'La conception du péché chez les théologiennes féministes,' in *Culpabilité et péché* (Heritage et Projet, 33), sous la direction d'Arthur Mettayer et Jacques Doyon, pp. 139–152. Montreal: Fides, 1986.

– 'Expériences des femmes et théologie,' in *Documentation sur la recherche féministe*, pp. 39–42. Toronto: OISE, Publication Spéciale, No. 8, 1980.

Edwards, James R. 'Does God Really Want to Be Called Father?' [How

We Refer to God Makes a Difference], *Christianity Today*, Vol. 30, No. 3 (Feb. 21, 1986), pp. 27–30.

Engel, Mary Potter. 'Tambourines to the Glory of God: From the Monarchy of God the Father to the Monotheism of God, the Great Mysterious,' *Word and World: Theology for Christian Ministry*, Vol. 7, No. 2 (Spring 1987), pp. 153–166.

Farley, Margaret Ann. 'Sources of Sexual Inequality in the History of Christian Thought,' *Journal of Religion*, Vol. 56, No. 2 (Apr. 1976), pp. 162–176.

Fatula, Mary Ann. 'On Calling God Father,' *Spirituality Today*, Vol. 38 (Winter 1986), pp. 361–368.

Fiorenza, Elisabeth Schüssler. 'Breaking the Silence: Becoming Visible,' in *Women Invisible in Theology and Church* (Concilium, 182), ed. by Elisabeth Schüssler Fiorenza and Mary Collins, pp. 3–6. Edinburgh: T. and T. Clark, c1985.

– 'Claiming Our Authority and Power,' in *The Authority of the Believers* (Concilium, 180), ed. by Johannes-Baptist Metz and Edward Schillebeeckx, pp. 45–53. Edinburgh: T. and T. Clark, 1985.

– 'Feminist Theology as a Critical Theology of Liberation,' *Theological Studies*, Vol. 36, No. 4 (Dec. 1975), pp. 605–626.

– 'For Women in Men's Worlds: A Critical Feminist Theology of Liberation,' in *Different Theologies, Common Responsibility: Babel or Pentecost?* (Concilium, 171), ed. by Claude Geffre, Gustavo Gutierez, and Virgil Elizondopp, pp. 32–39. Edinburgh: T. and T. Clark, 1984.

– 'On Feminist Methodology,' *Journal of Feminist Studies in Religion*, Vol. 1, No. 2 (Fall 1985), pp. 73–76.

– 'Why Not a Category of Friend/Friendship?' *Horizons: The Journal of the College Theology Society*, Vol. 2, No. 1 (Spring 1975), pp. 117–118.

Fiorenza, Elisabeth Schüssler, and others. 'Roundtable Discussion: On Feminist Methodology' [contributions by E.S. Fiorenza, K.M. Brown, C.T. Gilkes, M.E. Hunt, A.L. Barstow], *Journal of Feminist Studies in Religion*, Vol. 1, No. 2 (Fall 1985), pp. 73–88.

Fischer, Clare Benedicks. 'Women, Work and Theology/Religion,' *Journal of Women in Religion*, Vol. 6 (Winter 1987), pp. 2–44.

Fragoso, Antonio. 'The Image Suggested by the Words "Our Father," ' in *God as Father?* (Concilium, 143), ed. by Johannes-Baptist Metz and Edward Schillebeeckx, pp. 113–114. Edinburgh: T. and T. Clark, 1981.

Fraser, Elouise Renich. 'The Church's Language about God,' *Other Side*, Vol. 23, No. 10 (Dec. 1987), pp. 16–21.

Freeman, Arthur. 'Letty Russell's *Changing Contexts of Our Faith*,' *Ecumenical Trends: Graymore Ecumenical Institute*, Vol. 14, No. 8 (Sept. 1985), pp. 122–123.

Fulkerson, Mary McClintock. 'Book Review of *Womanguides: Readings toward a Feminist Theology* by R.R. Ruether,' *Journal of the American Academy of Religion*, Vol. 54, No. 3 (Fall 1986), pp. 607–608.

Gaventa, Beverly Roberts. '*In Memory of Her: A Feminist Theological Reconstruction of Christian Origins*, a Review Article' [E. Schüssler Fiorenza, 1983], *Lexington Theological Quarterly*, Vol. 20, No. 2 (Apr. 1985), pp. 58–60.

Gibson, Elsie. 'What Baptism Means to Women,' *Christian Ministry*, Vol. 6, No. 3 (May 1975), pp. 4–6.

Gilkes, Cheryl Townsend. 'On Feminist Methodology,' *Journal of Feminist Studies in Religion*, Vol. 1, No. 2 (Fall 1985), pp. 80–83.

Glick-Rieman, Beth. 'A Feminist View of Liberation Theology,' *Brethren Life and Thought: A Quarterly Journal Published in the Interests of the Church of the Brethren*, Vol. 22 (Summer 1977), pp. 145–154.

Gnanadason, Aruna. 'Feminist Theology: An Indian Perspective,' *Asia Journal of Theology*, Vol. 2 (Apr. 1988), pp. 109–118.

'God Is Nonanthropomorphic and Genderless,' *Context*, Vol. 16, No. 17 (Oct. 1, 1984), pp. 2–3.

Goldsmith, Dale. 'Review of *Household of Freedom: Authority in Feminist Theology*, by Letty M. Russell,' *Interpretation: A Journal of Bible and Theology*, Vol. 42, No. 1 (Jan. 1988), p. 101.

Gonzalez, Catherine Gunsalus. 'On the Way to Wholeness,' *Theology Today*, Vol. 34, No. 4 (Jan. 1978), pp. 378–385.

Gonzalez, Justo L. 'Searching for a Liberating Anthropology,' *Theology Today*, Vol. 34, No. 4 (Jan. 1978), pp. 386–394.

Grindal, Garcia. 'Luther's Theology as a Resource for Feminists,' *Dialog: A Journal of Theology*, Vol. 24, No. 1 (Winter 1985), pp. 32–36.

– 'Reflections on God "the Father," ' *Word and World: Theology for Christian Ministry*, Vol. 4, No. 1 (Winter 1984), pp. 78–86.

Gritsch, Eric W. 'Convergence and Conflict in Feminist and Lutheran Theologies,' *Dialog: A Journal of Theology*, Vol. 24, No. 1 (Winter 1985), pp. 11–18.

Grumbach, D. 'Father Church and the Motherhood of God,' *Commonweal: A Review of Public Affairs, Literature and the Arts*, Vol. 93, No. 11 (Dec. 11, 1970), pp. 268–269.

Gudorf, Christine E. 'The Power to Create: Sacraments and Men's Need to Birth,' *Horizons: The Journal of the College Theology Society*, Vol. 14, No. 2 (Fall 1987), pp. 296–309.

– 'Renewal or Repatriarchalization? Responses of the Roman Catholic Church to the Feminization of Religion,' *Horizons: The Journal of the College Theology Society*, Vol. 10, No. 2 (Fall 1983), pp. 231–251.

Haight, Roger. 'Women in the Church: A Theological Reflection,'

Toronto Journal of Theology, Vol. 2, No. 1 (Spring 1986), pp. 105–117.

Halkes, Catharina J.M. 'The Themes of Protest in Feminist Theology against God the Father,' in *God as Father?* (Concilium, 143), ed. by Johannes-Baptist Metz and Edward Schillebeeckx, pp. 103–112. Edinburgh: T. and T. Clark, 1981.

Hamerton-Kelly, Robert. 'God the Father in the Bible and in the Experience of Jesus: The State of the Question,' in *God as Father?* (Concilium, 143), ed. by Johannes-Baptist Metz and Edward Schillebeeckz, pp. 95–102. Edinburgh: T. and T. Clark, 1981.

Hampson, Daphne. 'The Challenge of Feminism to Christianity,' *Theology*, Vol. 88 (Sept. 1985), pp. 341–350.

– 'Luther on the Self: A Feminist Critique,' *Word and World: Theology for Christian Ministry*, Vol. 8, No. 4 (Fall 1988), pp. 334–342.

Hansen, Randall R. 'Motherhood in the Presence of the Dragon' [sermon], *Christian Ministry*, Vol. 16, No. 3 (May 1985), pp. 31–32.

Harrison, Beverly Wildung. 'Restoring the Tapestry of Life: The Vocation of Feminist Theology' [The Nelle Morton Lecture, 1984], *Drew Gateway*, Vol. 54, No. 1 (Fall 1983), pp. 39–48.

Haughton, Rosemary. 'Is God Masculine?' in *Women in a Men's Church* (Concilium, 134), ed. by Virgil Elizondo and Norbert Greinacher, pp. 63–70. Edinburgh: T. and T. Clark, 1980.

Hebblethwaite, Margaret. 'The Motherhood of God,' *Tablet*, Vol. 237, No. 7481 (Nov. 26, 1983), pp. 1149–1150.

Heeren, John, Donald B. Lindsey, and Marylee Mason. 'The Mormon Concept of Mother in Heaven: A Sociological Account of Its Origins and Development,' *Journal for the Scientific Study of Religion*, Vol. 23, No. 4 (Dec. 1984), pp. 396–411.

Heim, S. Mark. 'Gender and Creed: Confessing a Common Faith,' *Christian Century*, Vol. 102, No. 13 (Apr. 17, 1985), pp. 379–381.

Heyward, Isabel Carter. 'Ruether and Daly: Theologians Speaking and Sparking, Building and Burning,' *Christianity and Crisis: A Christian Journal of Opinion*, Vol. 39, No. 5 (Apr. 2, 1979), pp. 66–72.

Heyward, Isabel Carter, and Mary E. Hunt. 'Lesbianism and Feminist Theology,' *Journal of Feminist Studies in Religion*, Vol. 2, No. 2 (Fall 1986), pp. 95–99. Replies by Bernadette J. Brooten, pp. 100–103; Delores S. Williams, pp. 103–105; and Evelyn Torton Beck, pp. 105–106.

Holeton, David R. 'Changing the Baptism Formula: Feminist Proposals and Liturgical Implications,' *Ecumenical Trends: Graymore Ecumenical Institute*, Vol. 17, No. 5 (May 1988), pp. 69–72.

Horowitz, Maryanne Cline. 'The Image of God in Man – Is Woman Included?' *Harvard Theological Review*, Vol. 72 (1979), pp. 175–206.

Hughes, Frank Witt. 'Feminism and Early Christian History: Review of *In Memory of Her: A Feminist Theological Reconstruction of Christian Origins*, by E. Schüssler Fiorenza,' *Anglican Theological Review*, Vol. 69, No. 3 (June 1987), pp. 287–299.

Hultgren, Arland J. 'Gender and Theology,' *Word and World: Theology for Christian Ministry*, Vol. 8, No. 4 (Fall 1988), pp. 319–320.

Hunt, Mary Elizabeth. 'On Feminist Methodology,' *Journal of Feminist Studies in Religion*, Vol. 1, No. 2 (Fall 1985), pp. 83–87.

Jacobs, Lydia Peters. 'And the Walls Came Tumbling Down' [sermon], *Christian Ministry*, Vol. 16, No. 6 (Nov. 1985), pp. 29–31.

Jensen, Anne. 'Theologische Forschung von Frauen: Eine "Europäische Gesellschaft" formiert sich,' *Evangelische Theologie*, Vol. 48, No. 1 (1988), pp. 76–79.

Jensen, Anne, et al. 'Stellungnahme feministischer Theologinnen zum Vorwurf des Antijudaismus,' *Evangelische Theologie*, Vol. 48, No. 2 (1988), p. 158.

Johnson, Elizabeth A. 'The Incomprehensibility of God and the Image of God Male and Female,' *Theological Studies*, Vol. 45, No. 3 (Sept. 1984), pp. 441–465.

– 'Jesus, the Wisdom of God: A Biblical Basis for Non-Autocentric Christology,' *Ephemerides Theologicae Lovanienses: Commentarii de re Theologicae et Canonica*, Vol. 61, No. 4 (Dec. 1985), pp. 261–294.

Katoppo, Marianne. 'Perspectives for a Woman's Theology,' *Voices from the Third World*, Vol. 8, No. 3 (Sept. 1985), pp. 26–37.

Keane, Marié Henry. 'Woman in the Theological Anthropology of the Early Fathers,' *Journal of Theology of Southern Africa*, No. 62 (Mar. 1988), pp. 3–13.

Keightley, Georgia Masters. 'The Challenge of Feminist Theology,' *Horizons: The Journal of the College Theology Society*, Vol. 14, No. 2 (Fall 1987), pp. 262–282.

Kopas, Jane. 'Teaching Christology in Light of Feminist Issues,' *Horizons: The Journal of the College Theology Society*, Vol. 13, No. 2 (Fall 1986), pp. 332–343.

Krobath, Evi. 'Im Anfang ist die Beziehung' [Carter Heyward, Und sie rührte sein Kleid an: Eine feministische Theologie der Beziehung], *Evangelische Theologie*, Vol. 48, No. 1 (1988), pp. 80–82.

Kroeger, Catherine. 'The Open Circle: Review of *Household of Freedom: Authority in Feminist Theology*, by Letty M. Russell,' *Reformed Journal*, Vol. 38 (Mar. 1988), p. 31.

Kwok, Pui Lan. 'The Feminist Hermeneutics of Elisabeth Schüssler Fiorenza: An Asian Feminist Response,' *East Asia Journal of Theology*, Vol. 3, No. 2 (1985), pp. 147–153.

LaCugna, Catherine Mowry. 'Baptism, Feminists, and Trinitarian Theology,' *Ecumenical Trends: Graymore Ecumenical Institute*, Vol. 17, No. 5 (May 1988), pp. 65–74.

Lahutsky, Nadia M. 'So God Created Man in His Own Image: Male and Female He Created Them: Shaker Reflections on the Nature of God,' *Encounter*, Vol. 49 (Winter 1988), pp. 1–18.

Lambert, Jean C. 'An "F factor"; The New Testament Is Some White, Feminist, Christian Theological Construction,' *Journal of Feminist Studies in Religion*, Vol. 1, No. 2 (Fall 1985), pp. 93–113.

Lefevere, Patricia Scharber. 'Feminist Theology Still Seeking Its Way,' *National Catholic Reporter*, Vol. 17 (Apr. 24, 1981), p. 44.

Lefevre, Perry D. 'Liberation Theology: Feminist,' *Chicago Theological Seminary Register*, Vol. 72, No. 2 (Spring 1982), pp. 33–39.

Lehmann, Karl. 'The Place of Women as a Problem in Theological Anthropology,' *Communio: International Catholic Review*, Vol. 10 (Fall 1983), pp. 219–239.

Leonard, Ellen. 'Review of *Sexism and God-Talk: Toward a Feminist Theology*, by Rosemary Radford Ruether,' *Ecumenist: A Journal for Promoting Christian Unity*, Vol. 23, No. 4 (May/June 1985), pp. 61–63.

Lilburne, Geoffrey R. 'Christology: In Dialogue with Feminism,' *Horizons: The Journal of the College Theology Society*, Vol. 11, No. 1 (Spring 1984), pp. 7–27.

Little, Joyce A. 'Sexual Equality in the Church: A Theological Resolution to the Anthropological Dilemma,' *Heythrop Journal: A Quarterly Review of Philosophy and Theology*, Vol. 28, No. 2 (Apr. 1987), pp. 165–178.

Lovin, Robin W. 'Equality and Covenant Theology,' *Journal of Law and Religion*, Vol. 2, No. 2 (1984), pp. 241–262.

Lundeen, Lyman. 'Turning Points in Feminist Theology,' *Word and World: Theology for Christian Ministry*, Vol. 8, No. 4 (Fall 1988), pp. 348–356.

McAvoy, Jane. 'God-Talk: Three Modern Approaches,' *Lexington Theological Quarterly*, Vol. 22, No. 4 (Oct. 1987), pp. 106–117.

Mackenzie, Caroline. 'The Bride Becomes the Interior Son,' *Bangalore Theological Forum*, Vol. 19 (Oct.–Dec. 1987), pp. 301–311.

McKim, Donald. 'Harkening to the Voices: What Women Theologians Are Saying,' *Reformed Journal*, Vol. 35, No. 1 (Jan. 1985), pp. 7–10.

Maddox, Randy L. 'The Necessity of Recognizing Distinctions: Lessons from Evangelical Critiques of Christian Feminist Theology,' *Christian Scholar's Review*, Vol. 17, No. 3 (1988), pp. 307–323.

Malone, Nancy M. 'A Discussion of Sallie McFague's *Models of God*' [with response by S. McFague], *Religion and Intellectual Life*, Vol. 5 (Spring 1988), pp. 9–44.

Marshall-Green, Molly. 'When Keeping Silent Will No Longer Do: A Theological Agenda for the Contemporary Church,' *Review and Expositor: A Baptist Theological Journal*, Vol. 83, No. 1 (Winter 1986), pp. 27–33.

Martinez, Demetria. 'God the Ubiquitous Mother,' *National Catholic Reporter*, Vol. 22 (June 6, 1986), pp. 7–8.

Martinson, Roland. 'Androgyny and Beyond,' *Word and World: Theology for Christian Ministry*, Vol. 5, No. 4 (Fall 1985), pp. 370–390.

Marty, Martin M. 'Feminist Questions Promote New Insights into Basic Theology,' *Context*, Vol. 14, No. 1 (Jan. 1, 1983), p. 4.

Matossian, Mary. 'In the Beginning, God Was a Woman,' *Journal of Social History*, Vol. 6 (Spring 1973), pp. 324–343.

Mercadante, Linda. 'Core Issues in Theological Debate,' *Crux: A Quarterly Journal of Christian Thought and Opinion*, Vol. 20, No. 4 (Dec. 1984), pp. 7–11.

– 'Women's Realities: A Theological View,' *TSF Bulletin*, Vol. 8, No. 1 (Sept.–Oct. 1984), pp. 8–10.

Mertens, Herman-Emiel. 'Feminist Theology,' *Theology Digest*, Vol. 30, No. 2 (Summer 1982), pp. 103–106.

Meyers-Wilmes-M., Hedwig. 'Feminist Theology: Source of Renewal,' *Theology Digest*, Vol. 33, No. 2 (Summer 1986), pp. 235–238.

Michel, Walter L. 'Anthropology and Theology of the O.T.,' *Dialog: A Journal of Theology*, Vol. 24, No. 1 (Winter 1985), pp. 42–49.

Miller, Patrick D. 'Theses on the Gender of God,' *Haelan: Journal of Worship, Prayer and Meditation*, Vol. 6, No. 2 (Fall 1985), pp. 4–8.

Mitchell, Mozella G. 'The Black Woman's View of Human Liberation,' *Theology Today*, Vol. 39, No. 4 (Jan. 1983), pp. 421–425.

Mollenkott, Virginia Ramey. 'Female God-Imagery and Wholistic Social Consciousness,' *Studies in Formative Spirituality*, Vol. 5 (Nov. 1984), pp. 345–354.

– 'Unlimiting God: To Unlimit God Is to Unlimit Ourselves,' *Other Side*, Vol. 19, No. 146 (Nov. 1983), pp. 11–14.

– 'Who's Redeeming Who?: A Review of *The Redemption of God: A Theology of Mutual Relation*, by Isabel Carter Heyward,' *Christianity and Crisis: A Christian Journal of Opinion*, Vol. 43, No. 5 (Apr. 4, 1983), pp. 123–124.

Moltmann, Jürgen. 'The Motherly Father: Is Trinitarian Patripassianism Replacing Theological Patriarchalism?' in *God as Father?* (Concilium, 143), ed. by Johannes-Baptist Metz and Edward Schillebeeckx, pp. 51–56. Edinburgh: T. and T. Clark, 1981.

Moltmann-Wendel, Elisabeth. 'Toward a Wholistic Feminine Theology,' *Theology Digest*, Vol. 33, No. 2 (Summer 1986), pp. 239–243.

Morley, Janet. 'In God's Image?' *New Blackfriars*, Vol. 63, No. 747 (Sept. 1982), pp. 373–381.

Murray, Pauli. 'Black, Feminist Theologies: Links, Parallels, and Tensions,' *Christianity and Crisis: A Christian Journal of Opinion*, Vol. 40, No. 6 (Apr. 14, 1980), pp. 86–95.

– 'Black Theology and Feminist Theology: A Comparative View,' *Anglican Theological Review*, Vol. 60, No. 1 (Jan. 1978), pp. 3–24.

– 'The Holy Spirit of God and Language,' *Witness*, Vol. 66, No. 2 (Feb. 1983), pp. 7–9.

Ochs, Carol. 'Nomad and Settler in Patriarchal Religion,' *Feminist Studies*, Vol. 3, No. 3 and 4 (Spring and Summer 1976), pp. 56–61.

O'Connor, F. 'Christ and Women's Liberation,' *Liguorian*, Vol. 64 (Mar. 1976), pp. 41–46.

O'Connor, June. 'Liberation Theologies and the Women's Movement: Points of Comparison and Contrast,' *Horizons: The Journal of the College Theology Society*, Vol. 2, No. 1 (Spring 1975), p. 108.

– 'Sensuality, Spirituality, Sacramentality,' *Union Seminary Quarterly Review*, Vol. 40, No. 1 and 2 (1985), pp. 59–70.

– 'Toward an Inclusive Theology' [E.S. Fiorenza; R.R. Ruether; review article], *Christian Century*, Vol. 100, No. 36 (Nov. 30, 1983), pp. 1114–1117.

Oduyoye, Mercy Amba. 'Feminism: A Pre-condition for a Christian Anthropology,' *Africa Theological Journal*, Vol. 11, No. 3 (1982), pp. 193–208.

O'Hara Graff, Ann. 'Women Creating Theology,' *Catholic Theological Society of America Proceedings*, Vol. 43 (1988), pp. 95–97.

Oxford-Carpenter, Rebecca. 'Gender and the Trinity,' *Theology Today*, Vol. 41, No. 1 (Apr. 1984), pp. 7–25.

Pagels, Elaine H. 'What Became of God the Mother?' *Signs: Journal of Women in Cultural Society*, Vol. 2, No. 2 (Winter 1976), pp. 293–303.

– 'Women, the Bible and Human Nature: Review of *Womanguides: Readings toward a Feminist Theology*, by Rosemary Radford Ruether, and *Bread Not Stone: The Challenge of Feminist Biblical Interpretation*, by Elisabeth Schüssler Fiorenza,' *The New York Times Book Review*, Apr. 1, 1985, pp. 3–19.

Patrick, Anne E. 'Coming of Age: Women's Contributions to Contemporary Theology,' *New Catholic World*, Vol. 228, No. 1364 (Mar./Apr. 1985), pp. 61–69.

– 'Towards Renewing the Life and Culture of Fallen Man: *Gaudium et Spes* as Catalyst for Catholic Feminist Theology,' in *Questions of Special Urgency: The Church in the Modern World Two Decades after*

Vatican II, ed. by Judith A. Dwyer, pp. 55–78. Washington, DC: Georgetown University Press, 1986.

– 'Women and Religion: A Survey of Significant Literature 1965–1974,' *Theological Studies*, Vol. 36, No. 4 (Dec. 1975), pp. 737–765.

Patrick, Johnstone G. 'God, the Mother' [sermon], *Expository Times*, Vol. 96, No. 8 (May 1985), pp. 244–246.

Paul, D. 'Was Jesus a Feminist?' *U.S. Catholic*, Vol. 50 (Oct. 1985), pp. 41–44.

Pellauer, Mary D. 'Feminist Theology: Challenges and Consolation for Lutherans,' *Dialog: A Journal of Theology*, Vol. 24, No. 1 (Winter 1985), pp. 19–25.

– 'Violence against Women: The Theological Dimension,' *Christianity and Crisis: A Christian Journal of Opinion*, Vol. 43, No. 206 (May 30, 1983), pp. 208–212.

Peters, Ted. 'A Book Worth Discussing: *Faith, Feminism, and the Christ*' [by P. Wilson-Kastner, 1983; review article], *Currents in Theology and Mission*, Vol. 12 (Oct. 1985), pp. 313–314.

– 'McFague's Metaphors: *Metaphorical Theology: Models of God in Religious Language*,' *Dialog: A Journal of Theology*, Vol. 27, No. 2 (Spring 1988), pp. 131–140.

Phipps, William E. 'Eve and Pandora Contrasted,' *Theology Today*, Vol. 45, No. 1 (Apr. 1988), pp. 34–48.

Porterfield, Amanda. 'Feminist Theology as a Revitalization Movement,' *Sociological Analysis*, Vol. 48, No. 3 (Fall 1987), pp. 234–244.

Potter, Mary Lane. 'In the Procession of the Sons of Educated Men: Divinations of a Garden in a Desert' [Feminist Perspectives on Historical Theology], *Theological Markings: A UTS Journal*, Vol. 13 (Summer 1984), pp. 7–13.

Proctor-Smith, Marjorie. 'Images of Women in the Lectionary,' in *Christianity among World Religions* (Concilium, 183), ed. by Hans Küng and Jürgen Moltmann, pp. 51–62. Edinburgh: T. and T. Clark, c1986.

Prusak, B. 'Feminism and the CTS,' *Horizons: The Journal of the College Theology Society*, Vol. 3 (Spring 1976), pp. 83–84.

Quere, Ralph W. ' "Naming" God "Father," ' *Currents in Theology and Mission*, Vol. 12 (Feb. 1985), pp. 5–14.

Quitslund, Sonya. 'In the Image of God,' *Bible Today: A Periodical Promoting Popular Appreciation of the Word of God*, No. 84 (Apr. 1976), pp. 786–793.

Raming, Ida. 'From the Freedom of the Gospel to the Petrified "Men's Church": The Rise and Development of Male Domination in the Church,' in *Women in a Men's Church* (Concilium, 134), ed. by Virgil

Elizondo and Norbert Greinacher, pp. 3–13. Edinburgh: T. and T. Clark, 1980.

Ramsey-Moor, Ann. 'Toward a Feminist Theology of Work,' *Journal of Women in Religion*, Vol. 6 (Winter 1987), pp. 27–35.

Richardson, Nancy D. 'Claiming the Power of the Spirit,' *Christianity and Crisis: A Christian Journal of Opinion*, Vol. 47, No. 3 (Mar. 2, 1987), pp. 75–79.

Richardson, Peter. 'From Apostles to Virgins: Romans 16 and the Role of Women in the Early Church,' *Toronto Journal of Theology*, Vol. 2, No. 2 (Fall 1986), pp. 232–261.

Ross, Susan A. 'Seminar on Theological Anthropology: The Future of Humanity: Feminist Perspectives,' *Catholic Theological Society of America Proceedings*, Vol. 41 (1986), pp. 157–159.

Ross-Bryant, Lynn. 'Imagination and the Re-valorization of the Feminine,' *Journal of the American Academy of Religion: Thematic Studies*, Vol. 48, No. 2 (1981), pp. 105–117.

Roth, Robert Paul. 'Well-Intended Heresies,' *Word and World: Theology for Christian Ministry*, Vol. 8, No. 2 (Spring 1988), pp. 115–123.

Ruether, Rosemary Radford. 'Courage as a Christian Virtue,' *Cross Currents: A Quarterly Review to Explore the Implications of Christianity for Our Times*, Vol. 33, No. 1 (Spring 1983), pp. 8–16.

– 'Crises and Challenges of Catholicism Today,' *America*, Vol. 154, No. 8 (Mar. 1, 1986), pp. 152–158.

– 'The Female Nature of God: A Problem in Contemporary Religious Life,' in *God as Father?* (Concilium, 143), ed. by Johannes-Baptist Metz and Edward Schillebeeckx, pp. 61–66. Edinburgh: T. and T. Clark, 1981.

– 'Feminism and Patriarchal Religion: Principles of Ideological Critique of the Bible,' *Journal for the Study of the Old Testament*, Issue 22 (1982), pp. 54–66.

– 'A Feminist Perspective,' in *Doing Theology in a Divided World*, ed. by Virginia Fabella and Sergio Torres, pp. 65–71. Maryknoll, NY: Orbis Books, 1985.

– 'The Liberation of Christology from Patriarchy,' *New Blackfriars*, Vol. 66 (July–Aug. 1985), pp. 324–335; *Religion and Intellectual Life*, Vol. 2 (Spring 1985), pp. 116–128.

– 'Male Chauvinist Theology and the Anger of Women,' *Cross Currents: A Quarterly Review to Explore the Implications of Christianity for Our Times*, Vol. 21, No. 2 (Spring 1971), pp. 173–185.

– 'Of One Humanity: A Feminist Theologian Discusses Issues Confronting Women, Men, and the Church' [interview], *Sojourners*, Vol. 13, No. 1 (Jan. 1984), pp. 17–19.

- 'Prophetic Tradition and the Liberation of Women: A Story of Promise and Betrayal,' *Drew Gateway*, Vol. 55, No. 2–3 (Winter 1984–Spring 1985), pp. 114–124. Reply by K. Lowney, pp. 125–128.
- 'Re-contextualizing Theology,' *Theology Today*, Vol. 43, No. 1 (Apr. 1986), pp. 22–27.
- 'Ruether on Ruether,' *Christianity and Crisis: A Christian Journal of Opinion*, Vol. 39, No. 8 (May 14, 1979), p. 126.
- 'The Subordination and Liberation of Women in Christian Theology: St. Paul and Sarah Grimke,' *Soundings: An Interdisciplinary Journal*, Vol. 11, No. 1 (Summer 1978), pp. 168–181.

Russell, Letty M. 'Bread Instead of Stone,' *Christian Century*, Vol. 97, No. 22 (June 18–25, 1980), pp. 665–669.
- 'Feminist and Black Theologies,' *Reflection: Journal of Opinion at Yale Divinity School*, Vol. 74, No. 1 (Nov. 1976), pp. 14–16.

Saggan, E. 'A Review of *In Her Presence: Prayer Experiences Exploring Feminine Images of God*, by Virginia Ann Froehle,' *Sisters*, Vol. 59, No. 6 (Feb. 1988), p. 364.

Saiving, Valerie. 'Androcentrism in Religious Studies,' *Journal of Religion*, Vol. 56 (Apr. 1976), pp. 177–197.

Sakenfeld, Katherine Dobb. 'Feminist Perspectives on Bible and Theology: An Introduction to Selected Issues and Literature,' *Interpretation: A Journal of Bible and Theology*, Vol. 42, No. 1 (Jan. 1988), pp. 5–18.

Sawicki, Marianne. 'Christian Origins According to Fiorenza and Farley,' *Lexington Theological Quarterly*, Vol. 23, No. 4 (Sept. 1988), pp. 99–118.

Schmidt, Gail Ramshaw. 'De Divinis Nomibus: The Gender of God,' *Worship*, Vol. 56, No. 2 (Mar. 1982), pp. 117–131.

Schmitt, John J. 'The Motherhood of God and Zion as Mother,' *Revue Biblique*, Vol. 92, No. 4 (Oct. 1985), pp. 557–569.

Scott, Cynthia. 'Broadening Our Image of God,' *Exchange: For Leaders of Adults*, Vol. 10, No. 1 (Fall 1985), pp. 7–9.

Scroggs, Robin. 'The Next Step: A Common Humanity,' *Theology Today*, Vol. 34, No. 4 (Jan. 1978), pp. 395–401.

Setta, Susan M. 'The Mother-Father God and the Female Christ in Early Shaker Theology,' *Journal of Religious Studies (Ohio)*, Vol. 12 (1985), pp. 56–64.
- ed. 'In Memory of Her: A Feminist Theological Reconstruction of Christian Origins; Symposium' [American Academy of Religion, Dallas 1983], *Anima: An Experimental Journal of Celebration*, Vol. 10 (Spring 1984), pp. 95–112.

Shields, David L. 'Christ: A Male Feminist View,' *Encounter*, Vol. 45, No. 3 (Summer 1984), pp. 221–232.

Snijdewind, Hadewych. 'Ways towards a Non-Patriarchal, Christian Solidarity,' in *God as Father?* (Concilium, 143), ed. by Johannes-Baptist Metz and Edward Schillebeeckx, pp. 81–94. Edinburgh: T. and T. Clark, 1981.

Sölle, Dorothee. 'God and Her Friends,' *Ecumenical Trends: Graymore Ecumenical Institute*, Vol. 14, No. 4 (Apr. 1985), pp. 49–51.

– 'Mysticism, Liberation, and the Names of God: A Feminist Reflection,' *Christianity and Crisis: A Christian Journal of Opinion*, Vol. 41, No. 11 (June 22, 1981), pp. 179–185. Replies in Vol. 41, No. 15 (Oct. 15, 1981), pp. 271–272.

– 'Paternalistic Religion as Experienced by Women,' in *God as Father?* (Concilium, 143), ed. by Johannes-Baptist Metz and Edward Schillebeeckx, pp. 69–74. Edinburgh: T. and T. Clark, 1981.

Stahl, Janine. 'A propos d'un *Mémoire d'Elle*: Perspective et interprétations' [review article; E. Schüssler Fiorenza], *Revue des Sciences Religieuses*, Vol. 61 (Oct. 1987), pp. 225–235.

Stenger, Mary Ann. 'Male over Female or Female over Male: A Critique of Idolatry,' *Soundings: An Interdisciplinary Journal*, Vol. 59, No. 4 (Winter 1986), pp. 464–478.

Stock, Augustine. 'Mark in Feminist Hermeneutics,' *Priest*, Vol. 40 (Sept. 1984), pp. 43–45.

Storkey, Elaine. 'Review of *What Will Happen to God: Feminism and the Reconstruction of Christian Belief*, by William Oddie,' *Scottish Journal of Theology*, Vol. 40, No. 43 (1988), pp. 117–124.

Stortz, Martha E. 'The Mother, the Son, and the Bullrushes: The Church and Feminist Theology,' *Dialog: A Journal of Theology*, Vol. 23, No. 1 (Winter 1984), pp. 21–26.

Suchocki, Marjorie. 'The Challenge of Mary Daly,' *Encounter*, Vol. 41, No. 4 (Autumn 1980), pp. 307–317.

– 'The Unmale God: Reconsidering the Trinity,' *Quarterly Review: A Scholarly Journal for Reflection on Ministry*, Vol. 3, No. 1 (Spring 1983), pp. 34–49.

– 'Weaving the World' [feminist and process thought], *Process Studies*, Vol. 14 (Summer 1985), pp. 76–86.

Sullivan, P.J. 'Reviews of *Sexism and God-Talk*, by R. Ruether and *In Memory of Her*, by E.S. Fiorenza,' *Heythrop Journal: A Quarterly Review of Philosophy and Theology*, Vol. 28, No. 2 (Apr. 1987), pp. 204–206.

Swanston, Hamish F.G. '*Sexism and God-Talk: Towards a Feminist Theology*, by R.R. Ruether, 1983,' *King's Theological Review*, Vol. 8 (Spring 1985), pp. 17–20.

Swidler, Arlene. 'The Image of Woman in a Father-Oriented Religion,' in *God as Father?* (Concilium, 143), ed. by Johannes-Baptist Metz and

Edward Schillebeeckx, pp. 75–80. Edinburgh: T. and T. Clark, 1981.

Swidler, Leonard J. 'God, Father and Mother,' *Bible Today: A Periodical Promoting Popular Appreciation of the Word of God*, Vol. 22, No. 5 (Sept. 1984), pp. 300–305.

Taves, Ann. 'Theology, Gender, and Individualism in America,' *Word and World: Theology for Christian Ministry*, Vol. 8, No. 4 (Fall 1988), pp. 343–347.

Teitelbaum, Benjamin. 'Women and Theology' [reply to lecture by R.R. Ruether, College of Marin (Calif.), Jan. 27, 1984], *Epiphany: A Journal of Faith and Insight*, Vol. 4, No. 4 (Summer 1984), pp. 98–103.

Tennis, Diane. 'The Loss of God the Father: Why Women Rage and Grieve,' *Christianity and Crisis: A Christian Journal of Opinion*, Vol. 41, No. 10 (June 8, 1981), pp. 164–170.

Tepedino, Ana Maria. 'Martha's Passion: A Model for Theological Liberation,' *Other Side*, Vol. 24, No. 6 (June–Aug. 1988), pp. 22–25.

Terrien, S. 'Toward a Biblical Theology of Womanhood,' *Theology Digest*, Vol. 22, No. 1 (Spring 1974), pp. 29–31.

Thistlethwaite, Susan Brooks. 'The Spirituality of Liberation,' *Engage/Social Action*, Vol. 15, No. 4 (Apr. 1987), pp. 30–36.

Thomas, Owen C. 'Feminist Theology and Anglican Theology,' *Anglican Theological Digest*, Vol. 68, No. 2 (Apr. 1986), p. 125.

Thompson, John L. 'Creata ad Imaginem Dei, Licet Secundo Gradu: Woman as the Image of God According to John Calvin,' *Harvard Theological Review*, Vol. 81, No. 2 (Apr. 1988), pp. 125–143.

Thompson, Ross. 'Male and Female in Christ's Priestly Dance,' *Theology*, Vol. 87, No. 716 (Mar. 1984), pp. 95–101.

'Toward a Theology of Feminism; Symposium,' *Horizons: The Journal of the College Theology Society*, Vol. 2, No. 1 (Spring 1975), pp. 103–124.

Tracy, David. 'Christian Faith and Radical Equality,' *Theology Today*, Vol. 34, No. 4 (Jan. 1978), pp. 370–377.

Trible, Phyllis. 'Biblical Theology as Women's Work,' *Religion in Life*, Vol. 44 (1975), pp. 7–13.

– 'Review of *God the Father: Theology and Patriarchy in the Teaching of Jesus*' [by Robert Hamerton-Kelly], *Theology Today*, Vol. 37, No. 1 (Apr. 1980), pp. 116–119.

Verryn, Trevor D. 'The Mother Archetype,' *Theologica Evangelica*, Vol. 15, No. 3 (Dec. 1982), pp. 43–63.

Vogt, Kari. ' "Becoming Male": One Aspect of an Early Christian Anthropology,' in *Christianity among World Religions* (Concilium, 183), ed. by Hans Küng and Jürgen Moltmann, pp. 72–83. Edinburgh: T. and T. Clark, c1986.

Warner, R. 'Review of *Models of God: Theology for an Ecological Nuclear Age*, by Sallie McFague,' *Sisters Today*, Vol. 59, No. 4 (Dec. 1987), p. 240.

Washbourn, Penelope. 'Authority or Idolatry? Feminine Theology and the Church,' *Christian Century*, Vol. 92, No. 35 (Oct. 29, 1975), pp. 961–964.

– 'Feminine Symbols and Death,' *Theology Today*, Vol. 32, No. 3 (Oct. 1975), pp. 243–251.

Weber, Rose Michael. 'The Many Faces of God,' *Liquorian*, Vol. 72 (Dec. 1984), pp. 10–13.

Werner, Ben. 'Review of *Household of Freedom: Authority in Feminist Theology*, by Letty M. Russell,' *Journal of Psychology and Christianity*, Vol. 7 (Spring 1988), p. 103.

West, Cornel, and Ross S. Kraemer. '*In Memory of Her: A Feminist Theological Reconstruction of Christian Origins*, by E.S. Fiorenza,' *Religious Studies Review*, Vol. 11, No. 1 (Jan. 1985), pp. 1–4, 6–9.

Westfall, Charlie. 'Images of God,' *Grail: An Ecumenical Journal*, Vol. 3, No. 2 (June 1987), pp. 61–67.

Williams, Delores S. 'Womanist Theology: Black Women's Voices,' *Christianity and Crisis: A Christian Journal of Opinion*, Vol. 47, No. 3 (Mar. 2, 1987), pp. 66–70.

Williams, Jane, and Rowan Williams. 'Sexist Language and Theology: A Dialogue,' *Christian*, Vol. 6, No. 4 (Advent 1981), p. 14.

Williams, Jay. 'Yahweh, Women and the Trinity,' *Theology Today*, Vol. 32, No. 3 (Oct. 1975), pp. 234–242.

Wilson-Kastner, Patricia. 'Preaching the Theology of Grace,' *St. Luke's Journal of Theology*, Vol. 39, No. 4 (Sept. 1986), pp. 285–292.

Wire, Antoinette Clark. 'Theological and Biblical Perspective: Liberation for Women Calls for a Liberated World,' *Church and Society*, Vol. 76, No. 3 (Jan.–Feb. 1986), pp. 7–17.

'Women Doing Theology: Symposium,' *National Catholic Reporter*, Vol. 20 (Apr. 13, 1984), pp. 3–10.

Wren, Brian. 'Meeting the Awesome She' [personal perspective; femininity of God], *Christian Century*, Vol. 105, No. 5 (Feb. 17, 1988), p. 159.

Young, Pamela Dickey. 'Christianity's Male Saviour: A Problem for Women?' *Touchstone: Heritage and Theology in a New Age*, Vol. 4, No. 3 (Oct. 1986), pp. 13–21.

– 'Elisabeth Schüssler Fiorenza's Feminist Hermeneutic,' *Grail: An Ecumenical Journal*, Vol. 4, No. 2 (June 1988), pp. 27–35.

Zikmund, Barbara Brown. 'The Trinity and Women's Experience,' *Christian Century*, Vol. 104, No. 12 (Apr. 15, 1987), pp. 354–356.

OTHER RELATED RESOURCES

Lewis, Alan E., ed. *The Motherhood of God: A Report by a Study Group Appointed by the Women's Guild and the Panel on Doctrine on the Invitation of the General Assembly of the Church of Scotland.* Edinburgh: St. Andrew's Press, 1984.

Ethics

BOOKS, DISSERTATIONS, COLLECTED WORKS

Andolsen, Barbara Hilkert, Christine E. Gudorf, and Mary D. Pellauer, eds. *Women's Consciousness, Women's Conscience: A Reader in Feminist Ethics.* Minneapolis: Winston Press, 1985.

Bourassa, Lise. 'Les discours théologiques féministes au Québec francophone, de 1970 à 1983; la préponderance de leur aspect ethique.' M.A. Ethique dissertation, Université du Québec à Rimouski, 1986.

Cahill, Lisa Sowle. *Between the Sexes: Foundations for a Christian Ethics of Sexuality.* Philadelphia: Fortress Press, 1985.

Cannon, Katie Geneva. 'Resources for a Constructive Ethic for Black Women with Special Attention to the Life and Work of Zora Neale Hurston.' Ph.D. dissertation, Union Theological Seminary in City of New York, 1983.

Fiorenza, Elisabeth Schüssler, and Anne E. Carr, eds. *Women, Work and Poverty* (Concilium, 194). Edinburgh: T. and T. Clark, 1987.

Golding, Gail Campbell. 'The Response Ethics: Its Significance for Modern Issues of War and Peace, Structural Analysis, and Further Development in Feminist Theory.' M.Div. dissertation, Atlantic School of Theology, 1986.

Gudorf, Christine E. *Catholic Social Teachings on Liberation Themes.* Lanham, MD: University Press of America, 1980.

Harrison, Beverly Wildung. *Making the Connections: Essays in Feminist Social Ethics*, ed. by Carol S. Robb. Boston: Beacon Press, 1985.

– *Our Right to Choose: Toward a New Ethic of Abortion.* Boston: Beacon Press, 1983.

Lebacqz, Karen. *Professional Ethics: Power and Paradox.* Nashville: Abingdon Press, 1985.

Vaughan, Judith. *Sociability, Ethics and Social Change: A Critical Appraisal: Reinholt Niebuhr's Ethics in the Light of Rosemary Radford Ruether's Works.* Lanham, MD: University Press of America, 1983.

ARTICLES, BOOK REVIEWS

Allen, Joseph L. 'Review of *Between the Sexes: Foundations for a Christian Ethics of Sexuality*, by Lisa Sowle Cahill,' *Reflections: Perkins Journal*, Vol. 41, No. 1 (Jan. 1988), pp. 39–40.

Andolsen, Barbara Hilkert. 'Apace in Feminist Ethics,' *Journal of Religious Ethics*, Vol. 9 (1981), pp. 69–81.

– 'Gender and Sex Roles in Recent Religious Ethics Literature,' *Religious Studies Review*, Vol. 11, No. 3 (July 1985), pp. 217–223.

Bettenhausen, Elizabeth. 'The Concept of Justice and a Feminist Lutheran Social Ethic,' in *Annual of the Society of Christian Ethics*, 1986, pp. 163–182.

– 'Numbering the Sand on the Seashore: Population and Ethics,' in *Population Perils*, ed. by George W. Farell and William H. Lazereth, pp. 47–56. Philadelphia: Fortress Press, 1979.

– 'Woody Allen and/or Bethlehem: The Public Dilemma of the Abortion Debate,' *Dialog: A Journal of Theology*, Vol. 17, No. 2 (Spring 1978), pp. 111–115.

Blaney, Robert W. 'Review of *Between the Sexes: Foundation for a Christian Ethics of Sexuality*, by Lisa Sowle Cahill,' *Religious Studies Review*, Vol. 14, No. 2 (Apr. 1988), pp. 127–131.

Cahill, Lisa Sowle. 'Abortion, Autonomy, and Community,' in *Abortion: Understanding Difference*, ed. by Sidney Callahan and Daniel Callahan, pp. 261–276. New York: Plenum Press, 1984.

– 'Sexual Ethics, Marriage, and Divorce,' *Theological Studies*, Vol. 47, No. 1 (Mar. 1986), pp. 102–117.

– 'Sexual Issues in Christian Theological Ethics: A Review of Recent Studies,' *Religious Studies Review*, Vol. 4, No. 1 (Jan. 1979), pp. 1–14.

– 'Teleology, Utilitarianism, and Christian Ethics,' *Theological Studies*, Vol. 42, No. 4 (Dec. 1981), pp. 601–629.

– 'Toward a Christian Theory of Human Rights,' *Journal of Religious Ethics*, Vol. 8, No. 2 (Fall 1980), pp. 277–301.

Cannon, Katie Geneva. 'Resources for a Constructive Ethic in the Life and Work of Zora Neale Hurston,' *Journal of Feminist Studies in Religion*, Vol. 1, No. 1 (Spring 1985), pp. 37–51.

Dumais, Monique. 'Religion catholique et valeurs morales des femmes au Québec au XXe siècle,' *Religion/Cultural Études Canadiennes* (Ottawa, Association des Études Canadiennes), Vol. 7 (1985), pp. 164–180.

Farley, Margaret Ann. 'The Church and the Family: An Ethical Task,' *Horizons: The Journal of the College Theology Society*, Vol. 10, No. 1 (Spring 1983), pp. 50–71.

- 'Feminist Ethics,' in *Dictionary of Christian Ethics*, ed. by James F. Childress and John Macquarrie, pp. 229–231. Philadelphia: Westminster Press, 1986.
- 'Feminist Ethics in the Christian Ethics Curriculum,' *Horizons: The Journal of the College Theology Society*, Vol. 11 (Fall 1984), pp. 361–372.
- 'Fragments for an Ethic of Commitment in Thomas Aquinas,' *Journal of Religion*, Vol. 58, Supplement (1978), p. 135.
- 'Justice and the Role of Women in the Church: Thirteen Theses,' *Origins*, Vol. 5, No. 5 (June 1975), pp. 89–91.
- 'New Patterns of Relationship: Beginnings of a Moral Revolution,' *Theological Studies*, Vol. 36, No. 4 (Dec. 1975), pp. 627–646.

Fortune, Marie M. 'Confidentiality and Mandatory Reporting: A False Dilemma,' *Christian Century*, Vol. 103, No. 2 (June 18–25, 1986), pp. 582–583.

Fortune, Marie M., and Frances Wood. 'The Center for the Prevention of Sexual and Domestic Violence: A Study in Applied Feminist Theology and Ethics,' *Journal of Feminist Studies*, Vol. 4, No. 1 (Spring 1988), pp. 115–122.

Griscom, Joan. 'On Healing the Nature-History Split in Feminist Thought,' *Heresies*, Vol. 4, No. 1 (1981), p. 181.

Gudorf, Christine E. 'Review of *Between the Sexes: Foundations for a Christian Ethics of Sexuality*, by Lisa Sowle Cahill,' *Religious Studies Review*, Vol. 14, No. 2 (Apr. 1988), pp. 125–127.
- 'To Make a Seamless Garment Use a Single Piece of Cloth,' in *The Public Vocation of Christian Ethics*, ed. by Beverly W. Harrison, Robert L. Stivers, and Ronald H. Stone, pp. 271–286. New York: Pilgrim Press, 1986.

Gudorf, Christine E., and Robert W. Blaney. 'Recent Works on Christian Sexual Ethics,' *Religious Studies Review*, Vol. 14, No. 4 (Spring 1988), pp. 125–131.

Haney, Eleanor Humes. 'What is Feminist Ethics?' *Journal of Religious Ethics*, Vol. 8, No. 1 (Spring 1980), pp. 115–124.

Harrison, Beverly Wildung. 'The Power of Anger in the Work of Love: Christian Ethics for Women and Other Strangers,' *Union Seminary Quarterly Review*, Vol. 36, Supplement (1981), pp. 41–58.

Herman, Barbara. 'Mutual Aid and Respect for Persons,' *Ethics*, Vol. 95, No. 4 (1984), pp. 577–602.

Hunt, Mary Elizabeth. 'Lovingly Lesbian: Toward a Feminist Theology of Friendship,' in *A Challenge to Love: Gay and Lesbian Catholics in the Church*, ed. by Robert Nugent, pp. 135–155. New York: Crossroads, 1983.

- 'Toward a Gay Christian Ethic,' *World Faiths Insight*, Vol. 3, No. 4 (Spring/Summer 1979), pp. 7–8.
- 'Transforming Moral Theology – A Feminist Ethical Challenge,' in *Christianity among World Religions* (Concilium, 183), ed. by Hans Küng and Jürgen Moltmann, pp. 84–90. Edinburgh: T. and T. Clark, c1986.

Jung, L. Shannon. 'Feminism and Spatiality: Ethics and the Recovery of a Hidden Dimension,' *Journal of Feminist Studies*, Vol. 4 (Spring 1988), pp. 55–71.

Kenny, Mary. 'Abortion: What the Female Philosophers Say,' *Grail: An Ecumenical Journal*, Vol. 2, No. 1 (Mar. 1986), pp. 23–42.

Maguire, Daniel C. 'The Feminist Turn in Ethics,' *Horizons: The Journal of the College Theology Society*, Vol. 10, No. 2 (Fall 1983), pp. 341–347.
- 'The Feminization of God and Ethics,' *Christianity and Crisis: A Christian Journal of Opinion*, Vol. 42, No. 4 (Mar. 15, 1982), pp. 63–64.

Menne, Ferdinand. 'Catholic Sexual Ethics and Gender Roles in the Church,' in *Women in a Men's Church* (Concilium, 134), ed. by Virgil Elizondo and Norbert Greinacher, pp. 14–25. Edinburgh: T. and T. Clark, 1980.

Minas, Anne. 'How Reverse Discrimination Compensates Women,' *Ethics*, Vol. 88, No. 1 (Oct. 1977), pp. 74–79.

Mollenkott, Virginia Ramey. 'Reproductive Choice: Basic to Justice for Women,' *Christian Scholar's Review*, Vol. 17, No. 3 (1988), pp. 286–293.

Parsons, Susan F. 'The Intersection of Feminism and Theological Ethics: A Philosophical Approach,' *Modern Theology: A Quarterly Journal of Systematic and Philosophical Theology*, Vol. 4, No. 3 (Apr. 1988), pp. 251–266.

Pateman, Carole. ' "The Disorder of Women": Women, Love and a Sense of Justice,' *Ethics*, Vol. 91, No. 1 (Oct. 1980), pp. 20–34.

Pellauer, Mary D. 'Sex, Power, and the Family of God: Clergy and Sexual Abuse in Counselling,' *Christianity and Crisis: A Christian Journal of Opinion*, Vol. 47, No. 2 (Feb. 16, 1987), pp. 47–50.

Porter, Jean. 'The Feminization of God; Second Thoughts on the Ethical Implications of Process Theology' [abstracted from *Saint Luke's Journal of Theology*, Vol. 29 (1986), pp. 251–260], *Old Testament Abstracts*, Vol. 10, No. 1 (1987), p. 82.

Robb, Carol S. 'A Framework for Feminist Ethics,' *Journal of Religious Ethics*, Vol. 8, No. 1 (Spring 1981), pp. 48–68.

Saunders, Martha J. 'Review of *Making the Connections: Essays in Feminist Social Ethics*, by Beverly Harrison,' *Studies in Religion/Sciences Religieuses: A Canadian Journal*, Vol. 16, No. 1 (1987), pp. 124–125.

Smith, Ruth L. 'Morality and Perception of Society: The Limits of Self-

Interest,' *Journal for the Scientific Study of Religion*, Vol. 26, No. 3 (Fall 1987), pp. 279–293.

Thistlethwaite, Susan Brooks. 'God and Her Survival in a Nuclear Age,' *Journal of Feminist Studies in Religion*, Vol. 4, No. 1 (Spring 1988), pp. 73–88.

Welch, Sharon D. 'A Genealogy of the Logic of Deterrence: Habermas, Foucault and a Feminist Ethic of Risk,' *Union Seminary Quarterly Review*, Vol. 41, No. 2 (1987), pp. 13–32.

Young, Katherine. 'Woman at the Great Divide: Toward an Ethic of Human/Feminine Responsibility for Life and Death,' *Arc*, Vol. 9, No. 1 (Autumn 1981), p. 27.

Global

BOOKS, DISSERTATIONS, COLLECTED WORKS

Allison, Caroline. *It's Like Holding the Key to Your Own Jail: Women in Namibia*. Geneva: World Council of Churches, 1986.

Burghardt, Walter J., ed. *International Women's Year*. Special issue of *Theological Studies*, Vol. 36, No. 4 (Dec. 1977).

Castro, Emilio, ed. *Introducing the Ecumenical Decade for Churches in Solidarity with Women*. Special issue of *Ecumenical Review*, Vol. 40, No. 1 (Jan. 1988).

Cho, Wha Soon. *Let the Weak Be Strong: A Woman's Struggle for Justice*, ed. by Lee Sun Ai and Ahn Sang Nim. Oak Park, IL: Meyer Stone Books, 1988.

Eck, Diana L., and Davaki Jain, eds. *Speaking of Faith: Global Perspectives on Women, Religion and Social Change*. Philadelphia: New Society Publishers, 1987.

Fabella, Virginia, and Mercy Amba Oduyoye. *With Passion and Compassion: Third World Women Doing Theology*. Maryknoll, NY: Orbis Books, 1988.

Falk, Nancy Aver, and Rita M. Gross, eds. *Unspoken Worlds: Women's Religious Lives Series*. New York: Harper and Row, 1980.

Fenton, Thomas P., and Mary J. Heffron, comps. and eds. *Women in the Third World: A Directory of Resources*. Maryknoll, NY: Orbis Books, 1987.

Gross, Rita M., and Nancy Aver Falk, eds. *Unspoken Worlds: Women's Religious Lives in Non-Western Cultures*. San Francisco: Harper and Row, 1985.

Heyward, Isabel Carter, et al. (The Amanecida Collective). *Revolutionary Forgiveness: The Call of Nicaragua*. Maryknoll, NY: Orbis Books, 1986.

Katoppo, Marianne. *Compassionate and Free: An Asian Women's Theology.* Maryknoll, NY: Orbis Books, 1980.

King, Ursula, ed. *Women in the World's Religions, Past and Present.* New York: Paragon House, 1987.

Oduyoye, Mercy Amba. *Hearing and Knowing – Theological Reflections on Christianity in Africa.* Maryknoll, NY: Orbis Books, 1986.

Riley, Maria, ed. *I Am Because We Are, Because We Are, I Am: Meet with the Women of the World, Nairobe, Kenya, July 1985.* Washington, DC: Center of Concern, 1985.

Russell, Letty M., ed. *Inheriting Our Mothers' Garden: Feminist Theology in Third World Perspective.* Philadelphia: Westminster Press, 1988.

Sharma, Arrind, ed. *Women in World Religions.* New York: State University of New York Press, 1987.

Von Wartenberg-Potter, Bärbel, and John Pobee, eds. *New Eyes for Reading: Biblical and Theological Reflections by Women from the Third World.* Geneva: World Council of Churches, 1986.

Webster, Ellen, and John C.B. Lowe, eds. *The Church and Women in the Third World.* Philadelphia: Westminster Press, 1985.

ARTICLES, BOOK REVIEWS

Asedillo, Rebecca C. 'Singing Their Song in a Troubled Land: Report on the First National Assembly of the Association of Women in Theology, Quezon City, Philippines, Aug. 10–13, 1983,' *Voices from the Third World*, Vol. 7, No. 1 (June 1984), pp. 23–27.

Brock, Rita Nakashima, ed. 'Asian Women Theologians Respond to American Feminism,' *Journal of Feminist Studies in Religion*, Vol. 3, No. 2 (Fall 1987), pp. 103–134.

Deighton, J., R. Horsley, S. Steward, and C. Cain. 'Liberation Theology and the New Woman,' *Voices from the Third World*, Vol. 8, No. 3 (Sept. 1985), pp. 63–67.

Edet, Rosemary. 'Men and Women Building the Church in Africa,' *Voices from the Third World*, Vol. 8, No. 3 (Sept. 1985), pp. 78–81.

Ferro, Cora. 'Women in Christian Communities of the Common People,' *Voices from the Third World*, Vol. 8, No. 3 (Sept. 1985), pp. 46–49.

Hoover, Theressa. 'Black Women and the Churches: Triple Jeopardy,' *Voices from the Third World*, Vol. 8, No. 2 (June 1985), pp. 77–87.

– 'Faith Moving through Barriers: Mission and the Journey toward True Universality,' *Voices from the Third World*, Vol. 8, No. 3 (Sept. 1985), pp. 98–107.

Johnson, Elizabeth A. 'Review of *Women in the Third World: A Directory of Resources* by Thomas Fenton, Mary Heffron,' *Living Light: An Interdis-*

ciplinary *Review of Christian Education*, Vol. 24, No. 1 (Oct. 1987), pp. 87–88.

'Latin America: Emergence of Awareness,' *Voices from the Third World*, Vol. 8, No. 3 (Sept. 1985), pp. 59–62.

Leston, Doug. 'Feminist Theology Reflects on Nicaragua' [review of *Revolutionary Forgiveness: Feminist Reflections on Nicaragua*], *New Catholic Times*, Vol. 11, No. 3 (Feb. 8, 1987), p. 6.

Lindley, Susan Hill. 'Feminist Theology in a Global Perspective,' *Christian Century*, Vol. 96, No. 15 (Apr. 25, 1979), pp. 465–469.

Mujeres Para el Diologo. 'Women, Praxis and Liberation Theology,' *Voices from the Third World*, Vol. 2, No. 2 (Dec. 1979), pp. 12–17.

Oduyoye, Mercy Amba. 'Women and the Church in Africa: Perspectives from the Past,' *Voices from the Third World*, Vol. 3, No. 2 (Dec. 1980), pp. 17–24.

Perera, Marlene. 'Women's Theology in the Third World,' *Voices from the Third World*, Vol. 8, No. 3 (Sept. 1985), pp. i–vi.

'Position of Women in the Popular Class,' *Voices from the Third World*, Vol. 8, No. 3 (Sept. 1985), pp. 38–45.

Press, Mary Judith. 'Feminist Christians in Latin America,' *Voices from the Third World*, Vol. 8, No. 3 (Sept. 1985), pp. 55–59.

Rodas, Nelly Arrobo. 'Women in the Riobamba Church: Ecuador,' *Voices from the Third World*, Vol. 8, No. 3 (Sept. 1985), pp. 50–54.

Ruether, Rosemary Radford. 'Third World Women's Double Oppression,' *National Catholic Reporter*, Vol. 19 (Feb. 11, 1983), p. 20.

Searing, Susan E. 'Religion and Philosophy,' in *Introduction to Library Research in Women's Studies*, pp. 173–178. Boulder, CO: Westview Press, 1985.

Selvi, Y., and Ruth Manorama. 'Theological Reflection on Our Experience in the Struggle of Women in the Oppressed Section of Society,' *Voices from the Third World*, Vol. 8, No. 3 (Sept. 1985), pp. 1–5.

Zoe-Obianga, Rose. 'Resources in the Tradition for the Renewal of Community,' *Voices from the Third World*, Vol. 8, No. 3 (Sept. 1985), pp. 73–77.

Religious and Theological Education

BOOKS, DISSERTATIONS, COLLECTED WORKS

Blair, Christine Eaton. 'Liberating Biblical Education with Women: The Implications of Gender for Methodology in Religious Education.' Ph.D. dissertation, School of Theology at Claremont, 1988.

Bohn, Carole R. 'Women in Theological Education: Realities and Im-

plications.' Ed.D. dissertation, Boston University School of Education, 1981.

Cannon, Katie Geneva, Beverly Wildung Harrison, Isabel Carter Heyward, Ada Maria Isasi-Diaz, Bess Johnson, Mary D. Pellauer, and Nancy D. Richardson (The Mud Flower Collective). *God's Fierce Whimsy: Christian Feminism and Theological Education*. New York: Pilgrim Press, c1985.

Cha, Poong Ro. 'A Feminist Perspective on Education for Human Liberation in a Korean Context.' D.Min. dissertation, School of Theology at Claremont, 1985.

Coll, Regina Audrey. 'Paulo Friere and the Transformation of Consciousness of Women in Religious Congregations.' Ed.D. dissertation, Columbia University Teachers College, 1982.

Cornwall Collective. *Your Daughters Shall Prophesy: Feminist Alternatives in Theological Education*. New York: Pilgrim Press, c1980.

Durka, Gloria, and Joanmarie Smith, eds. *Emerging Issues in Religious Education*. New York: Paulist Press, 1976.

Finson, Shelley Davis. 'On the Other Side of Silence: Patriarchy, Consciousness and Spirituality – Some Women's Experiences of Theological Education.' D.Min. dissertation, Boston University School of Theology, 1986.

Giltner, Fern M., ed. *Women's Issues in Religious Education*. Birmingham, AL: Religious Education Press, 1985.

Gray, Joan G. 'Perspectives in Feminist Theology: An Analysis of a Group Guided Study Curriculum Based on the Educational Model of Thomas Groome.' D.Min. dissertation, Perkins School of Theology at Southern Methodist University, 1986.

Hough, Joseph C., and Barbara G. Wheeler, eds. *Beyond Clericalism: The Congregation as a Focus for Theological Education* (Studies in Religious and Theological Scholarship). Atlanta: Scholars Press, 1988.

Kirkpatrick, Patricia, ed. *Women and the Faculty of Religious Studies: Creating a Room of Our Own*. Special issue of *Arc*, Vol. 12, No. 2 (Spring 1985).

Langland, Elizabeth, and Walter Gove, eds. *A Feminist Perspective in the Academy: The Difference It Makes*. Special issue of *Soundings: An Interdisciplinary Journal*, Vol. 64, No. 4 (Winter 1981).

Little, Sara, ed. *Women and Religious Education*. Special issue of *Religious Education: The Journal of the Religious Education Association*, Vol. 76, No. 4 (July–Aug. 1981).

Malone, Mary T. *Women Christian: New Vision*. Dubuque, IA: Religious Education Division, W.C. Brown Co. Publishers, c1985.

Moore, Robert L., and Janet A. Mackenzie, eds. *Gender Issues and Super-*

vision. Special issue of *Journal of Supervision and Training in Ministry*, Vol. 6 (1983).

Morefield, Mary Anne. 'Introduction of a Course in "Women and Religion" into the Curriculum of a Small Secular College.' D.Min. dissertation, Boston University School of Theology, 1982.

Robbins, John W. *Scripture Twisting in the Seminaries*. Jefferson, MD: Trinity Foundation, c1985.

Sawicki, Marianne. *Faith and Sexism: Guidelines for Religious Education*. New York: Seabury Press, 1979.

Swidler, Arlene, and Walter Conn, eds. *Mainstreaming: Feminist Research for Teaching Religious Studies*. Lanham, MD: University Press of America; [London]: College Theology Society, 1985.

Ziegler, Jesse H., ed. *International Women's Year*. Special issue of *Theological Studies*, Vol. 36, No. 4 (Dec. 1977).

ARTICLES, BOOK REVIEWS

Bechtle, Regina M. 'Theological Trends: Feminist Approaches to Theology, 1,' *Way: Contemporary Christian Spirituality*, Vol. 27, No. 2 (Apr. 1987), pp. 124–131.

Bettenhausen, Elizabeth. 'A Feminist Future: Responses and Reflections: Towards a Political Base' [reply to R.R. Ruether, *Christianity and Crisis: A Christian Journal of Opinion*, Vol. 45, No. 3 (Mar. 4, 1985), pp. 57–62], *Christianity and Crisis: A Christian Journal of Opinion*, Vol. 45, No. 7 (Apr. 29, 1985), pp. 158–159.

Boys, Mary C. 'Women as Leaven: Theological Education in the United States and Canada,' in *Christianity among World Religions* (Concilium, 183), ed. by Hans Küng and Jürgen Moltmann, pp. 112–118. Edinburgh: T. and T. Clark, c1986.

– 'Women's Role in Theological Research, Reflection and Communication: A Religious Educator's Perspective,' *Catholic Theological Society of America Proceedings*, Vol. 38 (1983), pp. 58–63.

Buchanan, Constance H. 'Transformations: Ten Years of Women's Studies at HDS,' *Harvard Divinity Bulletin*, Vol. 12 (Jan. 1983), p. 84.

Chapman, Patricia A. 'A Realistic Look at Women's Place in Leadership,' *Christian Education Journal*, Vol. 4, No. 2 (1983), pp. 31–36.

Charlton, Joy. 'Women in Seminary: A Review of Current Social Science Research,' *Review of Religious Research*, Vol. 28, No. 4 (June 1987), pp. 305–318.

Christ, Carol P. 'Feminist Theology?' [reply to R.R. Ruether, *Christianity and Crisis: A Christian Journal of Opinion*, Vol. 45, No. 3 (Mar. 4, 1985),

pp. 57–62], *Christianity and Crisis: A Christian Journal of Opinion*, Vol. 45, No. 7 (Apr. 29, 1985), pp. 161–162.

– 'Women Studies in Religion,' *Bulletin of the Council on the Study of Religion*, Vol. 10, No. 1 (Feb. 1979), pp. 3–5.

Coll, Regina Audrey. 'Challenging and Reclaiming Symbols,' *Religious Education*, Vol. 80, No. 3 (Summer 1985), pp. 373–382.

Confoy, Maryanne. 'Women and Theological Education,' *Lutheran Theological Journal*, Vol. 17 (Aug. 1983), pp. 85–90.

Davis, Davena. 'Women in the Faculty of Religious Studies, 1884–1948–1984,' *Arc*, Vol. 11, No. 2 (Spring 1984), pp. 14–18.

Dorney, Judy. 'The Working Class Woman: Her Challenge to Religious Education,' *Religious Education*, Vol. 79, No. 2 (Spring 1984), pp. 229–242.

Dumais, Monique. 'Les femmes théologiennes dans l'église,' *Studies in Religion/Sciences Religieuses: A Canadian Journal*, Vol. 8, No. 3 (Printemps/Spring 1979), pp. 191–196.

– 'Quand les femmes "se mêlent de" parler de Dieu,' *Perspectives Universitaires, la Nouvelle Revue de L'AUPELF*, Vol. 3, Nos. 1 et 2 (1986), pp. 364–370.

Fiorenza, Elisabeth Schüssler. 'Toward a Liberative and Liberated Theology: Women Theologians and Feminist Theology in the USA,' in *Doing Theology in New Places* (Concilium, 115), ed. by Jean-Pierre Jossua and Johannes-Baptist Metz, pp. 22–32. New York: Seabury Press, 1979.

Gilmne, Martha, and Emma J. Justes. 'Daring to be Intimate: Male Supervisors Working with Female Supervisors in Theological Field Education,' *Journal of Supervision and Training in Ministry*, Vol. 6 (1983), pp. 205–215.

Gilson, Anne. 'Therefore Choose Life' [Lesbian Seminarian; Personal Statement], *Witness*, Vol. 68, No. 9 (Sept. 1985), p. 22.

Halkes, Catharina J.M. 'Feminist Theology: An Interim Assessment,' in *Women in a Men's Church* (Concilium, 134), ed. by Virgil Elizondo and Norbert Greinacher, pp. 110–123. Edinburgh: T. and T. Clark, 1980.

Hanson, Linda J. 'A Survey of Interests and Agendas of Women in U.S. Church Denominations,' *Theological Education*, Vol. 11, No. 2 (Winter 1975), pp. 82–95.

Hargrove, Barbara. 'The Women at YDS: Why They Come,' *Reflection: Journal of Opinion at Yale Divinity School*, Vol. 74, No. 1 (1977), pp. 6–9.

Harris, Maria. 'Weaving the Fabric: How My Mind Has Changed,' *Religious Education*, Vol. 79, No. 1 (Winter 1984), pp. 18–23.

Harrison, Beverly Wildung, and Robert Martin Jr. 'Is Theological Educa-

tion Good for Any Woman's Health?' *Center for Women and Religion Newsletter*, Vol. 4 (Winter 1978), pp. 6–10.

Hartman, Maureen. 'Women's Interseminary Conference' [Union Theological Seminary, Feb. 20–22, 1981], *Journal of Women and Religion*, Vol. 1, No. 1 (Spring 1981), p. 7.

Heyward, Isabel Carter, Katie Geneva Cannon, Beverly Wildung Harrison, Ada Maria Isasi-Diaz, Mary D. Pellauer, Nancy D. Richardson, and Delores Williams. 'Christian Feminists Speak,' *Theological Education*, Vol. 20, No. 1 (Autumn 1983), pp. 93–103.

Imbelli, Robert P. 'Ruether's Reconstruction' [reply to R.R. Ruether, *Christianity and Crisis: A Christian Journal of Opinion*, Vol. 45, No. 3 (Mar. 4, 1985), pp. 57–62], *Christianity and Crisis: A Christian Journal of Opinion*, Vol. 45, No. 7 (Apr. 29, 1985), pp. 159–160.

Jancoski, Loretta. 'Empowering Women to Claim Their Inheritance,' *Religious Education*, Vol. 82, No. 1 (Winter 1987), pp. 53–66.

Jewett, Julia, and Emily Haight. 'The Emergence of Feminine Consciousness in Supervision,' *Journal of Supervision and Training in Ministry*, Vol. 6 (1983), pp. 164–174.

Keohane, Nannerl O. 'Feminist Scholarship and Human Nurture,' *Ethics*, Vol. 93, No. 1 (Oct. 1982), pp. 102–113.

Klein, Christa Ressmeyer. 'Women's Concerns in Theological Education,' *Dialog: A Journal of Theology*, Vol. 24, No. 1 (Winter 1985), pp. 25–31.

McKenzie, Marna. 'Going Back to Seminary; an Old Wife's Tale,' *Theological Education*, Vol. 8, No. 4 (Summer 1972), pp. 257–259.

Maxey, Margaret N. 'To Catholic Women Contemplating Theological Education: Quo Vadis?' *Theological Education*, Vol. 8, No. 4 (Summer 1972), pp. 260–268.

Mayse, Marilyn, and Paula Jeanne Teague. 'Women Supervised by Men,' *Journal of Supervision and Training in Ministry*, Vol. 9 (1987), pp. 35–41.

Meadows-Rogers, Arabella. 'Association of Theological Schools Affirmative Action Plan,' *Theological Education*, Vol. 11, No. 2 (Winter 1975), pp. 101–105.

– 'Women in Field Education: Some New Answers to Old Questions,' *Theological Education*, Vol. 11, No. 2 (Summer 1975), pp. 301–307.

Mitrano, B.S. 'Feminist Theology and Curriculum Theory,' *Journal of Curriculum Studies*, Vol. 11, No. 3 (July–Sept. 1979), pp. 211–220.

Müller, Isis. 'The Vocational Prospects of Catholic Women Theologians and Their Situation in Catholic Theology Departments in German Universities (with special reference to the University of Münster, Westphalia),' in *Christianity among World Religions* (Concilium, 183),

ed. by Hans Küng and Jürgen Moltmann, pp. 101–111. Edinburgh: T. and T. Clark, c1986.

Neilsen, Mark. 'Vatican Seminary Study to Force Women Out?' *National Catholic Reporter*, Vol. 17 (Oct. 2, 1981), p. 25.

O'Connor, June. 'How to Mainstream Feminist Studies by Raising Questions: The Case of the Introductory Course,' *Horizons: The Journal of the College Theology Society*, Vol. 11, No. 2 (Fall 1984), pp. 373–392.

Olson, David W. 'Inclusiveness in Theological Education,' *Trinity Seminary Review*, Vol. 6 [Special Conference Issue] (1984), pp. 25–28. Reply by K.H. Sauer, pp. 29–30.

Plummer, Stuart A. 'Reflections in Supervisory Work with Women Students: Some Issues and Opportunities,' *Journal of Supervision and Training in Ministry*, Vol. 6 (1983), pp. 159–163.

Rayburn, Carole A. 'Sexism in Seminaries and Its Influence on the Church Community at Large,' *Journal of Pastoral Counseling*, Vol. 19, No. 2 (Fall–Winter 1985), pp. 89–98.

– 'Some Reflections of a Woman Seminarian: Woman Whither Goest Thou?' *Journal of Pastoral Counseling*, Vol. 16, No. 2 (Fall–Winter 1981), pp. 61–65.

Rhodes, Lynn. 'Supervision of Women in Parish Contexts,' *Journal of Supervision and Training in Ministry*, Vol. 10 (1988), pp. 198–207.

Richardson, Nancy D. 'Feminist Theology – Feminist Pedagogy: An Experimental Program of the Women's Theological Center,' *Journal of Feminist Studies in Religion*, Vol. 1, No. 2 (Fall 1985), pp. 115–120.

Ruether, Rosemary Radford. 'The Feminist Critique in Religious Studies,' *Soundings: An Interdisciplinary Journal*, Vol. 64, No. 4 (Winter 1981), pp. 388–402.

– 'Feminist Theology in the Academy,' *Christianity and Crisis: A Christian Journal of Opinion*, Vol. 45, No. 3 (Mar. 4, 1985), pp. 57–62. Five replies, Vol. 45, No. 7 (Apr. 29, 1985), pp. 158–165; rejoinder, Vol. 45, No. 8 (May 13, 1985), pp. 183–186.

– 'The Future of Feminist Theology in the Academy,' *Journal of the American Academy of Religion*, Vol. 53, No. 4 (Dec. 1985), pp. 703–713.

Russell, Letty M. 'Changing My Mind about Religious Education,' *Religious Education*, Vol. 79, No. 1 (Winter 1984), pp. 5–10.

Salazar, Pamela Reed. 'Theological Education of Women for Ordination,' *Religious Education*, Vol. 82, No. 1 (Winter 1987), pp. 67–79.

Schreckengost, George E. 'The Effect of Latent Racist, Ethnic and Sexual Biases on Placement,' *Review of Religious Research*, Vol. 28, No. 4 (June 1987), pp. 351–366.

Slee, Nicola. 'Parables and Women's Experiences,' *Religious Education,* Vol. 80, No. 2 (Spring 1985), pp. 232–245.

Squire, Anne. 'Women and the Church,' *Theological Education in the 80's,* Summer 1978, pp. 8–19.

Stierer, Sue. 'Women's Interseminary Conference,' *Journal of Women and Religion,* Vol. 2, No. 1 (Spring 1982), pp. 57–62.

Tennis, Diane. 'Of Space and Power' [reply to R.R. Ruether, *Christianity and Crisis: A Christian Journal of Opinion,* Vol. 45, No. 3 (Mar. 4, 1985), pp. 57–62], *Christianity and Crisis: A Christian Journal of Opinion,* Vol. 45, No. 7 (Apr. 29, 1985), pp. 162–163.

Thistlethwaite, Susan Brooks. 'The Feminization of American Religious Education,' *Religious Education,* Vol. 76, No. 4 (July–Aug. 1981), pp. 391–402.

Trible, Phyllis. 'Effects of Women's Studies on Biblical Studies,' *Journal for the Study of the Old Testament,* Issue 22 (Feb. 1982), pp. 3–5.

Way, Peggy Ann. 'Visions of Possibility: Women for Theological Education,' *Theological Education,* Vol. 8, No. 4 (Summer 1972), pp. 269–277.

Williams, Delores S. 'The Color of Feminism' [reply to R.R. Ruether, *Christianity and Crisis: A Christian Journal of Opinion,* Vol. 45, No. 3 (Mar. 4, 1985), pp. 57–62], *Christianity and Crisis: A Christian Journal of Opinion,* Vol. 45, No. 7 (Apr. 29, 1985), pp. 164–165.

OTHER RELATED RESOURCES

Golding, Gail Campbell, comp. and ed. *Hands to End Violence against Women: A Resource for Theological Education.* Toronto: Women's Inter-Church Council, 1988.

Huws, Glenys, ed. *Report on the Participation of Women in Theological Education.* Programme Unit on Faith and Witness. Programme on Theological Education. Geneva: World Council of Churches, 1980.

Naylor, Ann, and Wendy Hunt, eds. *Theological Education in the 80's: Report from the National Symposium on the Implications of Feminist Theology for Theological Education.* Toronto: Division of Ministry, Personnel and Education of the United Church of Canada, 1983.

11

Worship

Homiletics

BOOKS, DISSERTATIONS, COLLECTED WORKS

Bos, Johanna W.H. *Ruth, Esther, Jonah* (Knox Preaching Guides). Atlanta: John Knox Press, 1986.

Bracken, Janice, et al. *Women of the Word: Contemporary Sermons by Women*, ed. by Charles D. Hacket. Atlanta: Susan Hunter, 1985.

Church Employed Women, eds. *Women in the Pulpit*. New York: Church Employed Women, 1978.

Crotwell, Helen Gray. *Women and the Word: Sermons*. Philadelphia: Fortress Press, 1978.

Gonzalez, Justo, and Catherine Gonzalez. *Liberation Preaching*. Nashville: Abingdon Press, 1980.

Homburg, Arthur, ed. *Women of Passions*. Lima, OH: C.S.S., 1979.

Mitchell, Ella Pearson, ed. *Those Preachin' Women: Sermons by Black Women Preachers*. Valley Forge, PA: Judson Press, 1985.

Smith, Christine Marie. 'Weaving: A Metaphor and Method for Women's Preaching.' Ph.D. dissertation, Pacific School of Religion, Graduate Theological Union, Berkeley, California, 1987.

Spinning a Sacred Yarn: Women Speak from the Pulpit. New York: Pilgrim Press, 1982.

Taylor, Barbara Brown. *Mixed Blessings*. Atlanta: Susan Hunter, 1986.

Valenze, Deborah M. *Prophetic Sons and Daughters*. Princeton: Princeton University Press, 1985.

ARTICLES

Burghardt, Walter J. 'From Study to Proclamation,' in *A New Look at*

Preaching, ed. by John Burke, pp. 25–42. Wilmington, DE: Michael Glazier, 1983.

Dodson, Jualynne. 'Nineteenth Century A.M.E. Preaching Women: Cutting Edge of Women's Inclusion in Church Policy,' in *Women in New Worlds: Historical Perspectives on the Wesleyan Tradition*, Vol. 1, ed. by Hilah F. Thomas and Rosemary Skinner Keller, pp. 276–289. Nashville: Abingdon Press, 1981.

Duff, Nancy J. 'Wise and Foolish Maidens, Matthew 25:1–13' [sermon], *Union Seminary Quarterly Review*, Vol. 40, No. 3 (Summer 1985), pp. 55–58.

Fiorenza, Elisabeth Schüssler. 'Response to Walter Burghardt's "From Study to Proclamation," ' in *A New Look at Preaching*, ed. by John Burke, pp. 43–55. Wilmington, DE: Michael Glazier, 1983.

Hayes, Ardith Spierling. 'Homiletics in a New Context,' in *Preaching the Story*, ed. by E.H. Steimle, M.J. Niedenthal, and C.L. Rise, pp. 187–198. Philadelphia: Fortress Press, 1980.

Huie, Janice Riggle. 'Preaching through Metaphor,' in *Women Ministers*, ed. by Judith L. Weidman, pp. 49–66. San Francisco: Harper and Row, 1985.

Hunter, E. 'Weaving Life's Experiences into Women's Preaching,' *Christian Ministry*, Vol. 18, No. 5 (Sept.–Oct. 1987), pp. 14–17.

Kelly, Leotine T.C. 'Preaching in the Black Tradition,' in *Women in Ministry*, ed. by Judith L. Weidman, pp. 67–76. San Francisco: Harper and Row, 1985.

Kemper, Nancy Jo. 'As Those Who Withhold Nothing; As Imposters, Get True; As One Who Serves' [sermons], *Lexington Theological Quarterly*, Vol. 23 (Apr. 1988), pp. 25–42.

Kingston, M.J. 'Martha Gives the Right Answer' [sermon], *Expository Times*, Vol. 96 (Mar. 1985), pp. 181–182.

Proctor-Smith, Marjorie. 'Why Women Should Preach,' *Homiletic: A Review of Publications in Religious Communication*, Vol. 12 (1987), pp. 5–8.

Sanders, Cheryl J. 'The Woman as Preacher,' *Journal of Religious Thought*, Vol. 43, No. 1 (Spring–Summer 1986), pp. 6–23.

Sanderson, Judith E. 'Sermon on the Magnificat,' *Princeton Seminary Bulletin*, Vol. 8, No. 1, New Series (1987), pp. 53–59.

Sehested, Nancy Hastings. 'By What Authority Do I Preach?' [extemporaneous speech before the Shelby County Baptist Association, Oct. 19, 1987], *Sojourners*, Vol. 17, No. 2 (Feb. 1988), p. 24.

Spencer, Suzanne R. 'Why I Am a Feminist Christian' [sermon: Mark 5:24b–34, Mark 7:24–30, Luke 10:38–42], *Unitarian Universalist Christian*, Vol. 37, No. 3–4 (Fall–Winter 1982), pp. 5–10.

Walaskay, Maxine. 'Gender and Preaching,' *Christian Ministry*, Vol. 13, No. 1 (Jan. 1982), pp. 8–11.

Wiebe, Marie. 'God's Mother Love' [sermon: 1 Kings 3:16–28], *Covenant Quarterly*, Vol. 43, No. 3 (Aug. 1985), pp. 37–41.

Yeaman, Patricia A. 'Prophetic Voices: Differences between Men and Women,' *Review of Religious Research*, Vol. 28, No. 4 (June 1987), pp. 367–376.

Zikmund, Barbara Brown. 'Women as Preachers: Adding New Dimensions to Worship,' *Journal of Women and Religion*, Vol. 3, No. 2 (Summer 1984), pp. 12–16.

Zimmerman, Diana Heath. 'The Bible as a Source for Preaching by a Theologian Who Is Also a Feminist,' *Unitarian Universalist Christian*, Vol. 37, No. 3–4 (Fall–Winter 1987), pp. 28–34.

Liturgies

BOOKS, DISSERTATIONS, COLLECTED WORKS

Because We Are One People [traditional hymns rewritten in inclusive language]. Chicago: Ecumenical Women's Center, 1975.

Benguin, Rebecca, Beth Dingman, Barbara Hirchfild, Claudia McKay, and Amelia Sereen. *Spring Festival for Women: A Feminist Haggada*. Lebanon, NH: New Victoria Publishers, 1984.

Buckingham, Betty Jo, and Jean Lichty Hendricks, eds. *Women at the Well: Expressions of Faith, Life and Worship Drawn from Our Own Wisdom*. Elgin, IL: Woman's Caucus of Church of the Brethren, 1987.

Chamberlain, Gary. *The Psalms: A New Translation for Prayer and Worship*. Nashville: Upper Room, 1984.

Clark, Linda, Marian Ronan, and Eleanor Walker. *Image-Breaking/Image-Building: A Handbook for Creative Worship with Women of Christian Tradition*. New York: Pilgrim Press, c1981.

Craighead, Meinrad. *The Mother's Songs: Images of God the Mother*. New York: Paulist Press, 1986.

Duck, Ruth C., ed. *Bread for the Journey: Resources for Worship*. New York: Pilgrim Press, c1981.

Duck, Ruth C., and Mike G. Bausch, eds. *Everflowing Streams*. New York: Pilgrim Press, 1981.

Kirk, Martha Ann, and Colleen Fulmer. *Celebrations of Biblical Women's Stories – Tears, Milk and Honey*. Kansas City, MO: Sheed and Ward, 1987.

Leach, Maureen, and Nancy Schreck. *Psalms Anew: A Non-Sexist Edition*. Dubuque, IA: Sisters of St. Francis, 1984.

Levine, Ronnie, and Diann Neu. *A Seder for the Sisters of Sarah*. Silver
Spring, MD: Woman's Alliance for Theology, Ethics and Ritual,
1985.

Moore, Grace. *The Advent of Women*. Valley Forge, PA: Judson Press,
1975.

Neu, Diann, ed. *Women Church Celebrations: Feminist Liturgies for the
Lenten Season*. Silver Springs, MD: Woman's Alliance for Theology,
Ethics and Ritual, 1985.

Neufer Emswiler, Sharon, and Thomas Neufer Emswiler. *Sisters and
Brothers Sing!* 1975. Order from: Wesley Foundation, 211 N. School
St., Normal, IL 60761.

— *Wholeness in Worship*. San Francisco: Harper and Row, c1980.

— *Women and Worship: A Guide to Non-Sexist Hymns, Prayers, and Litur-
gies*. New York: Harper and Row, 1974.

New Jersey Agenda, comp. *The Shalom Seders: Three Haggadahs*. New
York: Adama Books, 1984.

Reifman, Toby Fishbein, and Ezrat Nashim, eds. *Blessing the Birth of a
Daughter: Jewish Naming Ceremonies for Girls*. [Englewood Cliffs, NJ]:
Ezrat Nashim, c1976.

Schaffran, Janet, and Pat Kozak. *More Than Words: Prayer and Ritual for
Inclusive Communities*. Oak Park, IL: Meyer Stone Books, 1988.

Sing a Womansong [50 original songs, with words and music]. Chicago:
Ecumenical Women's Centre, 1975.

Swidler, Arlene, ed. *Sistercelebrations: Nine Worship Experiences*. Philadel-
phia: Fortress Press, 1974.

Watkins, Keith. *Faithful and Fair: Transcending Sexist Language in Worship*.
Nashville: Abingdon Press, 1981.

Winter, Miriam Therese. *Woman Prayer, Woman Song: Resources for
Ritual*. Oak Park, IL: Meyer Stone Books, 1987.

ARTICLES, BOOK REVIEWS

Burns, Gail. 'The First Saturday in May' [celebrate women service], *New
Catholic Times*, Vol. 11, No. 10 (May 17, 1987), p. 16.

Chinnici, Rosemary. 'Review of *Woman Prayer, Woman Song*, by Miriam
Therese Winter,' *Worship*, Vol. 62, No. 2 (Mar. 1988), pp. 182–183.

Dunstan, Sylvia. 'An Outline for Worship,' *Exchange: For Leaders of
Adults*, Vol. 11, No. 2 (Winter 1987), p. 33.

Faus, Nancy Rosenberger. 'Review of *Women at the Well: Expressions of
Faith, Life and Worship Drawn from Our Own Wisdom*, Betty Jo Buck-
ingham and Jean Lichty Hendricks, eds.,' *Brethren Life and Thought: A*

Quarterly Journal Published in the Interests of the Church of the Brethren, Vol. 33 (Winter 1988), pp. 68–69.

Fetter, Judy. 'A Hymn,' *Exchange: For Leaders of Adults*, Vol. 10, No. 2 (Winter 1986), p. 34.

Johnson, Lieurance Kathy. 'Liturgy of Reconciliation between Men and Women,' *Witness*, Vol. 62, No. 7 (July 1979), pp. 14–16.

Keefe, Donald Joseph. 'Gender, History, and Liturgy in the Catholic Church,' *Review for Religious*, Vol. 46, No. 6 (Nov.–Dec. 1987), pp. 866–881.

Kirk, Martha Ann. 'Blest Are You amongst Women and Blest Are Other Women Too,' *Modern Liturgy*, Vol. 9, No. 3 (May 1982), pp. 34–35.

Kuenning, D. 'Feminists Challenge Traditional Catholic Belief and Worship,' *Our Sunday Visitor Magazine*, Vol. 64 (Feb. 15, 1976), p. 1.

Lesher, A. Jean. 'Lutheran Woman and Creative Worship,' *Christian Century*, Vol. 94, No. 25 (Aug. 3–10, 1977), pp. 697–700.

Logan, Marion, and Barbara Riley. 'Who Shall Inherit the Earth? Bless the Meek for They Shall Inherit the Earth,' *Exchange: For Leaders of Adults*, Vol. 8, No. 2 (Winter 1984), pp. 40–43.

MacDonald, Elizabeth. 'Our Lenten Journey: Light along the Way,' *Exchange: For Leaders of Adults*, Vol. 11, No. 2 (Winter 1987), pp. 31–32.

McMurtry, Joan. 'A Non-Sexist Model for Christian Worship,' *Perspective*, Vol. 3, No. 3 (Aug. 1979), p. 3.

Neu, Diann. 'Our Name Is Church: The Experience of Catholic-Christian Feminist Liturgies,' in *Can We Always Celebrate the Eucharist?* (Concilium, 152), ed. by Mary Collins and David Powers, pp. 75–86. Edinburgh: T. and T. Clark, 1982.

Northup, Lesley Armstrong. 'The Woman as Presider: Images Drawn from Life,' *Worship*, Vol. 58, No. 6 (Nov. 1984), pp. 526–530.

Park, Sandra Winter. 'ERA Liturgy' [Campus Ministry Women; Chicago, April 22, 1982], *Journal of Women and Religion*, Vol. 2, No. 1 (Spring 1982), pp. 49–56.

Proctor-Smith, Marjorie. 'Liturgical Anamnesis and Women's Memory,' *Worship*, Vol. 61, No. 5 (Sept. 1987), pp. 405–424.

Schrom, Mary. 'When a Woman Presides,' *Modern Liturgy*, Vol. 11, No. 8 (Nov. 1984), pp. 10–11.

Smith, Christine Marie. 'Worship, the Sacred Act of Weaving,' *Journal of Women and Religion*, Vol. 3, No. 2 (Summer 1984), pp. 17–23.

Turcott, Betty. 'A Worship Service for Women,' *Exchange: For Leaders of Adults*, Vol. 5, No. 3 (Spring 1980), pp. 41–43.

Walton, Janet. 'Ecclesiastical and Feminist Blessing: Women as Objects

and Subjects of the Power of Blessing,' in *Blessing and Power* (Concilium, 178), ed. by Mary Collins and David Power, pp. 73–80. Edinburgh: T. and T. Clark, 1985.

'A Worship Service' [Responses of Women in Jesus' Parables], *Exchange: For Leaders of Adults*, Vol. 9, No. 1 (Fall 1984), p. 41.

'Worship Service of Women in the Bible,' *Exchange: For Leaders of Adults*, Vol. 8, No. 1 (Fall 1983), pp. 36–37.

OTHER RELATED RESOURCES

Chamberlain, Rita, and Shelley Davis Finson. *Our Ministry, Our Lives.* Toronto: Produced for the United Church of Canada by the Division of Mission in Canada, 1982.

Churches in Solidarity with Women: Worship and Meditation Resources for the Ecumenical Decade 1988–1998. Geneva: World Council of Churches, 1989.

Eberhart-Moffat, Elizabeth. 'Uniting Body and Spirit' [study guide and worship on sexuality], *Exchange: For Leaders of Adults*, Vol. 9, No. 2 (Winter 1985), pp. 15–18.

Gjerdung, Iben, and Katherine Kinnamon. *No Longer Strangers* [a resource for women and worship]. Geneva: World Council of Churches, 1986.

Bibliographies, Journals, and Newsletters

Bibliographies

American Theological Library Association Preservation Board. *Women and the Church in America: A Collection of 19th Century Resources*. [n.p.], 1987.

Barnhouse, R.T., Michael Fanes, Bridget Oram, and Bailey Walker. 'The Ordination of Women to the Priesthood: An Annotated Bibliography,' *Anglican Theological Review, Supplementary Series*, No. 6 (June 1976), pp. 81–106.

Bass, Dorothy C. *American Women in Church and Society 1607–1920: A Bibliography*. New York: Auburn Theological Seminary, 1973.

Bass, Dorothy C., and Sandra H. Boyd. *Women in American Religious History: An Annotated Bibliography*. Boston: G.K. Hall, 1986.

Brewer, Joan Scherer. *Sex and the Modern Jewish Woman: An Annotated Bibliography*. Essays by Lynn Davidman and Evelyn Avery. Fresh Meadows, NY: Biblio Press, 1986.

Cantor, Aviva. *A Bibliography on the Jewish Woman: 1900–1978*. New York: Biblio Press, 1976.

Carson, Anne. *Feminist Spirituality and the Feminine Divine: An Annotated Bibliography*. Trumansburg, NY: Crossing Press, c1986.

Choquette, Diane. *The Goddess Walks among Us: Feminist Spirituality in Thought and Action: A Select Bibliography*. Berkeley, CA: Graduate Theological Union Library, 1981.

Conn, Harvie M. 'Evangelical Feminism: Bibliographical Reflections on the State of the Union,' *Westminster Theological Journal*, Vol. 46, No. 1 (Spring 1984), pp. 104–124.

Durka, Gloria. 'Feminist Images' [books for religious educators; annotated], *Religious Education*, Vol. 79, No. 1 (Winter 1984), pp. 137–140.

Engelsman, Joan Chamberlain. 'Patterns in Christian Feminism: A Bibliographic Essay,' *Drew Gateway*, Vol. 56, No. 1 (Fall 1985), pp. 1–15.

Frasier, Ruth F., ed. *Women and Religion: A Bibliography Selected from the ATLA Religion Database*. 3rd rev. ed. Chicago: American Theological Library Association, 1983.

Frey, Linda, Marsha Frey, and Joanne Schneider. *Women in Western European History: A Select Chronological, Geographical and Topical Bibliography: The Nineteenth and Twentieth Centuries*, pp. 16–37, 156, 223–225, 523, 574, 662–664, 697. Westport, CT: Greenwood Press, 1982.

Honig, A.G. 'Asian Women Theology' [list of 30 conferences on Asian Christian women], *Exchange: Bulletin of Third World Christian Literature*, Vol. 16 (Sept. 1987), pp. 1–49.

Ignatius, L. Faye. 'Feminism Bibliography,' *Foundation: A Baptist Journal of History, Theology and Ministry*, Vol. 24 (July–Sept. 1981), pp. 264–275.

Jongeling, M.C. 'Indonesian Theologians on Women-Men Relationships in Church and Society' [annotated], *Exchange: Bulletin of Third World Christian Literature*, Vol. 16 (Sept. 1987), pp. 49–67.

Kendall, Patricia A. *Women and the Priesthood: A Selected and Annotated Bibliography*. Pennsylvania: Committee to Promote the Cause of and to Plan for the Ordination of Women to the Priesthood, Episcopal Diocese of Pennsylvania, 1976.

Kleiner, Heather J. *Towards a Wholistic Theology: A Christian Feminist Bibliography*. Saskatoon: Lutheran Theological Seminary, 1983.

Kléjment, Anne, and Alice Kléjment. *Dorothy Day and the Catholic Worker: A Bibliography and Index*. New York: Garland, 1986.

Langley, Wendell E., and Rosemary Jermann. 'Women and the Ministerial Priesthood: An Annotated Bibliography,' *Theology Digest*, Vol. 29, No. 4 (Winter 1981), pp. 329–342.

Muldoon, Maureen. *Abortion: An Annotated Indexed Bibliography* (Studies in Women and Religion, 3). Lewiston, NY: E. Mellen Press, 1980.

Pethick, Jane. *Battered Wives: A Select Bibliography*. Toronto: Centre of Criminology, University of Toronto, 1979.

Richardson, Marilyn. *Black Women and Religion: A Bibliography*. Boston: G.K. Hall, 1980.

Storrie, Kathleen. 'Contemporary Feminist Theology: A Selective Bibliography,' *TSF Bulletin*, Vol. 7, No. 5 (May–June 1984), pp. 13–15.

Szasz, Ferenc M. 'An Annotated Bibliography of Women in American Religious History: The Christian Tradition 1607–1900,' *Iliff Review*, Vol. 40 (Fall 1983), pp. 41–59.

Tardiff, Mary. 'Bibliography: Rosemary Radford Ruether,' *Modern Churchman*, Vol. 30, No. 1 (1988), pp. 50–55.

Thomas, Evangeline, Joyce L. White, and Lois Wachtel, eds. *Women Religious History Sources: A Guide to Repositories in the United States.* New York: R.R. Bowker, 1983.

World Council of Churches. *Bibliographies in Four Languages on the Community of Women and Men in the Church Study.* Geneva: World Council of Churches, 1980.

Journals

Journal of Feminist Studies in Religion, Scholars Press, New York

Journal of Women and Religion, Centre for Women and Religion of the Graduate Theological Union, 2465 La Conte Ave., Berkeley, CA 94709

Vox Benedictina, St. Peter's Press, Meunster, Saskatchewan

Newsletters

L'Autre Parole, Feuillet de liaison pour féministes chrétiennes du Québec depuis septembre 1976. Université du Québec à Montréal, C.P. 393, Succursale 'C,' Montreal, PQ, H2L 4K3

CCWO: Canadian Catholics for Women's Ordination, Newsletter, Box 242, Station Q, Toronto, ON, M4T 2M1

Centre Canadien de Recherches sur Femmes et Religions/Canadian Centre for Research on Women and Religion, Université d'Ottawa/University of Ottawa, Sciences Religieuses/Religious Studies, 177 Waller, Ottawa, ON, K1N 6N5

The Church Woman, Church Women, United, 475 Riverside Drive, Room 812, New York, NY 10115

Claiming Our Gifts, Women in Ministry Project, American Baptist Churches, 475 Riverside Drive, Room 1700, New York, NY 10115

Common Lot, United Church of Christ, 105 Madison Ave., New York, NY 10016. Subscription information: Marilyn Breitling, Coordinating Center for Women, 1400 North 7th, St. Louis, MO 63106

Daughters of Clara: A Newsletter for Clergywomen of the Christian Church (Disciples of Christ), 222 S. Downey, P.O. Box 1986, Indianapolis, IN 46206

Daughers of Sarah: A Magazine for Christian Feminists, 3801 N. Keeler, Chicago, IL 60641

The Disciple Woman, Division of Homeland Ministries, P.O. Box 1986, Indianapolis, IN 46206

Femmes et Hommes dans l'Église, Bulletin international publié depuis 1970, 14, rue Saint-Benoît, 75006 Paris, France

From a Women's Perspective: Committee on Women in Ministry, c/o The Board of Ministry, The Presbyterian Church in Canada, 50 Wynford Drive, Don Mills, ON, M3C 1J7

Journal of Women's Ministries, Council for Women's Ministries, The Episcopal Church Center, 815 Second Avenue, New York, NY 10017

Lutheran Woman Today, 426 South 5th St., Minneapolis, MN 55440

Miriam's Song, Priests for Equality, P.O. Box 5243, West Hyattsville, MD 20782

The Newsletter, Association of Professional Church Workers, Anglican and United Churches of Canada, Centre for Christian Studies, 77 Charles St. West, Toronto, ON, M5S 1K5

Newsletter, Women's Inter-Church Council of Canada, 77 Charles St. West, Toronto, ON, M5S 1K5

Newsletter from Canadian Women and Religion, 1332 Osler Street, Saskatoon, SK, S7N 0V2

New Witnesses, The United Methodist Center, Division of Ordained Ministry, Board of Higher Education and Ministry, P.O. Box 871, Nashville, TN 37202

New Woman, New Church, Newsletter of the Women's Ordination Conference, P.O. Box 29124, Washington, DC 20017

No Name Newsletter, A newsletter sponsored by the National Women in Ministry Committee. Division of Ministry Personnel and Education, The United Church of Canada, 85 St. Clair Ave. East, Toronto, ON, M4T 1M8

Sharing (Presbyterian Church, USA), Office of Women in Ministry, The Vocation Agency, 475 Riverside Drive, Room 406, New York, NY 10115

South of the Garden, Resource Center for Women and Ministry in the South, Inc., P.O. Box 1365, Greensboro, NC 27402

The Unbeaten Path. A collection of articles, thoughts, poetry, humour, and news items for Christian feminist women. Saskatchewan Conference Office, The United Church of Canada, 1805 Rae St., Regina, SK, S4T 2E3

United Church of Christ Clergywomen's Network, June Gowdey, c/o Marilyn Breitling, Coordinating Center for Women, 1400 North 7th, St. Louis, MO 63106

Water, The Women's Alliance for Theology, Ethics and Ritual (WATER), 8035 13th Street, Silver Spring, MD 20910

The Well Woman: Lutheran Women's Caucus, 1100 East 55th Street, Chicago, IL 60615

The Woman's Pulpit: Official Journal of the International Association of Women Ministers, 579 Main Street, Stroudsburg, PA 18360

Women in a Changing World, World Council of Churches, 150, route de Ferney, 1211 Geneva 20, Switzerland

Women in Ministry Newsletter, Women in Ministry Community, ANW Conference, Lori Crocker, Box 1204, Innisfail, AB, T0M 1A0

Women's Concerns. A Quarterly distributed by Ministry with Adults – Women, Division of Mission in Canada, United Church of Canada, 85 St. Clair Ave. East, Toronto, ON, M4T 1M8

Author Index